Tales from the Land of Dragons:

1,000 Years of Chinese Painting

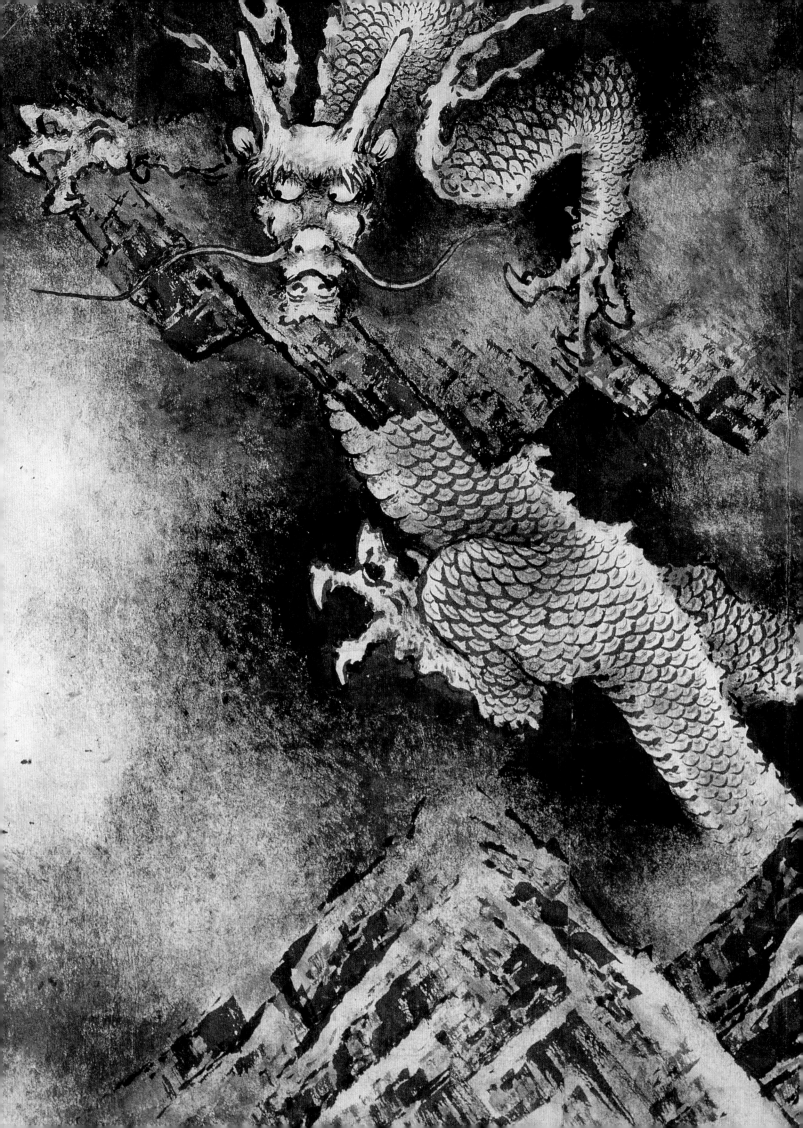

Tales from the Land of Dragons:

1,000 Years of Chinese Painting

WU Tung

Museum of Fine Arts, Boston

MFA Publications

a division of the Museum of Fine Arts, Boston

465 Huntington Avenue

Boston, Massachusetts 02115

www.mfa-publications.org

For a complete listing of MFA Publications, please
contact the publisher at the above address, or call
617 369 3438.

Designed by Carl Zahn

Edited by Carl Nagin and Brian Hotchkiss

Photographs by Photographic Services Department,
Museum of Fine Arts, Boston

Printed by C&C Offset, Hong Kong

Cover, jacket illustrations, and frontispieces:
Cat. 92. Chen Rong (act. first half 13th century).
Nine Dragons (details). Francis Gardner Curtis Fund
17.1697

Second printing, 2003

Available through D.A.P. / Distributed Art Publishers

155 Sixth Avenue, 2nd Floor

New York, New York 10013

Tel.: 212 627 1999 Fax: 212 627 9484

Printed in China

Table
of
Contents

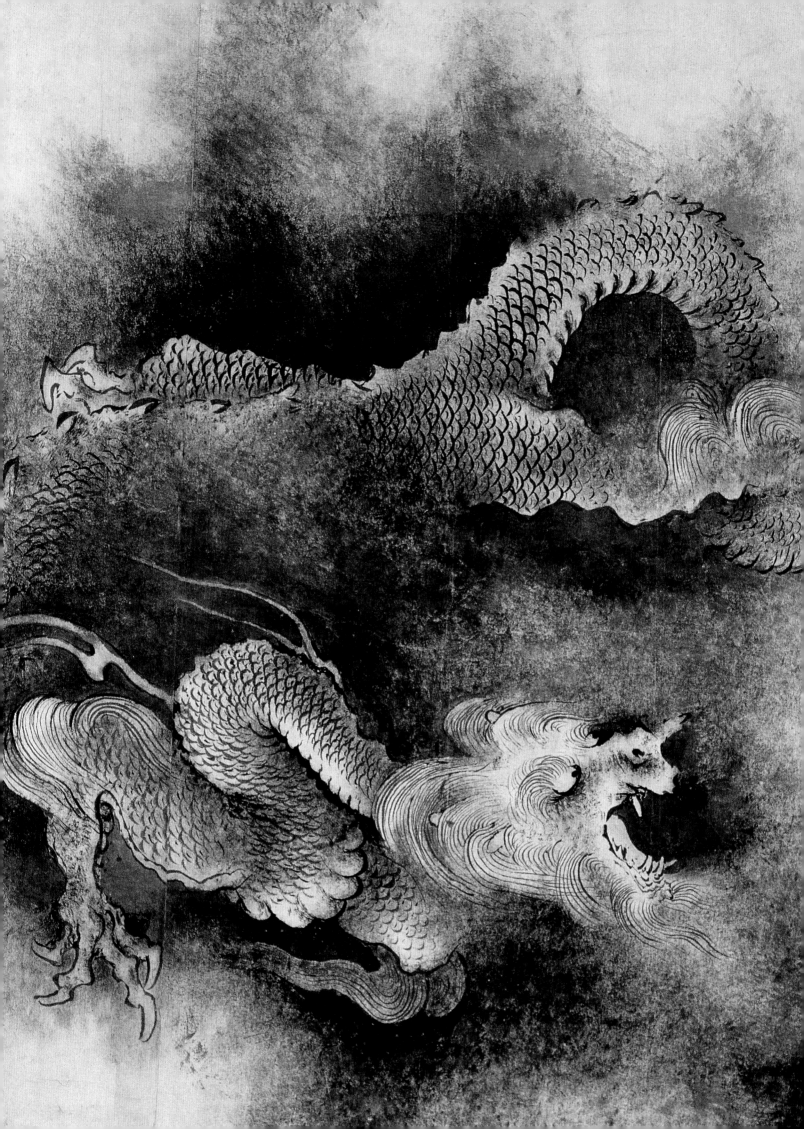

Director's Foreword

As part of its ancient cultural heritage, China nurtured the world's oldest continuous painting tradition. This aesthetic achievement enshrines thousands of years of history and legends, customs and religious beliefs, as well as distinctive views of art, nature and society. The Museum of Fine Arts, Boston is renowned throughout the world for its extensive collection of early Chinese painting. This is the first time that these masterpieces from our collection have been shown together in a comprehensive exhibition, *Tales from the Land of Dragons*. The exhibition highlights how, over a century, Bostonians have gathered together a superb collection of classical painting from a country that has intrigued and enticed so many New Englanders since the days of the China Trade. That fascination with Chinese culture coupled with the dedication and scholarship of three late curators of the Asiatic Department, Ernest Fenollosa, Okakura Tenshin and Kojiro Tomita, enabled the MFA to acquire many of these great works. Today, a thriving Asian community has made New England its home, and the Museum welcomes large numbers of visitors from many Asian countries daily. It has therefore been foremost in my thoughts to showcase in our major exhibition space, one of the Museum's heretofore hidden treasures.

The Museum has worked to carry out this mission, producing several special exhibition programs for the different needs and interests of the visiting public. Bilingual materials and bilingual gallery talks will be provided for the convenience of New England's Chinese communities. Special lectures by two leading Chinese painting scholars have been scheduled during the exhibition period, from April to July 1997. A program of documentaries on Chinese art and culture, as well as new movies from China, Hong Kong and Taiwan will be screened as well. *Tales from the Land of Dragons* demonstrates the collective effort and collaboration of many sectors and individuals within and outside the Museum. We are especially grateful to Fidelity Investments whose generous support through the Fidelity Foundation was instrumental in making this exhibition possible.

Malcolm Rogers
Ann and Graham Gund Director

April 1997

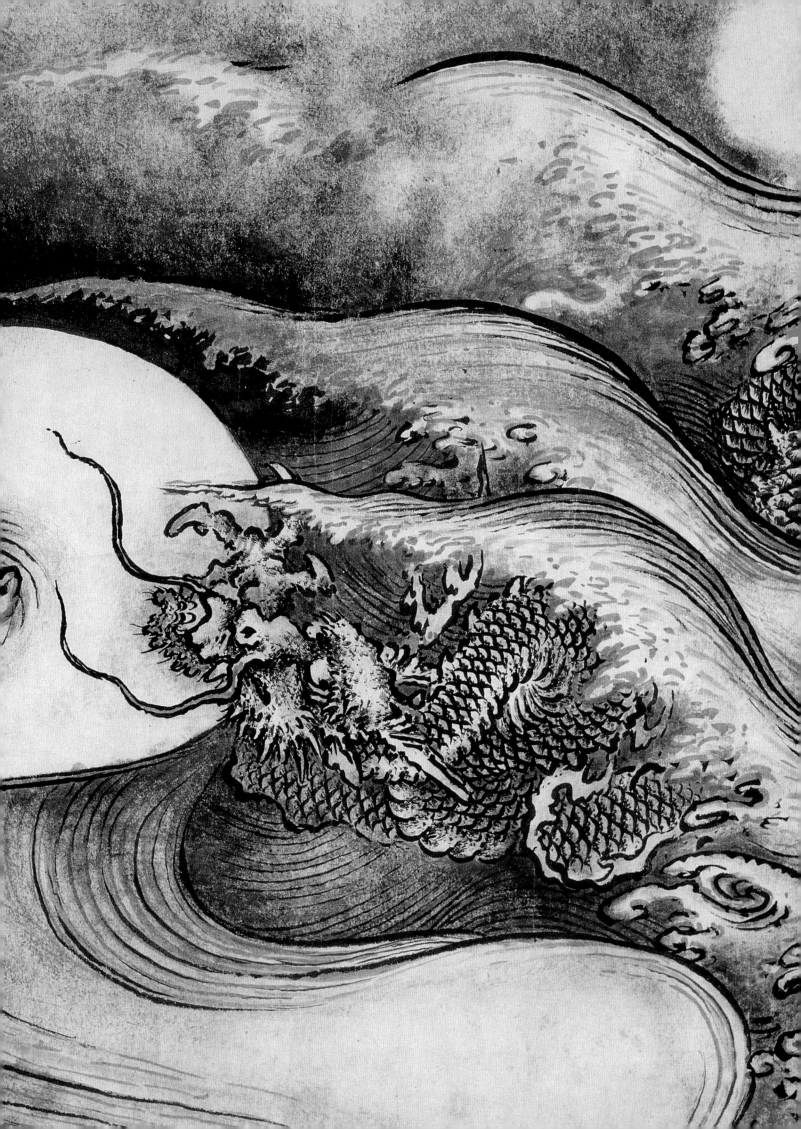

Preface
and
Acknowledgments

Ever since the 1961 exhibition of Chinese imperial treasures from Taiwan's National Palace Museum, which was presented in Boston and four other cities in the United States, American interest in Chinese painting has dramatically increased. Today, public and private holdings of Chinese painting in the United States as well as academic programs at universities here have surpassed their European counterparts, making this country a center for the study and appreciation of China's artistic and cultural traditions. In response to a call by Malcolm Rogers, Ann and Graham Gund Director, to share the Museum's rich collection with the public, the staff of the MFA has organized *Tales from the Land of Dragons: 1,000 Years of Chinese Paintings*—our first comprehensive exhibition of early Chinese painting in nearly a century. The title of this exhibition and its catalogue was chosen, in part, due to the many dragons depicted in paintings presented here, but also in recognition of the traditional Chinese belief that they are the descendants of the mighty *Long*, which is translated into English as "dragon."

Among numerous American collections of Chinese painting, that of the Museum of Fine Arts, Boston, represents a unique assemblage, notable for its quality, breadth, and quantity. The rarity of individual works like *The Thirteen Emperors* (cat. 3), is evidence of the collection's importance not only for scholars but for all who share a fascination with Chinese culture. This outstanding early Chinese figure painting is significant not only because it is the oldest Chinese handscroll currently in any American collection, but also because it is the only extant example of its genre and subject matter—a depiction for a didactic purpose of a series of emperors from various dynasties—anywhere in the world. The strength of Boston's Chinese painting collection lies not only in the quality of such early works but also in its broad representation of early periods of Chinese painting, namely the Tang, Song, and Yuan dynasties. Equally important are its numerous examples of early Chinese Buddhist and Daoist art. In this respect, Boston's is something of an anomaly among other American museum collections: Many of our Chinese paintings were acquired from old collections in Japan. Thus, to some extent, our holdings reflect Japanese rather than traditional Chinese tastes in collecting. The Museum's set of *Ten Lohan Paintings from Daitoku-ji* (cat. 34–43), for example, was originally created by professional artists in China and then acquired by Japanese temples in the early thirteenth century. Because Chinese scholar-collectors traditionally disdained such painting by professional artisans, works like these can no longer be found in China.

The 153 paintings selected for the present exhibition reflect these unique characteristics of the Museum's collection. More than a third of the works on display treat Buddhist or Daoist subject matter. Most of the round fans and album leaves were, at one time, mounted in the Japanese *kakemono* style as small hanging scrolls, and were included by Japanese tea masters in their ceremonies and rituals. Other great early masterworks were the proud acquisitions of our early curators, obtained in the Far East as paintings that had once been in the imperial collection of the Manchu Emperor Qianlong (r. 1736–95).

The Museum's success in obtaining early Chinese painting is due to the tremendous generosity of collectors as well as the far-sighted vision of trustees and directors who gave full support to curators in search of rarity and excellence. The former are exemplified by two outstanding trustee-collectors, William Sturgis Bigelow and Denman Waldo Ross, both of whom bequeathed their Chinese paintings to the Department of Asiatic Art. The latter are represented by such connoisseur-curators as Ernest Fenollosa, Okakura Tenshin, John Lodge, Kōjirō Tomita, and Hsien-chi Tseng. Together, over a period of eighty years (1889–1969), they built an impressive collection of Chinese paintings for which the Museum is internationally renowned.

This catalogue has been written for both the general public and specialists in the field. Its introductory essay provides general background for readers less familiar with the techniques, cultural context, and stylistic development of Chinese painting.

The 153 catalogue entries provide more detailed research into art historical issues surrounding the quality, authenticity, dating, and subject matter of each individual work. The catalogue's appendix consists of black-and-white illustrations of 80 additional Chinese paintings from our collection. The selection of these works was based on earlier attributions assigned by previous owners that continued to be accepted after they entered the Department's collection. In writing captions for this appendix, we tried to provide approximate dates and attributions for each of the pieces; these should not be regarded as definitive or final.

To complement the paintings, we have included in the exhibition a selection of calligraphic works as well as three-dimensional artifacts from the major periods of Chinese history and culture. All except three of these works are from the Museum's collection. Viewers will thus have an opportunity to examine the impact of Chinese painting upon a variety of other Chinese art works.

The staff of the Department of Asiatic Art, administrative, conservational, and curatorial, diligently worked together as a team on this splendid project. I especially wish to thank Zoë Adler for her project coordination. We sincerely wish to express our indebtedness to our Museum colleagues: to Malcolm Rogers for his encouragement and personal participation in the preparation of this exhibition; to Brent Benjamin, Deputy Director for Curatorial Affairs, for his supervision; to Carl Zahn, former Director of Publications and Design, and Susan Wong, Head Exhibition Designer, for their great efforts in producing the catalogue and the exhibition; to Arthur Beale, Richard Newman, and Pam Hatchfield of the Objects Conservation and Scientific Research Department, for their help with the conservation of the three-dimensional objects; to Janice Sorkow of MFA Enterprise, and Gary Ruuska and Tom Lang of the Photo Studio for the timely production of high-quality transparencies and photographs; to Pat Jacoby and Paul Bessire in Development and Marketing for their fund raising efforts; to Bill Burback, Barbara Martin, and Tamsen George in the Education Department for outreach; to Katie Getchell, Director of Exhibitions and Design, for coordinating the project; to David Geldart and his Facilities staff for their efforts in mounting the exhibition; and to the Friends of Asiatic Art for their continued support.

I gratefully acknowledge the vital support the exhibition has received from many contributors: Fidelity Investments through the Fidelity Foundation; the E. Rhodes and Leona B. Carpenter Foundation and the Cornelius Van Der Starr Foundation for grants to support the conservation and documentation that facilitated the exhibition. I am grateful to Dr. Eugene Wu of the Harvard-Yenching Library for making his rare books available to this project. A special appreciation goes to my two readers: Professor Richard Edwards and Dr. Jan Fontein for reviewing the manuscript and giving scholarly advice throughout the project. In the same regard, I am much indebted to the editors Carl Nagin and Brian Hotchkiss for their tremendous effort in refining my English prose. Mr. Nagin also produced text for the maps, time line, and glossary. His involvement was particularly instrumental not only in the writing of this catalogue, but also of the earlier volume entitled *Masterpieces of Chinese Painting from the Museum of Fine Arts, Boston: Tang through Yuan Dynasties,* published by Otsuka Kogeisha Co., Ltd., upon which most of the entries in this catalogue are based. Finally, I want to express my deepest gratitude to my wife, Chin Ying, East Asian Art Librarian at Harvard University, for her unfailing support, extraordinary patience, and scholarly input throughout the research and writing of this work.

WU Tung
Matsutaro Shoriki Curator of Asiatic Art

April 1997

The Lure
of
Antiquity

China can claim as part of its cultural heritage the world's oldest continuous painting tradition—a history that encompasses more than twenty-five hundred years of works on silk or paper. If one includes classical literary references to painting, and modern archaeological evidence of mural fragments from ruins, it is possible to extend this heritage even farther into antiquity. Defining features of its continuity were the reverence for ancient masters held by later artists and the transmission and transformation of classical styles of painting and calligraphy. The oldest extant critical theory of painting in China dates from the fifth century A.D., roughly a thousand years before Leon Battista Alberti's *On Painting,* the first surviving European painting treatise.[1] As one of six aesthetic criteria, its author Xie He (act. late fifth century) emphasized the notion of transmitting the spirit, not just the form, of old paintings when replicating or making copies. The time-honored Chinese practice of copying to capture the "spirit resonance" of ancient masterworks is one reason for the survival of classical styles, many of which are known today only through period-style copies or imitations.

Chinese connoisseurs call old paintings *gu hua.* In this phrase, *gu* means "ancient" or "classical," and elsewhere refers broadly to antiquity—both the historical and the mythological past. But the continuity of Chinese painting traditions was sustained by more than the practice of copying or even a generalized reverence for antiquity. It was the outgrowth of several related cultural forces. Of these, the most striking was the close affinity between painting and the art of calligraphy, China's distinctive writing system, which can be traced as far back as the Shang dynasty (sixteenth–eleventh century B.C.) if not earlier. As an art form, calligraphy was held in the highest esteem by China's earliest connoisseurs, who derived their critical emphasis on brushwork from calligraphic paradigms. The evolution of calligraphy in style and technique had enormous impact on aesthetic trends in painting. During the reign of Emperor Huizong (r. 1101–25), calligraphy, poetry, and painting—which the Chinese referred to as *san jue,* the Three Perfections—were combined as a unified form of artistic expression, a synthesis that remains one of China's most exemplary contributions to the world history of art. The interplay of brushwork in calligraphy and painting helped spawn this marriage of word and image as well as the early appearance of abstraction in the motifs of Chinese landscape painting.

The lure of antiquity in painting traditions and styles had even earlier cultural sources, the most ancient of which was the indigenous cult of ancestor worship, an expression of which appears in the ritual vessels and ceremonial practices of China's Bronze Age in the second and first millennia B.C. This religious reverence for the past grew from clan and family loyalties, a notion of *gu* that evolved into the Confucian ethos of filial piety.

A third factor contributing to the authority of antiquity was the Chinese preoccupation with historical cycles. Across the broad sweep of its

history, China expanded and disintegrated, dynasties rose and fell, empire building gave way to withdrawal and isolation; the Mandate of Heaven withered under corrupt and ineffectual rulers, and the Middle Kingdom, as China called itself, perennially threatened by nomadic invaders, absorbed and sinicized these foreign cultures. To understand these cycles of transformation and to promote a sense of national identity and shared cultural heritage, China's rulers and thinkers sought a vantage point, some memorialized place of return, idealized in a variety of "Golden Ages," known as *gu dai* (ancient dynasties), whose harmony and enlightened order could provide a model for the next turn of history's wheel. In philosophy, statecraft, and the arts, emperors and officials, sages and scholars, poets and painters, looked back to these classical ages for authority, inspiration, and guidance.

Paintings could enhance an emperor's mandate. As the ninth-century connoisseur Zhang Yanyuan observed, some ancient scrolls and palace wall paintings functioned as didactic symbols of authority. Such official art served "to perfect the civilizing teachings [of the sages] and to help [illustrate] social relationships."[2] One painter who created such works was Yan Liben (d. 673), a high minister and portraitist at the court of Emperor Taizong (r. 626–49), one of the founding rulers of the Tang dynasty. The Boston Museum's *Thirteen Emperors* (cat. 3), which is attributed to Yan Liben, is a work such as those recorded by Zhang Yanyuan. It is the earliest Chinese handscroll in any American collection and the only surviving example of this genre that depicts ancient sages and emperors for the moral edification of the imperial family.

Classical Tradition and the Confucian Imperative

The tradition of didactic painting had philosophical roots in the teachings of Confucius (551–479 B.C.), the most ardent advocate of the ideal of *fu gu* (return to antiquity). The Confucian paradigm was both historical and ethical, modeled after ancient sage–kings whose example Confucius memorialized as beacons of enlightened rule and moral conduct. Confucius himself lived in a feudal world in which factious nobles and clans struggled for power in rival states. The declining fortunes of Confucius' own aristocratic family typified the precarious nature of the nobility toward the end of China's Bronze Age. He idealized early kings of the Western Zhou dynasty (eleventh century–771 B.C.), who lived five hundred years before him. Returning to their ways was the Confucian imperative for a more just, humane, and harmonious society than the chaotic world of his own time. Reverence for these ruler-sages of antiquity was the essence of Confucian *fu gu,* and Confucius tried in vain to find a ruler who would follow such ideals.

Following his death, disciples of Confucius compiled many of his sayings in a collection known as *Lunyu* or the *Analects.* Later generations, particularly the emperors, virtually deified him, developing a cult replete with votive icons, temples, and ritual ceremonies of worship. But beyond such quasi-theocratic permutations of his original teachings, mainstream Confucianism was above all a philosophy of human relationships intended to guide every member of Chinese society, from the humblest peasant to the most powerful emperor. Its precepts stressed concepts like *xiao* (filial piety), *li* (etiquette), *ren* (human kindness), and a

code of behavioral norms suitable for the cultivated gentleman, or *junzi*. From the Han dynasty (206 B.C.–A.D. 220) onward, Confucianism formed the foundation for the imperial bureaucracy, most notably the system of civil service examinations that theoretically allowed a man of letters, or *wenren*, to serve the state and rise according to the merit of his learning and character. With Confucianism the official state ideology of Han rulers, his teachings in turn entered the canon of court-prescribed classics that generations of scholars and officials would study, memorize, and follow. It was from this literati class that many of China's greatest artists emerged, including such emblematic figures as Su Shi (1036–1101) and Mi Fu (1051–1107), both of whom defined Confucianist norms of artistic taste during the Song dynasty (960–1279). The Boston Museum's *Northern Qi Scholars Collating Classic Texts,* a masterpiece of Northern Song figure painting, (cat. 9; also see discussion on pages 16–17), reflects the impact of that classical canon, just as *Tales from History and Legends* (cat. 1), the narrative scenes on the much earlier Western Han-dynasty tomb tiles, reflect Confucian ideals of righteousness and etiquette. For more than two millennia, Confucianism remained imbedded in mainstream Chinese thought, with the preservation of classical traditions of art and literature, philosophy and history, a prime responsibility of elite scholar-officials.

The Eternal *Dao*

Alongside Confucianism, another system exercized a no less-powerful hold on China's literati—the philosophical teachings of Daoism. Its founder, Laozi (act. sixth century B.C.), a contemporary of Confucius, and Daoism's other great sage, Zhuangzi (ca. 369–ca. 286 B.C.), envisioned a less-historical idea of antiquity, one reflected in the mythos of primordial time. The term *Dao,* or Way, appears in both teachings. If the Confucian *Dao* emphasized behavioral norms for the individual, family, state, and public life, Daoism emphasized the inner life, with Nature rather than human history as the true Way. While Confucius and his disciples stressed reason and moral conduct, Daoist sages espoused a more intuitive path to tranquility and Enlightenment. They argued that the true *Dao* could not be described or explained, as followers of Confucius attempted to do. For Daoists, it was manifest in the changing forms and eternal laws of Nature—whether the inward-outward rhythms of breathing or the Yin and Yang of Earth and Heaven. It was embodied in the *qi,* or spirit-energy, of a rock, the evanescent mists and clouds of mountain peaks, or the roaring thunder of a waterfall—the animating breath of life itself.

In painting, one of the more arresting attempts to combine Daoist metaphysics and aesthetics appears in the Museum's *Nine Dragons* handscroll (cat. 92), completed in 1244 by the Southern Song literatus Chen Rong (act. first half of thirteenth century). The artist was a failed Confucian scholar–official who relieved his frustrations with political life by painting fierce dragons—archetypal symbols in Daoist cosmology of what Boston's late curator Okakura Kakuzo (1862–1913) called "the spirit of change . . . the great mystery itself."[3]

Chen Rong's scroll depicts a series of dragon epiphanies amidst clouds, mists, craggy gorges, whirlpools, and fire—all manifestations of

the *Dao*. Their nine transformations mirror a supernatural world at work in stages of the creative process, which Chen Rong describes in his poem inscribed at the end of the painting. In a deliberately induced intoxicated state, the artist sought the kind of spontaneous expression and mind-altering experience characteristic of Daoist transcendental practices. His splash-ink technique and sweeping brushwork convey the untrammeled effects of this process. Later colophons by prominent Daoist teachers and priests praise its dynamism; one writer even interpreted the nine dragons as symbols of Laozi on his path to Enlightenment!

As Chen Rong's scroll suggests, the Eternal *Dao* transcended Man himself, even those historical paragons whose "Way of Virtue and Enlightened Rule" was so revered by Confucians. The Daoist Zhuangzi, for example, wrote of a paradisiacal time "when life was full and there was no history." In this more ancient *gu,* no "great men" were singled out and people "were honest and righteous without realizing they were 'doing their duty.' . . . They lived freely together, giving and taking, and did not know that they were generous. For this reason their deeds have not been narrated. They made no history."[4] By following the Eternal *Dao,* humankind could return to this natural state in which human history was insignificant. For Chinese painters, Daoist naturalism found a profound artistic expression in the monumental landscape art of Northern Song (960–1127) painters like Fan Kuan (act. late tenth–early eleventh century) and Guo Xi (ca. 1001–ca. 1090). Confucian and Daoist paradigms influenced the public and private worlds of the *wenren.* To be a complete person, the Chinese literatus, especially one who served the court, needed to incorporate elements of both Confucian and Daoist thought in their way of life. Chen Rong's career as an artist and scholar–official attests to the tensions those often contrasting demands could make. Taken from classical Chinese literature, the *Illustrations to Tao Qian's Prose Poem "Homecoming"* (cat. 89) provides a more celebrated example of a literatus who, at the age of forty-one, abandoned government service and returned to nature to live a simple, contemplative life. (His eccentricities included removing the strings from a zitherlike instrument called the *qin* so he could better appreciate the hidden meaning of its music!) Tao Qian (365–427) had served briefly as a district magistrate before adopting a more Daoist lifestyle, but this prototypical trajectory was, with some variations, carried on by a long line of poets, painters, and scholars. The literati struggled to balance Confucian ideals and rationalism on the one hand, with Daoist individualism and otherworldliness on the other—a tension that historically had political as well as aesthetic consequences.

Classical Traditions, East and West

The contrasting viewpoints of Daoist and Confucian thought show how the Chinese understood their past and its classical traditions in ways that were quite distinct from those in which they were approached in the West. Still, some basic parallels are worth considering. Both China and Europe preserved cultural legacies whose ideas and values continue to shape the development of their civilizations. Both were rooted in a canon of literary, philosophical, religious, and historical writings that

provided inspiration and authority for artists and scholars, rulers and commoners alike. Their aesthetic traditions also shared similar concerns and debates: The Chinese recognized parallels between poetry and painting just as Renaissance artists and thinkers rediscovered the analogy *ut pictura poesis* (as in painting, so in poetry) uttered by the Latin poet Horace. But in painting, the differences between East and West become more striking than the similarities, especially with regard to the impact of classical traditions. In Europe, Renaissance humanism was spawned by a literary rediscovery of the world of Greece and Rome that began in the late Middle Ages at a time roughly contemporary to China's Southern Song (1127–1279) and Yuan (1279–1367) dynasties. The revival of antiquity, so passionately articulated by Italian poets like Petrarch (1304–74), who was moved "beyond words" by the grandeur and ruins of ancient Rome,[5] had few, if any, visible referents in classical painting. Indeed, the revival of classical aesthetic ideals that so influenced the painting of fifteenth- and sixteenth-century Italy derived, at least in practice, from models that were exclusively sculptural and architectural. Renaissance painters like Raphael, who served as Inspector of Ancient Monuments and Excavations in Rome under Pope Leo X, had neither examples of paintings from antiquity nor manuals of ancient painting techniques and styles at their disposal.[6]

The case was altogether different in China as the aforementioned critical treatise by Xie He makes so clear. Chinese painters had pictorial models with which to sustain, copy, and sometimes reinvent their tradition. What literary evidence describes as norms in the fifth century are all the more evident from the twelfth century onward, when artists serving in the Song imperial painting academies regularly copied and imitated ancient masterworks. For example, the Museum's *Court Ladies Preparing Newly Woven Silk* (cat. 14), from the Northern Song Emperor Huizong's academy, was derived from a now lost Tang original by Zhang Xuan (act. 714–41). A body of literature on art history, brushwork, and connoisseurship and, more importantly, original classical scrolls and calligraphy were all available to Song literati. This corpus was far more extensive than what was known in the West about painting from its antiquity (as distinct, of course, from literature, sculpture, and architecture) during the Renaissance. As late as the Yuan dynasty, under Mongol rule, even those Chinese literati painters and calligraphers who, for political and moral reasons, retreated from public life and the court understood the ancient styles and brushwork that flourished nearly a millennium before them. The preservation of such art in Song imperial and private collections, either as original works or later copies, insured this remarkable continuity.

Perhaps the legacy of classical traditions in China can best be illustrated by looking at diverse examples of how Chinese artists used the past. Copying was but one method of *fu gu,* which was an aesthetic theme with many creative variations. More than six hundred years separated the archaistic revival by Yuan literati of the blue-and-green style (see cat. 150) from its Tang-dynasty (618–906) prototypes. The bright mineral colors and simple elegance of brushwork emulated from antiquity by artists like Zhao Mengfu (1254–1322), a Southern Song prince who elected to serve Mongol emperors, involved more than a slavish imitation of the past. Zhao Mengfu used ancient calligraphic techniques

derived from the writing style known as seal script and adapted them to motifs of tree trunks and rocks in such works as the *Mind Landscape of Xie Youyu* (Art Museum, Princeton University) and *Twin Pines, Level Distance* (Metropolitan Museum of Art, New York). Here again is an instance of how the close relationship of calligraphy and painting proved so critical in China's literati aesthetics. James Cahill has likened such continuous revival of "art based on art based on art" to Picasso's stylistic references to Hellenic styles or Stravinsky's musical quotations from the Baroque. With stylistic allusion as the foundation of this new Yuan artistic synthesis, an understanding of earlier traditions was necessary from both artist and audience.[7]

For some Yuan literati, archaism may also have had political undertones that embodied resistance by educated Chinese to their Mongol conquerors. The quotations of Tang painting styles echoed another "Golden Age," the period of China's most expansive and cosmopolitan empire, a world whose greatness stood in sharp contrast to the cultural and political humiliation many Chinese scholars and artists endured under Mongol rule. The expressive use of line and symbolism by Yuan literati painters marked a bold aesthetic shift, even if the classical past was needed to legitimize that creative leap.

It marked a far different use of tradition than what the literatus Su Shi had advocated earlier, when he praised the Northern Song landscape master Fan Kuan as the only artist of his day to retain the *gu fa,* or ancient aesthetic, of the Tang. Such praise may seem suprising since the Tang dynasty was known as the great age of figure painting rather than for its landscape painting. Indeed, apart from the polychromatic passages in early Buddhist art, few Tang landscapes have survived in modern times,[8] but Su Shi probably had in mind the works of the Tang poet-painter Wang Wei (699–759) known for his wintry ink monochrome snowscapes. Unlike Su Shi, Fan Kuan was not himself a scholar–official or a poet. Although little is known of his life, he seems to have spent much of it as a Daoist recluse contemplating the mountain scenery of northern China's Shaanxi province. The few utterances ascribed to him suggest that he held a much more immediate relationship to his subject matter than the deliberate stylistic archaism characteristic of the Yuan literati: "The method of earlier painters derived directly from things in Nature. Rather than learning from men, I should instead follow Nature. But even study from Nature is not as profound as following one's heart." Whatever debt Fan Kuan may have owed to Tang masters, his monumental landscape art was imbued with a Daoist reverence for inner essences of natural forms, not erudite stylistic allusions to antiquity typical of some Yuan literati.

Yet another appropriation of antiquity can be seen in the eleventh-century handscroll *Northern Qi Scholars Collating Classic Texts* (cat. 9), a work illustrating a historical episode from the sixth century. According to official annals of the Northern Qi dynasty (550–77), the brutal Emperor Wenxuan (r. 550–59) ordered a group of Confucian scholars to anthologize thousands of Chinese classics for the moral instruction of his crown prince. (The event itself suggests how the classical canon was used and abused to legitimize imperial authority.) According to literary records, an ink drawing of the same subject had been composed four centuries earlier by Yan Liben, and this now-lost prototype inspired

other versions of a popular narrative scene whose figures, in turn, provided models for Southern Song and Yuan portraitists. Thus, from the seventh to the fourteenth centuries, the continuity of classical tradition is evident in representations of this subject, an emblematic example of historical *fu gu*. From a stylistic viewpoint, however, *Northern Qi Scholars* is all the more remarkable for its preservation of a painting style that predates even the Sui (581–618) and Tang dynasties. While certain motifs reflect typical Northern Song characteristics, recent archaeological discoveries show a link to the styles of datable murals in Northern Qi tombs from the sixth century.[9] In both, the drawing style, figure type, costumes, and even the use of color have recognizable similarities.

Chinese artists who looked to the past for inspiration and authority found more than one classical tradition to use as models. In distinguishing them from their Western counterpart, Wen Fong has observed that "in the history of Chinese painting, no single period of antiquity represents a prescriptive classical norm. Despite the ubiquitous references to antiquity through the centuries, no one period in particular can be said to be more classical than another."[10]

Buddhism and the Three Teachings

Prior to modern times, China's cultural traditions were influenced by three main philosophical and religious systems—Confucianism, Daoism, and Buddhism, known collectively as the Three Teachings, or *san jiao*. While Confucius, Laozi, and Siddhartha Gautama, their respective founders, all lived during the sixth century B.C.,[11] Buddhism originated in India and arrived in China via Central Asia much later, in the first century A.D., during the Han dynasty. This was long after Confucianism and Daoism had established their hold on Chinese society. Buddhism was the first foreign religion to challenge these native systems, and it did so both through doctrine and organized monastic institutions. It introduced doctrines of salvation, karma, reincarnation, and the multiplicity of existence, which were utterly novel to many Chinese. The apogee of its influence came during the expansive Tang dynasty, whose imperial capital at Chang'an was the world's most populous and cultured city in its time. Until the mid-ninth century, many Sui and Tang emperors embraced Buddhism much as earlier Han rulers had promoted Confucianism. But it was the cultural impact of this foreign religion that left the most enduring mark on Chinese civilization. That legacy was visible throughout the Tang empire, in temples of cosmopolitan Chang'an as well as grottoes along the Silk Road and, most notably, Dunhuang's Caves of the Thousand Buddhas. Dunhuang, as the gateway to Chang'an and terminus of Asia's most active trade routes, was China's link to Central Asia, India, and the West. Dunhuang became a repository of Buddhist murals and statuary from more than a millennium. It was also a library of sūtras and religious texts translated from a panoply of ancient languages and scripts, which were rediscovered at the turn of the twentieth century by such archaeologists as Paul Pelliot and Sir Aurel Stein.[12] The Buddha's imprint was also seen in the massive cave-temple sculptures at Longmen in today's Honan province, among them the towering fifty-foot Vairocana Buddha commissioned by the Tang Emperor Gaozong (r. 650–83) and Empress Wu (r. 684–704). Longmen became a cen-

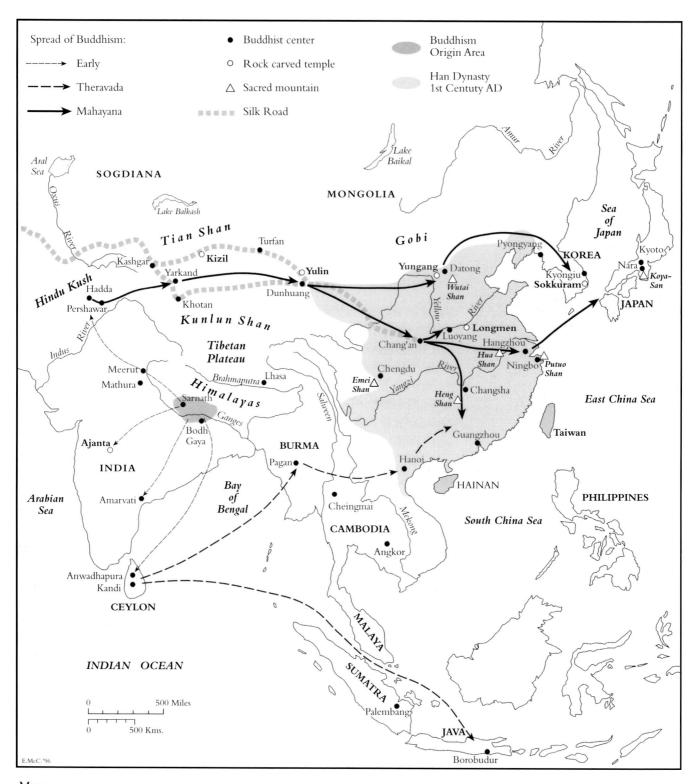

Map 1
The Spread of Buddhism in Asia

ter for the popular Pure Land sect of Mahayana Buddhism with its cults of Buddhas past, present, and future; and of bodhisattvas, the saintly disciples who vow to help others find salvation before attaining full Enlightenment themselves. But the visible, missionary presence of a Buddhist monastic hierarchy paved the way for periodic persecutions of its clergy, most dramatically at the hand of the Tang Emperor Wuzong (r. 841–46), a devout Daoist who called for the destruction of Buddhist temples, monasteries, and sculptures.

While its ideas both fascinated and threatened adherents of the Confucian and Daoist persuasions, Buddhism, assumed an increasingly Chinese character early on. Sinicized and transformed, it survived persecutions at the end of the Tang dynasty primarily in the school known as Chan, the origin of what came to be known as Zen in Japan and the West. Chan teaching was said to have been brought to China by the legendary sage Bodhidharma in the sixth century. Iconoclastic in doctrine and practice, it had a close affinity with more philosophical strands of Daoism. Like Daoists, Chan masters eschewed Confucian intellectual analysis in favor of an intuitive and instantaneous path to Enlightenment. They also abandoned the devotional worship of Buddhist icons including the sūtras and complex rituals derived from more esoteric forms of Tantric Buddhism. As the Chan master Yixuan (d. 867) urged: "If you see the Buddha on the road, kill him." Buddha-nature lay within; and the aim of Chan teaching was the experience of sudden awakening of *wu* or *satori*, "an awareness of the undifferentiated unity of all existence."[13] Its popularity grew during the Song dynasty when a more inward-looking China replaced the worldly materialism of the Tang empire in its heyday. The eccentricities and eremitic cast of Chan monks, who abandoned all worldly possessions to live as "wild mountain men," was perfectly in keeping with Daoist sensibilities as well as the aesthetic interest of those Northern Song literati who returned to China's natural wonders for inspiration.[14]

The transmission of Buddhist art from Central Asia to metropolitan China revolutionized Chinese painting styles, especially during the Tang dynasty. Three-dimensional modeling, the application of brilliant colors, and foreign imagery and subject matter (as in narrative scenes of the life of the Buddha) were all part of this new visual culture. Drawing techniques such as the so-called iron-wire style (*tiexian miao*) derived from Buddhist figure-painting traditions. Emergent painting styles like the "boneless" (*mogu*) and concavo-convex (*aotu*) techniques likely had their prototypes in Buddhist murals from Ajanta (fig. 1) and Kizil (see cat. 2). It is no accident that the great age of Chinese figure painting coincides with the spread of Buddhism throughout the Tang Empire.

Fig. 1. *The Conversion of Nanda.* Mural fragment from cave 16 at Ajanta, India, late-fifth century. Museum of Fine Arts, Boston. Clara Bertram Kimball Fund. 21.1286

Buddhism's impact on Chinese art can be traced by means of a number of works in the exhibition. Buddhist art from Central Asia appears in the fresco fragments from Kizil (cat. 2) and its pronounced stylistic influence is evident even in a Dunhuang banner, *Bodhisattva Standing on Lotus* (cat. 4), painted by an anonymous Chinese artist. By comparison, the ninth-century fragments from Turfan (cat. 5) show noticeably Chinese features. This sinicization of Buddhist iconography and doctrine occurs dramatically in representations of Avalokiteśvara (the Indian bod-

hisattva of compassion), who came to be adopted by the Chinese in the popular cult of Guanyin. The male gender of the Indian prototype is maintained in *Guanyin as Savior from Perils* (cat. 7), an anonymous tenth-century Northern Song hanging scroll, but later, in Southern Song and Yuan paintings, Guanyin appears as a female. Not only her gender, but her attributes and functions have changed as well. In the Museum's *Guanyin with Fish Basket* (cat. 118), the bodhisattva is depicted in a new guise: as a beautiful, barefoot maiden who offers herself in marriage to anyone who can memorize the Buddhist sūtra that will free him from the damnation of lust. While the cult of the fish-basket Guanyin was quite popular in eastern coastal China, her iconography had no counterpart in Indian or Central Asian representations.

Sinicized Buddhism also remade the early Indian figures called Arhats—monastic disciples who attain Enlightenment on their own through asceticism and meditative practice. Little more than the names of these original Arhats—or Lohan in China—is known, but Chinese painters in the early sixth century were the first to depict them, originally in sets of sixteen. By the Song dynasty, their numbers had increased to as many as five hundred. Chinese Buddhist temples sometimes commissioned workshops of professional painters in the trading port of Ningbo to produce sets of Lohan scrolls that were used for devotional purposes. They also became popular in Korea and Japan. Examples from three such sets are included in the exhibition: a group of ten, from Japan's Daitoku-ji temple, by Zhou Jichang and Lin Tinggui, two Ningbo artists who were active during the second half of the twelfth century (cat. 34–43); a second group from the set of *Sixteen Lohans* (cat. 48–62) by Lu Xinzhong (act. late twelfth century–early thirteenth century); and a third series by an anonymous Yuan-dynasty artist (cat. 144–46). While the early Chinese iconography of Lohans accented their austere, ascetic nature, Southern Song artists emphasized their miraculous powers, often in dramatic scenes or supernatural settings. One such portrayal, Zhou Jichang's *Lohan Demonstrating the Power of Buddhist Sūtra to Daoists* (cat. 41), suggests the ongoing rivalry between Daoism and Buddhism: A group of court officials and Daoist priests appear dumbstruck as lightning bursting from a bundle of Buddhist sūtras burns the Daoist writings beneath them.

Whatever their rivalries, a new syncretism of the Three Teachings emerged during the Southern Song dynasty. From the outset, proponents of each system had debated their philosophies at court symposia. The Daoist Chen Zhuan (d. 989) was among the first to attempt to reconcile the three doctrines. As early as the Five Dynasties period (907–60), imperial catalogues record paintings in which Laozi, Confucius, and Buddha appear together.[15] During the Song dynasty, China's literati played an increasingly important role in synthesizing these teachings, both through their art and by advancing the theory of "three doctrines–one source." Song and Yuan art reflect a mixture of the Confucian reverence for humanity and antiquity, Daoist beliefs in spontaneous creativity, and Chan Buddhist meditative practices. That fusion erased doctrinaire tendencies that had plagued sectarian zealots and fostered political upheaval. The emergent literati synthesis has often been called the only true religion of China's educated elite.

Literati Lore and Legends

Much as the West developed its own mythos of artists as rebels, prodigal geniuses, aesthetes, and/or eccentrics, so China's literati created an often-idealized image of themselves as cultural heroes.[16] Particularly toward the end of the Southern Song, many literati promoted the idea of amateurism, both to distinguish themselves from court painters, who worked in the imperial academies, and professional "artisans," who painted in workshops from which works were commissioned by temples or private collectors. During the Yuan period, promotion of the "amateur ideal" was spurred by resistance to Mongol rule and a desire to return to the more ennobled Confucian view of art as a vehicle for moral persuasion. Literary accounts of earlier classical artists laid the foundation for these idealized attitudes and lifestyles.[17] They appear in the anecdotes of early painting histories, classical poetry, and the essays of Song literati as well as their encomia and colophons attached to scrolls. Like Giorgio Vasari's *Lives of the Artists,* they often blur the boundaries between history and myth. But, for the literati, they were myths that became truer than history. Beyond the evidence provided by the paintings and calligraphy left behind by these artists, their written lore gives us a window into their aesthetic visions and self-conceptions—how they wished to remember the past and be remembered by future generations.

An Emperor and His Portraitist

Chinese remember Emperor Taizong (r. 627–49) of the Tang dynasty as one of the most successful and enlightened rulers in history. He was also what literary scholar Stephen Owen has called "a master of political and cultural images," who rewrote the historical record to stress his virtues and enhance his role as architect and "founder" of the great Tang Empire.[18] Taizong succeeded in subduing nomads in the northern and western frontiers, promoting culture, and launching what was arguably the most brilliant, cosmopolitan era in Chinese history. What distinguished him from other rulers was his ability to attract talented ministers and encourage dissent within the court. When one such respected but contentious official died, Taizong said that he had just lost his "mirror," recalling that although he had been angered by the minister's criticisms, they later taught him to see his own mistakes. Taizong, while tolerating Buddhism, understood the value of Confucianism. He once commanded his highest court officials to compare his own rule with that of China's previous emperors and to identify their good and bad policies. When they had finished their disquisitions, the emperor offered his own: Previous rulers, he said, were too chauvinistic, while he would treat Chinese and non-Chinese with the same respect. Whereas past emperors had punished or killed ministers who made mistakes, he pardoned them. And while others were jealous of talented people, he would love their gifts as if they were his own.

For his son, Taizong himself wrote instructions known as *Di Fan* (Imperial Admonitions), so that the crown prince would learn from the virtues and mistakes of past emperors. Such didactic exercises may well have prompted the commissioning of the *Thirteen Emperors* scroll (cat. 3)

Khazars

Western Turks

TURKESTAN

Aral Sea

SOGDIANA

DZUNGARIA

Lake Balkash

Bukhara

Oxus River

Samarkand

Pamirs

Uighurs

• Turfan

• Yarkand

• Khotan

TRANSOXIANA

Kabul •

FERGHANA

KASHMIR

Indus River

TIBET

Himalayas

Brahmaputra • Lhasa

NEPAL

Ganges

Nalanda •

Pagan •

PYO

Bay of Bengal

Arabian Sea

Lake Baikal

Eastern Turks

BOHAI

Khitans

NINGXIA

Dunhuang

Yellow River

Lanzhou •

Chang'an •

Luoyang •

Yangzhou •

Chengdu •

River

Yangzi

NAN-CHAO

Guangzhou •

Sea of Japan

SILLA

JAPAN

Yellow Sea

East China Sea

ANNAM

KHMER

Mekong

CHAMPA

South China Sea

INDIAN OCEAN

0 500 Miles

0 500 Kms.

E.McC. '96

Map 2
The Tang Empire, ca. A.D. 660

by Yan Liben, the emperor's best figure and political painter, who had befriended Taizong when he was still Prince Qin.

Yan Liben came from a distinguished family of artists: Both his father, Yan Bi (act. late sixth century), and brother, Yan Lide (act. early seventh century), who were recorded in early painting annals and collections, had close ties to the royal households of the Northern Zhou, Sui, and Tang dynasties. As a court portraitist, Yan Liben produced major works of historical and political significance, including imperial portraits and murals such as the *Eighteen Scholars of the Palace of Prince Qin* and *Twenty-Four Court Officers at the Lingyan Palace,* a work said to commemorate the diversity of talent within Taizong's court. Neither mural has survived and the only extant works attributed to him are Boston's *Thirteen Emperors* and *Emperor Taizong Receiving the Tibetan Envoy* (Beijing Palace Museum).

Yan Liben's artistic career is significant because he achieved the highest court position of any painter in Chinese history—prime minister of the right. Yan Liben's portrait of Emperor Taizong was so admired that it was copied for public display on the front wall of the Buddhist Xuandu temple.[19] Boston's *Thirteen Emperors,* a series of portraits depicting past rulers, is emblematic of Tang figure-painting styles and the official Tang portraiture for which Yan Liben was best known.

Taizong's artistic patronage also extended to calligraphy and poetry, both of which were included in the imperial examinations for the *Jinshi* (highest degree). Students came from Korea, Japan, Central Asia, and Tibet to study in Chang'an. The emperor himself zealously collected and imitated works by the great calligrapher Wang Xizhi (ca. 303–ca. 361). So passionate was his desire for Wang's scrolls that he dispatched his minster Xiao Yi (act. first half of seventh century) to cheat a Buddhist monk—himself a descendent of the calligrapher—out of the original version of Wang's most famous masterpiece, *Lanting xu* (Preface to the Gathering at the Orchid Pavilion). A handscroll narrating this old story is still preserved at the National Palace Museum, Taipei.[20] (Although traditionally attributed to Yan Liben, the work is a later copy.) According to literati lore, the emperor could not bear to part with his beloved piece of calligraphy, insisting that it be buried with him.

Wu Daozi—"The Sage of Painting"

Unlike Yan Liben, the great muralist Wu Daozi (act. ca. 710–60) came from humble origins. Orphaned as a child, he spent his youth in poverty. While still in his early twenties, his prodigious painting talents were recognized and he was appointed court painter by Emperor Xuanzong, better known as Tang Minghuang (r. 712–56). A Tang general named Pei Min once offered Wu Daozi a large commission for a mural commemorating the general's parents. Wu refused the offer, insisting that a demonstration of the general's swordsmanship would be a fee "more than sufficient to inspire my brushwork."[21] Such disdain of money prefigures the professed attitude of later Yuan, so-called "amateur" painters, many of whom were, in fact, entirely dependent upon patrons and commissions for a livelihood.

Wu Daozi's painting, Pei Min's swordsmanship, and the cursive calligraphy of Zhang Xu (act. eighth century) were praised as the Three

Excellences of their day. A hundred years after his death, Wu's genius both in figure and landscape painting had already been canonized by the critic Zhang Yanyuan, who wrote: "Some god must be painting through his hand, so profoundly does his work fathom the power of Creation itself."[22] His stature can be further measured by the many, perhaps apocryphal, literati legends surrounding his feats. Buddhist monks recounted stories of butchers changing their profession upon seeing his murals depicting the horrible punishments awaiting them in Hell for having killed animals in this life. When Emperor Xuanzong wanted a landscape of the Jialing River in Sichuan province for the palace, Wu was dispatched to make sketches. When he returned with no sketches, Wu reported to the emperor that he had memorized all the views instead. Wu then finished his composition of the three-hundred-mile river in a single day, whereas an earlier master had taken months to complete a similar work. In the most imaginative tale of them all, Wu Daozi was commissioned to paint a landscape on an imperial palace wall; within days of completion, he had to erase it because the "noise" of its waterfall interrupted the emperor's sleep!

None of Wu Daozi's paintings have survived, but his style is preserved in a few works, including Boston's three *Daoist Deities* (cat. 21–23), which are traditionally attributed to him, and *Daoist Procession,* attributed to Wu Zongyuan (d. 1050) in the collection of the C. C. Wang family in New York.

Zhang Xuan: A Painter of Palace Beauties

No artist captured the sensuality and materialism of court life in the High Tang period (first half of the eighth century) better than Zhang Xuan. Although all of his original works are lost, his compositions are known from copies, notably those by his follower Zhou Fang (ca. 740–800). Two early twelfth-century copies, Boston's *Court Ladies Preparing Newly Woven Silk* (cat. 14) and *Lady Guoguo's Spring Outing* (Liaoning Provincial Museum), preserve an intimate vision of the opulence of the Tang world at its height. Zhang's paintings frequently drew from literary works such as the somewhat satirical poem *Liren xing* (Parade of Beauties) by the poet Du Fu (712–70), which was the inspiration for *Lady Guoguo's Spring Outing.* Both allude to scandalous affairs at the court, notably between relatives of the emperor's favorite concubine Yang Guifei (719–56). In this famous Liaoning handscroll, her relative, Prime Minister Yang Guozhong, leads an entourage of palace women that includes her sister, Lady Guoguo (the prime minister's mistress), parading on horseback through the imperial capital of Chang'an.[23] The richly colored, ornate costumes worn by these palace women resemble those in Boston's *Court Ladies.* Lavishly portrayed by Zhang Xuan and his followers, such vignettes and leisure pursuits capture the intrigue and luxurious world of Tang aristocrats before the dynasty's disastrous demise.

Yang Guifei, celebrated as the most striking beauty of her day, personified the decadent lifestyle at Emperor Xuanzong's court. The emperor's infatuation with his concubine caused him to neglect his rule, while her nepotistic influence at court aggravated rivalries between such regional commanders as An Lushan and ministers like her relative, Yang

Guozhong, both of whom had benefited from her patronage. Sensing a military advantage, in 755 An Lushan revolted and his armies soon sacked the Tang capital of Chang'an. As the emperor fled west to Shu (today's Sichuan province), his Imperial Guard mutinied and forced him to order the executions of Yang Guifei and Yang Guozhong. Their tragic romance and the calamitous events that ensued were commemorated by the great Tang poets Li Bai (701–62), Bai Juyi (772–846), and Du Fu. Generations of Chinese painters portrayed the story in a variety of narrative and figure paintings as well. Included among them are *Tang Minghuang's Journey to Shu* (National Palace Museum, Taipei) and the Boston Museum's *Yang Guifei Mounting a Horse* (cat. 82), an album leaf by an anonymous Southern Song academy artist.

The Rise of Song Landscape

In the entirety of Chinese history, no rulers were as open to the world beyond China's borders as the Tang emperors. But their very worldliness allowed foreigners to serve as ministers and generals, opening the door for non-Chinese armies to plunder and occupy the capital. An Lushan himself came from Turkish stock, and his rebellion was a national trauma that brought about not only an emperor's downfall, but also massive civil strife. The upheaval continued well into the tenth century, after the definitive collapse of the Tang dynasty in 906. Imperial census figures recorded the rebellion's impact and its ensuing dislocation: Some thirty-six million people were left "dead or displaced and homeless."[24] China remained a decentralized, fractured society until the founding of the Song dynasty in 960.

Map 3
Song China, late 10th century

By Song times, the threat to Chinese identity was no longer perceived to be a foreign religion like Buddhism, but something more tangible—the nomadic tribes of the Khitan, the Jurchen Tartars, and the Mongols from the northern frontiers (see maps, pages 25 and 31). Song rulers succeeded in reunifying China after nearly a century of fragmentation. Whereas Tang emperors enhanced the military dimension (*wu*) of traditional statecraft, creating an empire through alliances and conquests, their Song successors preferred using culture (*wen*) to unify the nation. Perhaps the barbarian threat as well as the lessons of the Tang decadence and decline influenced the more conservative, insular vision embraced by Song literati. Once again, China's elite searched for a cultural and spiritual expression of essential values that, in painting, found its vehicle in the more monumental, monochromatic landscape art of the tenth and eleventh centuries.

Landscape emerged as an independent painting genre in China much earlier than in the West. Two Six Dynasties painters, Gu Kaizhi (ca. 344–ca. 406) and his contemporary Zong Bing (375–443), wrote essays on their methods of painting landscape that address the representation of magical, symbolic, and topographic features of the mountains they painted. The idea of landscape as spiritual space had ancient roots in China. Like their counterparts in Greek mythology, mountains were the homes of gods and spirits. Court rituals as early as the Zhou dynasty indicate such animistic beliefs in the divinity of mountains, and from the Bronze Age to the end of the Qing dynasty in 1912, China's rulers prayed at imperial altars to the five sacred mountains—one for each cosmic direction. A Tang-dynasty text records such a prayer to Mount Heng, the sacred mountain of the North, written by Emperor Taizong in 645:

> The sacred mountains contain fine soaring peaks and fields of wilderness
> with special markers where strange animals roar and dragons rise to heaven
> and the spots where wind and rain are generated, rainbows stored
> and cranes beautifully dressed. These are the places where divine immortals
> keep moving in and out. . . .
> The rugged mass is forever solid together with Heaven and Earth.
> Its great energy is eternally potent in the span from the ancient to the
> future.[25]

In Daoist lore, Mount Tai in Shandong province was the seat of the realm of the underworld. Buddhism had its sacred geography as well, and such mountains as Emei in Sichuan province became famous as pilgrimage sites. At the fall of the Tang dynasty, many of China's artists and scholars withdrew to the mountains, where they lived in temples and humble retreats as recluses.

"The country is shattered but the mountains and rivers remain," wrote Du Fu in the wake of the An Lushan rebellion. Du Fu's lines perfectly express the sentiment of those painters who found refuge and aesthetic inspiration in the natural wonders of China's countryside. *Shanshui* (landscape art) is a combination of the essential elements of mountains and water affirmed by Du Fu in his poetry and Fan Kuan in his painting (see cat. 11). In landscape art, Fan Kuan and his followers sought to evoke the absolute reality inherent in Nature, the heart of things as they are. The dominant, towering peaks, rhythmic repetition of mountain

contours, and precipitous waterfalls—with their emphasis on volume, lucid symmetry of forms, and vast space—contribute to the sense of heroic grandeur in such works. Inevitably, art historical terms like realism and naturalism are applied to these landscapes. They are meaningful only with this caveat: The aesthetic impulse of the Northern Song was deeply metaphysical, not mimetic in a Western sense. To borrow a phrase from Ananda Coomaraswamy (1877–1947), it was an art form concerned not with Nature but the nature of Nature.[26] The new landscape style set the tone for the aesthetic reawakening that began in the tenth century and reflected the integrated view of the Three Teachings that emerged in the Song dyansty. Stylistically, the polychromatic surface brilliance of Tang figure painting, its attention to narrative detail, and the Central Asian–style descriptive modeling were supplanted as ink landscape emerged as the dominant genre of the Northern Song. Originators of the new landscape aesthetic, were such painters as Jing Hao (act. ca. 870–ca. 930), Guan Tong (act. tenth century), and Li Cheng (919–67), a descendent of Tang nobility, all of whom made little distinction between the process of artistic creation and Nature itself.

Su Shi's Bamboo and Mi Fu's Rock

For early Song painters, art did not represent, it embodied the essence of things, a view advocated by the Northern Song literatus Su Shi. "It is childish," he wrote "to see painting in terms of likeness." In the rarefied world of these calligraphers and painters, brushwork revealed an artist's moral and spiritual character. Su Shi and his friend, the eccentric scholar–official Mi Fu, were enormously erudite—perhaps no two figures in literati history better deserved the Western term "Renaissance man." In their lives and art, they set standards for Northern Song taste and quality that would be embraced for generations to come. As an innovative calligrapher, painter, and poet, Su Shi combined the Three Perfections. A master of classical literary forms as well as more informal prose, his couplets were copied by many, including the Southern Song Emperor Xiaozong (r. 1163–89, d. 1194; see cat. 64). Longer works by Su Shi, like his *Red Cliff Odes* (see cat. 151), became canonical subjects for literati painters. He shared many of the views of the eminent Song historian and offical Ouyang Xiu (1007–72), who advocated the ideal of *fu gu* in education and statecraft and helped promote Su Shi's career. Su's essays and writings reveal a broad, critical understanding of connoisseurship and ancient styles. The colorful realism of Tang court painters impressed him less than the more austere wintry ink landscapes of Wang Wei, whose brushwork reached beyond representational forms. China, he believed, had attained its aesthetic summit by the eighth century in such work as Du Fu's poems and Wu Daozi's painting. On seeing a scroll by the latter in 1085, Su wrote that all the artistic "variations of past and present and all the possibilities in the world were over."[27]

His interests were not purely artistic: As a district prefect, he won renown for life-saving, preventative measures during a flood. As a scholar–official, he enjoyed an illustrious and controversial career. His objections to the reformist policies of Wang Anshi (1021–86) led to official disfavor. Wang's zeal made him blame others when his policies failed, and Su Shi was tried, imprisoned, and nearly sentenced to death

for writings deemed too critical. While this earned him respect as a man of principle among other disaffected literati, his dissent led to exile on the southern island of Hainan during his final years.

Leading Daoists and Buddhists were among Su Shi's friends, and his syncretic spirit was perhaps best revealed in his painting specialty—ink bamboo—possibly the most abstract of Chinese painting genres. Confucianists saw bamboo as a symbol of righteousness (see cat. 137); its popularity among scholar-officials also derived from the close relationship between calligraphy and the art of painting bamboo. Su Shi himself would memorialize the bamboo technique of the literatus Wen Tong (ca. 1040–79) in a poem:

> At the moment Wen Tong was painting bamboo
> he saw the bamboo and no person—
> Not just that he saw no person
> he was emptied, let go of the self;
> He was a person transformed with bamboo
> in an endless production of freshness—
> There is no Zhuang Zhou alive in this world
> who now grasps such fusion of spirit?[28]

The poem, with its final reference to the Daoist sage Zhuang Zhou, identifies the creative process with the inherent nature of bamboo. Wen Tong becomes bamboo as he paints it, a notion of self-transformation that echoes a famous Daoist parable: One night, Zhuang Zhou dreamt he had become a butterfly. His spirits soared so high that he forgot all about being Zhuang Zhou. When he awoke, he did not know if he was a man dreaming he was a butterfly or a butterfly dreaming he was a man.

Confucian symbolism is also present in the poem: Bamboo represents moral character because it is outwardly firm (and therefore principled) and inwardly hollow (and therefore selfless). In his life, Su Shi combined both qualities, just as in his art he fused both teachings.

No less influential, the innovative calligrapher, painter, and connoisseur Mi Fu was perhaps the most eccentric literatus of his day. The son of a Confucian scholar, he authored *Hua shi* (a history of painting) and spent ten years traveling to view important collections in China and to compile a catalogue of ancient calligraphy. As an accomplished copyist, he delighted in fooling socially prominent, but less-discerning, connoisseurs with his forgeries. His antiquarian passions extended to old ink stones, rare garden rocks, and ancient garb and headgear, which he periodically wore. All these collections were kept on a houseboat that bore the sign THE MI FAMILY CALLIGRAPHY AND PAINTING BARGE.[29]

Mi Fu studied the most ancient calligraphic forms and styles found on Bronze Age ritual vessels, bamboo slips, and stone engravings. Such practice of *fu gu* made him appreciate the expressive quality of pictographic forms, which he incorporated in his free-form, large-size calligraphy. An equally expressive and primitivist quality appears in his monochrome landscapes (see cat. 138), where dotting techniques of calligraphy were applied to the vocabulary of abstracted motifs. The "Mi-dot" tradition, carried on by his son Mi Youren (1074–1151),

was enormously influential among painters in China, Korea, and Japan.

As an official, Mi Fu had a far-less distinguished career than his friend Su Shi and was even dismissed from his post as a district magistrate. Only at the end of his life did he receive significant imperial recognition when Emperor Huizong appointed him to be a kind of curator of calligraphy and painting in 1104.

The most famous of the literati lore surrounding the life of Mi Fu concerns his passion for unusual rock forms. As standard accouterments in scholars' studios and gardens, these twisted, geomorphic, limestone shapes were originally dug up from lakes and riverbeds. Literati especially prized Lake Taihu rocks, whose perforated void-and-solid forms seemed a perfect expression of the *Dao*. After receiving a government post in Anhui province, Mi Fu was expected to make the obligatory first appearance before the local prefect and present his credentials. An ardent petrophile, Mi Fu first insisted on viewing a renowned rock specimen in the district. So awed was he by its form, that he made a point of donning his official robes, bowing, and addressing the rock as Elder Brother. Paying homage to a rock before greeting a local official was a serious breach of protocol—one of many such episodes that compromised Mi's advancement up the ladder of officialdom. His insistence that truth in Nature took precedence over official ceremony typified his aesthetic vision of *fu gu*. And his veneration of the rock earned him the respect of generations of Chinese literati who, even in modern times, painted and memorialized this episode.

The Emperor Aesthete

As the last Northern Song ruler, Emperor Huizong epitomized the dynasty's predilection for cultural patronage and military miscalculation. His achievements in painting and calligraphy were unsurpassed by any emperor in Chinese history. This devout Daoist became so obsessed with the study of natural and supernatural phenomena (as well as aesthetic pursuits) that he completely mismanaged his worldly governmental affairs. He was more concerned with constructing lavish imperial parks and gardens—which replicated all the sacred mountains and rivers of China—than with military incursions by nomads from the north. Such neglect precipitated the sack of the capital Kaifeng by the Jin or Jurchen Tartars, his capture, and the collapse of the Northern Song dynasty in 1127.

Huizong was an outstanding literatus, artist, gardener, art connoisseur, and educator, whose studies and writings covered a diverse range of topics: antiquities, architecture, botany, ceramics, ornithology, rocks, zoology, etc. His innovations in painting and calligraphy can be seen in Boston's *Five-Colored Parakeet on Blossoming Apricot Tree* (cat. 13). Its coloristic and realistic style make it a masterpiece of the bird-and-flower genre, which was a favorite of Huizong's—his imperial catalogue listed 2,786 exemplars of this subject matter. The taut, elegant precision of his calligraphy came to be known as the *shoujin,* or slender-gold, style. Huizong was the first emperor to emphasize the literary quality of painting, a tradition that was carried on by his successors in the Southern Song. At his imperial painting academy, artists were evaluated by means of the compositions they could create based on poetic couplets. Often they were

judged on creativity rather than verisimilitude. For example, when the verse "An ancient temple hides behind the mountains" was proposed, first-place award went to an artist whose composition displayed not a single temple building; instead, a lone Buddhist banner on a staff amidst endless mountains was the sole suggestion of the presence of such a structure. Because it emphasized what was "hidden" in the verse rather than a more literal depiction, the painting was thought to have captured the poem's more subtle meaning. Conveying what was absent and invisible was as essential to the Song aesthetic as showing what was actually there. In another recorded example, an examination for painters was based on this couplet:

> Returning from viewing flower blossoms
> my horse's hooves bring back a fragrant smell.

In this instance, the award went to a composition depicting several butterflies circling the rolling hooves of the horse. While other entries focused on replicating the blossoms themselves, this artist, by adding butterflies, moved beyond mere illustration to capture the essence of the poem.[30]

To improve their knowledge and stylistic repertoire, artists at Huizong's academy were regularly given ancient paintings from the imperial collection to copy and imitate. Any damage to the original work was punishable by military law. The emperor personally assessed these exercises, and copies that failed to meet his high standards were immediately destroyed. Such rigorous training and the emperor's strong emphasis on detailed depiction from life (as in his *Five-Colored Parakeet*) created a new direction for Chinese painters. Even in captivity under the Jin Tartars, Huizong continued to write lyric poems, including one on the apricot blossoms he saw during his imprisonment in Manchuria. They reminded him of those in the old palace garden he had left behind. Only in dreams could he visit them, the fallen emperor lamented, and now even dreams were scarce.

The Art of the Southern Song

The Jurchen conquered northern China after establishing their own Jin dynasty in 1115. With the fall of the Northern Song capital of Kaifeng, they abducted Emperor Huizong, his son Emperor Qinzong (r. 1126–27), most of his family, and thousands of his followers, including some scholar–officials and some academy painters. The deposed emperor's ninth son, Prince Kang, fled south where he proclaimed himself Emperor Gaozong (1107–87; r. 1127–62). Resisting the Jin invasion, the exiled court reestablished itself at Hangzhou in the 1130s and, with China's political borders secured south of the Yangzi River, the emperor officially designated the new era *Shaoxing* (Continuing Prosperity). Peace with the Jin, however, carried a high price: humiliating treaties and monetary tributes. They infuriated the more orthodox Confucians at the court, many of whom saw Gaozong's appeasement of the Jin as cowardice and wanted to continue fighting. Thousands of Chinese had been massacred by the Jurchen invaders at Yangzhou after Gaozong fled in 1129. When the patriotic general Yue Fei (1103–41) continued to fight victorious

battles in northern expeditions, Gaozong ordered his execution. The emperor wanted peace and stability because he had come to power by chance, not legitimate succession. Although the Jin released his mother from captivity in 1142, his elder brother, Emperor Qinzong, remained their captive until his death in 1161. Gaozong's policies alienated many Confucian scholar–officials, but his actions spurred an economic and cultural revival that increased trade and helped stabilize southern China through the mid-thirteenth century.

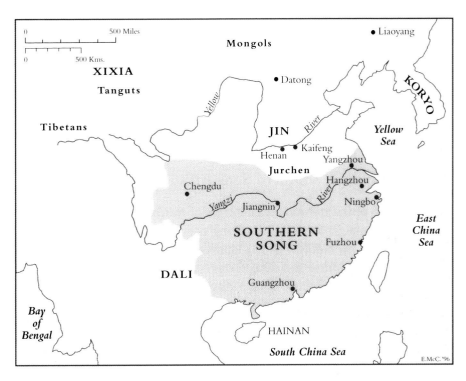

Map 4
Southern Song China, after 1127

Prosperity and cultural promotion helped legitimize Emperor Gaozong's authority. As his vice minister and art advisor, Mi Fu's son Mi Youren rebuilt the imperial collections. Gaozong himself was an accomplished calligrapher (see cat. 32) and he sponsored new editions of classic Confucian texts like the *Book of Songs.* Court calligraphers and artists worked together to illustrate selections from this anthology, which is said to have been compiled and edited from thousands of ancient lyrics and odes by Confucius himself. One such Song academy handscroll is the Boston Museum's *Illustrations to Six Texts from the Xiaoya Section of the Book of Songs* (cat. 24) painted by Ma Hezhi (act. second half of twelfth century), who was ranked among the ten best court artists of his day. The combination of text and image in this work reflect a Southern Song *fu gu* that is both political and aesthetic: While the texts celebrate the harmony and virtue of ancient Zhou-dynasty rulers, Ma Hezhi's expressive brushwork and archaistic manner echo the style of the Tang painter Wu Daozi, whose works could still be seen in Song imperial collections.

The Southern Song revival developed amidst a burgeoning urban economy and merchant-class society whose more successful households craved aristocratic luxury and refinements. The new-found wealth from Hangzhou commerce spurred the rise of genre paintings much as it would five centuries later in Japan and Holland. They reflected a taste for artworks depicting more prosaic and humorous aspects of everyday life, as in the album leaf, *Returning from a Village Feast* (cat. 100) and an earlier hanging scroll, *Bullock Carts Traveling over Rivers and Mountains* (cat. 30). Domestic life, too, was featured in paintings like *Children Playing with a Balance Toy* (cat. 26) and *Lady at Her Dressing Table in a Garden* (cat. 25) by Su Hanchen (act. 1120s–1160s), an academy artist during the reigns of both Emperor Huizong and Emperor Gaozong.

The more intimate vision of Southern Song painting is reflected in landscape as well. The grandeur of Northern Song monumentality was reduced and replaced by a more lyrical approach to design, composition, and brushwork. Surrounded by lakes and rivers, the environment of Hangzhou and southern China invited this lyricism.

The Ma Family: A Southern Song Artistic Dynasty

The towering peaks and mountain ranges of northern China remained an image of nostalgia for Southern Song painters like Ma Yuan (act. 1190–1235) and his family. The Ma landscape style, with its distinctive one-corner composition and design, represented a turning point in the history of Chinese painting. Along a diagonal axis, motifs such as riverbanks or trees with twisted branches were concentrated in one corner of the picture plane, leaving vast empty spaces in the other. Not all of Ma Yuan's works followed this schema (see cat. 68 and 69), but it was well-suited to representing the low-lying hills and the riverways of southern China, particularly in the miniaturized format of round fans or square album leaves. Little Confucian ideology or political allusion is apparent in the works of Ma Yuan, who was the most distinguished court painter during the Southern Song. It was the very popularity of his style that led some orthodox Confucian critics to dismiss his work and that of his contemporary Xia Gui (act. late twelfth to early thirteenth century) as vulgar and emblematic of court decadence.

Ma Yuan was remarkable as a fourth-generation member of a lineage of academy artists, an entirely unique phenomenon in Chinese painting history. His great-grandfather Ma Fen (act. early twelfth century), a bird-and-flower painter, had served in Emperor Huizong's academy during the twilight years of the Northern Song dynasty.[31] Originally from Shaanxi province in northern China, the professional artists in the Ma family specialized in Buddhist figure paintings. Later family members probably never had seen their homeland in northern China. But Ma Yuan and his son Ma Lin (act. 1220s–1260s) certainly understood northern painting styles, particularly those derived from Li Tang (1060s–after 1150; see cat. 66 and 67) and earlier generations of their own family. They adapted them to the soft, lush, watery landscape in the lake region of Hangzhou where they grew up. Indeed, this merging of north and south helped create the new style. Ma Yuan's approach is generally more linear than that of his other well-known contemporary, Xia Gui, whose use of rich, wet ink tones and graded washes to model motifs enhanced

the atmospheric quality of such works as *Sailboat in Rainstorm* (cat. 63). Paintings of the "Ma–Xia school" defined a more popular (as opposed to scholarly) taste of the Southern Song era, and hundreds of works by followers and imitators of "one-cornered Ma" made their way abroad, inspiring, in turn, a new landscape school in Japan.

Nomads and Barbarians

Chinese, like others, viewed the peoples beyond their borders with a mixture of fascination and fear. The frontier world of the northern tribes, with their exotic apparel, customs, horses, tents, and migratory life was a theme in both classical literature and genre painting. Nomadic subjects appear in several Song works in Boston's collection, including the eleventh-century handscroll *Nomads with a Tribute Horse* (cat. 10) and the later *Khitan Falconer with Horse* (cat. 16). The poetic cycle known as *Eighteen Songs of a Nomad Flute* by the Tang writer Liu Shang (act. ca. 773) became a favorite subject for narrative painters, the earliest example of which appears in Boston's *Lady Wenji's Return to China* (cat. 17–20). Originally part of a long handscroll, these four early Southern Song album leaves painted on silk with ink, color, and gold illustrate episodes of the story of Lady Wenji (ca. 177–ca. 239), a Han-dynasty noble-woman and poet who was captured by Huns (*Xiongnu*) in A.D. 195 and ultimately returned to China. The story would have been a particularly poignant subject for an early Southern Song artist, given the capture of Emperor Gaozong's own mother and the death of his first wife while they were hostages of the Jin Tartars. However, a later treatment of this same subject, *Wenji and Her Family* (cat. 33), by an anonymous artist presents a more intimate and sympathetic picture of the interracial relationship between Lady Wenji and her non-Chinese husband. Such a "revision" of historical events and themes from the original poem could reflect the more peaceful attitude Song rulers hoped to promote toward nomadic tribes at the northern frontier.

The rise of Genghis Khan (ca. 1162–1227) and his Mongol armies in the early thirteenth century would eventually destroy that geopolitical balance of power the Southern Song rulers had hoped would sustain their dynasty. With superior horsemen and tactics, the Mongols destroyed the Jin capital in 1215, then moved west to conquer Turkistan in 1220. This juggernaut quickly left most of Central Asia in their control. Song rulers sought an alliance against the Jurchen, whose defeat by combined Chinese and Mongol forces in 1234 marked the end of the Jin Tartar dynasty. The pact was short-lived as Kublai Khan (1215–94) set his sights on southern China. After declaring himself the founding emperor of the Yuan dynasty, he became China's first nomad ruler, and Southern Song rule came to its definitive end in 1279 in a naval battle off Guangdong, during which its last imperial claimant drowned.

From their new capital at Dadu (present-day Beijing), Yuan rulers dismantled many of the Confucian civil institutions that had administered China for more than a millennium. The imperial examination system was effectively abolished, and foreign vassals of the Mongols were entrusted with high positions of authority. The diminished status of scholar–officials under the Yuan intensified ethnic hostility between native Chinese and Mongols. Song loyalists—the *yimin* (leftover sub-

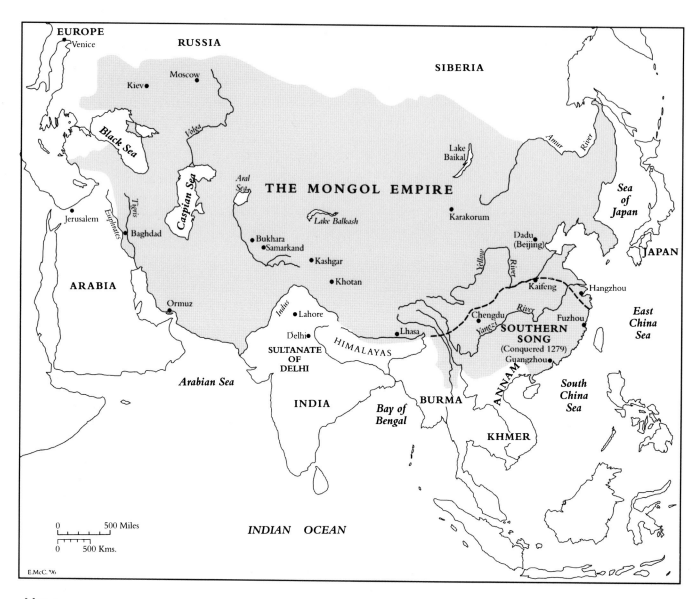

Map 5
The Mongol Empire

jects)—continued to resist the new regime by refusing government service and withdrawing from public life. A few, like the painter and calligrapher Zhao Mengfu, a descendant of the founding Song emperor, accepted Kublai Khan's invitation to serve at the Mongol court. Others, like Qian Xuan (ca. 1235–after 1301), steadfastly refused. The alienation of Confucian literati during the Yuan dynasty widened the gap between the so-called amateur painters and the professional artists and artisans under court patronage. Yet the distinction remained ambiguous at best. In their writings, amateur painters professed contempt for money, social advancement, and the vulgar work of professional artists. But in reality, many of the former sought patronage from the very merchants and collectors whose worldly pursuits and tastes they so disdained. Nor was the relationship between patronage and aesthetic choices so clear-cut among the literati. Both Qian Xuan and Zhao Mengfu pursued similarly archaistic styles in their paintings. Yuan literati art, such as the anonymous *Landscape in Blue-and-Green Style* (cat. 150), owed nothing to Mongol influence. The amateur painters reaffirmed classical Chinese traditions in both calligraphy and painting and used them to create a revolutionary style.

A Yuan Monk and His Ink Grapes

The Yuan literati emphasis on expressive brushwork had much in common with another painting tradition that flourished in Song and Yuan times, the monochrome tradition of Chan Buddhist art. Chan Buddhism emphasized values of spontaneity and spirituality in its aesthetic expressions as is seen in the hanging scroll *Ink Grapes* (cat. 136) attributed to the priest Ziwen Riguan (act. second half of thirteenth century). Such works frequently applied unconventional techniques such as using a hand or piece of cloth as a brush to produce simple, direct compositions, whether of landscapes, figures, or fruit, or in the bird-and-flower genre. Ziwen Riguan was an accomplished calligrapher known for his cursive-style script. He is said to have been inspired by the shadows of grapes cast by moonlight on his wall, and he often painted them in an intoxicated state. His method was to splash ink with his hand and then use his brush and calligraphic skill to depict grapes, leaves, and vines.[32]

The expressive and suggestive quality of Chan brushwork styles was greatly admired by Song and early Yuan amateur literati. Such painters as Liang Kai (act. early thirteenth century) left the Song academy because of the influence of that aesthetic. Between Chan and amateur-literati styles, it is difficult to say which influenced the other first. Their affinity becomes apparent when comparing *Ink Grapes* with the *Landscape in the Style of Mi Fu* (cat. 138) and the handscroll *Scenery of Yixing* (cat. 139), the only known surviving work by the late-Yuan literatus Zhou Zhi (d. 1367).

Fig. 2. Vessel. Machang culture, Neolithic period, third millennium B.C. Pottery with ink-painted motifs and sculptured shaman's head. Museum of Fine Arts, Boston. E. Rhodes and Leona B. Carpenter Foundation and Edwin E. Jack Fund. 1988.29

Techniques, Materials, and Formats

Traditional Chinese connoisseurs often applied the aesthetic ideas and terminology of calligraphy to the judgment of painting. "Calligraphy

Fig. 3. Ritual Weapon *Ge* (detail). Warring States Period, 5th century B.C. Cast bronze with engraved 24-character inscription on the handle. Museum of Fine Arts, Boston. Keith McLeod Fund. 1996 B45.1

Fig. 4. Wu Changshuo (1842–1927). *Calligraphy in Clerical Script,* 1903. China, modern. Ink on paper. Museum of Fine Arts, Boston. Keith McLeod Fund. 1980.150

and painting," wrote the ninth-century critic Zhang Yanyuan, "share the same origin." Zhang could trace that affinity at least as far back as a millennium before him, to the Han dynasty. The famous Chu silk document (Sackler Foundation, New York) provides early evidence of parallels between seal-script writing and the even-width drawing of figures. Modern archaeological discoveries confirm a yet-earlier parallel in Chinese Neolithic ceramics, the painted motifs and pictographic markings of which display similar forms and characteristics (fig. 2). So natural was this transfer of calligraphic brushwork to figure and landscape techniques that Chinese connoisseurs frequently referred to painting as *xie* (something written). From their perspective, brushwork in painting could not be appreciated apart from an understanding of calligraphy.

The development of three new Chinese writing styles after over a thousand years of domination by rigid seal scripts (fig. 3) helped inspire the way brush techniques were used by Chinese painters. During the late Western Han period (206 B.C.–A.D. 24), the emergence of the popular clerical script style known as *li shu* (fig. 4) greatly influenced painting techniques, as is evident in the exaggerated drawing of human and animal figures on Boston's Han tomb tiles (cat. 1). With its modulated lines, this animated Han figure style expanded the expressive possibilities of brush techniques typical of pre-Buddhist, Chinese figure-painting styles.

Early landscape painters like Fan Kuan, Guo Xi, Li Tang, and their followers owed much to the development of *kai shu* (regular script; see cat. 7) and *xing su* (semi-cursive script). They replaced seal and clerical scripts as mainstream styles of Chinese calligraphy from the fourth century right up to the present day. Their symmetric structure and highly disciplined brushwork are reflected in the refined articulation and realism of motifs in Song landscape art (see cat. 11).

A third influence of calligraphy on Chinese painting was the spread of *cao shu,* or cursive script (see cat. 32), which originated during the Han dynasty. It inspired both literati painters and Buddhist monks to apply similarly expressive, spontaneous brushstrokes to their paintings. Its impact is apparent in three Yuan-dynasty works in the Museum's collection: two anonymous paintings—*Ink Landscape in the Style of Mi Fu* and *Ink Bamboo*—and *Ink Grapes,* attributed to the priest Ziwen Riguan.

Materials

Chinese describe the essential materials needed for painting as *Wenfang sibao,* or the four treasures of a scholar's study, which include paper, ink stick, ink stone, and brushes. The general design of a brush required affixing a layered bundle of animal hairs to the hollowed end of a bamboo tube. At least three basic brush types were used: a small, thin brush for outlining; a wide, larger type for washing and shading; and a medium-sized brush for outlining, texturing, and dotting. Brushes were shaped with two kinds of fur tips, soft or hard, to achieve different effects. Chinese painters used color pigments derived both from mineral and vegetable bases. The preference of academy and professional painters was for the former, while amateur literati tended to use the latter. Similarly, silk was generally used as the support for academy works while scholar–painters often used paper.

Fig. 5a. Big and small ax-cuts, used by Li Tang and followers. (Ma Yuan, *Scholars Conversing Beneath Blossoming Plum Tree,* cat. 69; detail)

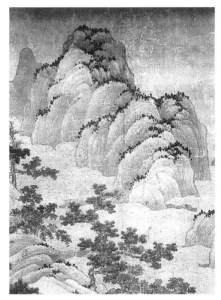

Fig. 5b. Hempstrokes, a speciality of the Southern Dong-Ju school. (Anonymous, *Dragon King Worshipping the Buddha,* cat. 142; detail)

Brushwork in Figure Painting

Not all Chinese-painting brushwork originated in calligraphy. Central Asian drawing techniques introduced to China through Buddhism developed independently of Chinese calligraphy. Non-Chinese innovations such as three-dimensional modeling owed much to Buddhist sculpture and cave murals and significantly expanded the repertoire of native styles. In his *Tuhua Jianwenzhi* (Experiences in Painting), the connoisseur Guo Ruoxu (act. mid-eleventh century) distinguished between two contrasting brushwork styles in Chinese figure painting. The first was the native, calligraphic approach as represented by Wu Daozi; the other was the style imported from Samarkand by the Central Asian artist Cao Zhongda (act. second half of sixth century). Traditional connoisseurs often used poetic similes to describe effects and styles: Wu Daozi's brushwork is likened to "a scarf fluttering in the wind" (*Wudai dang feng*), while Cao Zhongda's is like "drapery drenched in water" (*Caoyi chu shui*).[33] In other words, Wu Daozi's drawing technique shows lines of shifting, uneven width, executed with modulated speed and force in an expressive, spontaneous rhythm. On the other hand, Cao Zhongda's pencillike, even-width, linear drawing is more descriptive, defining motifs, forms, and their spatial relationship. Therefore, Wu Daozi's brushwork is more emotionally charged, whereas Cao Zhongda's line represents its subject matter more objectively.

Broadly speaking, these two types—the expressive and the descriptive—represent the main polarities of brushwork in classical Chinese painting. With the former, figures appear more animated and less confined by space. Even facial expressions of such figures seem more exaggerated and dramatized, as in the Han tomb tiles. For their part, Central Asian painting techniques are better suited to realistic depiction of figures and three-dimensional forms. These techniques had enormous impact during the Tang dynasty. What the Chinese termed iron-wire drawing was probably derived from such Central Asian techniques, which in turn originated from the Gandarian/Gupta styles. The figures in the *Thirteen Emperors* handscroll (cat. 3) and those in the *Northern Qi Scholars Collating Classic Texts* (cat. 9) all display such characteristics. A more traditional Chinese technique emphasizing calligraphic execution is seen in Boston's *Court Ladies Preparing Newly Woven Silk.* Here, one can see subtle, elegant shifts in the line widths that resulted from changes in brush pressure and speed as it completed the drawing.

Landscape Techniques

From the tenth century on, landscape gradually replaced figure painting as the dominant genre, and a variety of new brush techniques evolved. The early Tang painters had used ink to produce one of many colors for landscapes. Later, Song landscapists who worked in the monochromatic style referred to five shades or tones of ink: dry, wet, deep, light, and "burnt." Their sophisticated use of ink created effects of depth, volume, and the spatial illusion of vast distance, as well as finely detailed motifs. The brushwork types characteristic of early landscape painting are traditionally categorized as *cun* (texturing), *ca* (shading), *dian* (highlighting), *ran* (washing), and *gou* (outlining).

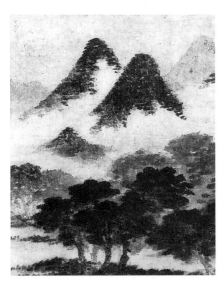

Fig. 5c. Mi-dots, created by Mi Fu. (Anonymous, *Landscape in the Style of Mi Fu*, cat. 138; detail)

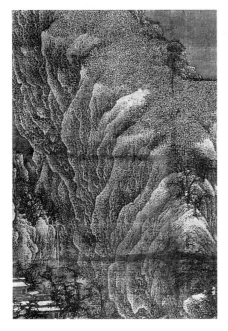

Fig. 5d. Raindrops, used by Fan Kuan and followers. (Fan Kuan, attrib., *Winter Landscape with Temples and Travelers*, cat 11; detail).

The *cun* techniques include texture strokes known as big and small ax-cuts, which were used by Li Tang and his followers (fig. 5a; cat. 69); hempstrokes, a specialty of the southern Dong-Ju school (fig. 5b; cat. 142); Mi-dots created by Mi Fu (fig. 5c; cat. 138); and raindrops, developed by Fan Kuan and his followers (fig. 5d; cat. 11). In *ca* techniques, shading is achieved by using the side rather than the tip of the brush to rub ink onto a paper or silk surface. In so doing, a motif such as a rock or tree trunk can be modeled or shaped (fig. 5e; cat. 21). The *dian* technique is not limited to dotting but also involves short vertical or horizontal strokes, usually applied to the tops of rocks, hills, or mountains, or on the surfaces of tree trunks, as a way of accentuating certain painted areas. The washing technique *ran* can create a soft definition of distant mountains or enhance both painted areas (e.g., the dark side of rocks or tree trunks, the lower part of a waterfall, or shading in snow-covered motifs) and unpainted space (sky, land, water).(See details of *A Fisherman's Abode after Rain* (cat. 65) and *Clear Weather in the Valley* (cat. 90)). The outline technique known as *gou* was used for contours of landscape motifs. It has the longest history in Chinese painting, so its application varied according to periods and schools. Generally, Northern Song landscapes are outlined in rich ink tones with forceful brushstrokes, whereas the outlines in Southern Song landscapes evidence a more refined brushwork. Later, during the Yuan dynasty, literati painters outlined their landscapes using a spontaneous, expressive, and calligraphic technique.

The coloristic approach of Central Asian Buddhist painting also inspired Chinese artists to produce an exotic style known as *qinglü shanshui* (blue-and-green landscape). It combined ink outlines with rich mineral colorings, sometimes with the addition of gold. From this Tang-dynasty blue-and-green style, a new type of landscape emerged—*mogu shanshui* (boneless landscape)—which was created purely with color and without the application of the "bone"—i.e., ink. Some Yuan literati, however, tried to inject new life into an ancient tradition by adding ink to their colored landscapes (see cat 150).

Formats

The formats of early Chinese paintings consist of three basic types: handscroll, hanging scroll, and album leaves. Handscrolls appeared earliest. During the Eastern Zhou (770–221 B.C.) and Western Han dynasties, prior to the invention of paper, Chinese written texts were usually preserved on thin bamboo strips bound together so they could be rolled up from left-to-right and stored. It is probable that the highly portable, horizontal handscroll format evolved from this ancient prototype. The horizontal presentation of Han-dynasty murals was also a likely influence in its development. A highly versatile viewing format, it allowed for a cinematic presentation of successive narrative or landscape passages. As Indian Buddhism and Buddhist art became increasingly popular, its disciples adopted the Chinese handscroll format to narrate episodes from the life of the Buddha. Whether on silk or paper, such works were backed by a layer of thin paper to give support to the painted surface. Then they were mounted with silk borders and brocaded ends prior to more layers of finishing backing being added. Horizontal scrolls are viewed by first unrolling the cover section and then moving leftward, section by section.

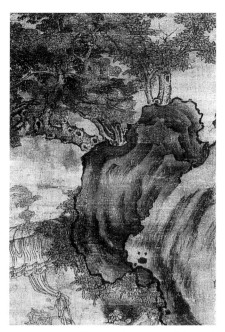

Fig. 5e. *Ca* (rubbing) technique, widely used by all landscapists. (Anonymous, *Daoist Deity of the Earth*, cat. 21; detail).

The vertical format known as the hanging scroll evolved from an unexpected circumstance: the importation of Central Asian–style chairs and stools in the eighth century. Previously the Chinese customarily sat on mats, but the addition of taller chairs and tables necessitated higher ceilings and more wall space for interiors. Tang literature describes the appearance of standing painted screens and vertical scrolls hung on walls. Prior to its remounting (for preservation purposes), the anonymous, fourteenth-century hanging scroll, *Two Carp Leaping among Waves* (cat. 119) must originally have been a screen, not unlike the wave painting shown on the screen depicted in Su Hanchen's *Lady at her Dressing Table in a Garden* (cat. 25).

Emperor Huizong's *Five-Colored Parakeet* is perhaps the earliest prototype of the album-leaf format in existence. Most later album leaves of painting and calligraphy exist in circular or square forms. The round form originally served as the two sides of a round fan. First the leaf was backed with a layer of paper and then its was mounted on a fan frame. Five such painting/calligraphy pairs are shown in the exhibition (cat. 31 and 32, 63 and 64, 70 and 71, 72 and 73, and 133 and 134). Some were deliberately created to be complimentary works, as is evident from the match of painted subject matter and written text. But collectors would also mount two unrelated works together (see cat. 79 and 80). Square or rectangular leaves were generally used to decorate a piece of furniture or an architectural space. For preservation purposes, such works were later removed from their frames and remounted onto album-sized leaves by collectors.

Since the fourteenth century, Chinese have produced their own folding fans fashioned after Japanese and Korean prototypes imported by traveling monks and traders. The new folding fans became quite popular among the literati, and they gradually replaced the native round fans. Like the earlier round fans, folding fans usually displayed a painting on one side and calligraphy on the other. When executed by well-known masters, collectors preferred to save the art by remounting it on paper for inclusion in an album.

Notes

1. See Baxandall, p. 117. The "now-lost" painting criticism of classical Greece, as Baxandall notes, survives only in fragments or from such derived sources as Pliny's *Natural History* (Books 34–6), the stylistic terminology of which is literary rather than pictorial.

2. Quoted in Fong, *BR*, p. 13.

3. Quoted in Lodge, p. 68.

4. Merton, p. 76.

5. See Panofsky, pp. 10–21.

6. See R. Lee, p. 6, n. 20, and Appendix 1, p. 69. Even in the early eighteenth century, critics like Roger de Piles were lamenting this loss. In his *Cours de Peinture*, de Piles claimed that because there was, as Lee notes, "nothing left to give a just idea of painting as practiced by the ancients in its period of greatest perfection, painting in modern times has not yet been recovered in its fullest extent." For discussion of the debt of Renaissance artists to antiquity and the influence of classical literary and sculptural models, see Gombrich, pp. 122–28, and Panofsky, op. cit.

7. Cahill, *Chinese Painting*, p. 101. That Zhao Mengfu's stylistic amalgam in fourteenth-century China anticipates aesthetic trends of Western modernism has been noted by other scholars as well. See discussion in Fong *BR*, pp. 438–40, where the abovementioned Zhao Mengfu scrolls are reproduced.

8. See the landscape scroll *You chun tu* (Traveling in Spring), a late-Tang copy after an earlier original attributed to Zhan Ziqian (act. second half of sixth century), and the hanging scroll *Minghuang xing Shu tu* (Emperor Minghuang's Journey to Shu), a Song copy after an eighth-century original, in *ZMQ*, pls. 1 and 15.

9. See *ZMQ*, vol. 12, pls. 62–68, pp. 24–26.

10. See Fong, *BR*, p. 8. As early as the ninth century, connoisseurs like Zhang Yanyuan had classified painters according to *san gu*, or the Three Antiquities, which covered artists from the first through the sixth centuries A.D., a historical span that encompasses roughly five separate dynastic periods. See *Lidai minghua ji*, juan 2, pp. 25–27, in Yu Anlan, *HC*, vol. 1.

11. The traditional dates for Prince Siddhartha Gautama—who, after his Enlightenment in Bodh Gaya, India, became known as Śākyamuni Buddha—are 563–483 B.C. While the dates of Confucius are firmly established as 551–479 B.C., little historical evidence exists concerning his older contemporary, the sage Laozi, also known as Li Er and "Old Dan." Laozi's dates are sometimes given as 604–531 B.C., and Daoist texts such as the *Way of Zhuangzi* contain amusing anecdotes of his encounters and conversations with Confucius. But these were likely written down much later, after the founding of the Han dynasty. For discussion of the dating, authorship, and history of early Daoist texts, see D.C. Lau's translation and commentary in Lao-tzu.

12. See Whitfield. For a popular account of the modern rediscovery of Dunhuang, see Hopkirk.

13. K.S. Chen, p. 358.

14. For the aesthetic impact of Chan Buddhism in China and Japan, see Fontein and Hickman.

15. For discussion and later Japanese examples, see ibid., pp. 91–93.

16. See Kries.

17. For a recent critical assessment of the "amateur ideal" in post-Song painting, see James Cahill's provocative lectures published as *The Painter's Practice*.

18. See Owen, p. 365.

19. See Zhu Jingxuan, *Tangchao minghualu* (Famous Paintings of the Tang Dynasty), in Yang Jialu, pp. 18–19.

20. See *Masterpieces of Chinese Figure Painting in the National Palace Museum*, pl. 1 and p. 131.

21. The story appears in Zhu Jingxuan, ibid., p. 14; a more embellished version is found in Guo Ruoxi's *Tuhua jianwenzhi*, in Yu Anlan *HC*. See Soper, *Kuo Jo-hsü's Experiences in Painting*, p. 75.

22. Quoted in Fong, *BR*, p. 20.

23. See Wu Tung, "Zhangzong ti Tianshui…," pp. 1–11.

24. See David Hinton's introduction to his translation of the *Selected Poems of Li Po* (New York: New Directions, 1996), p. xxiii.

25. Quoted in Munakata, p. 2. As Munakata notes, mountain worship was a major component of Chinese state religion, and the attendant court rituals at imperial altars served to "ensure the stability of the state." See also his illuminating discussion of the abovementioned texts by Gu Kaizhi and Zong Bing, ibid., pp. 36–41.

26. Quoted in Sickman and Soper, p. 204.

27. Owen, p. 618.

28. Ibid., p. 642.

29. See Fong, *BR*, p. 153.

30. See Deng Bai, p. 20.

31. The lineage continued as follows: After Ma Fen came the grandfather Ma Xingzu (act. 1131–62), who was a painting advisor to Emperor Gaozong and served in the imperial academy at Hangzhou. Next in line, Ma Shirong (act. mid-twelfth century), also a court painter, was the father of Ma Kui and Ma Yuan, both of whom were academy painters. Ma Yuan's son Ma Lin and grandson Ma Gongxian (act. second half of thirteenth century) continued the tradition. (Ma Gongxian has been identified erroneously as the uncle, rather than grandson, of Ma Yuan.) For literary and art historical evidence of his "post-Ma Yuan" style, see Zhuang Su, p. 14; and the signed hanging scroll in the Nanzen-ji temple, Kyoto accepted as a genuine work of Ma Gongxian. See Cahill, *Index*, p. 148.

32. See Chen Gaohua, *Yuandai huajia shiliao*, p. 305.

33. See Guo Ruoxu, *On the Style of Cao Zhongda and Wu Daozi* (in *Tuhua jianwenzhi*, juan 1, p. 10), in Yu Anlan, *HC*, vol. 1.

Color
Plates

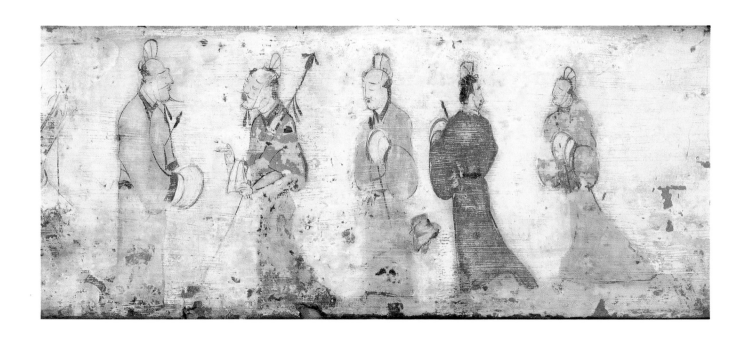

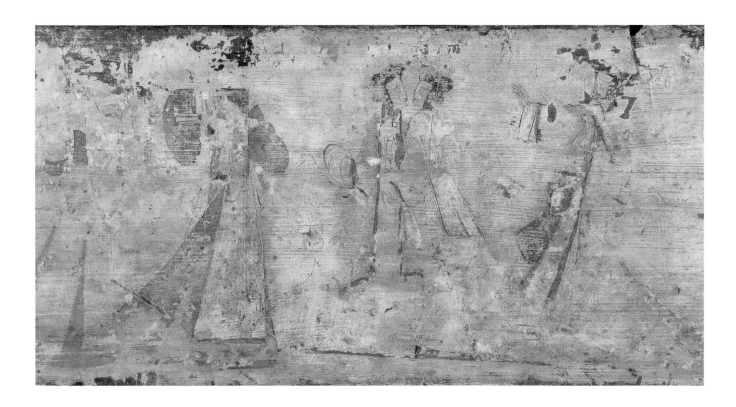

1

Anonymous
Tales from History and Legends
Western Han dynasty, late 1st century B.C.
Denman Waldo Ross collection 25.10-13
and Gift of C.T. Loo 25.190

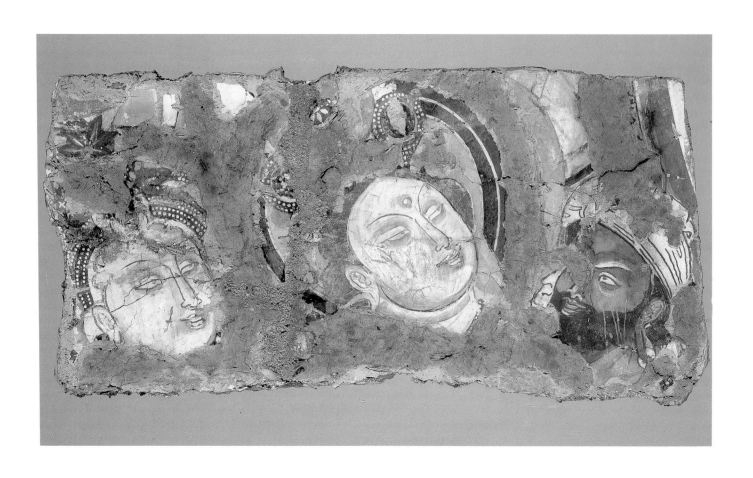

2
Anonymous
Three Kizil Buddhist Heads
Central Asia, 6th–7th century
Francis Gardner Curtis Fund 23.253

3
Attributed to Yan Liben (d. 673)
The Thirteen Emperors
Tang dynasty, second half 7th century
(with later replacement)
Denman Waldo Ross Collection 31.643

44

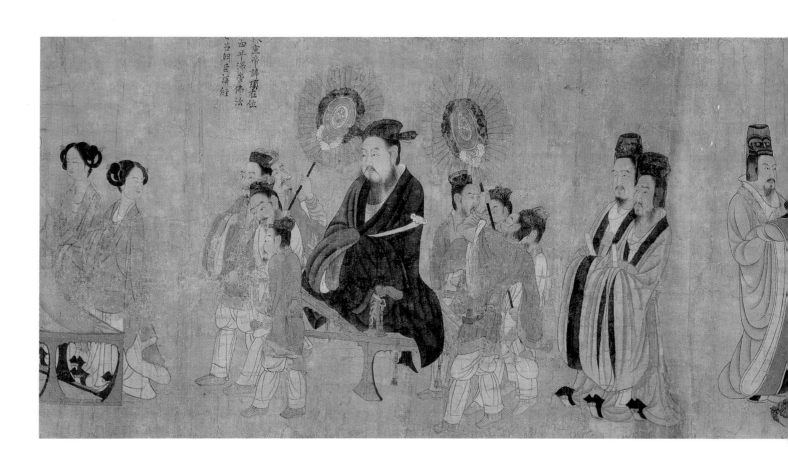

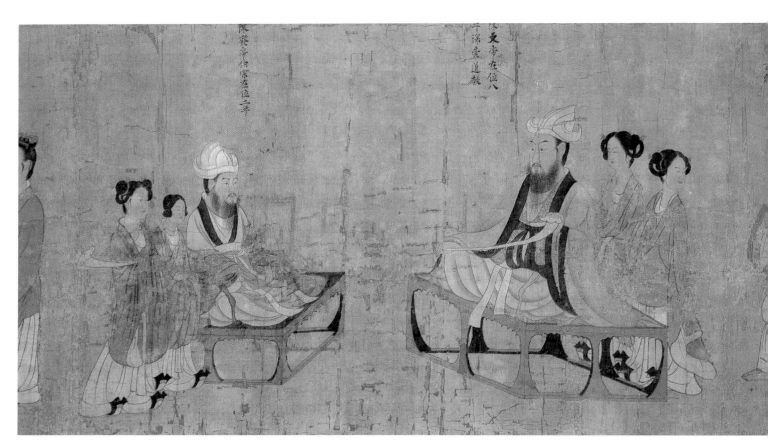

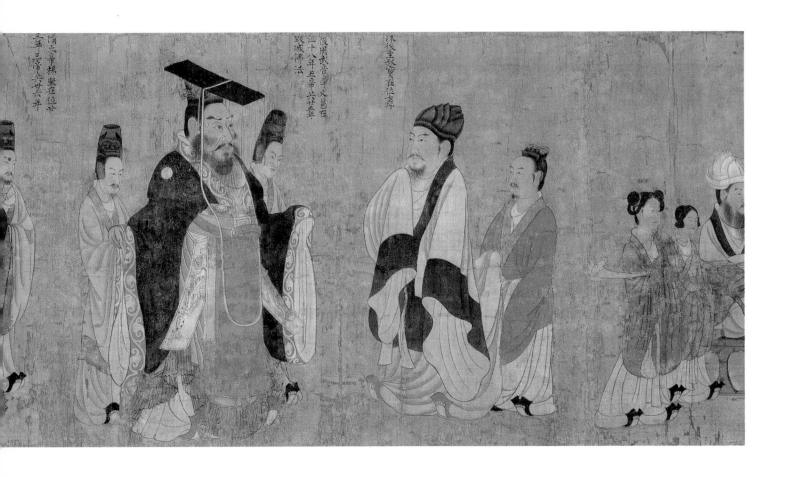

予家亦有右相所畫八璽圖

象圖得之無為子家今殘

缺過半非此可比紹興改

元二月既望獲觀于

儀仲覽古齋愛玩久之

不能去手淮海野人錢愐

趙令穰　　俟楙

秦梓　　俟憲

吳說

紹興四年歲在甲寅
三月十七日同觀于溫

淳熙三年九月廿日
新安羅願觀

淳熙十三年二月癸未
琅邪臨沂王正己觀

淳熙五年二月廿八日陽夏
趙粹觀

劉彥適宋孝先趙伯璨
呂源同觀紹興王子二
月十四日

徐康國馮純任紳鄭著紹
興癸丑十一月朔同觀

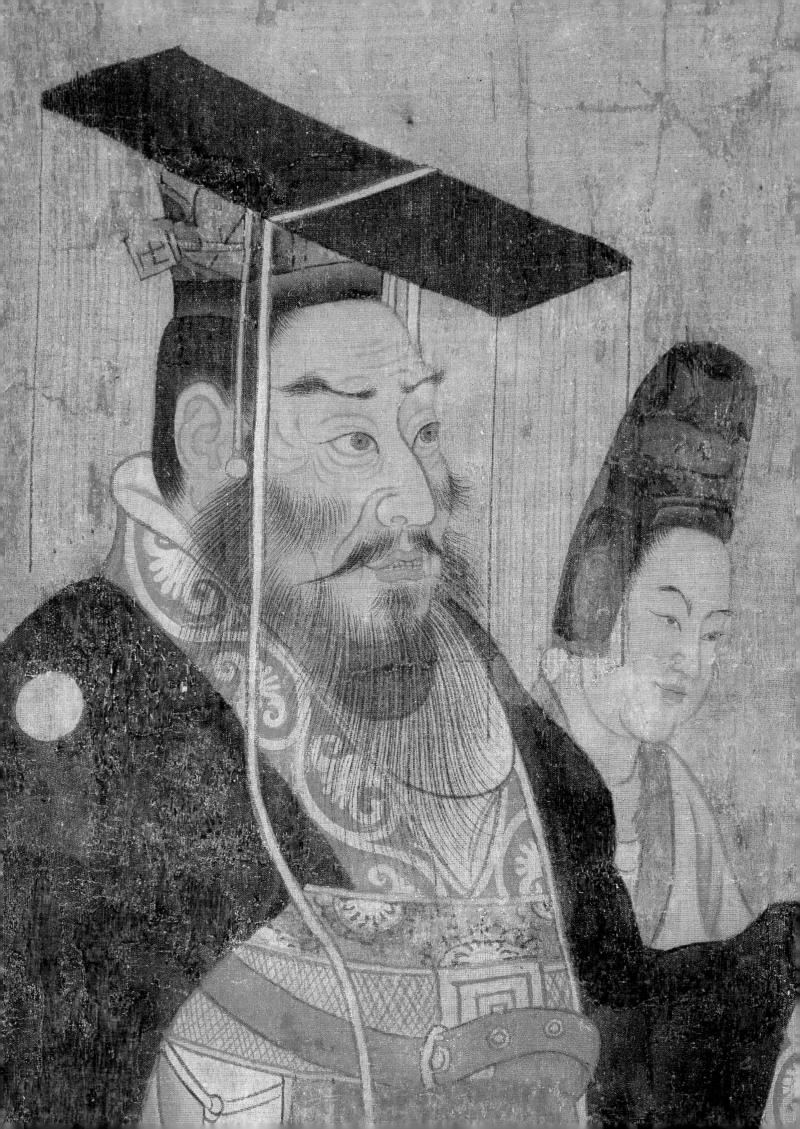

5
Anonymous
Turfan Buddhist Figures
Tang dynasty, 9th century
Denman Waldo Ross Collection
29.927a–b

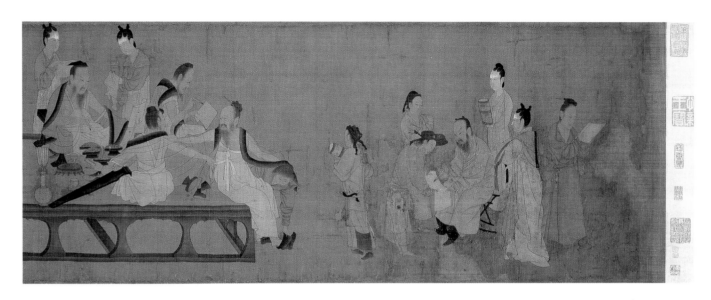

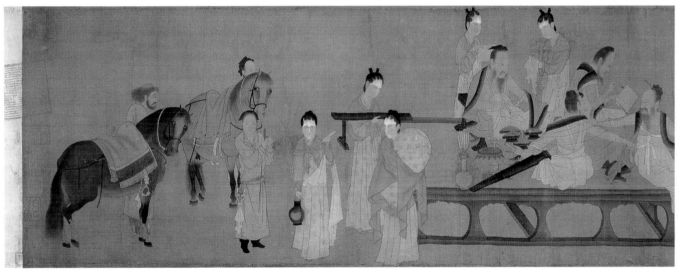

9

Anonymous (traditionally attributed to Yan Liben)
Northern Qi Scholars Collating Classic Texts
Northern Song dynasty, 11th century
Denman Waldo Ross Collection 31.123

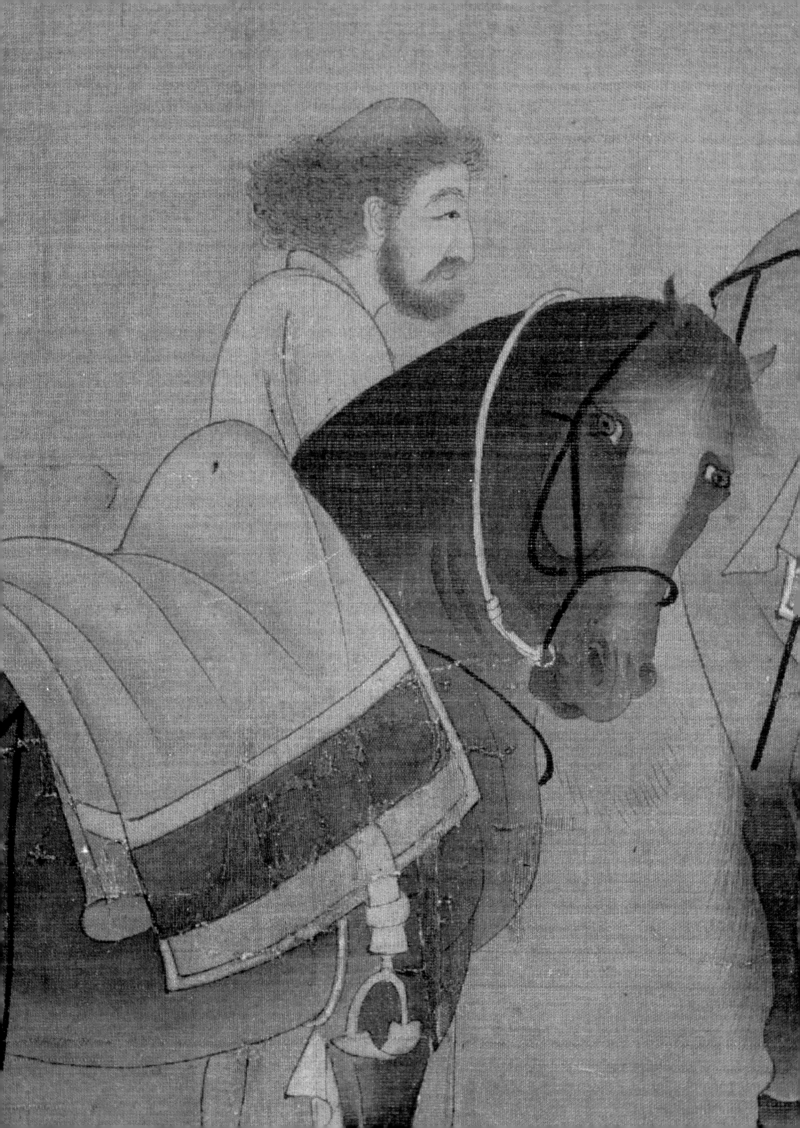

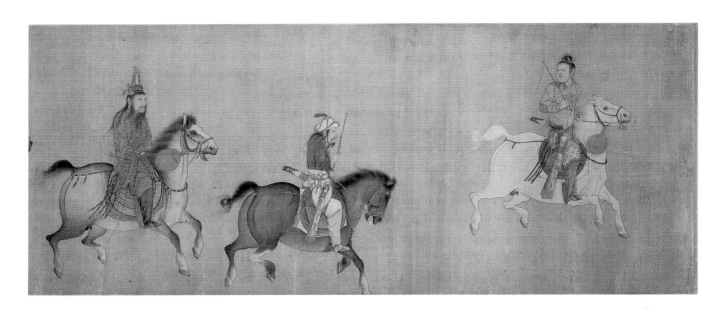

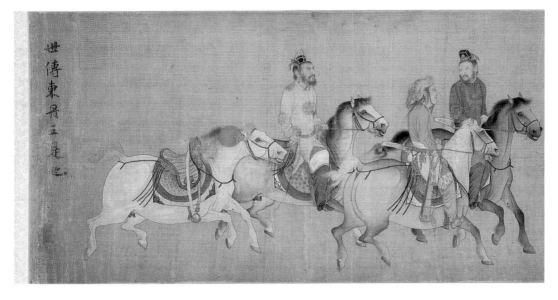

10

Anonymous (traditionally attributed to Li Zanhua)
Nomads with a Tribute Horse
Northern Song dynasty, 11th–12th century
Keith McLeod Fund 52.1380

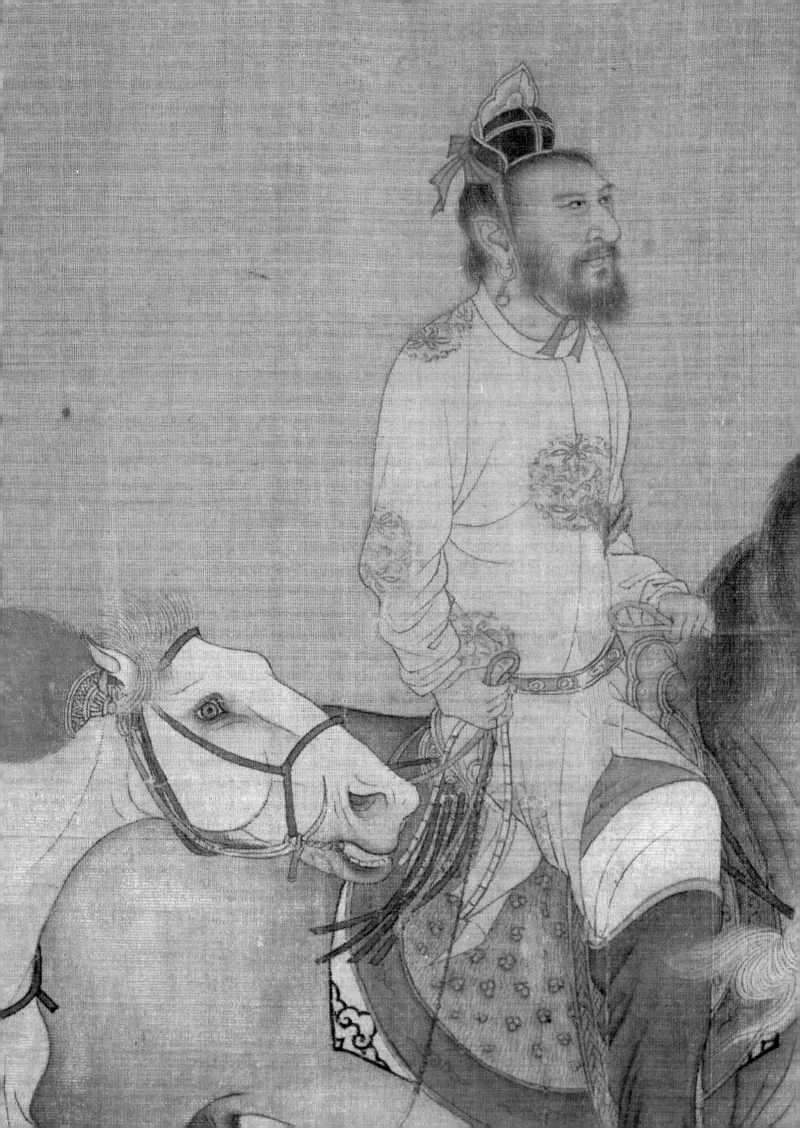

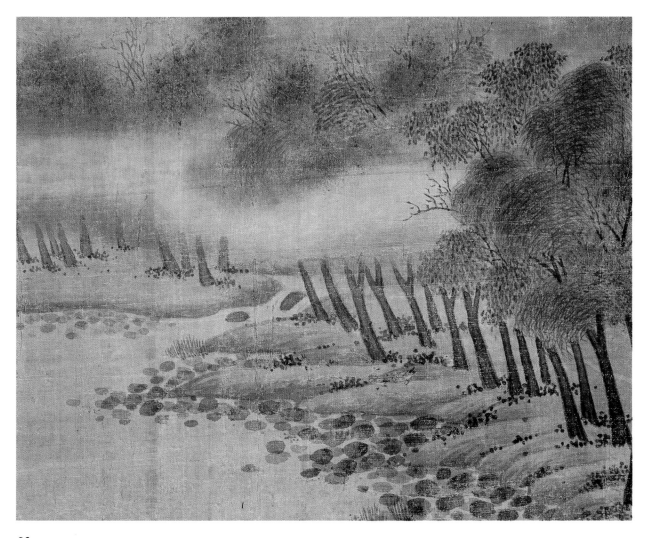

12

Zhao Lingrang (act. late 11th–early 12th century)
Summer Mist along the Lake Shore
Northern Song dynasty, dated 1100
Keith McLeod Fund 57.724

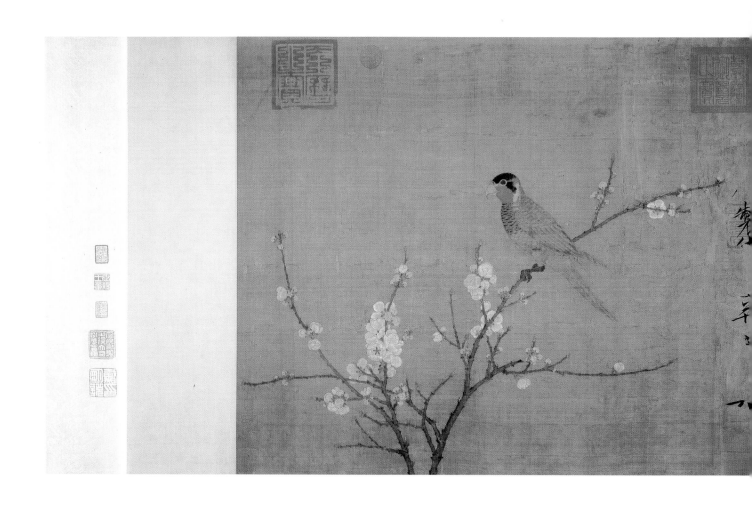

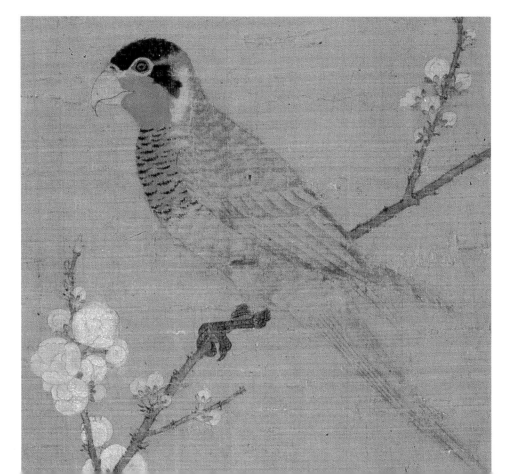

五色鸚鵡來自嶺表養之禁
籞馴服可愛飛鳴自適往來
於苑囿間方中春繁杏遍開
翔翥其上雅詫容與自有一
種態度縱目觀之宛勝圖畫
因賦是詩焉

天產乾皐此異禽
體全五色非凡質
飛鳴似解憐毛羽
遷陔來貢九重深
惠吐多言更好音
貴徘徊如飽稻粱心

相將日甘止咸嶲雅驚為武貯篤少弍今

13
Emperor Huizong (r. 1101–25, d. 1135)
Five-Colored Parakeet on Blossoming Apricot Tree
Northern Song dynasty, datable to 1110s
Maria Antoinette Evans Fund 33.364

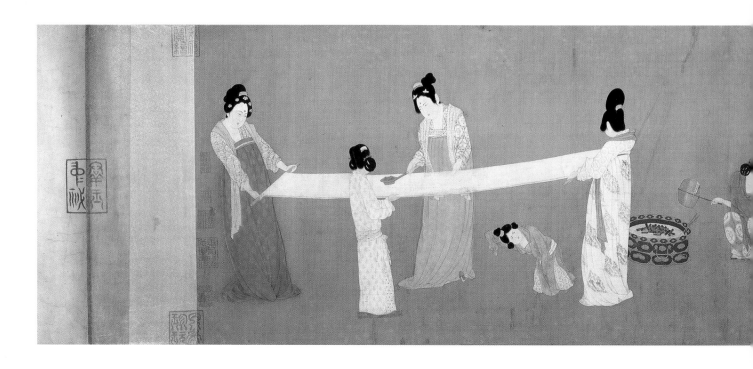

右宣和臨張萱搗練圖明昌以郡望題

籤欵之七璽蓋亦憂之之深乃知嬻母之

姿亦有効其顰者何邪齋郡張紳

14

Attributed to Emperor Huizong (r. 1101–25, d. 1135)
Court Ladies Preparing Newly Woven Silk
Northern Song dynasty, early 12th century
Chinese and Japanese Special Fund 12.886

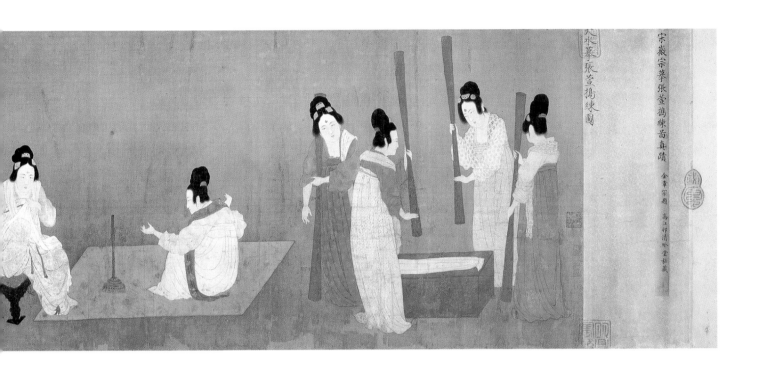

宋徽宗摹張萱搗練圖真蹟
金章宗題
馬三郎清味堂秘藏

天水摹張萱搗練圖

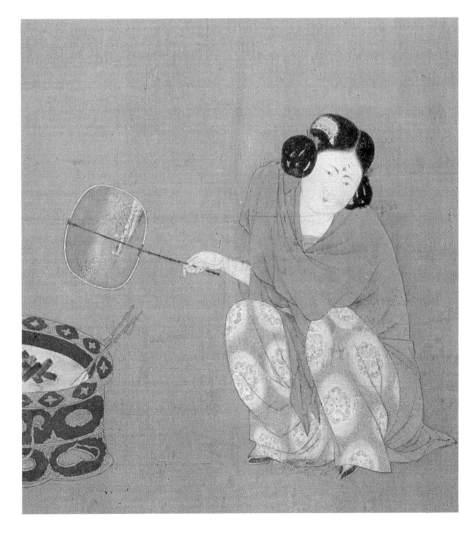

15

Anonymous (traditionally attributed to Hao Cheng)
Horse and Groom
Northern Song dynasty, early 12th century
Denman Waldo Ross Collection 17.741

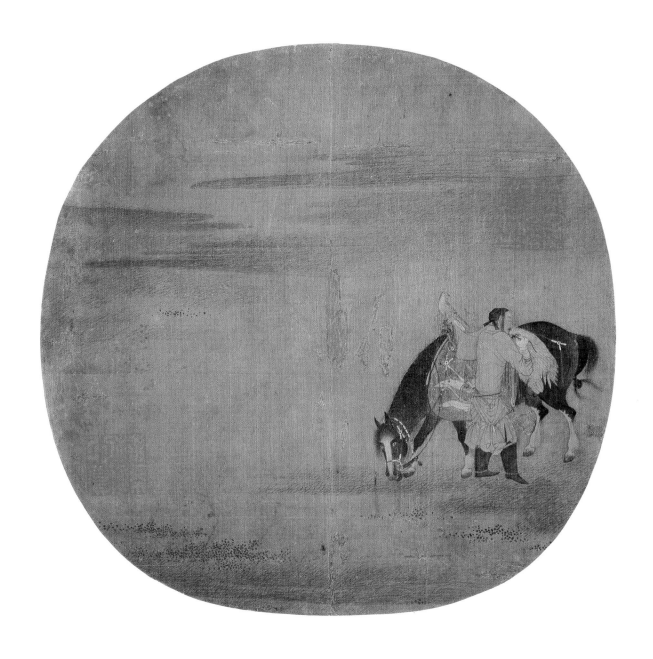

16

Anonymous (traditionally attributed to Hu Gui)
Khitan Falconer with Horse
Southern Song dynasty, 12th century
Chinese and Japanese Special Fund 12.895

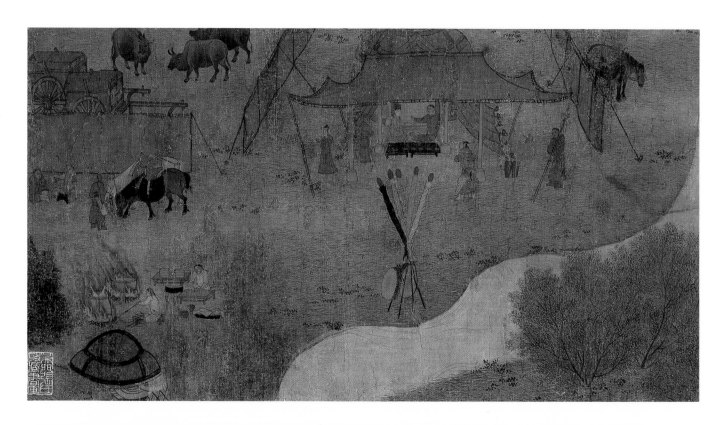

18

Anonymous
Lady Wenji's Return to China: Encampment by a Stream
Southern Song dynasty, second quarter 12th century
Denman Waldo Ross Collection 28.63

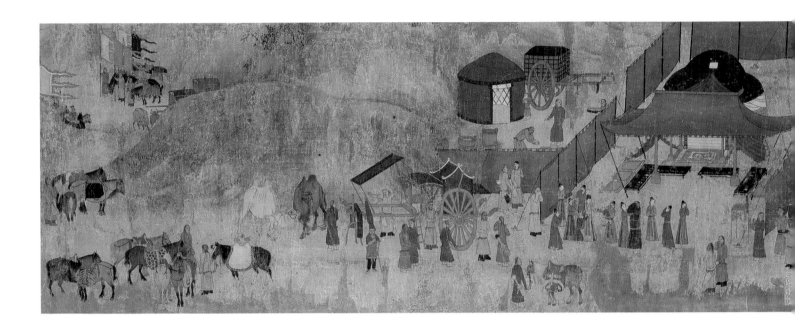

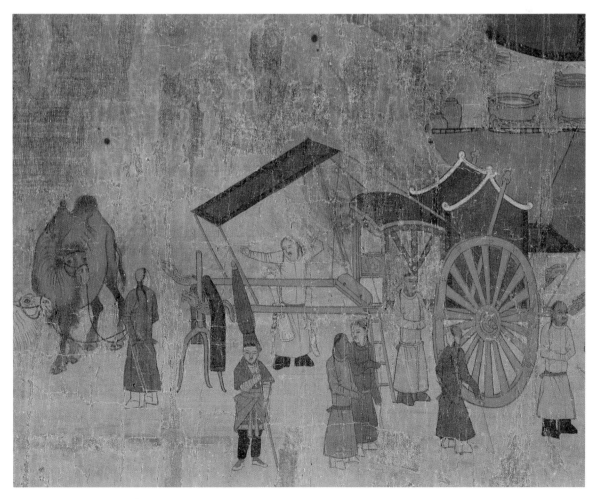

19
Anonymous
Lady Wenji's Return to China: Parting from Nomad Husband and Children
Southern Song dynasty, second quarter 12th century
Denman Waldo Ross Collection 28.64

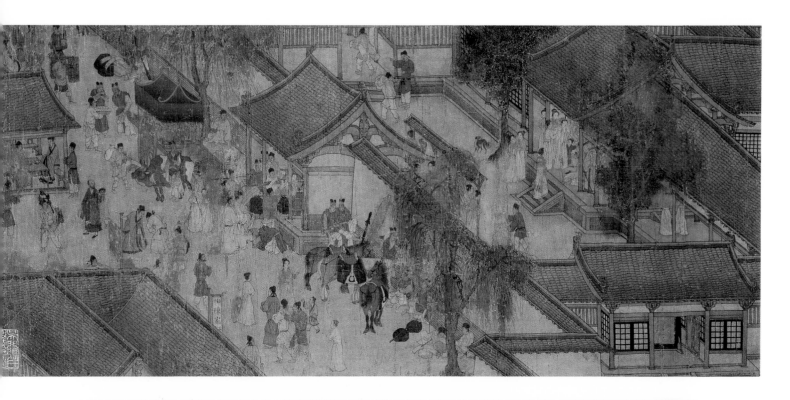

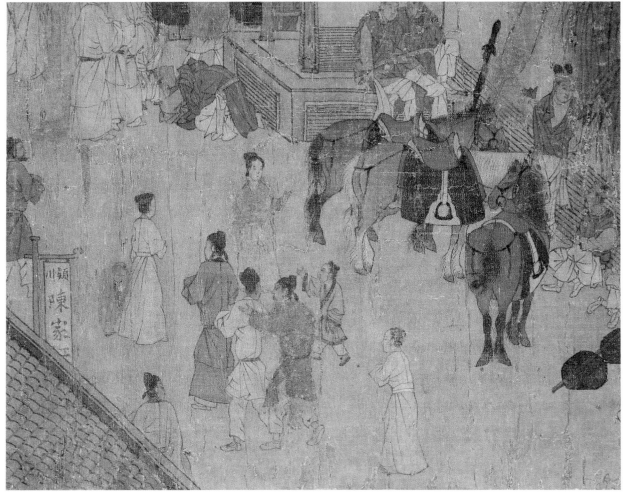

20

Anonymous
Lady Wenji's Return to China: Wenji Arriving Home
Southern Song dynasty, second quarter 12th century
Denman Waldo Ross Collection 28.65

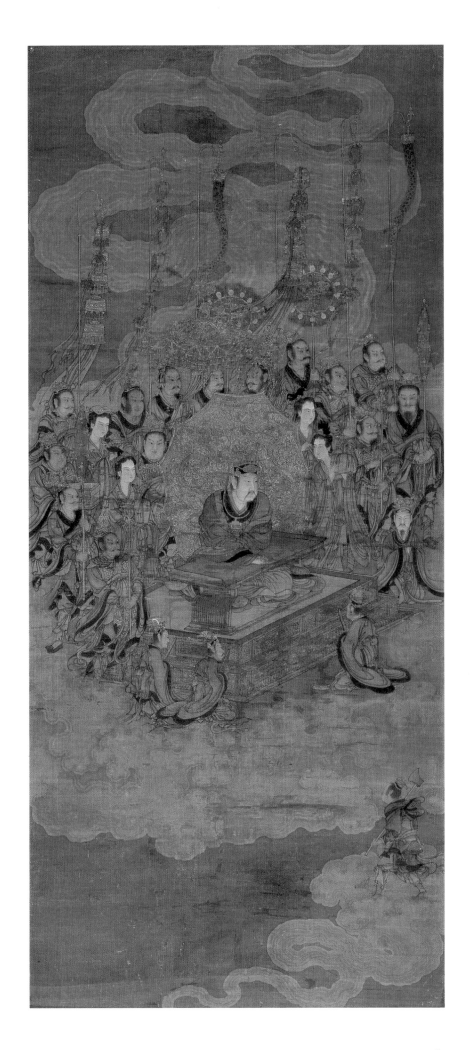

21

Anonymous
(formerly attributed to Wu Daozi)
Daoist Deity of Earth
Southern Song dynasty,
first half 12th century
Chinese and Japanese Special Fund 12.880

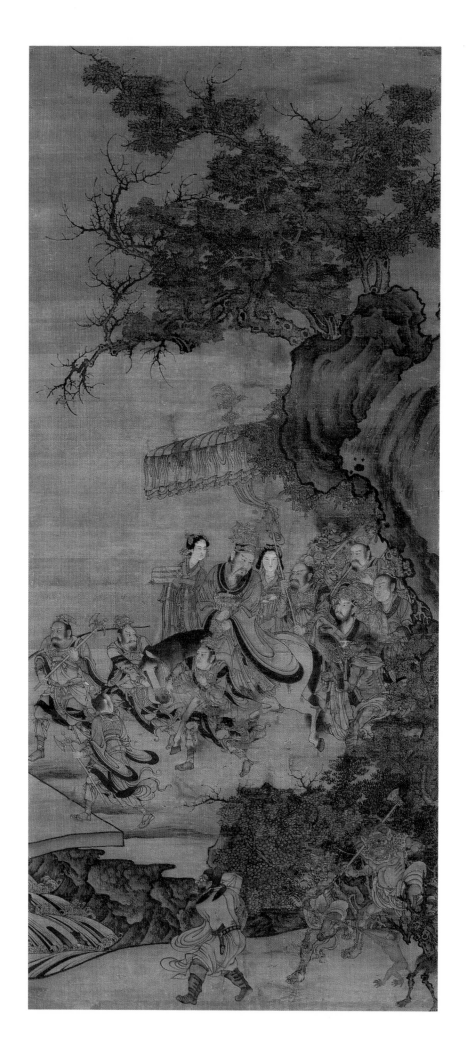

22

Anonymous
(formerly attributed to Wu Daozi)
Daoist Deity of Heaven
Southern Song dynasty,
first half 12th century
Chinese and Japanese Special Fund 12.881

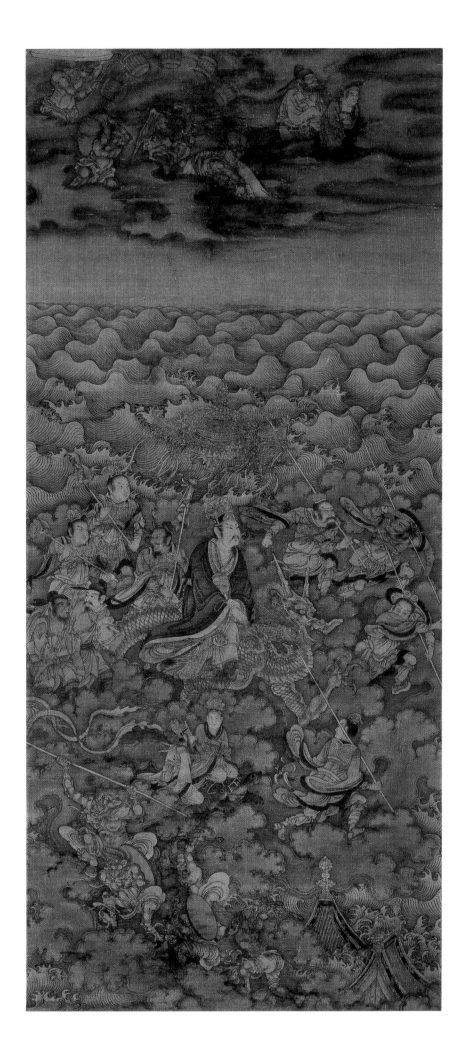

23
Anonymous
(formerly attributed to Wu Daozi)
Daoist Deity of Water
Southern Song dynasty,
first half 12th century
Chinese and Japanese Special Fund 12.882

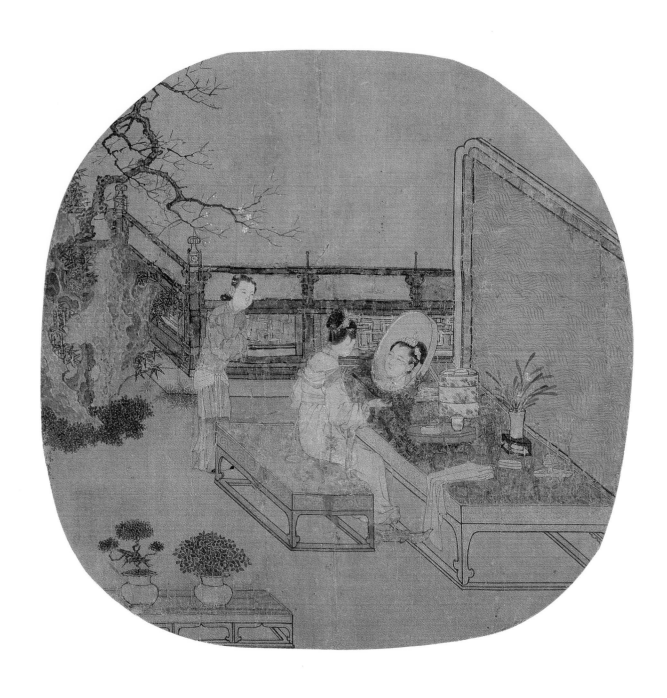

25
Su Hanchen (act. 1120s–1160s)
Lady at Her Dressing Table in a Garden
Southern Song dynasty, mid-12th century
Denman Waldo Ross Collection 29.960

31
Attributed to Jiang Shen (ca. 1090–1138)
Evening Mist over a Valley
Southern Song dynasty, late 12th century
Denman Waldo Ross Collection 28.838a

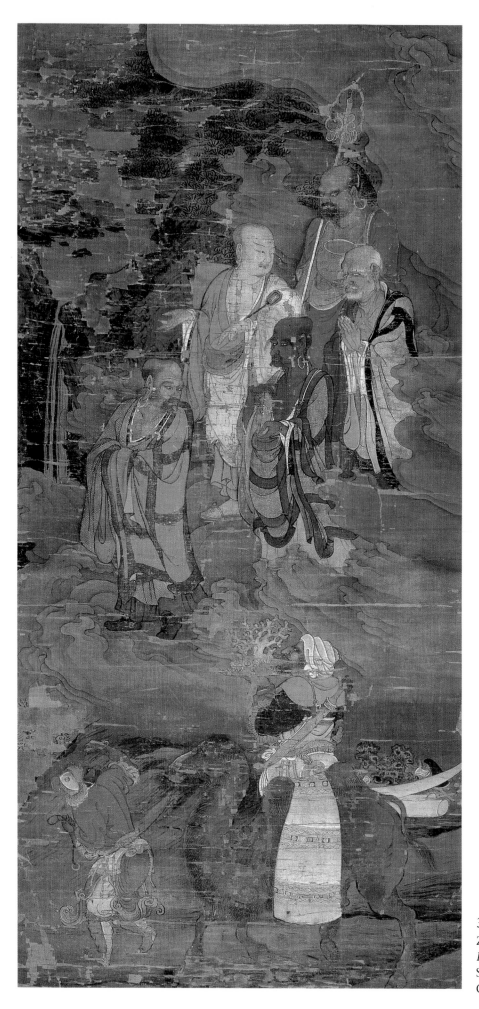

34
Zhou Jichang (act. second half 12th century)
Pilgrims Offering Treasures to Lohans
Southern Song dynasty, ca. 1178
General Fund 95.2

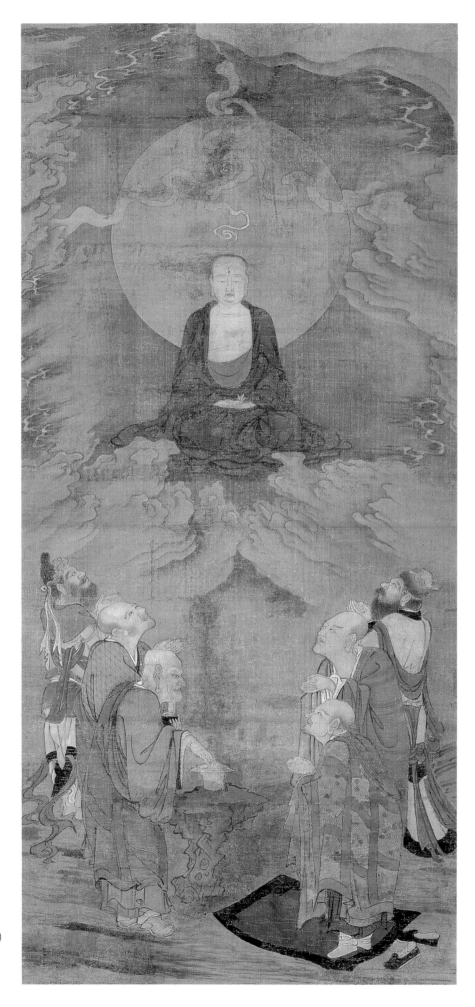

35
Zhou Jichang (act. second half 12th century)
The Transfiguration of a Lohan
Southern Song dynasty, ca. 1178
General Fund 95.3

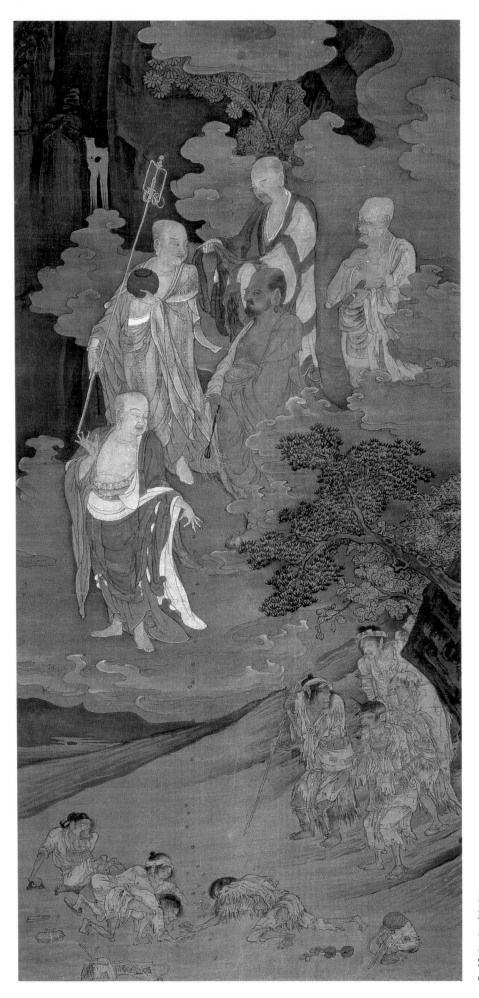

36

Zhou Jichang (act. second half 12th century)
*Lohans Bestowing Alms on Suffering
Human Beings*
Southern Song dynasty, ca. 1178
General Fund 95.4

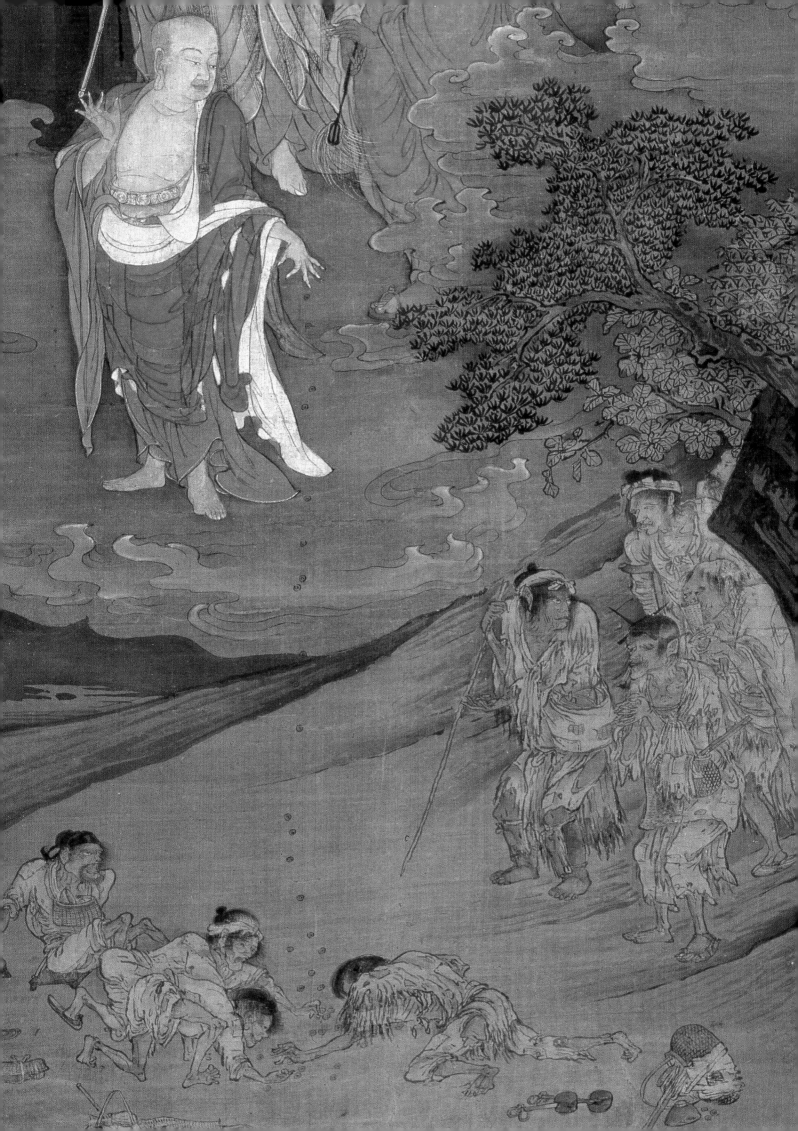

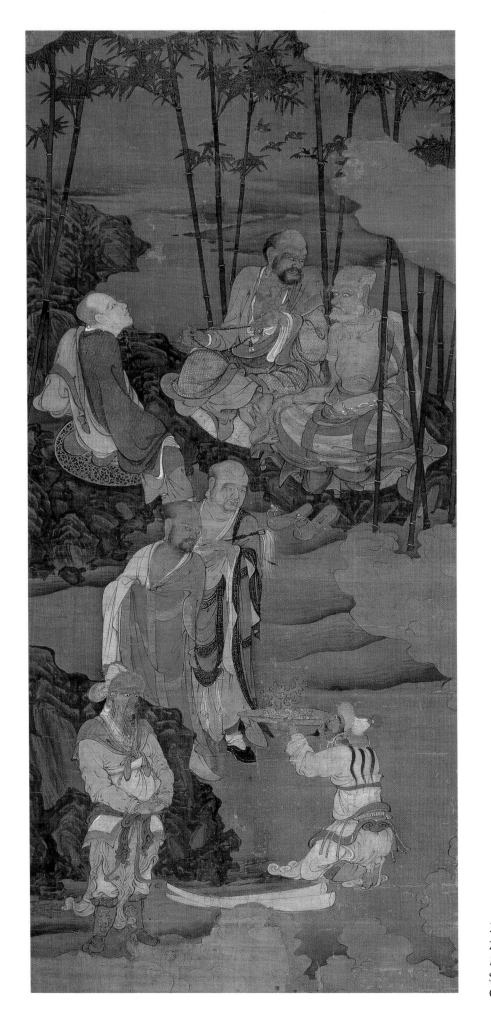

37

Zhou Jichang (act. second half 12th century)
Lohans in a Bamboo Grove Receiving Offerings
Southern Song dynasty, ca. 1178
General Fund 95.5

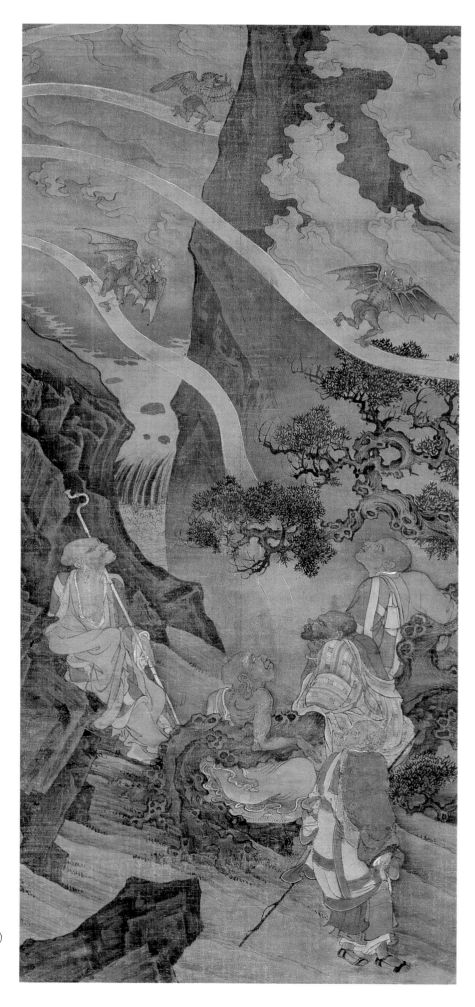

38

Zhou Jichang (act. second half 12th century)
Lohans Watching the Distribution of Relics
Southern Song dynasty, about 1178
General Fund 95.6

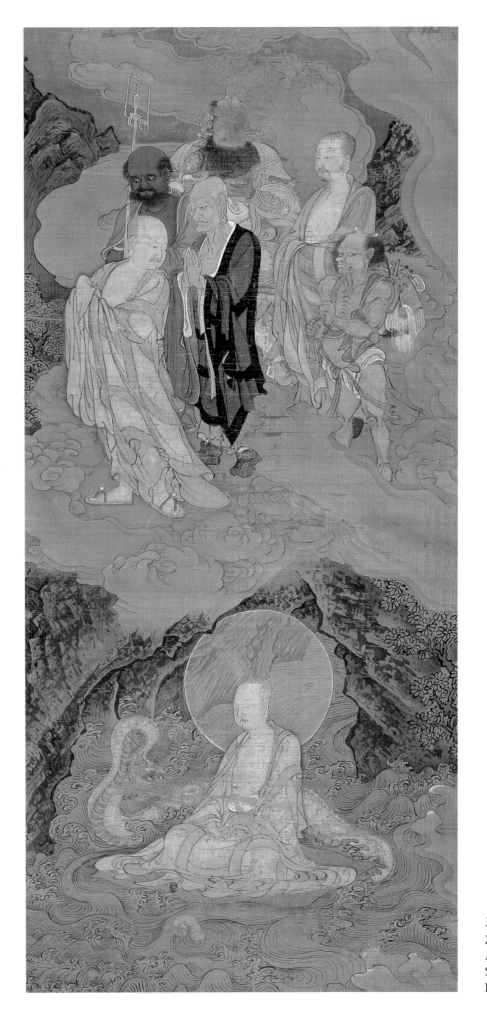

39
Zhou Jichang (act. second half 12th century)
Lohan in Meditation Attended by a Serpent
Southern Song dynasty, ca. 1178
Denman Waldo Ross Collection 06.288

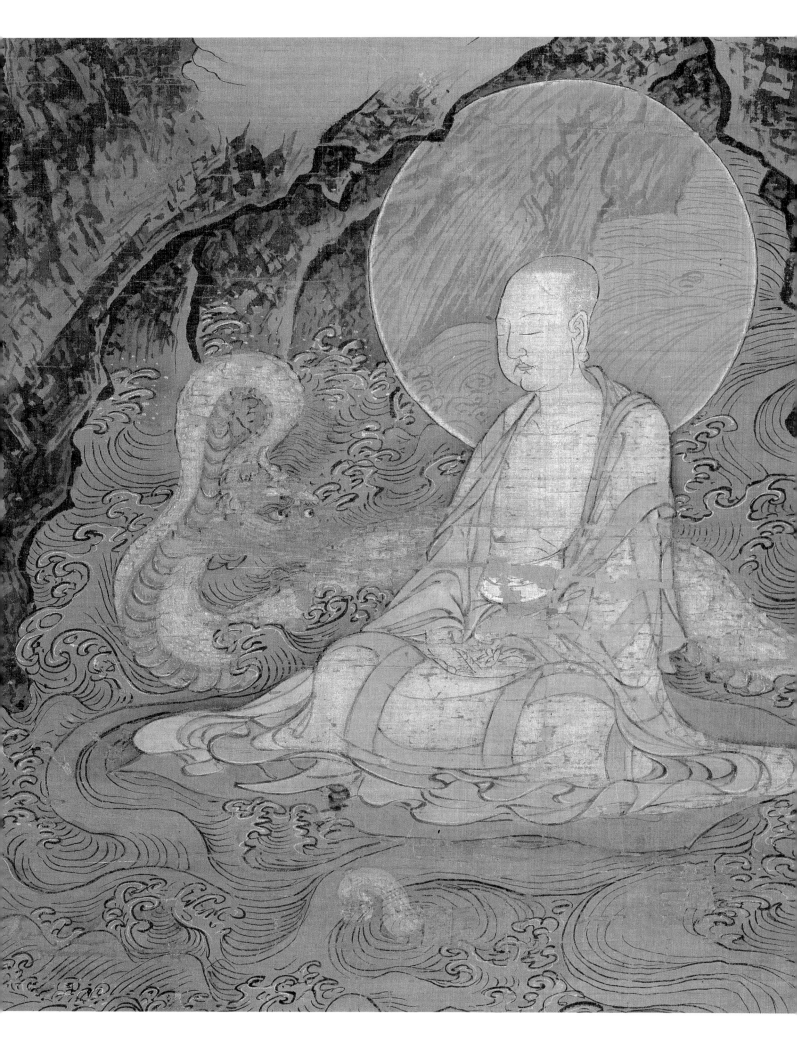

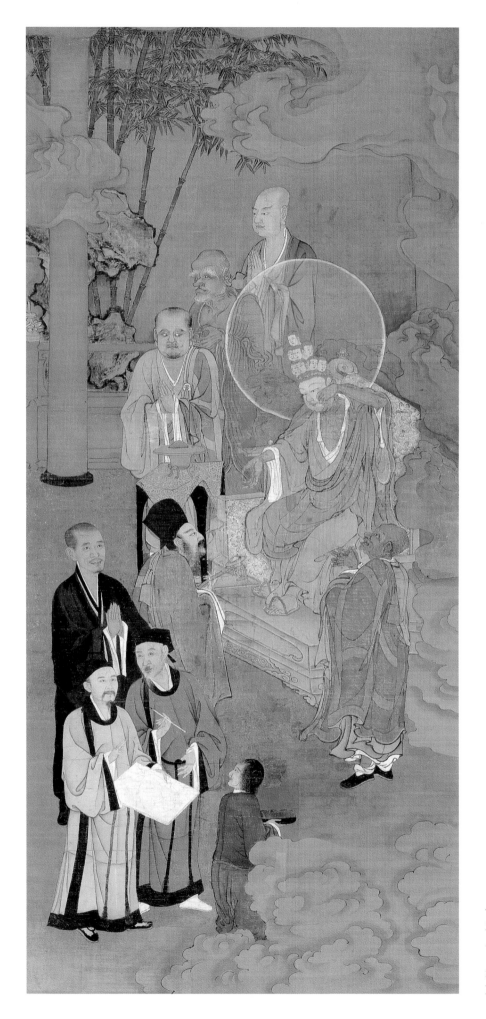

40

Zhou Jichang (act. second half 12th century)
Lohan Manifesting Himself as an Eleven-Headed Guanyin
Southern Song dynasty, ca. 1178
Denman Waldo Ross Collection 06.289

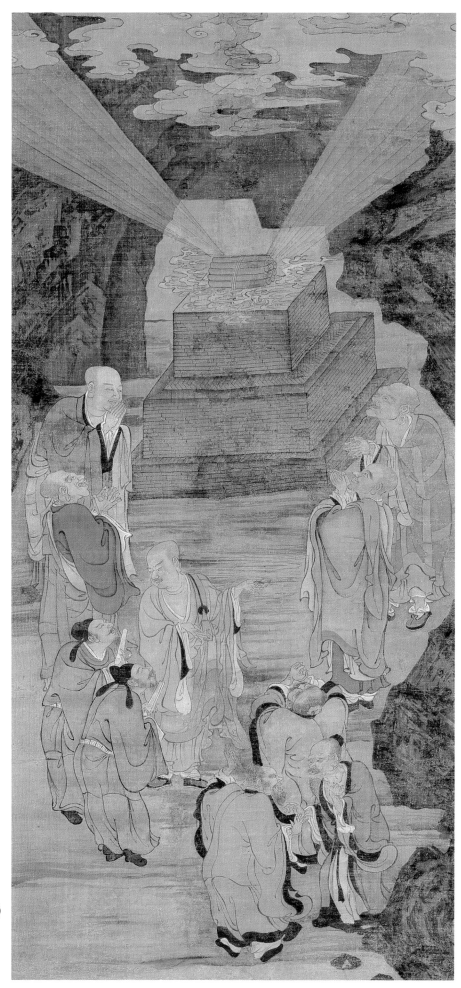

41

Zhou Jichang (act. second half 12th century)
*Lohan Demonstrating the Power of Buddhist
Sūtras to Daoists*
Southern Song dynasty, ca. 1178
Denman Waldo Ross Collection 06.290

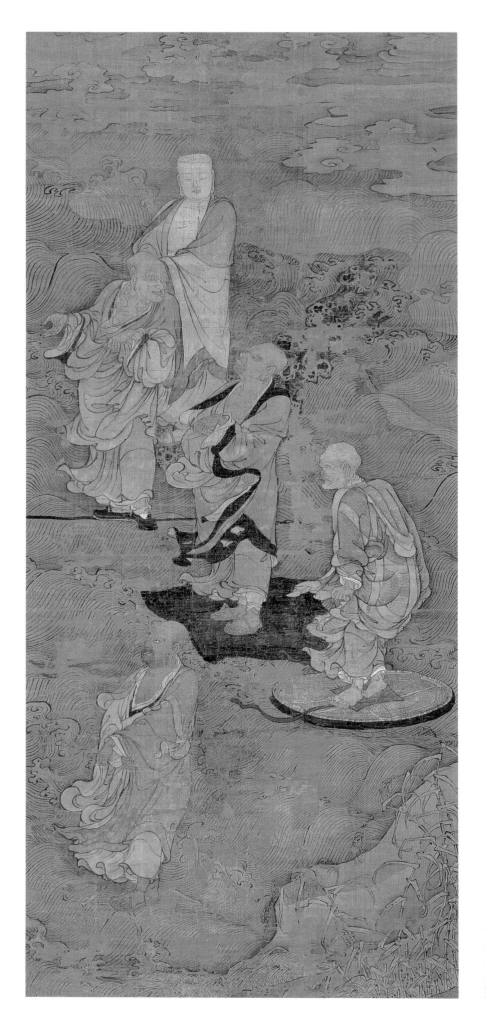

42

Zhou Jichang (act. second half 12th century)
Lohans Crossing the River
Southern Song dynasty, ca. 1178
Denman Waldo Ross Collection 06.291

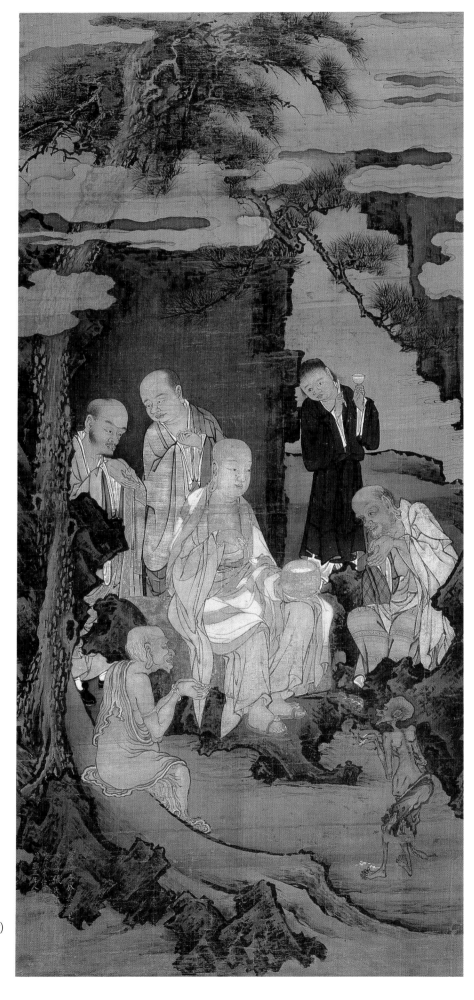

43
Lin Tinggui (act. second half 12th century)
Lohans Feeding a Hungry Spirit
Southern Song dynasty, datable to 1178
Denman Waldo Ross Collection 06.292

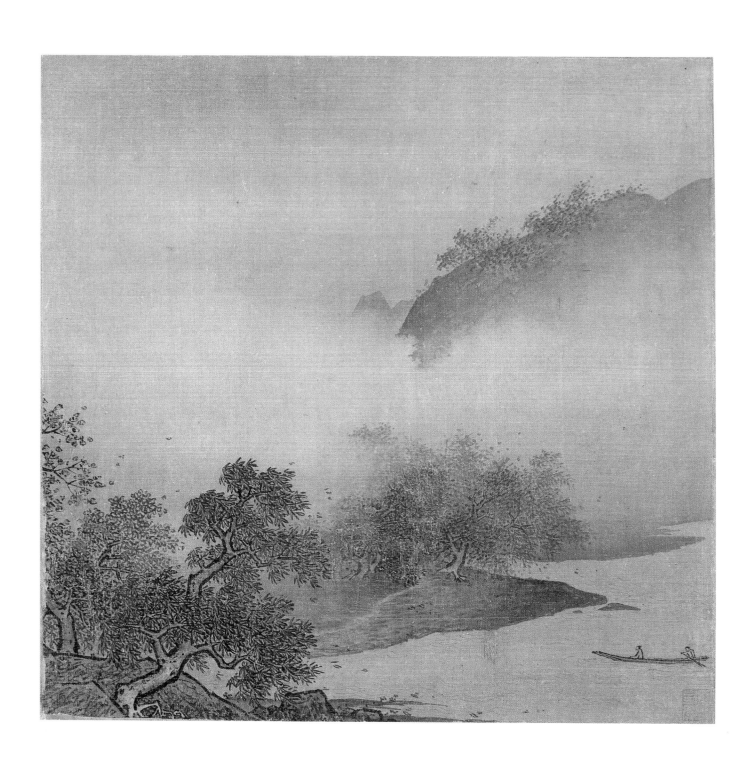

67

Anonymous (formerly attributed to Li Tang)
Autumn Foliage along a River
Southern Song dynasty, late 12th century
Denman Waldo Ross Collection 29.2

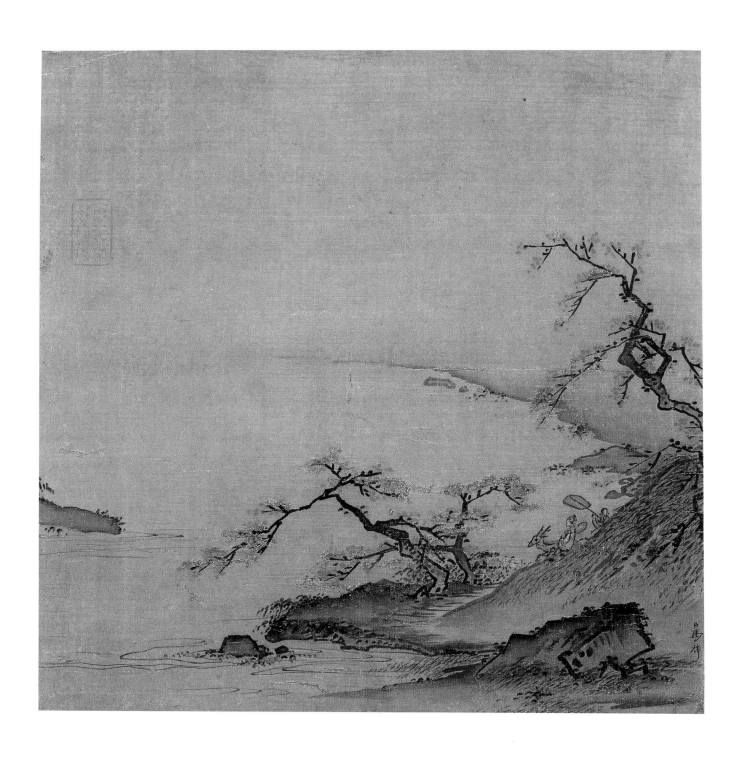

72

Ma Lin (act. 1220s–1260s)
Lake View with a Palace Lady Riding a Deer
Southern Song dynasty, second quarter 13th century
Denman Waldo Ross Collection 28.837a

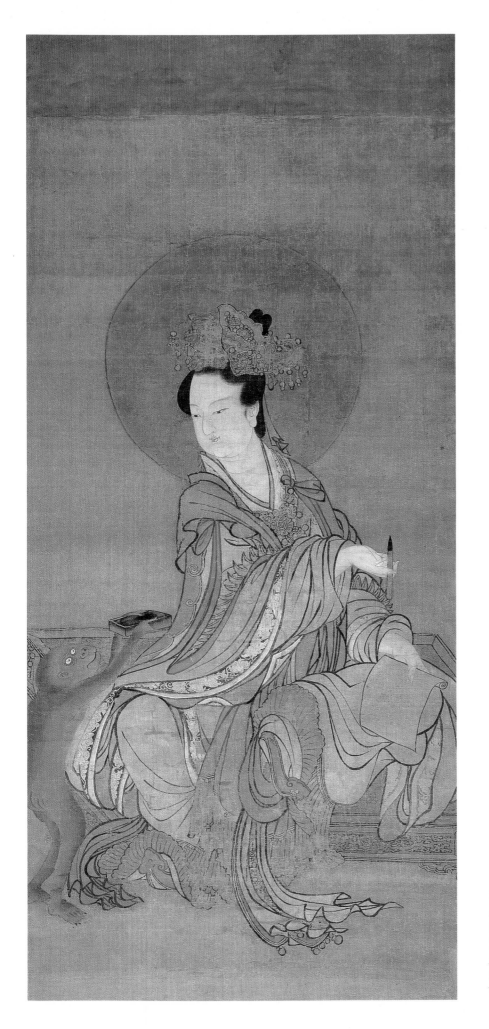

77
Anonymous (traditionally attributed to
Zhang Sigong)
The Planet Deity Chenxing (Mercury)
Attended by a Monkey
Southern Song dynasty, early 13th century
William Sturgis Bigelow Collection 11.6121

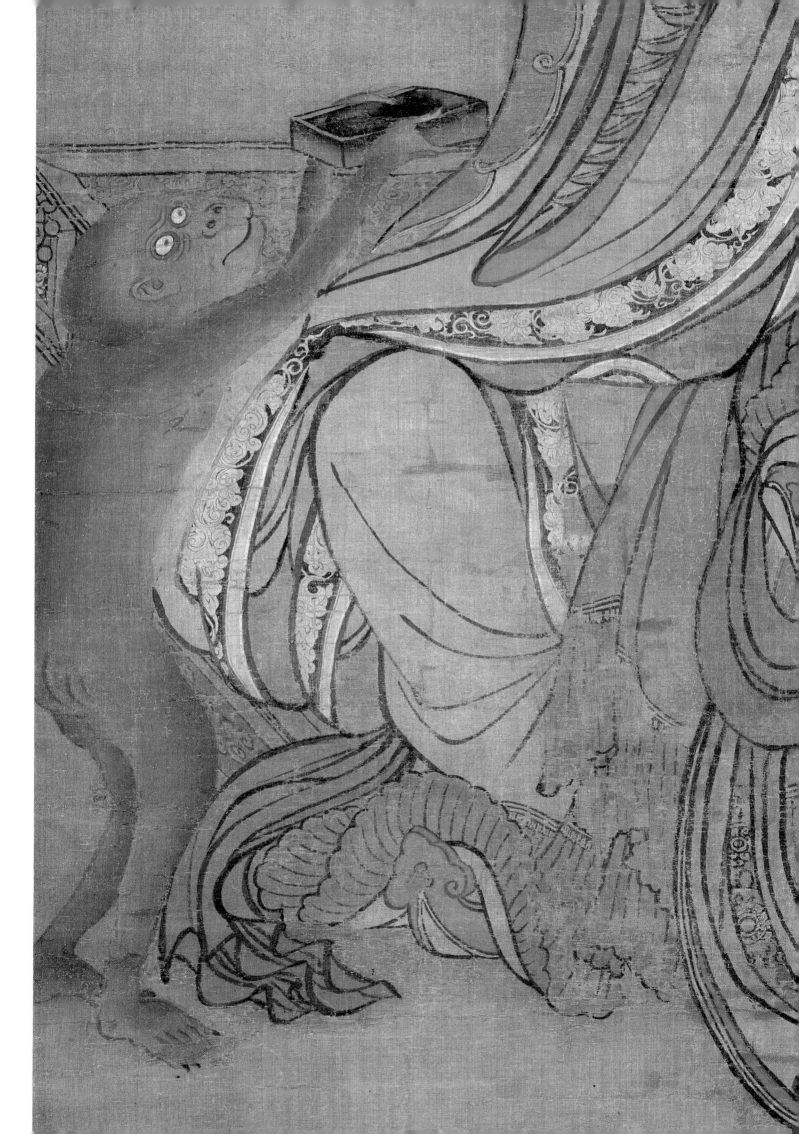

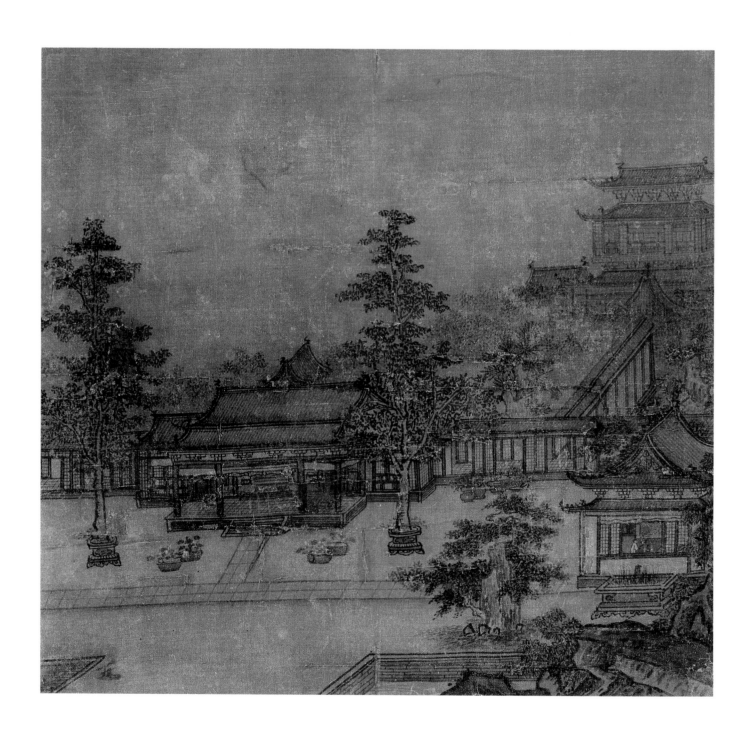

78

Anonymous
Palaces with a Garden
Southern Song dynasty, early 13th century
Denman Waldo Ross Collection 29.1

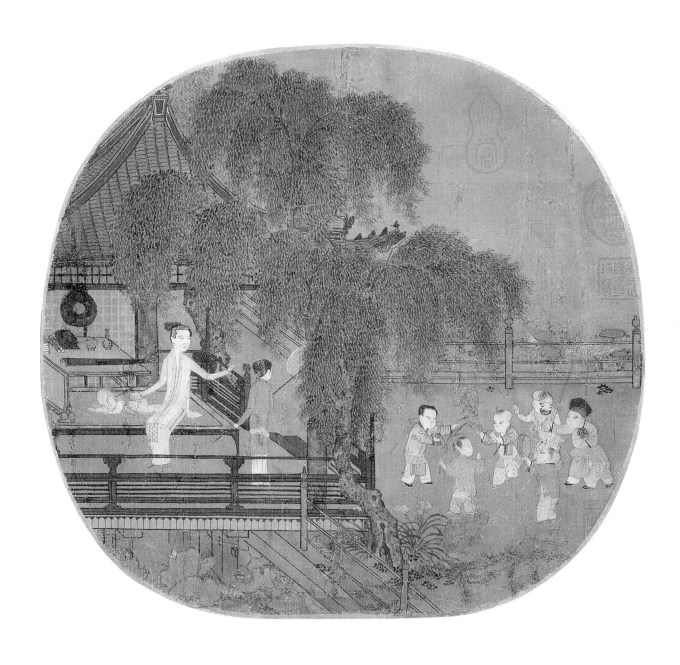

79
Anonymous (formerly attributed to Wang Qihan)
Women and Children by Lotus Pond
Southern Song dynasty, first half 13th century
Denman Waldo Ross Collection 28.842a

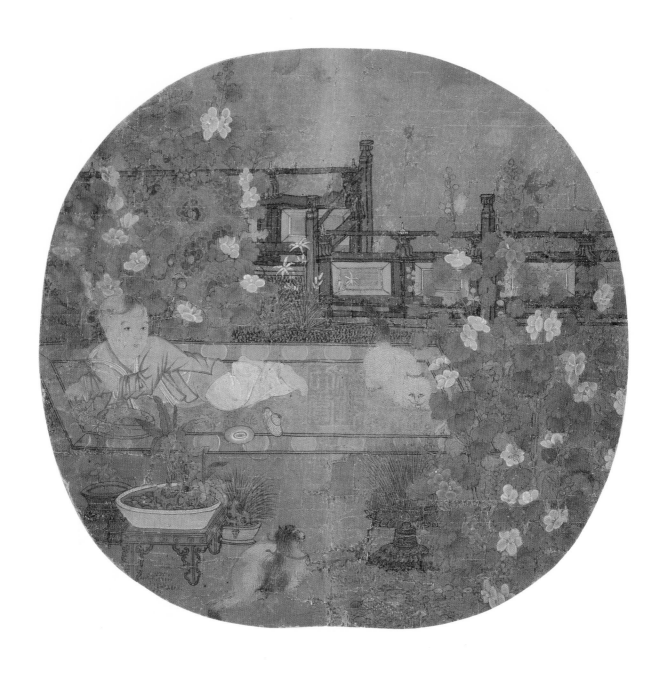

81

Anonymous (formerly attributed to Zhou Wenju)
Child with His Pets in a Flower Garden
Southern Song dynasty, 13th century
Chinese and Japanese Special Fund 12.897

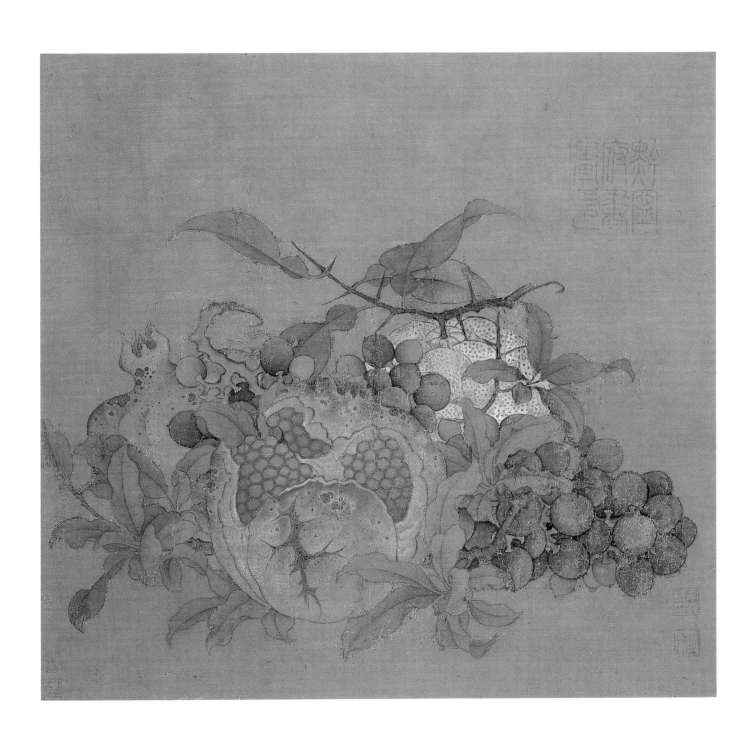

84
Lu Zonggui (act. 13th century)
Orange, Grapes, and Pomegranates
Southern Song dynasty, 13th century
Charles B. Hoyt Collection 50.1454

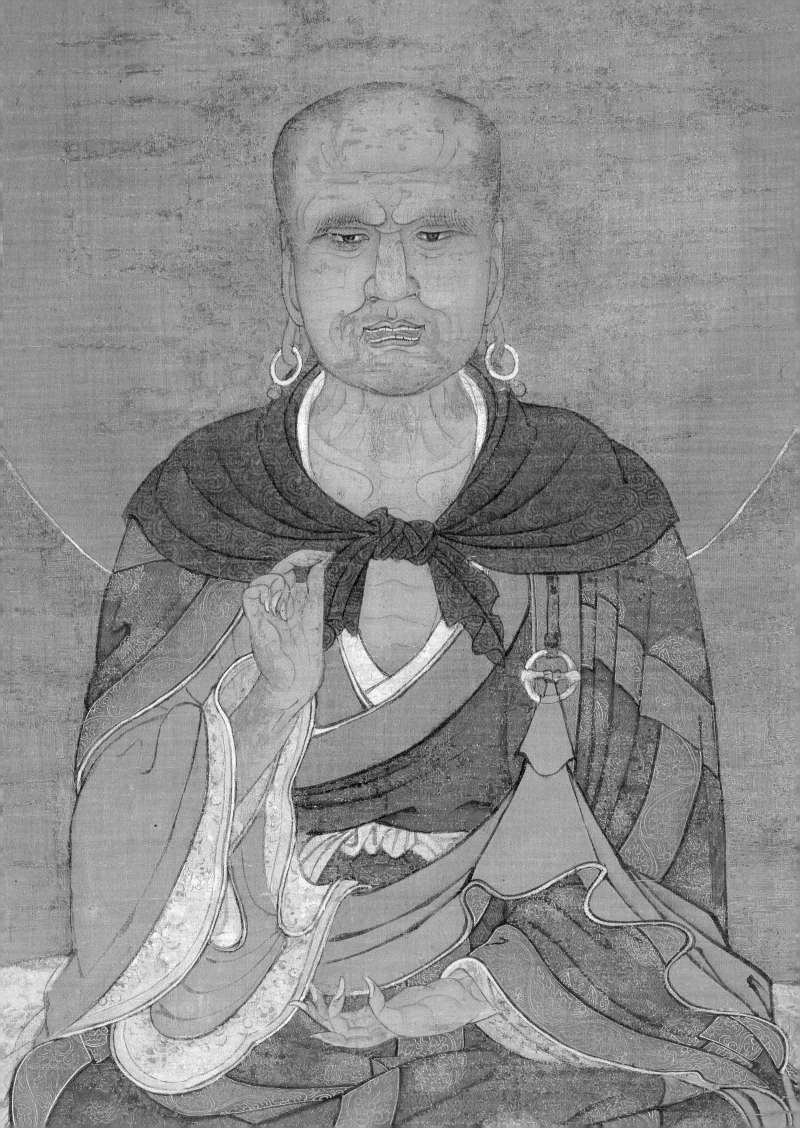

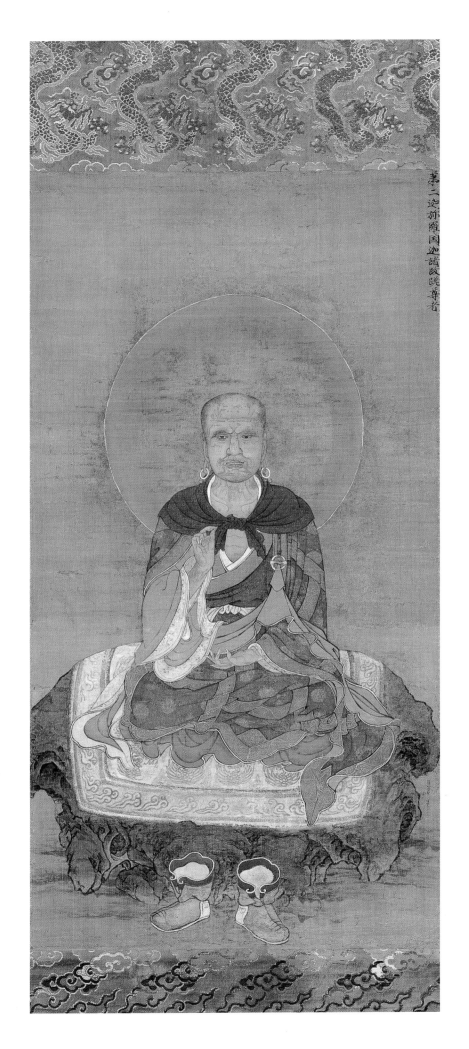

96
Zhao Qiong (act. 13th century)
The Second Lohan Kanakavatsa of Kasmira
Southern Song dynasty, mid-13th century
Keith McLeod Fund 54.1423

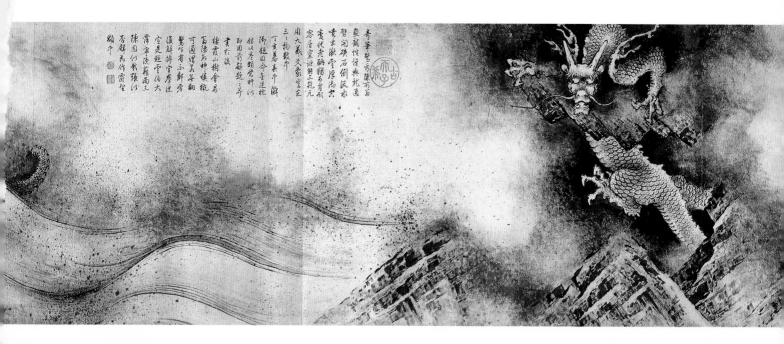

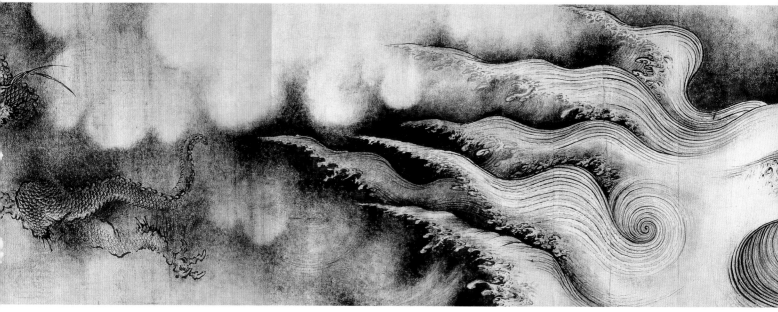

92

Chen Rong (act. first half 13th century)
Nine Dragons
Southern Song dynasty, 1244
Francis Gardner Curtis Fund 17.1697

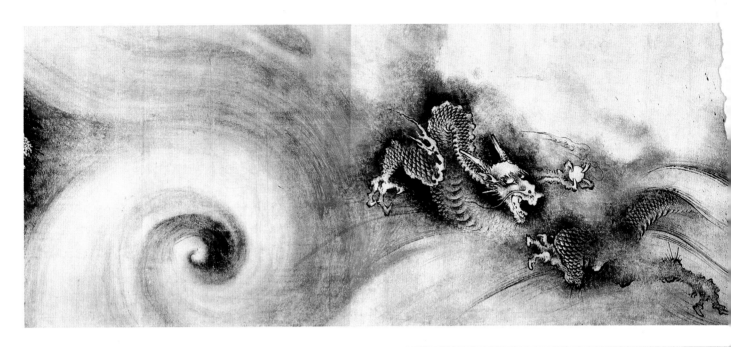

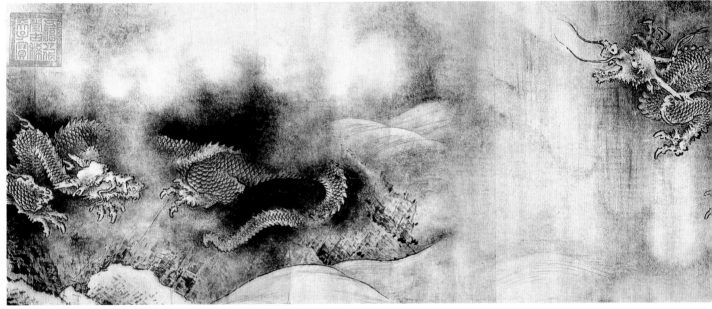

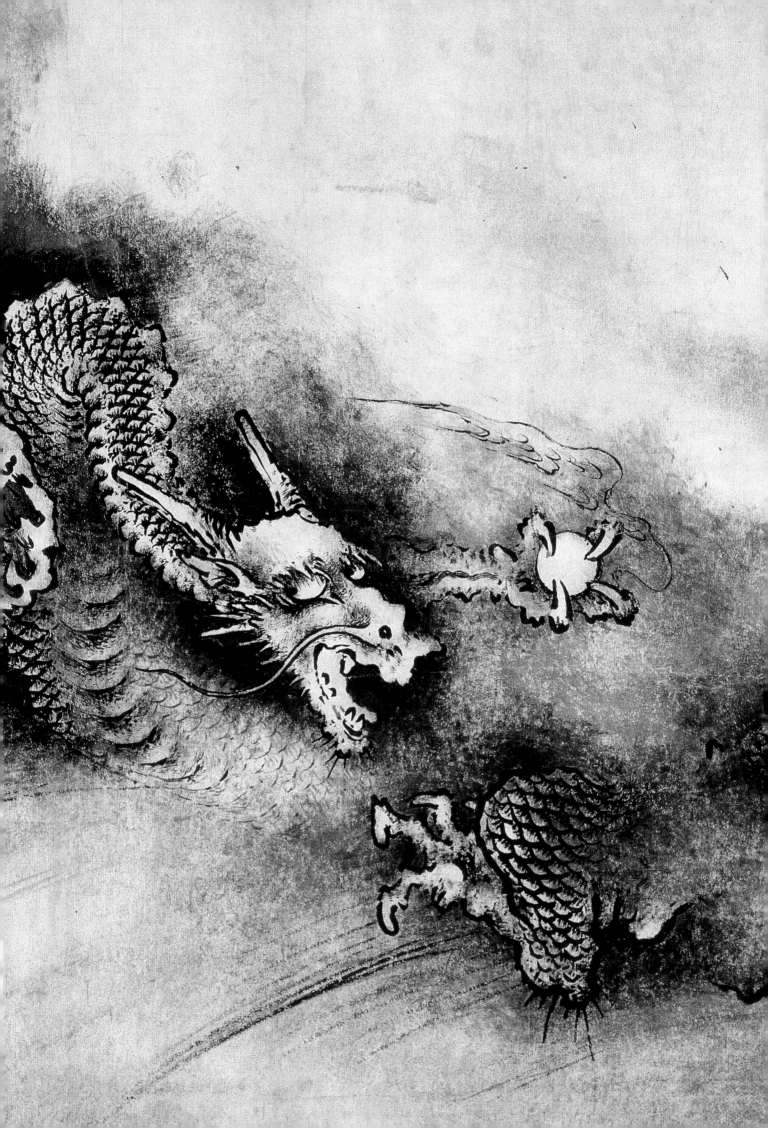

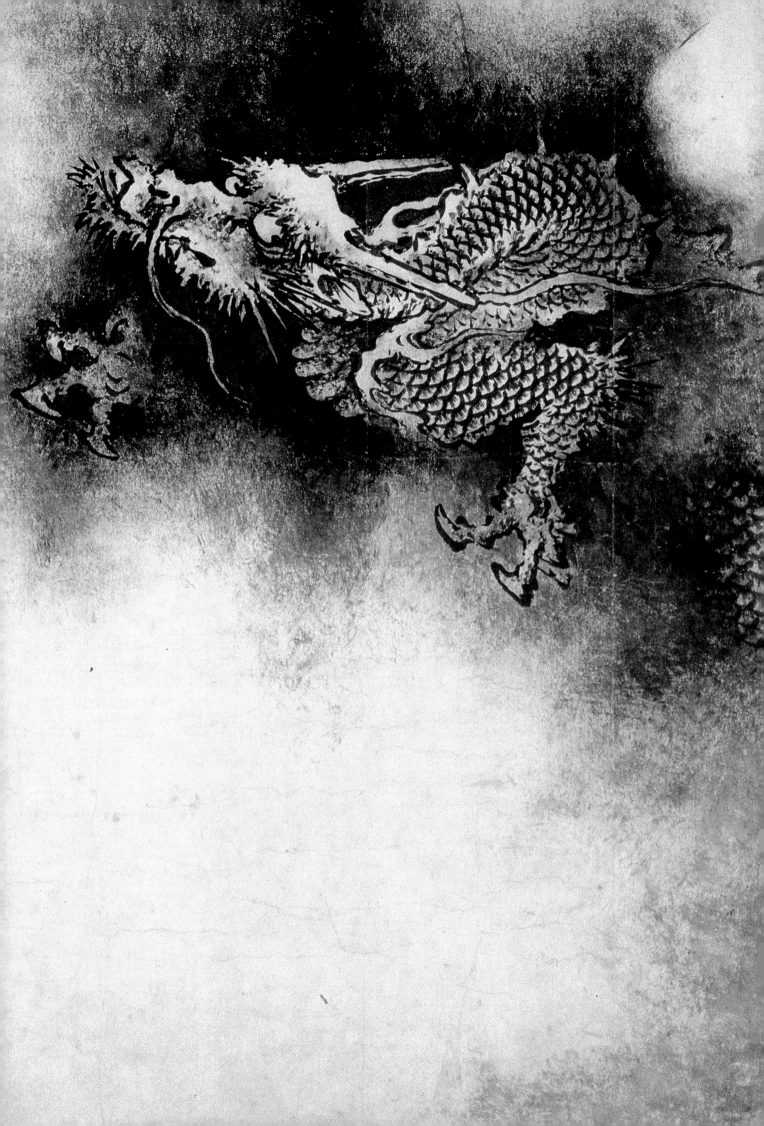

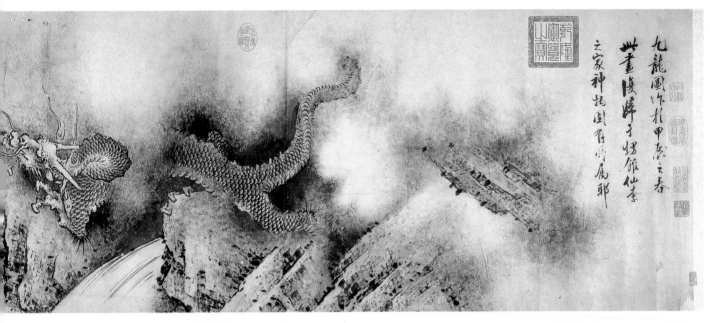

九龍圖作於甲辰之春
此畫陵辟于楊饒仙李
之家神物固有所屬耶

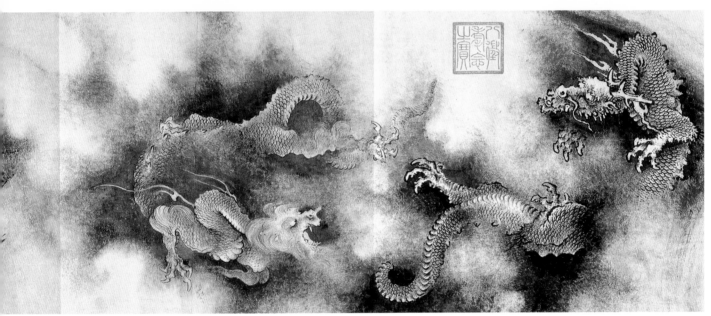

其一寫鼇頭真龍窺金陵點眼雙龍躍諸
梁羽化張牙去雌雄嘆殺劉洞微八軸畫龍
六龍掛辟余曾見睿中畫龍所三峽浪春注九
似山後更潑天風大噴和龍出峽騰
河之棚石敢降一龍天池載赤木蘭養雄者
雲霧那釣天奇叉遭謫雷公擘山天
地黑玉龍晚摩蒼崖瑳坑似避陽陵
客窣阜睡起金蛇奔軒轅頭雨當海
門摩牙屬爪搜明月天吳起舞搖
天根雲頭攪子野金鑠第五圖中龍
最老兩龍插活黎與燕昌黎夜半天
飄倒桃花浪暖透三層禹所貴業雌

敢登鼇幕幕鋒火燒尾十月霹靂
隨氣騰蜀侯高臥南陽武韻出金形
奇止古神功收斂待時來天下蒼生
莫霖雨所莉窩十九龍圖畫華滿妙畫
世肝無達觀雲水似孟動即之題是神
所蓥宣城龍公生九子書畫八九葉圖畫

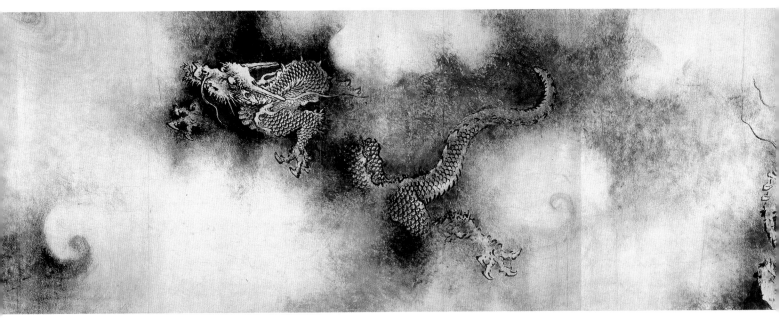

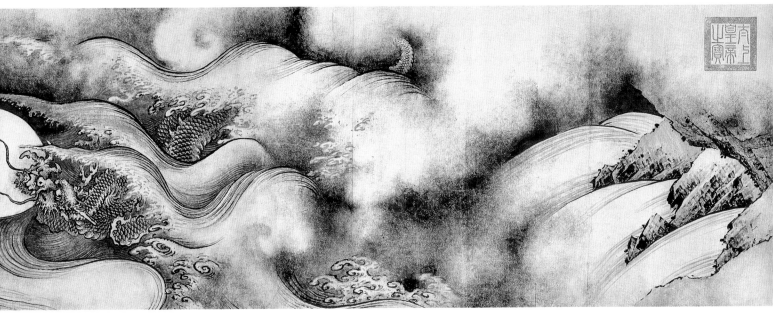

九龍畫跡於滋莉九為之圖
接花坡老而莉之龍雖非底
馬孟與歇倣蘇黄二先生賛詠
州余堂散結述以誌歲月

至順二年孟春
天師太玄子書

雷雨天垂：電火飛墨水
解衣盤礡衿神物聽庵指
雪蘭起風雲瞬息幾萬里
用九贊
乾元猶龍師老子
閒：道人吳全節書

乾陽六爻陽為實其名六龍象
龍貞維乾用九神變化後世遂
稱九龍出湖南馬氏鍾其訛八
龍繞柱身當龍如何枯蒼大
手華六復畫此風雷室

歐陽玄

羽人示我九龍圖知是雷電堂中物摶拏
金帛三十天一一蜿蜒寫奇崛劃斷峽
據石崖欻駕奔濤卷滇渤控搏驪珠爭照
崖歆為盡雲日出夋門子雙崖走天全真

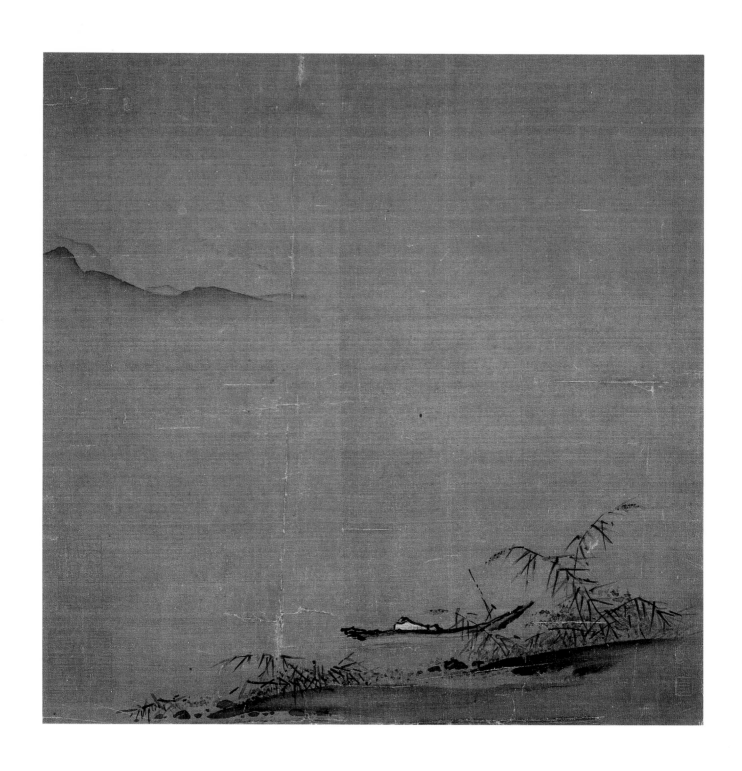

105
Anonymous (formerly attributed to Ma Yuan)
Boating Near Lake Shore with Reeds
Southern Song dynasty, mid–13th century
Denman Waldo Ross Collection 29.963

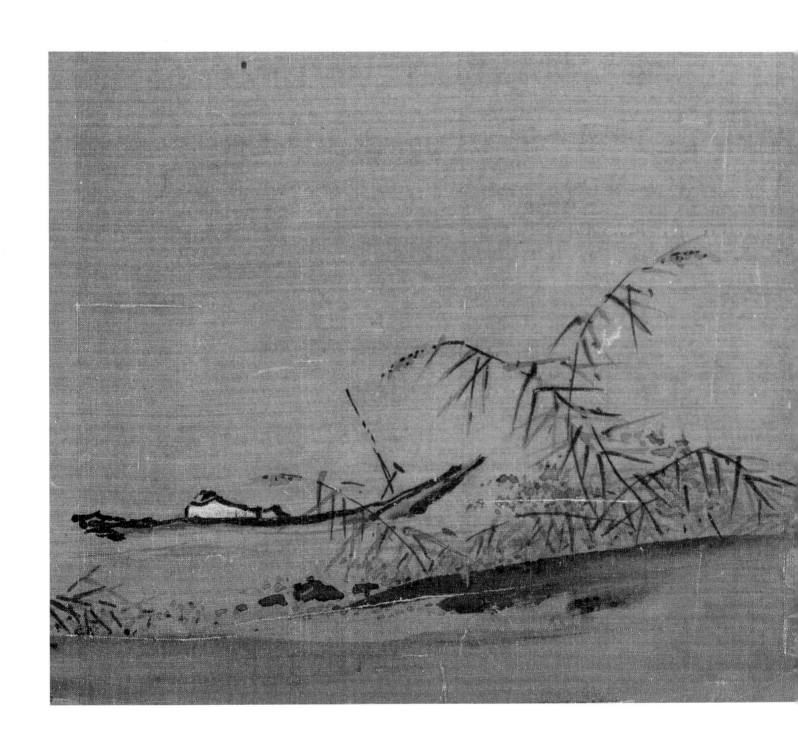

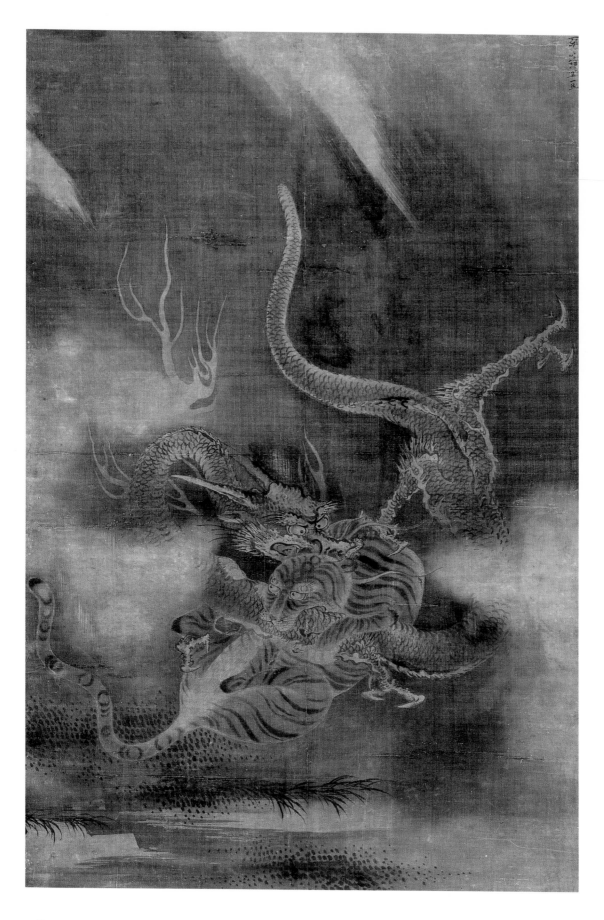

108
Anonymous (formerly attributed to Chen Rong)
Dragon and Tiger Embracing
Southern Song dynasty, second half 13th century
William Sturgis Bigelow Collection 11.6162

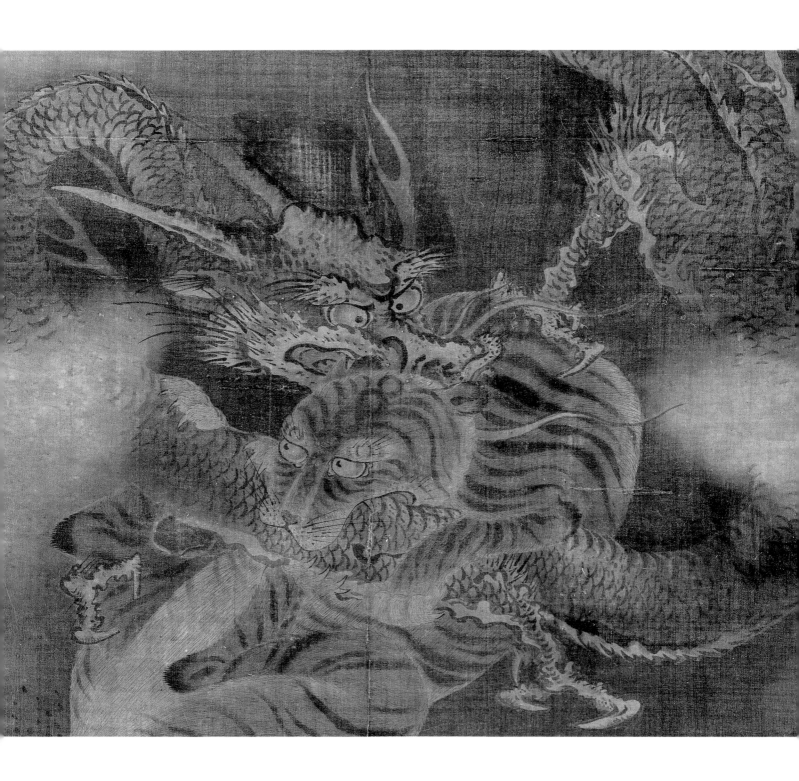

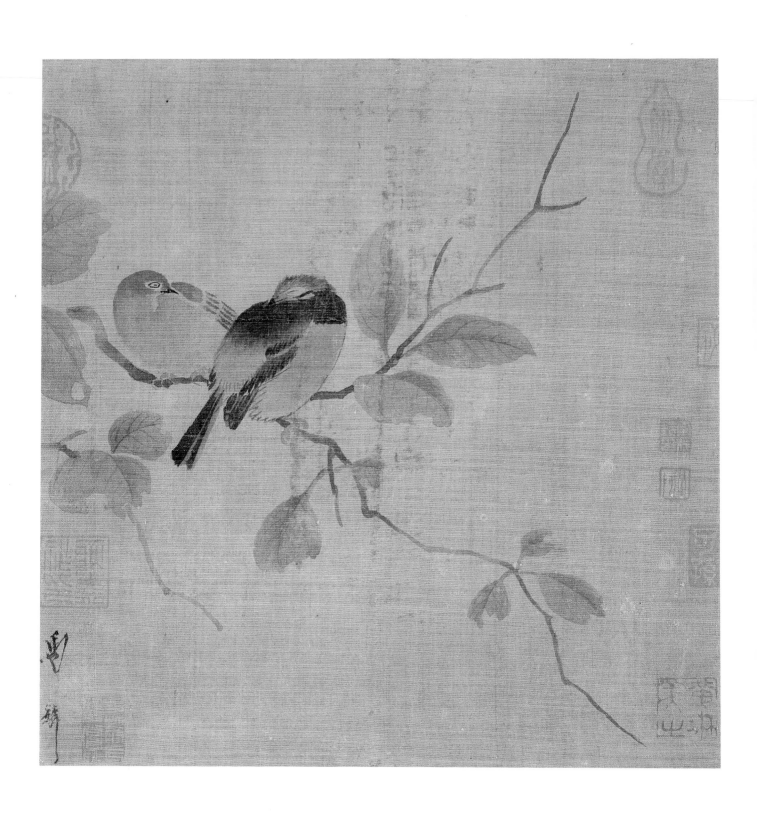

107

Anonymous (traditionally attributed to Ma Lin)
Pair of Redstarts with Autumn Leaves
Yuan dynasty, late 13th–early 14th century
Denman Waldo Ross Collection 28.841

100

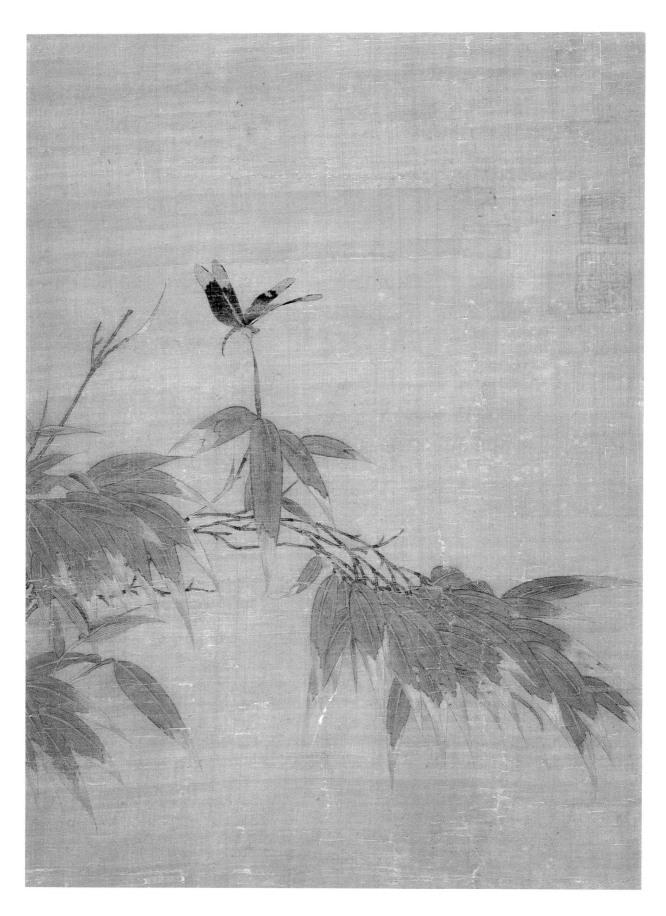

110

Anonymous (traditionally attributed to Qian Xuan)
Dragonfly on a Bamboo Spray
Yuan dynasty, 14th century
William Sturgis Bigelow Collection 11.6146

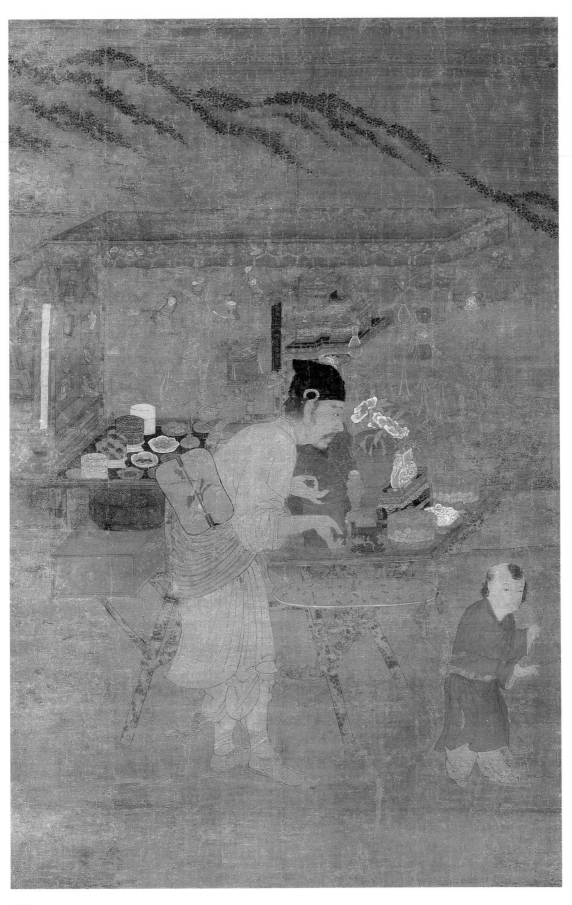

III

Anonymous (formerly attributed to Su Hanchen)
Sweetmeat Vendor and a Child
Yuan dynasty, 14th century
Charles B. Hoyt Collection 50.1458

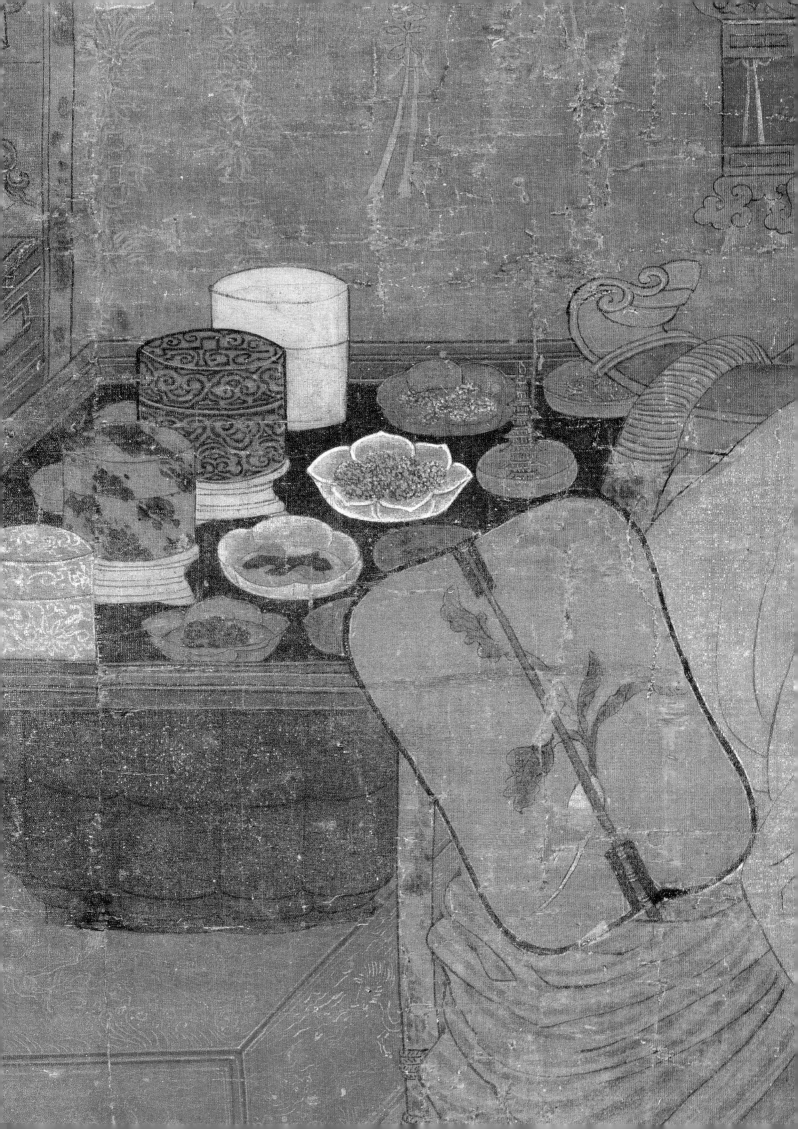

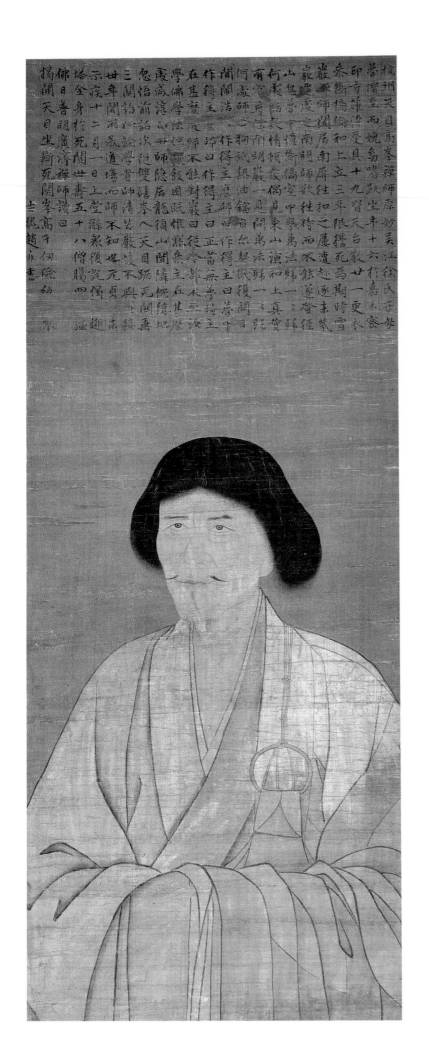

115

Attributed to Zhao Yong (ca. 1289–ca. 1362)
Portrait of the Chan Master
Gaofeng Yuanmiao
Yuan dynasty, early 14th century
Denman Waldo Ross Collection 28.355

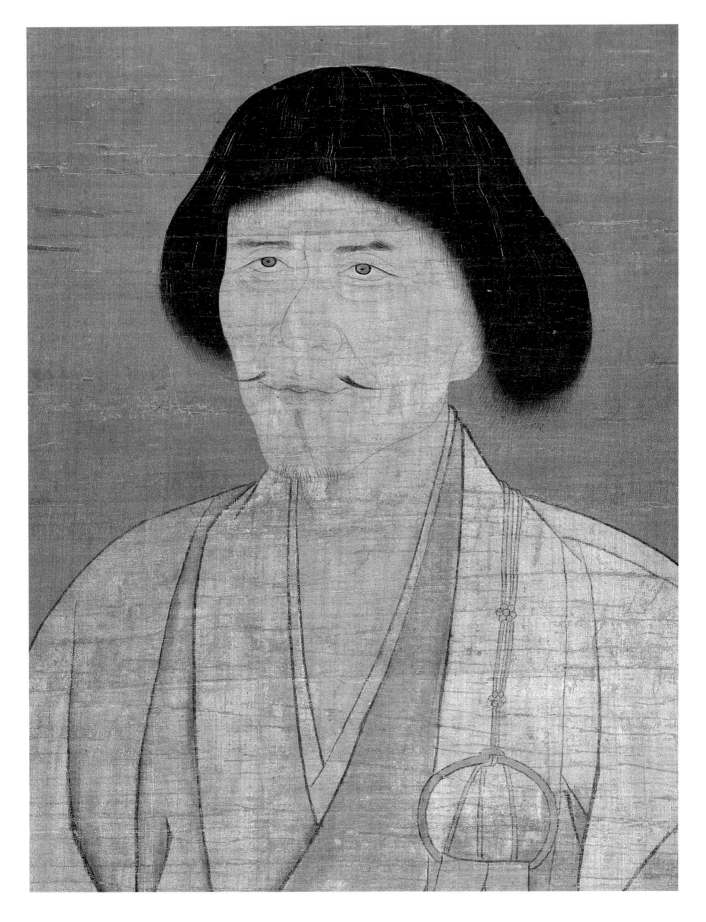

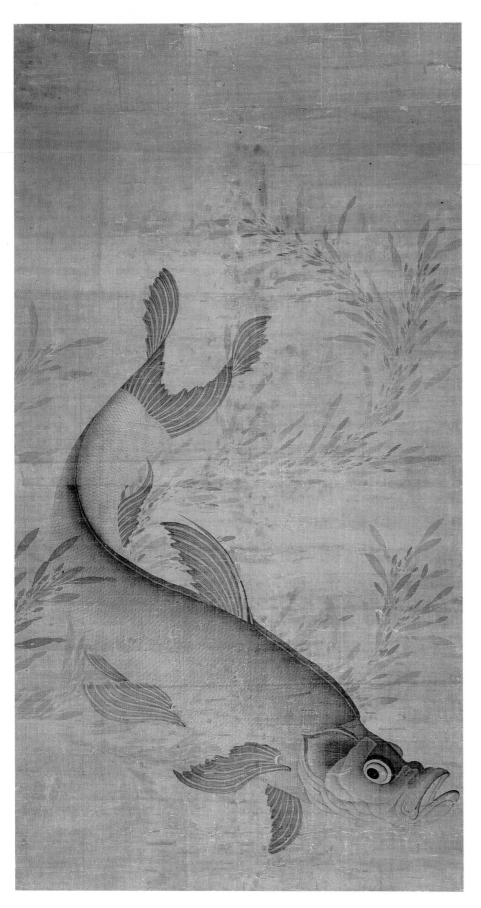

120

Attributed to the Priest Laian
Fish among Water Plants
Yuan dynasty, 14th century
William Sturgis Bigelow Collection 11.6170

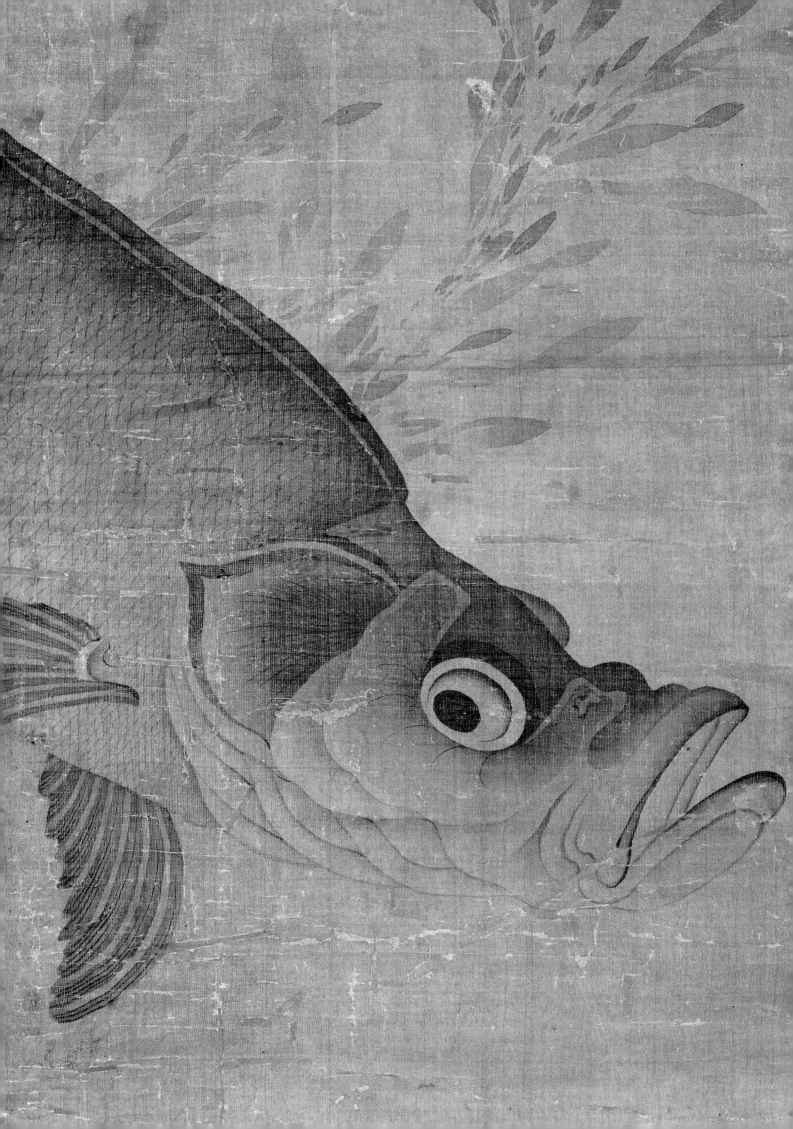

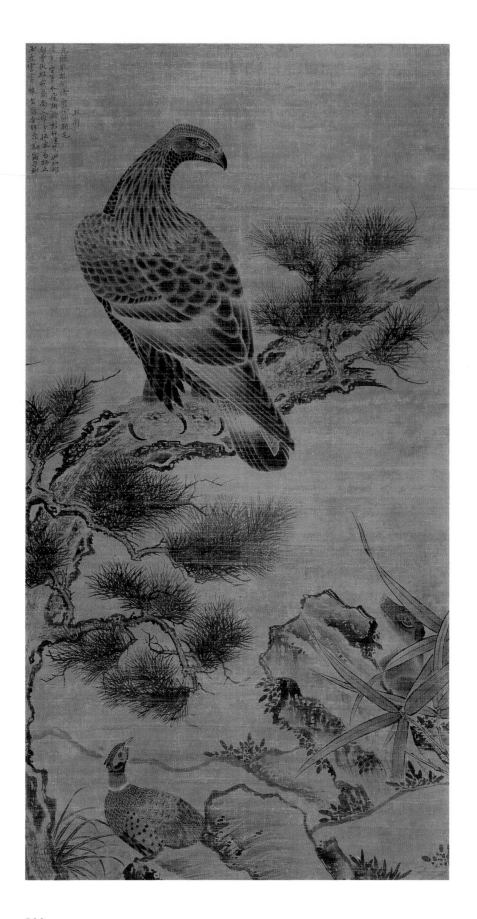

122

Anonymous
Hawk on Pine Tree
Yuan dynasty, second half 14th century
Marshall H. Gould Fund, Frederick Jack Fund,
and Asiatic Curator's Fund 1996.2

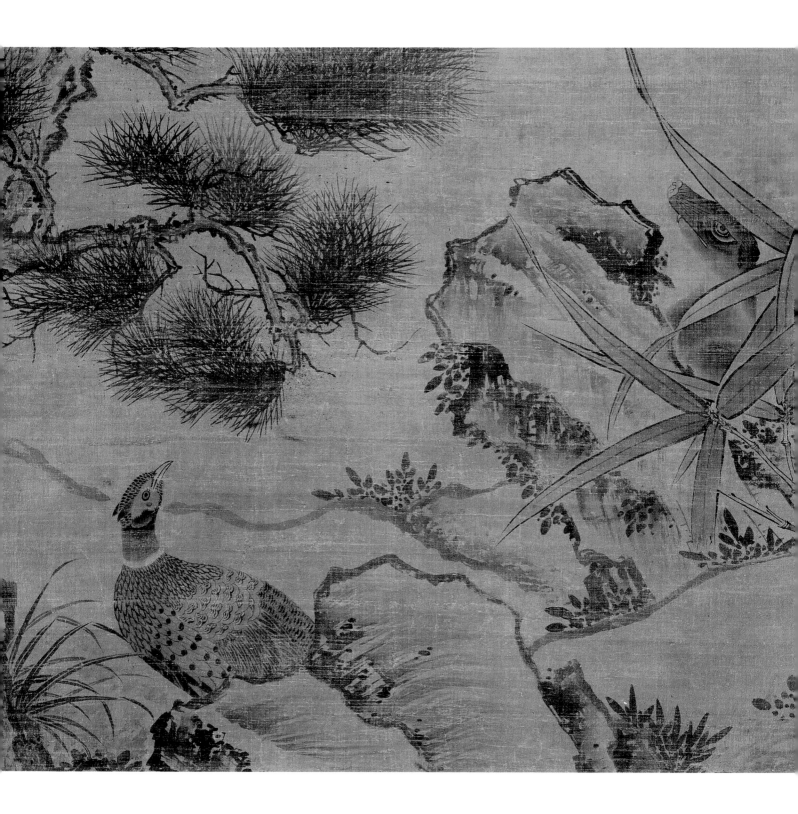

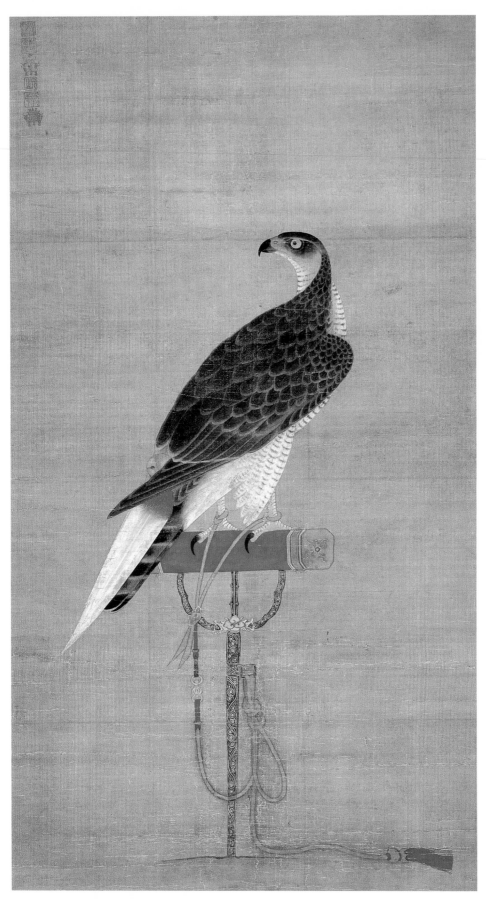

124

Attributed to Xu Ze (act. second half 14th century)
Goshawk Standing on a Perch
Yuan dynasty, second half 14th century
William Sturgis Bigelow Collection 11.6164

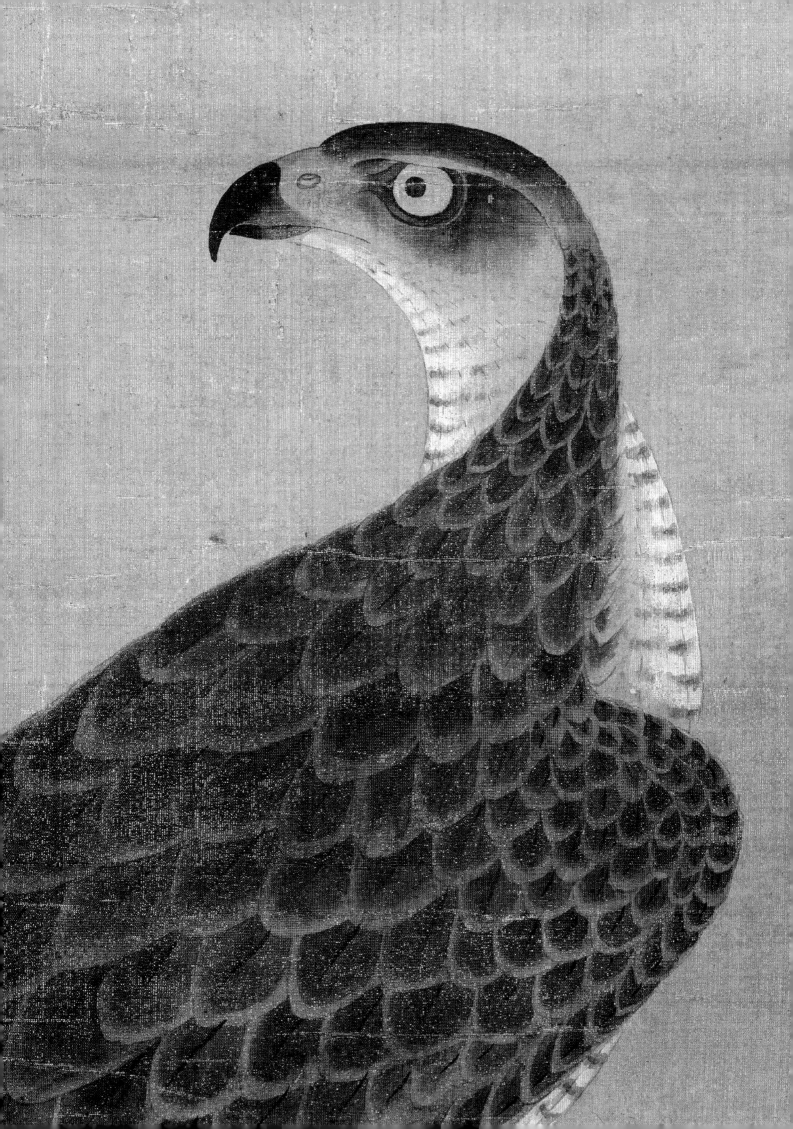

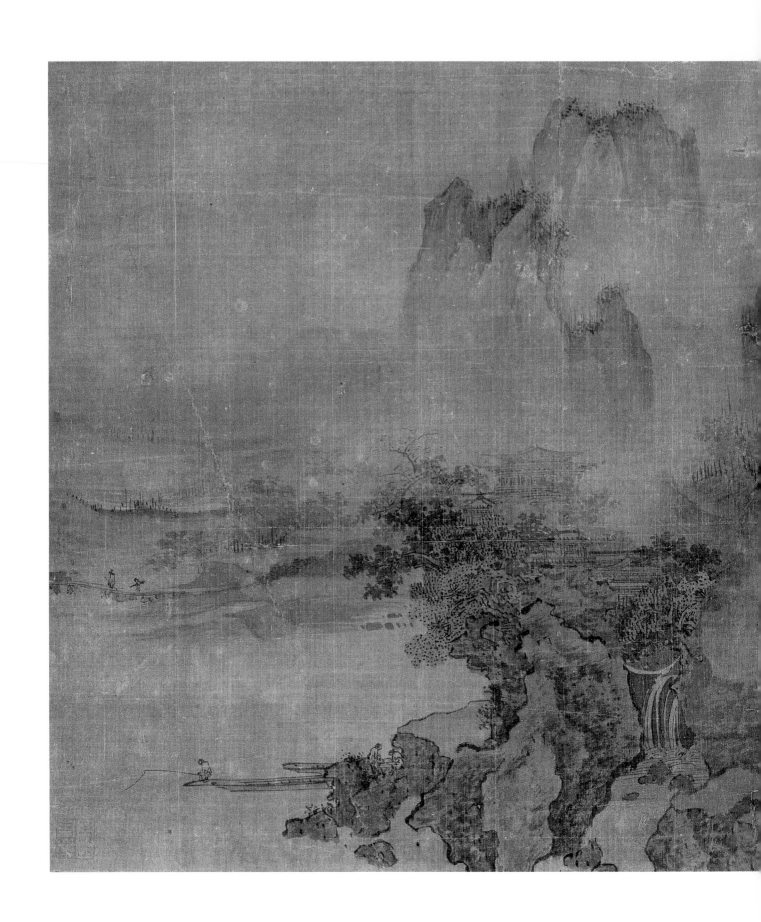

127
Anonymous (formerly attributed to Guo Xi)
Landscape with Fishermen
Yuan dynasty, late 13th century
Denman Waldo Ross Collection 28.863

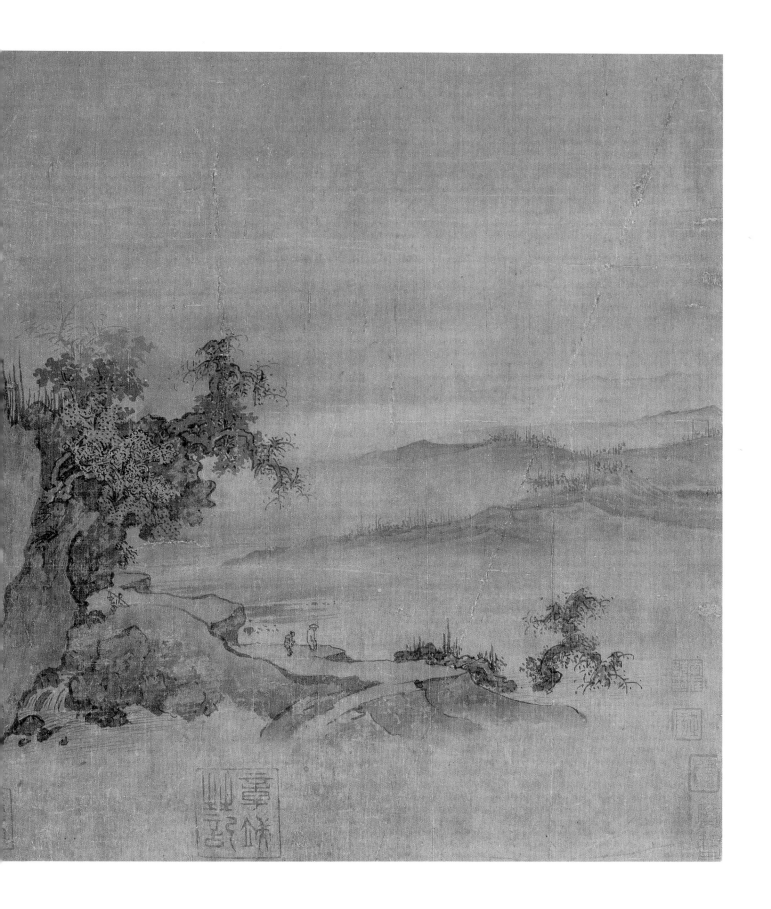

126

Anonymous (formerly attributed to Guo Xi)
Riverscape with Figures
Yuan dynasty, late 13th century
Denman Waldo Ross Collection 28.839

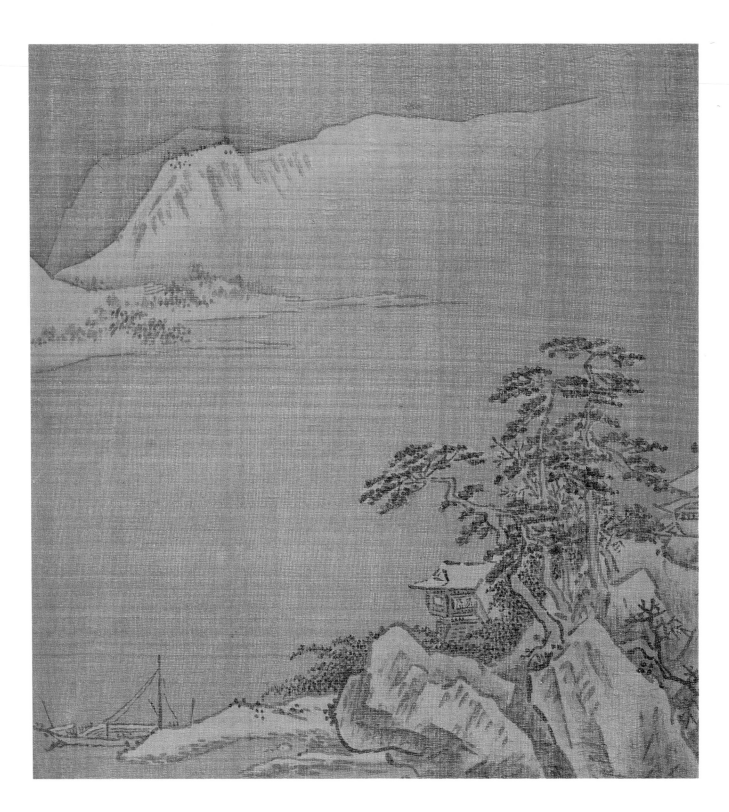

129

Anonymous (traditionally attributed to Xia Gui)
Winter Riverscape
Yuan dynasty, late 13th–early 14th century
Denman Waldo Ross Collection 17.734

130
Anonymous (formerly attributed to Zhang Fu)
Herd-Boys with Water Buffaloes under Willow Trees
Yuan dynasty, 14th century
Chinese and Japanese Special Fund 14.49

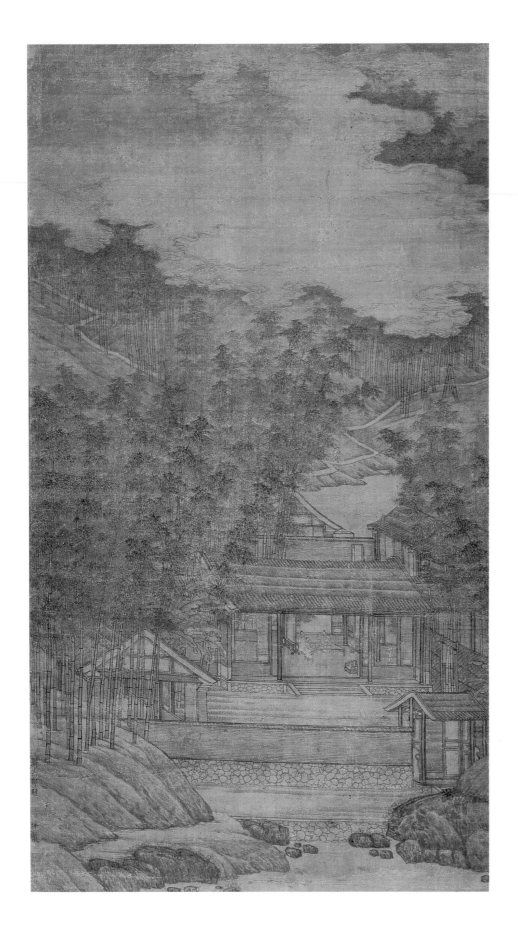

131

Anonymous (traditionally attributed to Li Wei)
Retreat in a Bamboo Grove
Yuan dynasty, 14th century
Chinese and Japanese Special Fund 12.904

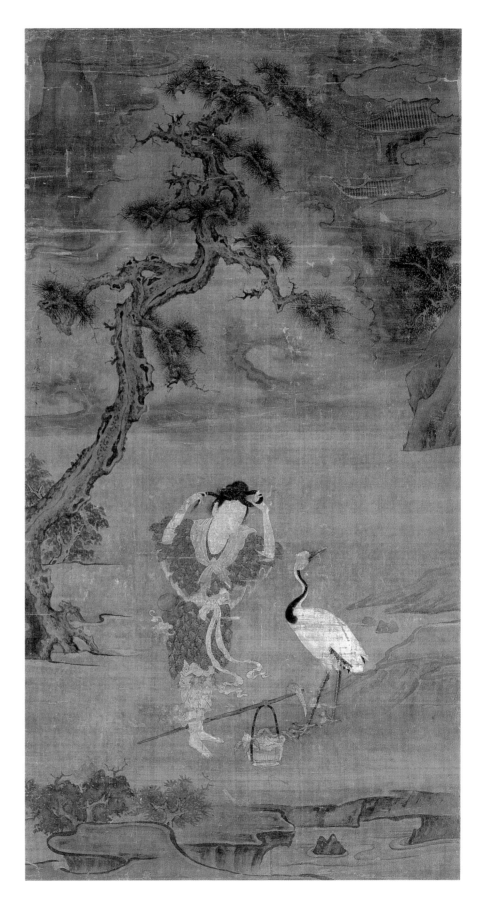

148

Chen Yuexi (14th century [?])
The Daoist Immortal Magu with a Crane
Yuan dynasty, 14th century
William Sturgis Bigelow Collection 11.6168

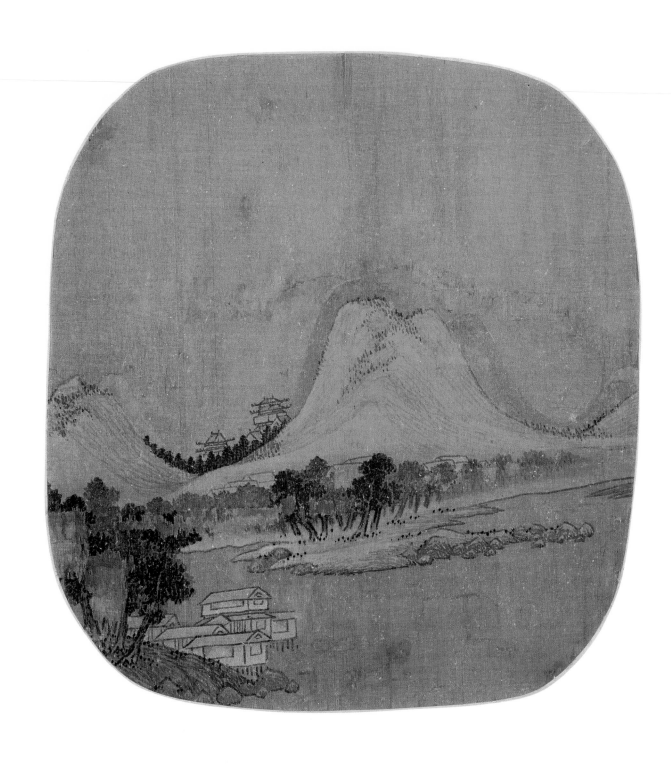

150

Anonymous
Landscape in Blue-and-Green Style
Yuan dynasty, 14th century
Denman Waldo Ross Collection 17.735

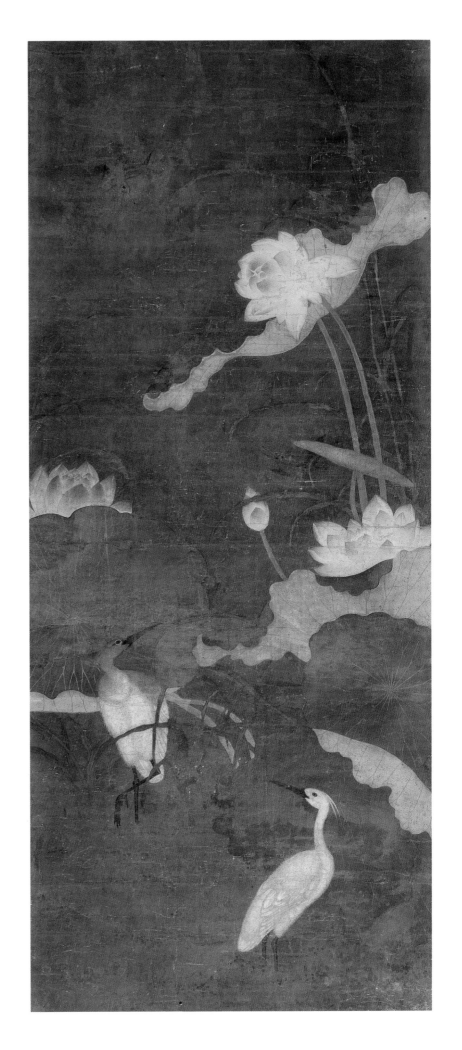

152

Anonymous
White Egrets and Red Lotus Blossoms
Yuan dynasty, late 13th–early 14th century
Gift of Mrs. Richard E. Danielson 48.1273

153

Wei Jiuding (act. ca. 1350–70)
River Crab
Yuan dynasty, early 14th century
Keith McLeod Fund and Asiatic Curator's Fund 1996.244

Time Line

History	Major Cultural Figures and Trends
Shang Dynasty (16th–11th century B.C.) China's Bronze Age.	Development of early forms of calligraphy; known through surviving ritual vessels, incised tortoise shells, and oracle bones.
Zhou Dynasty (11th century–221 B.C.) Spring and Autumn period (770–476 B.C.) Warring States period (475–221 B.C.)	Compilation of *Shijing* or *Book of Songs.* Laozi (act. 6th century B.C.), Daoist sage. Confucius (551–479 B.C.). Hundred Schools of Chinese Philosophy.
Qin Dynasty (221–206 B.C.) China unified by its first Emperor Qin Shihuangdi. Completion of the Great Wall. Confucian classics burned by imperial decree.	
Han Dynasty (206 B.C.–A.D. 220) Civil service examinations created for imperial bureaucracy. Confucianism established as state religion. Arrival of Buddhism in China (1st century A.D.)	Rise of mural painting, lacquer ware, and clerical script. Gu Kaizhi (ca. 344–ca. 406), painter.
Jin Dynasty (265–420) Spread of Buddhism and translation of sacred texts.	Wang Xizhi (ca. 303–ca. 361), *Preface to the "Orchid Pavilion Poems"* (353). Tao Qian (365–427), poet. Xie He (act. late 5th century), *Treatise on Painting* (5th century).
Northern Qi Dynasty (550–77) Emperor Wenxuan (r. 550–59) commissions compilation of classic Chinese texts.	

History	Major Cultural Figures and Trends
Tang Dynasty (618–907)	Yan Liben (d. 673), imperial portraitist.
Emperor Taizong (r. 627–49) establishes the Great Tang Empire; height of the Silk Road trade and expansion of international commerce.	Wu Daozi (act. ca. 710–60), "Painting Sage."
	Great age of Chinese figure painting, poetry, and monumental Buddhist art. Popularity of Central Asian music and dance, seated furniture.
Longmen and Dunhuang flourish as Buddhist centers. Rise of Chan Buddhism.	
	Wang Wei (699–759), poet/painter. Li Bai (701–62) and Du Fu (712–70), poets.
Tang Wars in Central Asia. An Lushan Rebellion 755. Rebel armies sack the Tang capital at Chang'an.	Zhang Xuan (act. 714–41) and Zhou Fang (ca. 740–ca. 800), painters.
Emperor Xuanzong (r. 712–56) flees to Shu (Sichuan) and is forced to order the execution of his beloved concubine Yang Guifei (719–56).	Bai Juyi (772–846), poet of "Song of Everlasting Sorrow."
Buddhist persecutions (843–45).	
Widespread civil strife continues into the 10th century.	Li Cheng (919–67), painter.
Northern Song Dynasty (960–1127)	Age of monumental landscape painting and the great literati figures Su Shi (1036–1101) and Mi Fu (1051–1107).
Reunification of China under Song emperors who favor political reform over military expansion.	Rise of Neo-Confucianist thought.
Wang An-shi (1021–86), "New Laws" policy (1069). State-sponsored printing of Confucian classics.	Fan Kuan (act. late 10th–early 11th century) and Guo Xi (ca. 1001–ca. 1090), painters.
	Scholar-official Ouyang Xiu (1007–72) advocates *fu gu* as a civic ideal.
Jin Tartars sack the Song capital at Kaifeng and occupy northern China, taking Emperor Huizong (r. 1101–25) captive in 1126.	Artists at Emperor Huizong's painting academy copy ancient masterworks in the imperial collections.

Southern Song Dynasty (1127–1279)

Emperor Gaozong (r. 1127–62) reestablishes the Song court in southern China at Hangzhou and eventually negotiates peace with the Jurchen. Commerce and foreign trade bring prosperity to the merchant class under the Southern Song.
Growth of commercial printing.

Mongols destroy Jin capital in 1215 and conquer Turkestan in 1220, gaining control of Central Asia.
Death of Genghis Khan, 1227.
Chinese and Mongol armies end Jin dynasty in 1234.

Ma Yuan (act. 1190–1235) and Xia Gui (act. late 12th–early 13th century), painters whose landscape styles dominate Southern Song academy art.
Buddhist Lohan painting by professional artists in Ningbo.

Kublai Khan (r. 1260–94) declares himself emperor of China and establishes Mongol capital at Dadu (Beijing) in 1271.
Mongol armies cross the Yangzi River in 1275 and the Song are defeated in a naval battle off Guangdong.

Chen Rong (act. 1st half 13th century) completes *Nine Dragons* (1244).

Yuan Dynasty (1260–1368)

Marco Polo visits China (1275–95).

Mongol emperors abolish imperial examination system and dismantle other Confucian civil institutions, alienating China's scholar–official class.

Zhao Mengfu (1254–1322), a Southern Song prince and painter, serves at the Mongol court.

Rise of literati and "amateur" art; revival of "blue-and-green" painting style; popularity of blue-and-white ceramics and Chan painting.

Fall of the Yuan and founding of the Ming dynasty (1368).

Chronology

Shang Dynasty
16th century–11th century B.C.

Zhou Dynasty
Western Zhou 11th century–771 B.C.
Eastern Zhou
Spring and Autumn period
770–476 B.C.
Warring States period
475–221 B.C.

Qin Dynasty 221–206 B.C.

Han Dynasty
Western (Former) Han
206 B.C.–A.D. 24
Eastern (Later) Han
A.D. 25–220

Three Kingdoms
Wei 220–265
Shu 221–263
Wu 222–280

Jin Dynasty
Western Jin 265–316
Eastern Jin 317–420

Southern Dynasties
Liu Song 420–479
Southern Qi 479–502
Liang 502–557
Chen 557–589

Northern Dynasties
Northern Wei 386–534
Eastern Wei 534–550
Western Wei 535–556
Northern Qi 550–577
Northern Zhou 557–581

Sui Dynasty 581–618

Tang Dynasty 618–907

Five Dynasties 907–960

Song Dynasty
Northern Song 960–1127
Southern Song 1127–1279

Liao Dynasty 916–1125

Jin Dynasty 1115–1234

Yuan Dynasty 1260–1368

Ming Dynasty 1368–1644

Qing Dynasty 1644–1911

Catalogue
of
the Exhibition

I

Tales from History and Legends

Western Han dynasty, late 1st century B.C.
Hollow tiles of a tomb lintel and
pediment; ink and color on whitened ground
Total h. 73.3 cm; w. 240.7 cm
Denman Waldo Ross collection 25.10–13 and
Gift of C.T. Loo 25.190

After restoration

This set of hollow tiles of the Western Han dynasty (206 B.C.–A.D. 25) is one of very few examples in the West that shows the style, color, and brushwork of figure painting as it existed in China before the arrival of Buddhist art from Central Asia. Apart from some second-century B.C. banners, and similar paintings on silk from the Warring States period (475–221 B.C.), our understanding of such early styles is based largely on excavated murals and literary evidence; hence the importance of these tomb tiles. Discovered around 1915 near Luoyang, one of the two capitals of the Han dynasty, they were originally dated by Tomita as works of the second to fourth century A.D.[1] Based on recent archaeological discoveries, they are now datable to the late Western Han dynasty.[2]

The scenes on the front of these tiles depict male figures who appear to be court officers, scholars and, as Jan Fontein has suggested, historical heroes such as Zhou Bo (d. 169 B.C.), the fourth standing figure from the right on the lintel. According to official histories of the Western Han, the Empress Lü (241–180 B.C.) came to power by murdering Crown Prince Ruyi in 194 B.C. and Emperor Shaodi in 184 B.C. With the help of relatives, she launched a ruthless campaign to eliminate political opponents. Right after her death, Zhou Bo, a prime minister loyal to the murdered emperor, led a coup d'état against her powerful relatives to restore the kingdom to Emperor Zhaowen (r. 179–157 B.C.; see cat. 3). In the lintel, Zhou Bo is shown rolling up his sleeve to expose his right arm—a gesture that signaled his coconspirators to begin the coup.

Now much damaged, the scene on the pediment originally displayed bears, tigers, soldiers, and a mythical animal mask below the ram's head. In all likelihood, most of these were animals from the imperial zoo, part of an entertainment spectacle in which the zookeepers made preparations for animal combat. In

Western Han times, the bear was an auspicious totemic creature, while the tiger was associated with the direction West. The character "*hao*" (good) appears in clerical script above the ram, another auspicious symbol.

The historical and/or legendary events portrayed on the back of the lintel are more obscure. A distinguished male figure presents jewelry to a female, who appears to reject this suitor. Such depiction of a thwarted attempt to curry favor with an attractive woman celebrates Confucian ideals of female conduct. It is not unlike scenes of Confucian virtue painted in the earliest extant Chinese handscroll, *Admonitions of the Instructress to the Palace Ladies* (British Museum, London), traditionally attributed to the fourth-century master Gu Kaizhi (ca. 344–ca. 406). This well-known work provides useful points of stylistic comparison with the Han tiles since it shows the unmistakable imprint of Buddhist art from Central Asia on Chinese figure-painting styles. While the motifs in each work reflect the same "native" tradition of free-floating figures, semiabstract forms, and shifting perspectives, the outline drawing in *Admonitions* exhibits the disciplined, descriptive linear mode derived from Buddhist art. Renowned as a painter of Buddhist subject matter (including a mural depicting Vimalakīrti), Gu Kaizhi lived during the

Eastern Jin dynasty (317–420), when Buddhism was the dominant religion. While the British Museum's handscroll is most likely a later, Tang-dynasty (618–906) tracing copy of an original Gu Kaizhi composition, the Buddhist influence would have been even stronger then.

By contrast, the drawing technique used for Boston's Han tile figures derives from indigenous Chinese calligraphic traditions. Expressive rather than descriptive, the drawing articulates semiabstract contours instead of precisely defined forms or anatomically correct figures. The brushwork aims for highly charged, spiritualized depiction emphasizing gesture, facial expression, and exaggerated body movement. The strokes are applied with variable speed and thickness, showing sudden twists and turns—all of which defy the uniform, orderly application so characteristic of Buddhist art. Whereas the latter focused viewers' attention on form and more realistic description of motifs, the painter of these tiles was more concerned with the expressive potential and quality of line.

The Han tiles handle space and render motifs in a flat, multiperspectival plane. They are free of the three-dimensional modeling and illusion of depth so apparent in Central Asian art (see cat. 2). This abstract, but still naturalistic, composition relied on the expressive, curvilinear draw-

ing style produced with the soft, pointed tip of a Chinese brush. Its characteristics are rooted in the calligraphic techniques that were known and practiced by Han artists prior to the advent of Buddhism.[3]

1. See Tomita, *Portfolio*, p. 3.

2. For archaeological documentation of this and other related works, see Fontein and Wu, *Unearthing China's Past*, cat. 40, pp. 96–100.

3. Such characteristics are already evident in pre-Han examples, such as the two figure paintings in ink on silk unearthed from tombs of the Warring States period in Changsha, Hunan. See *ZMQ: huihuabian*, vol. 1, pp. 49–50.

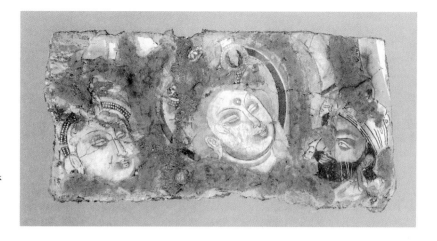

2

Anonymous
Three Buddhist Heads

6th–7th century
Rectangular fragment from Kizil;
color on fresco
33.1 x 16.9 cm
Francis Gardner Curtis Fund 23.256

Indian Buddhism came to China, via Central Asia, along the ancient trade routes known as the Silk Road. Buddhist monks and artisans introduced a dazzling array of new aesthetic ideas that informed the art of this foreign religion. Artists like Yuchi Yiseng, a seventh-century Khotanese painter who resided in the Tang capital, helped transmit to Chinese artists these revolutionary techniques, which included the use of three-dimensional modeling and illusion, brilliant color, foreign imagery, Western perspective, and even-width, pencillike line drawing. The descriptive, coloristic approach of Buddhist art transformed the flat, expressive ink renderings of early Chinese figure painting. Emergent Chinese painting techniques like the *mogu* (boneless) and *aotu* (concavo-convex) styles may well have originated from Indian prototypes, evident in the Ajanta cave painting (e.g. 21.1286 in the Museum's collection), or Central Asian ones like the Buddhist murals of Bamiyan, Khotan, Miran, and Kizil. The early sixth-century painter Zhang Sengyou (act. 500–50), of the Southern Liang dynasty (502–557), is known to have adopted such imported techniques.[1] It is even more likely that what is known today as the "iron-wire" drawing style (*tiexian miao*) developed

from the introduction of Buddhist figure painting. The Central Asian painter Cao Zhongda, who lived in China during the Northern Qi dynasty (550–77),[2] is thought to have played a major role in bringing Central Asian figure styles and iconography to China. The painting term *Cao yi chu shui* (Cao's drapery appears wet) suggests how he adopted Central Asian line-drawing technique to depict drapery folds. It implies as well that his figure paintings were stylistically related to Gandharan art in the Gupta tradition. The imported style became so popular during the Tang dynasty that Cao Zhongda's reputation was matched with that of Wu Daozi (act. 710–60), the Chinese "painting sage," whose work epitomized the native curvilinear and expressive tradition.

This fresco fragment from Kizil exhibits three non-Chinese images as well as some fundamental characteristics of Central Asian painting: bright and rich colors, shadings to enhance three-dimensional effects, and pencillike line drawings. The deep lapis-blue color is a common feature of murals discovered in the Buddhist caves of Kizil, just west of today's Kucha in Xinjiang, China. Kizil was an important Buddhist site known in Chinese annals as the ancient kingdom of Qiuzi. It was one of five colonies established in Xinjiang during the Han dynasty. Although these three Buddhist heads appear typically Central Asian, some striking stylistic links exist between this fresco and figures depicted in a much later handscroll, *Northern Qi Scholars Collating Classic Texts* (cat. 9): for example, the oval-shaped face, the pronounced nose bridge, and the even-width, noncalligraphic line drawing. The flatly applied colors and the slight shading along the robe folds in the latter scroll may well have had roots in Central Asia, with

which the Northern Qi dynasty had close relations.

1. According to Xu Song's *Jiankang shilu*, in the late 530s, the painter Zhang Sengyou used Indian painting techniques to depict flowers in red, blue, and green over the gateway of the Yichengsi temple in the capital (today's Nanjing). See Wu Shichu, *Zhang Sengyou*, in *Lidai huajia pingzhuan*, vol. 1 (Reprint ed. Hong Kong: Zhonghua shuju, 1979), pp. 6–7.

2. The Samarkand origin for Cao Zhongda is given by the ninth-century art historian Zhang Yanyuan in his *Lidai minghua ji*, juan 8, p. 97, in Yu Anlan, *HC*, vol. 1 See also Bussagli, p. 53.

3

Attributed to Yan Liben (d. 673)
The Thirteen Emperors

Tang dynasty, second half 7th century (with later replacement)
Handscroll; ink and color on silk
51.3 x 531 cm (pictorial section)
Denman Waldo Ross Collection 31.643

Chinese scholars have always revered the Tang dynasty as the apogee of figure painting. Although few nonreligious examples survive today, figure painting was the dominant genre of the period, just as monumental landscape was during the Northern Song (960–1127). This work is probably the earliest Chinese handscroll painting in American collections. It exhibits many characteristic features of Tang figure styles: the interest in volume, weight, and sculptural, three-dimensional modeling; strength of line; rich and varied facial expressions; and the robust appearance of the figures portrayed.

Although its subject matter—a series of emperors from various dynasties—is unique among existing Chinese paintings, the tradition of such depictions began

127

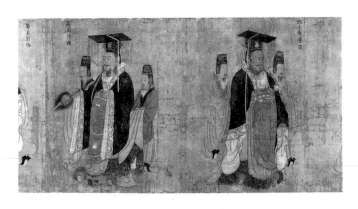

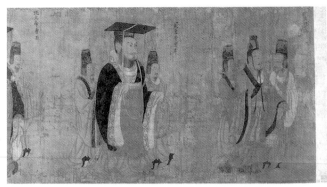

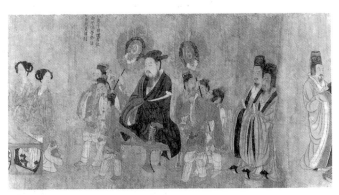

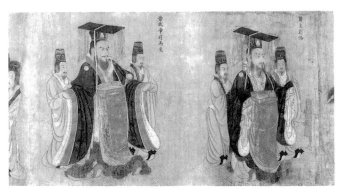

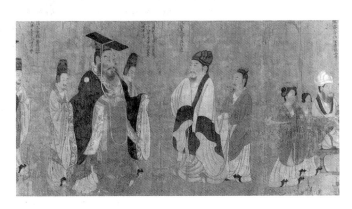

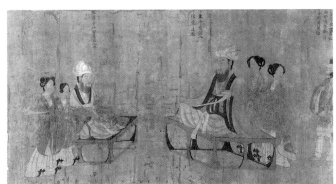

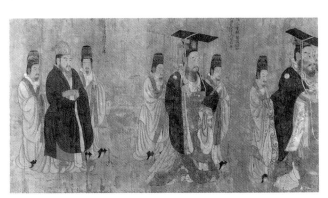

early in China. The Tang art historian Zhang Yanyuan included an anonymous picture, *Gu shengxian diwang tu* (Painting of Ancient Sages and Emperors), among the ninety-seven rarest ancient masterpieces known to him, which he described in *Lidai minghua ji* (A Record of Famous Paintings from All Dynasties), completed in 847.[1] From Zhang's emphasis on the antiquity of this group of paintings, the *Sages and Emperors* scroll most likely was a pre-Tang work created to serve as moral admonition for a member of the imperial family, such as a crown prince, receiving a Confucian education. Another work depicting emperors and officers from this group of ancient paintings demonstrates even better such moral and didactic purposes. The painting is entitled *Yizhou xuetang tu* (Painting of the Confucian School in Yizhou).[2] According to Zhang Yanyuan, seventy ancient emperors and good officers were painted on the walls of the school. Later on, more emperors and officers from the Han and as well as worthy ministers and governors from the Shu State were added. The existence of these two ancient paintings of emperors supports the view of many scholars that the Boston scroll was created to foster moral education among the nobility.

The scroll depicts thirteen emperors with attendants. Each ruler is identified by an inscription at the upper right of his group. If accurate, these figures would represent, from right to left, the following royal personages: Emperor Zhaowen (r. 179–157 B.C.) of the Western Han dynasty (206 B.C.–A.D. 8); Emperor Guangwu (r. 25–57) of the Eastern Han dynasty (9–220); Emperor Wendi (r. 220–26) of the Wei State (220–65) during the Three-Kingdom period (220–80); Sun Quan (r. 222–52), founder of the Wu State (222–80) of the Three-Kingdom period; Liu Bei (r. 221–23), founder of the Shu State (221–65) of the Three-Kingdom period; Emperor Wudi (r. 265–90) of the Western Jin dynasty (265–316); Emperors Xuandi (r. 569–82), Wendi (559–66), Feidi (r. 566–68), and Houzhu (r. 582–89)—all of the Southern Chen dynasty (557–89); Emperor Wudi (r. 561–78) of the Northern Zhou dynasty (560–81); Emperors Wendi (r. 581–604) and Yangdi (r. 605–17)—both of the Sui dynasty (581–618). The inscriptions for the first six emperors are noticeably simpler than those for the last seven. The latter group state, variously, each emperor's

dynastic, imperial, and personal names, as well as his reign duration. Some also indicate a particular emperor's religious preference. In the case of Wudi, the third emperor of the Northern Zhou dynasty, the inscription not only records his destruction of Buddhism but also mentions that the Northern Zhou dynasty had five emperors in its twenty-five-year history. Interestingly, at the end of this inscription, the two characters *wu dao* (ruthless) have been partially erased.

Although the depictions of all thirteen emperors appear stylistically related, a clear division exists between the first group of six emperors and the remaining seven. Five of the first six emperors are depicted uniformly in size, pose, and expression.[3] But from the seventh to the thirteenth emperors, the artist has demonstrated his ingenuity by creating a variety of poses, sizes, movements, expressions, costumes, and groupings, and has even managed to add different kinds of furniture. The original silk between the sixth and the seventh emperors clearly shows damage and separation, but was thoroughly repaired in premodern times. This damaged area divides the handscroll into two sections, which differ more in artistic quality and originality than iconography. The first section of six emperors probably was a Northern Song replacement for the badly worn original.

If the inscriptions for each emperor were originally part of the portraits, then the selection of rulers betrays a preference on the part of the artist (or his patron) for some dynasties over others. For instance, a total of four emperors from the short-lived Southern Chen dynasty were included whereas the other dynasties generally have but one historical exemplar. A possible reason for the Sui dynasty having two representatives is that Emperor Wendi unified China by deposing the last emperor of the Northern Zhou in 581 and defeating the Southern Chen dynasty in 589. His son Yangdi, who built the Grand Canal, was the last Sui ruler before the rise of the great Tang empire.

This handscroll was known to be in poor condition for centuries and it was repaired and remounted several times. During one of the early remountings, the chronological sequence of the four emperors of the Southern Chen dynasty must have been disrupted, resulting in the present awkwardness in compositional and chronological sequence. The correct his-

torical arrangement should be Emperor Wendi first, followed by his son Feidi, who was then deposed by his uncle, Emperor Xuandi. In turn, Xuandi was followed by his son Houzhu. To reflect this chronologically correct lineup in the composition of the present painting, the section depicting Emperor Xuandi and his attendants should be relocated, which would also make sense compositionally. It then would visually progress from the seated level of Wendi and Feidi, both dressed in Daoist costume, to the elevated level of the black-robed Emperor Xuandi—who is carried in a wooden sedan chair and accompanied by a large entourage, as if in a religious parade—then to the timid, humble last Southern Chen emperor, Houzhu, who stands in front of the large, imposing image of Wudi of the Northern Zhou dynasty.

The inclusion of Emperor Wudi of the Northern Zhou dynasty is significant. It reflects more than just his notorious anti-Buddhist, pro-Confucianist policies. Other historical factors are at work as well. The master painter Yan Liben, to whom this painting has long been attributed, came from a family with strong ties to the Northern Zhou and the succeeding Sui and Tang dynasties. According to official history, his father Yan Bi (act. late sixth century) was not only the son-in-law of Emperor Wudi, but also the emperor's favorite artist.[4] The family's prominence and prosperity in imperial circles was carried on into the early Tang period by Yan Liben and his elder brother Yan Lide (act. early seventh century).

As Tomita discussed in his 1933 *Portfolio*, the traditional attribution of the Boston scroll to Yan Liben started no later than the Northern Song period. Many well-known Song scholars' colophons are attached to the present handscroll. By the early Yuan dynasty (1279–1368), Wang Yun (1227–1304), a Chinese scholar who was close to the Mongol rulers, inspected a large group of Chinese paintings and calligraphy that had been removed from the former imperial collection of the Southern Song dynasty (1127–1279) in Hangzhou to the capital, Dadu (today's Beijing), after the Mongol conquest in 1276. Among them was a handscroll entitled *Yan Liben hua gu diwang yishisi ming* (Fourteen Ancient Emperors and Kings Painted by Yan Liben).[5] What Wang Yun saw in 1276 must have been the same as the present handscroll in the Boston col-

lection. The imperial seal *Zhongshusheng yin* (Seal of the Zhongshusheng) of the Southern Song court, stamped in several places on the scroll, is convincing proof that this painting was once in the Southern Song imperial collection.

Stylistically, the Boston *Emperors* scroll compares extremely well with the emperor image depicted on the east wall of cave 220 at Dunhuang. The cave is dated to 642 (the sixteenth year of the Zhenguan era of the Tang dynasty). The Dunhuang emperor, with his large entourage including two attendants holding large fans similar to those in the present scroll, resembles the Boston *Emperors* in almost all respects. Both demonstrate a profound sense of volume, weight, grandeur, and movement. To achieve such qualities, the artists of both the Boston and Dunhuang works incorporated a powerful display of line drawing with solid, forceful brushstrokes as well as simple, yet strong, coloring. The type, pose, expression, and movement of the emperors and their attendants are virtually identical in the Dunhuang and Boston paintings. An image of Vimalakīrti dating about half a century later than the painting in Dunhuang cave 220, is painted on the east wall of cave 103 at Dunhuang.[6] Though not as grand as the emperor image from cave 220, this figure is also closely related to the style and type of the emperor figures in the Boston scroll.

The Boston *Emperors* scroll also relates to murals on either side of the corridor in the tomb of Prince Zhanghuai, who died in the second year of the Jinyun era of the Tang dynasty (711). The wall paintings show Tang court officers in charge of diplomacy, dressed in formal court robes, receiving foreign visitors.[7] The high officers are more simply rendered, but they exhibit the same characteristics as those seen in the Dunhuang and Boston *Emperors*.

These datable murals provide convincing evidence for dating the Boston *Emperors* scroll (or, more precisely, its latter half) to a period between the second half of the seventh century and the early eighth century. The attribution to Yan Liben is less certain because of the paucity of surviving works. Of those attributed to him, Boston's comes closest to the style and brushwork of figure paintings produced during the time of Yan Liben. The early colophons, written by both Northern and Southern Song scholars, add to the

understanding of the scroll. They help verify its provenance as outlined by Mi Fu (1051–1107) in his publication, *Huashi*, which mentions Fu Bi (1004–82), Han Qi (1008–75), and the Wu family as owners of the work. The Northern Song names all appear in the first section of the silk attached to the painting. Damage prevents a full accounting of these scholars' names. Among those that can be deciphered, the first name, beginning at the right, is Fu Bi and the last, at the left, is Li Wei (eleventh century).[8]

1. *Lidai minghua ji,* juan 3, p. 55, in Yu Anlan, *HC.* vol.1.
2. Yizhou is today's Chengdu in Sichuan province.
3. The distinct coloring, ink tone, and drawing for the sixth emperor, as well as the different calligraphy in the title, suggest the hand of a second artist.
4. See Wei Zheng, et. al., vol. 68, p. 1594.
5. The numerical discrepancy between Wang Yun's version with "fourteen emperors" and the Boston scroll with thirteen emperors is clearly due to Wang Yun's mistake in counting Emperor Xuandi twice.
6. For cave 220, see *ZMQ: huihuabian,* vol. 15 pls. 21 and 24; for cave 103 see *ZMQ: huihuabian,* vol. 15 pl. 67.
7. See Fontein and Wu Tung, *Han and Tang Murals,* cat. 113.
8. In between are Northern Song colophons by Ma Yonggong, Qian Mingyi, Han Qi, Wu Kui, Cai Xiang, Sun Lin, Lu Jing, Zhang Heng, Li Yanhong, Li Zhongxiong, Zhang Mai, Xue Shaopeng, and Qian Ruqing. The eighteen Southern Song colophons are written on paper. The most extensive is by the connoisseur Zhou Bida, dated in the fifteenth year of the Chunxi era (1188), which details the history of the scroll from Tang through Northern Song times. Some later colophons are also extant, as mentioned in Tomita's 1933 *Portfolio.*

4

Anonymous
Bodhisattva Standing on Lotus

Tang dynasty or slightly later, 9th–early 10th century
Buddhist banner mounted as panel; ink and color on silk
42.3 x 14 cm
Chinese and Japanese Special Fund 14.47

This banner reportedly came from one of the Buddhist caves at Dunhuang in Gansu province. Buddhists used such banners during processions in rituals and festivals. This one has lost all its attached elements: banner legs, arms, and head; only the "body" with a picture of a bodhisattva remains. The complete format as well as the original function of such banners can be seen from undamaged examples in the British Museum collection.[1] Although painted by a Chinese artist, a recognizable Central Asian influence can be discerned in the iconography of the bodhisattva. The eyes are depicted almost in the middle section of a round face with a triangular nose, a broad chin, and high eyebrows. Such features differ from the conventional facial structure for a Chinese bodhisattva but resemble many Buddhist figure paintings from Central Asia.[2]

The Chinese influence at Dunhuang, which affected both Buddhism and the art produced there, is evident as early as the fifth century, during the Northern Wei dynasty (386–534). This banner's Dunhuang provenance explains some of its stylistic blend: While the linear components reflect either Chinese techniques or tastes, the coloristic features are more in keeping with Central Asian traditions and practice. The lower part of the skirt and the lotus petals display Chinese calligraphic brushwork, with its gradations of thickness in the lines. Here the lines play a significant role, and such effects can only be achieved with the soft, pointed tip of a Chinese brush. The artist's restrained treatment of the chest and the hip accords with the conservative Chinese view of human anatomy. On the other hand, the long, wavy scarf, draped symmetrically on both sides of the body, derives from Central Asia. The hairstyle of the bodhisattva, which is tied like a bun behind the head and hangs down to the shoulders, is also non-Chinese.

Although the coloring of the bod-

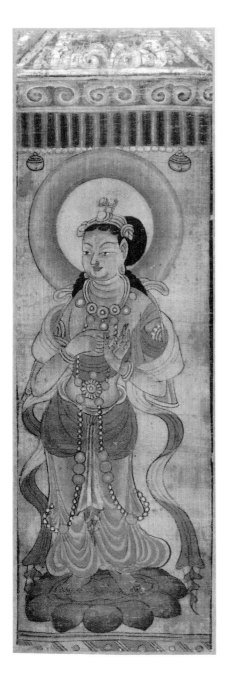

surrounding lotus ponds, which may be seen in the more elaborate Dunhuang paintings.[3] This small banner, though lacking the sophistication a highly trained artist would have brought to it, serves as an example of the type of early Buddhist art that flourished at Dunhuang from the ninth to tenth centuries.

1. Whitfield, vol. 2, pl. 10–1 and p. 307.
2. A good example is the so-called *Blue-Lotus Maitreya* discovered in the monastery of Fondukistan and now in the collection of the Archaeological Museum in Kabul. See Bussagli, p. 41.
3. Whitfield, pl. 12–1.

5

Anonymous
Buddhist Figures

Tang dynasty, 9th century or slightly later
Album of fragments from Turfan; ink and/or color on silk
18 x 13 cm (overall pictorial areas)
Denman Waldo Ross Collection 29.927 a–b

The album contains 104 fragments of varied sizes, mediums, and Buddhist subject matter, which are pasted on seven double pages. A title label written in Chinese characters on the cover of the album can be rendered as: "Sūtra painting fragments of the Tang—Suwen obtained them from an ancient temple at Turfan. Number 80." One of the two pages illustrated here was first published by Tomita in his 1933 *Portfolio* (pl. 25A). It consists of four unrelated faces and the top of a head of a small Buddhist figure painted on silk. The sketchy nature of the drawing on these fragments suggests that they were not parts of major Tang compositions. Nevertheless, it is informative to see how much sinicization had occurred by the ninth century in Turfan—one of the active Buddhist towns in the ancient Central Asian kingdom, which is referred to as Gaochang in Chinese historical records.

The other page, not published by Tomita, shows a well-sketched but incomplete head of a monk or Lohan. This idealized young monk appears to be a Han Chinese type with shaved head, thick, hairy eyebrows and a pair of so-called "phoenix's eyes" separated by a small nose. His mouth (except for the raphe of the upper lip), right ear, and chin have not survived. The three-quarter view of

his face is drawn with delicate brush-strokes to create a three-dimensional illusion. Such a pictorial approach is typical of the late-Tang style. It differs both from High Tang (first half of eighth century) works, with their more forceful, expressive facial features, and the later Song type, which preferred realism over the idealized three-dimensional modeling evident here.

hisattva is simple, the shading along the folds of the skirt and the subtle coloring around the eyes and chin show the artist's interest in adopting Central Asian techniques.

The halo behind the bodhisattva, colored in bright blue, red, and green, appears in many Central Asian paintings. Above the bodhisattva, two bells painted in yellow hang from a curtain decorated with an auspicious *ruyi* cloud motif. Above the curtain, a lavish floral design is painted in a triangular space that represents the canopy. In front of the lotus-blossom stand is a horizontal band, decorated in orange, blue, red, and green, which serves as a border. Such borders derive from stylized architectural elements like those representing the glazed tiles

banner of a standing bodhisattva reportedly from Dunhuang (cat. 4). Here the facial structure is closer to Tang Chinese iconography, with a rounder face, lower forehead, fuller torso, and Tang hand type.

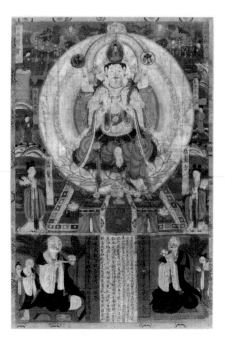

6

Anonymous
Head and Torso of a Bodhisattva

Tang dynasty, 9th century
Fragment from Tuyoq; ink and color on silk
17 x 18.5 cm
Samuel Putnam Avery Fund 31.888

According to museum records, this fragment of a Buddhist figure painting was among the materials brought back from China in 1905 by the second German expedition led by the Orientalist A. von Le Coq (1860–1930). Its precise origin is given as Tuyoq (Toyuk), an ancient town along the northern route of the Silk Road, to the southeast of today's Kucha in Xinjiang. This area, an active Buddhist center, belonged to the ancient Central Asian kingdom known in early Chinese annals as Gaochang. Because of early contact with Han China and its proximity to the northwestern frontier, its culture and art received a stronger Chinese influence than other Central Asian cities.

This simple but revealing fragment of a bodhisattva attests to how extensively Central Asian Buddhist art had become sinicized by the ninth century. From the viewer's perspective, the bodhisattva faces leftward, with his right shoulder slightly behind a decorated column. The remnant of a shoulder of another Buddhist figure appears alongside the bodhisattva. His pose and surroundings suggest that the Boston fragment originally was the right-hand part of a larger Buddhist composition.

The facial features and rendering of the image differ slightly from the Boston

7

Anonymous (formerly attributed to the Buddhist nun Jiejing)
Guanyin (Avalokiteśvara Bodhisattva) as Savior from Perils

Northern Song dynasty, dated 975
Hanging scroll mounted as panel;
ink and color on silk
88 x 58.6 cm
Maria Antoinette Evans Fund 27.570

The sinicized Buddhist deity called Guanyin[1] has been popular in China, Korea, Japan, and Vietnam for centuries. After the eleventh century in China, this deity's iconography underwent a gender change from its original Indian masculine prototype to a Chinese feminine representation. The Boston painting dates from 975, hence its facial features still maintain the masculine manifestation, as vaguely indicated by a thinly drawn mustache over the deity's upper lip. The figure of the six-armed Guanyin is portrayed within concentric circles of green, orange, and white. He is shown in a standardized fashion—wearing a reddish scarf and skirt, and additional golden ornaments, and is seated on a lotus that emeges from a square pond bordered by colored tiles. On either side of the Guanyin figure are stylized presentations of selected perils: "Falling from the Diamond Mountains"; "Drifting in Vast Seas"; "On Top of Mount Sumeru"; and "Thrown into a Giant Burning Pit." According to the *Lotus Sūtra (Saddharmapundarikasūtra)*, those who believe in the power of Guanyin and call upon him will be delivered from these perils. The rendering of mountains, waterways, trees, and fire recalls the style of Tang Buddhist paintings. In front of Guanyin is an offering table with vessels. At the lower right and left corners stand two young men, each holding in his arms a roll that records good and bad deeds. They are identified

on the cartouches as the "virtuous boy" and "evil boy," respectively, representing Śākyamuni and his half-brother Devadatta.

Paintings of varying quality with the same subject matter and datable to the same period are found in several collections.[2] Such works are based on the *Lotus Sūtra,* especially chapter twenty-five, "Pumen pin." In a spontaneous manner, a provincial painter created the Boston Guanyin following a conventionalized esoteric Buddhist tradition. The Guanyin is presented frontally, his left foot stepping on a lotus petal. Each of his natural hands holds a lotus blossom in front of his chest; the upper hands hold high the symbols of the red sun and the white moon; and the lower pair of hands, placed on either side of the deity's Lotus throne, gesture in the Varada mudrā, signifying bountifulness.[3] The unusually large image of a seated Amitābha Buddha, painted in reddish color in the center of his crown, identifies this deity as Guanyin. A bejeweled and highly stylized canopy is seen above the halo.

The long inscription in the center of the lower register gives the precise date of the work: "Inscribed on the sixth day of the seventh moon in the eighth year of the Kaibao era," which corresponds to August 15, 975. The two nuns in the painting are identified by additional inscriptions written in green-colored cartouches. The nun at left sits on a Tang-style Buddhist platform, holding a portable censer in her hands, her shoes neatly placed under the platform. She is

attended by a disciple and a maid. Two palmlike trees behind her serve as a token garden scene. The inscription next to her identifies her as the nun Jiejing from the Lingxiusi nunnery. The votive description states that Jiejing "respectfully painted" this picture, but it is more likely that she commissioned a local professional to paint it. In contrast, the nun Mingjie, at the lower right, sits on a simple piece of carpet and is attended only by a young maid with one palm tree in the background. As identified by her accompanying inscription, she is a lower-ranking and perhaps younger nun from the same nunnery. Both nuns bear the same family name— Li—and may be related.

According to a colophon mounted on the back of the painting, which was written by a certain Wang Guan in 1907, this painting was discovered in Dunhuang in the twenty-fifth year of the Guangxu era (1899). Afterward, it was in the collection of Duan Fang (1862–1911), the powerful Manchu governor of Zhili. The museum acquired this painting from the Yamanaka Company in Japan in 1927.

1. Guanyin is an abbreviated form of Guanshiyin. According to the great monk Xuanzang (596–644) and other early Buddhist writers, Guanshiyin was a mistranslation of the Sanskrit name for this bodhisattva whose correct name in Chinese should be Guanzizai. See *Da Tang xiyu ji*, juan 3, in Ding Fubao, p. 731.
2. See Whitfield, vol. 2, pls. 18 and 21.
3. See Tomita, "A Dated Buddhist Painting from Tunhuang," pp. 87–89.

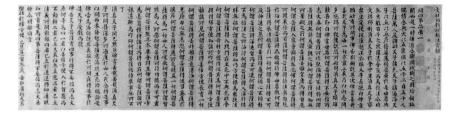

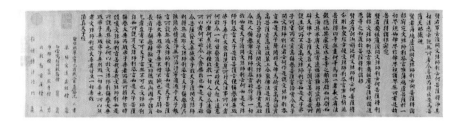

8

Shen Li (act. 11th century)
Buddhist Sūtra in Regular Script: Xuzhen Tianzi Jing (Suvikrānta Cintādevaputra Paripricchā Sūtra)

Northern Song dynasty, dated 1069
Handscroll; ink on sūtra paper
24 x 1328 cm
Keith McLeod Fund 1977.176

Although little is known about the artist Shen Li, he appears to have been a professional sūtra calligrapher (*xiejingsheng*). His inscription on this handscroll states that the sūtra was written in the third moon of the second year in the Xining era of the Northern Song period (1069). It also mentions that the calligrapher was a native of Liyang, which is southwest of today's Nanjing, in Hexian county, Anhui province. The name and birthplace of the calligrapher as well as the date of the sūtra provide a rare opportunity to understand the practice and style of Buddhist sūtra writing after it had reached its apogee during the Tang dynasty. The Tang style was so influential that it had a lasting impact on later sūtra writing, not only in China, but in Korea and Japan as well.

The Boston sūtra confirms the existence of an independent Song style that signals a departure from the Tang prototype. Compared to Tang-style sūtra writing, the structure of each character in the Song sūtra is not as methodically constructed with balance and symmetry. Nor is the brushwork as precise and consistent; the spatial relationship between the characters is less rhythmic and the execution less decisive and forceful. Rather, the Song style, as seen from the Boston example, is softer and more spontaneous, suggesting at least an indirect influence from the Northern Song master-calligrapher Cai Xiang, who died in 1067, two years before this sūtra was completed.

The text, in black ink on a yellowish sūtra paper, comprises seventeen characters in each of its vertical columns, which have thin red lines drawn between them. Smaller-size characters at the beginning of the scroll provide the name of the monk who translated the text from Sanskrit into Chinese. At the end of the sūtra, again in smaller characters, are found the names of the calligrapher, the head priest, the "editor," and the monk who raised funds to produce it. The scroll is impressed with nine imperial seals of emperors of the Qing-dynasty (1644–1911). It is registered in the 1793 catalogue of religious paintings and calligraphy in the collection of Emperor Qianlong (r. 1736–95).[1]

1. Wang Jie, et al., vol. 3, p. 99a.

9

Anonymous (traditionally attributed to Yan Liben, d. 673)
Northern Qi Scholars Collating Classic Texts

Northern Song dynasty, 11th century
Handscroll; ink and color on silk
27.6 x 114 cm
Denman Waldo Ross Collection 31.123

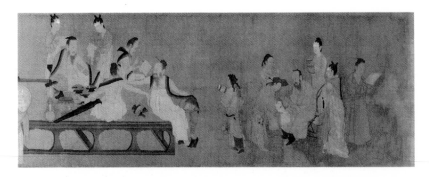

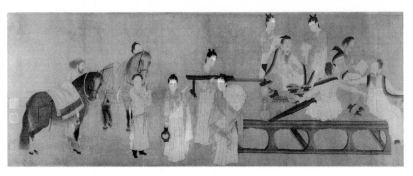

The recent archaeological discovery in China of a number of murals from datable Northern Qi tombs has underscored the uniqueness and importance of Boston's *Northern Qi Scholars* handscroll. Among these murals, the figure style of those from the tomb of Lou Rui (prince of Dong'an, d. 570) in today's Taiyuan, Shanxi province, is particularly close to those portrayed in the Boston handscroll. The similarities—in figure type (oval-shaped face, high forehead), dress (simple, rigid forms), drawing style (thin, firm, refined, and of even-width), and coloring (flatly applied original colors)—between the mural and the handscroll are striking. In terms of style and quality, the *Northern Qi Scholars* handscroll has few equals among surviving early Chinese paintings.

Description

The painting consists of five senior scholars, seven male servants, seven maids, and one boy attendant, as well as two horses, all of which are organized into three groups. The composition emphasizes the overall rhythm of the arrangement and spatial relationship among them. Since the painting is set against a blank background and the artist wanted to convey a sense of depth and order, he took pains to position strategically each figure in each company on a different plane. The first, on the right side of the scroll, centers on a scholar in red nomadic costume, who sits in the Western manner on a folding stool, known in ancient China as a *huchuang* (nomad's seat).[1] To his front, back, right, and left are four servants. The symmetry of this group of figures is further enhanced by the addition of one servant to the right and one to the left of this group. All the servants are busy with their assigned duties: One handles a piece of paper for the scholar to write upon while the others variously prepare a new brush,

hold a roll of paper, or review the writing. A fashionably dressed maid, shown in profile, brings an official girdle to the scholar who, perhaps, will soon leave for the palace.

The next group occupies center stage in the composition. The visual transition from the lone scholar surrounded by servants to the next episode is provided by a servant bearing a bundle of finished texts, who is seen walking toward the group of scholars at center. Relying on superb linear drawings and effective coloring, the artist produces a theatrical scene among the four scholars, who are shown sitting on a large wooden couch. One scholar's sudden desire to leave has stirred up a commotion. Another, who is playing the *qin*, abandons his musical instrument to reach backward and grab the departing

colleague; but this scholar, who has already moved toward the edge of the couch where his servant is helping him put on his boots, pushes the *qin* player away. In the struggle, a high-footed lacquer plate is thrown off balance, scattering food. The scholar sitting across the couch from them seems annoyed by the disruption. Their open mouths suggest an exchange of unkind words. Only one scholar, his body turned away from the other three, appears indifferent to the commotion and continues his writing.

To the left and the back of the couch, five maids are variously engaged in bringing a black-and-red-lacquer jar of wine, a lavishly designed cushion, or an armrest, or in holding a piece of cloth to clean a wine cup. On top of the couch, food plates on high stands are displayed,

together with writing implements, drinking vessels, and games. At the left, the composition ends with one attendant in charge of two grooms and two horses who await the scholars' summons for services.

Sources

As suggested by its Song colophons, the subject matter of the handscroll represents a historical episode. According to *Beiqi shu*, the official history of the Northern Qi dynasty, in the year 556 Emperor Wenxuan (r. 550–59) invited twelve Confucian scholars to collate more than three thousand Chinese classics to be used for the education of the crown prince. Yet the Boston painting shows only five scholars. Addressing this discrepancy, the Song scholar Fan Chengda (1126–93), author of the painting's first colophon, surmised that this scroll had probably lost half its original composition. He quotes a text written in 1101 by the calligrapher Huang Tingjian (1045-1105), who recalls seeing an ink drawing by the Tang master Yan Liben that depicted twelve scholars, thirteen attendants, and two couches.

What Fan Chengda did not realize is that sometime between the late-eleventh and early twelfth centuries, at least two versions were already in existence—one with twelve scholars, the other with six. The differences between these versions was pointed out as early as 1117 by the connoisseur Huang Bosi (1079–1118). The Boston scroll differs from both these versions. Its composition, with two horses at the end of the scroll, appears complete and there is no room for another group of seven scholars as Fan Chengda had proposed. This would suggest that the Boston scroll is yet one more version of this famous painting, all of which are perhaps related to an ink drawing (now lost) by Yan Liben.

This work was well known among connoisseurs and artists of succeeding dynasties. Its importance is evident not only from the colophons of leading Southern Song scholars but also from a copy in the collection of the National Palace Museum, Taipei, now attributed to Qiu Wenbo (act. mid-tenth century) of the Five Dynasties period (907–60).[2] Although there are no colophons by Yuan scholars, the scroll's popularity during the Mongol period is certain. The anonymous portrait of Ni Zan (1301–74), now in the National Palace Museum, Taipei, was based in part on this *Northern Qi Scholars* scroll. This portrait, showing the leading literatus sitting on a couch, imitates the centrally positioned scholar in the Boston scroll in several ways: In both works, the seated figure holds a brush in his right hand and paper in his left, and their respective right arms are similarly positioned on armrests.

In the anonymous portrait of Ni Zan, the young woman carrying a wine jar in her right hand derives from a similar figure in the second group of the Boston painting. The boy servant in the Ni Zan scroll most likely follows the young horse groom standing next to the wine-vessel bearer in the Boston scroll.[3]

Dating and Style

Eleven colophons written by various connoisseurs from the twelfth to early twentieth centuries are attached to the left of the pictorial section. Of these, five are by important Southern Song scholars.[4] Stamped over the pictorial and colophon sections are twenty official seals of various governmental posts of the early Southern Song period. They were probably applied onto the scroll sometime after 1189 when the last Song colophon was written.

It seems that Boston's *Northern Qi Scholars* handscroll, although a Northern Song copy, accurately preserved a Chinese painting style that, according to literature, had far-reaching impact upon Sui and Tang painters like Zhan Ziqian (act. second half of sixth century) and his follower Yan Liben (see cat. 3). Copyists of later generations always leave marks of their own times. Although the Boston painting derived from the mature style of the Northern Qi dynasty (late sixth century), possibly via the influence of the master Yang Zihua (act. third quarter of sixth century), some motifs, such as the horse, the stirrups, and the whips, all exhibit Northern Song characteristics. The precise and deliberate positioning of the figures as well as the way they are grouped together accords closely with Boston's *Court Ladies Preparing Newly Woven Silk*, attributed to Emperor Huizong (r. 1101–25, d. 1135; see cat. 14). Both paintings are selectively copied after Tang originals. They no longer possess the sense of movement so prominent in the Tang paintings. The only part of the Boston painting that evinces some movement is the group of scholars on the couch.

The line drawing of these figures is executed in what Chinese call *tiexian miao*, or iron-wire style. Ideally this technique produces a line executed with consistent width, rhythm, and speed. It generally serves a descriptive purpose rather than the more calligraphic, expressive strokes characteristic of earlier Chinese figure-painting traditions, such as the celebrated style of Wu Daozi (act. 710–60). Iron-wire may originally have been an imported style inspired by Buddhist art from Central Asia or even India. The descriptive nature of the drawing in this handscroll enhances the detached, impersonal atmosphere of the entire composition. Even the dramatic scene staged among the scholars in the central group gives a visual impression of simplicity and coolness, much like stone sculptures of the Northern Qi period.

1. See Wu Tung, "From Imported Nomad's Seat to Chinese Folding Armchair," pp. 36–51.
2. *Gugong shuhua tulu,* vol. 1, p. 125.
3. For further discussion, see Fontein and Wu, *Unearthing China's Past,* cat. 117, pp. 218–21.
4. The first, by Fan Chengda, dates from the early 1180s. The others are, successively, by Han Yuanji (1118–87), dated 1181; Guo Jiangyi (act. late twelfth century); the poet Lu You (1125–1210), dated 1181; and Xie E (1121–94), a well-known Confucian scholar and court censor, whose colophon was written in 1189.

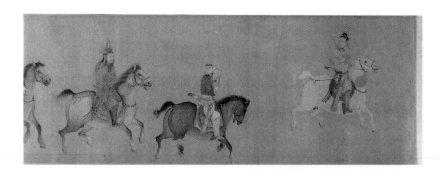

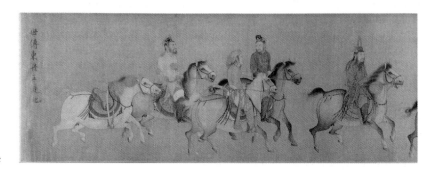

Anonymous (traditionally attributed to Li Zanhua, 899–936)
Nomads with a Tribute Horse

Northern Song dynasty, 11th–12th century
Handscroll; ink, color and gold on silk
27.8 x 125.1 cm (painting only)
Keith McLeod Fund 52.1380

Attribution, Style, and Dating

Based on an inscription by an unknown hand at the end of the painting, this scroll has traditionally been attributed to Li Zanhua and was thought to represent Khitan nomads bringing a tribute horse to China. Li Zanhua, also known as the Prince of Dongdan, was the eldest son of Emperor Taizu (872–926; r. 907–26) of the Liao dynasty (916–1125), the first Khitan ruler. Li Zanhua fled his younger brother's political plots against him and was given refuge in 931 at the court of the Later Tang Emperor Mingzong (866–933; r. 926–33). The artistic talents of this exiled prince made a strong impression on his Chinese patrons and at least four Northern Song art critics detailed his noble background and the paintings he created. Fifteen works by him are listed in the catalogue of the Emperor Huizong.

Only a handful of paintings loosely attributed to Li Zanhua have survived to modern times, and they are in collections both inside and outside China. The Boston handscroll, together with an album leaf of a Khitan warrior and horse (National Palace Museum, Taipei), and a short handscroll of a stag hunt (Metropolitan Museum of Art, New York), are the better-known examples of high-quality works attributed to him. Unfortunately, none of these exhibit any stylistic or historical evidence to support an early tenth-century Khitan authorship.

Although the figures depicted in the Taipei and New York paintings are convincing representations of Khitan nomads, none of the six horsemen in the Boston scroll wear the typical hairstyle or native Khitan costumes. The headgear worn by these riders has no known precedent in any murals or scroll paintings related to Khitan subject matter.

Other anomalies in the Boston scroll raise questions about its traditional attribution and the identification of its subject matter. In the middle of the composition,

a distinguished-looking noble appears in a luxurious costume that includes a well-designed, high, metal crown; a richly patterned brocade robe, its long sleeves extending well over his hands;[1] and, possibly, embroidered pants. This princely rider bears clearly non-Chinese facial features: deep eyes, long nose, a broad forehead, thin lips, and a squarish chin. Such a facial structure also contrasts with the generally moon-faced Khitan or Jurchen nomads from Manchuria. Interestingly, the last horseman, who leads a saddled, riderless white horse, has a similar facial structure to the nobleman.

These two riders most likely belong to a Central Asian ethnic group, which would explain why the princely figure's official garment displays a typically Central Asian textile design of two birds facing each other on a medallion. The rest of the patterns on his robe relate to Chinese textiles with Central Asian influences.[2] While the facial rendering of the first and fourth riders more closely resembles the Chinese type, all these riders wear earrings—a tradition unknown among Chinese males but popular in Central Asia.

According to the eleventh-century critic Guo Ruoxu, Li Zanhua only painted figures and horses of his native country.[3] Yet the figures depicted here are all probably from Central Asian regions rather than from Manchuria, the homeland of the Khitan nomads. The Boston scroll also shows delicate coloring and a portraitlike naturalism for the riders and

horses. But the Northern Song critic Liu Daochun (act. mid-eleventh century) identifies two main shortcomings in Li Zanhua's works: First, he was careless in applying color; second, his figures were too short and petite.[4] Since the opposites of both criticisms are true of the Boston scroll, the traditional attribution to Li Zanhua cannot be confirmed.

Compositionally this scroll resembles two twelfth-century works: *Lady Wenji's Return to China* (attributed to a Zhang [Yu?] of the Jin-dynasty painting academy) in the Jilin Provincial Museum and *Lady Guoguo's Spring Outing* (attributed to Emperor Huizong), in the collection of the Liaoning Provincial Museum. In all three works, the spacing and grouping of riders in motion are treated similarly. In addition, all three scrolls portray one or more riders with their heads turned back. Such stylistic similarities would support dating the Boston scroll to a period between the late-eleventh century and the first half of the twelfth century.

Interpretation

The Boston scroll shows a type of Mongolian pony rarely painted by Tang or early Northern Song artists. During that time, only the idealized horses imported from Central Asia merited artistic attention (horses like those in paintings attributed to Han Gan (ca. 715–after 781) in the Metropolitan Museum of Art, New York, and the National Palace Museum, Taipei). These works were even imitated

by such Northern Song scholar–painters as Li Gonglin (ca. 1049–1106). Even as late as the late Southern Song and Yuan periods, orthodox painters like Zhao Mengfu (1254–1322) still preferred the Tang model to the new Mongolian type. In most cases, the Mongolian horse was associated with nomadic subject matter and only became more popular from the twelfth century on. By then, professional and academic artists showed more interest in painting them.[5]

The Boston scroll details the results of a peculiar custom: cutting horses' ears. Such incisions, practiced exclusively by the Khitan, only appear in horse paintings associated with these nomads.[6] In the early twelfth-century publication *Guangchuan huaba,* the author Dong You describes the "damaged" (cut) ears and nostrils of horses in paintings by the early tenth-century artists Zhang Kan and Hu Gui (act. first half of tenth century). When he asked the Khitan people for an explanation, he was told that "if the ears of the horses were not cut, then the noises created by the wind would not be discerned; and if the nostrils were not broken wide, then the unrestrained temper of the horses might affect their lungs."[7]

Our identification of a typical Mongolian horse with cut ears raises an intriguing question: If the riders are indeed Central Asian or Uigurian types, why would they ride on Khitan horses instead of Central Asian ones? An obvious inconsistency exists between the lifelike portraits of Central Asian riders and their typically Khitan horses. The Boston scroll suggests a cultural link between Manchuria and Central Asia and a closer relationship between Khitans and Uigurs than has generally been assumed. Historical evidence supports this: A typical Xixia (Tangut) Buddhist painting found in 1909 in today's Inner Mongolia shows a group of four Khitan dancers, with two Mongolian horses at the lower right corner.[8] The kingdom of Xixia maintained a careful relationship with both the Northern Song and the Khitan in the tenth and eleventh centuries. The official history of the Liao dynasty records that special quarters were established in the Khitan capital to accomodate both Uigurian traders and emissaries from the Xixia kingdom.[9] Apparently an unknown painter with an in-depth understanding of both Khitan and Central Asian art and culture was able to produce this unique work; however, its

specific historical context and meaning are lost to us today. One can only speculate that the scroll records a Uigurian diplomatic delegation leaving the Khitan capital en route back to Central Asia mounted upon and leading the Khitan horses they received while there.

At least three later copies were made after the Boston scroll: two handscrolls in the collection of the Freer Gallery (Washington, D.C.) and a large album leaf with two riders in the National Palace Museum, Taipei.[10] They give further evidence of the high artistic quality and originality of the Boston scroll.

1. Similar long-sleeved silk robes can be seen on the first rider of the early twelfth-century handscroll attributed to Emperor Huizong, *Lady Guoguo's Spring Outing* (Liaoning Provincial Museum).
2. Several examples are preserved in the Xinjiang Uighur Autonomous Regional Museum. For related medallion design, see a tenth-century mural reproduced in *ZMQ:huihabian,* vol. 15, pl. 161.
3. See Guo Ruoxu, *Tuhua Jianwenzhi,* juan 2, p. 21, in Yu Anlan, *HC,* vol. 1; also, *Xuanhe huapu,* juan 7, p. 88, in Yu Anlan, *HC,* vol. 2.
4. See *Wudai minghua buyi,* pp. 28b–29a, in *Wangshi huayuan,* juan 6.
5. See, for example, the hanging scroll *Emperor Shizu and His Hunting Entourage* by Liu Guandao (act. ca. 1270–1300), dated 1289, in the collection of the National Palace Museum, Taipei.
6. Lin Boting, cat. 5, 6, and 12. Another example can be found on a painted wooden panel depicting horse and groom, possibly an early Liao funeral painting, now in the collection of the Princeton University Museum. Both of that horse's ears are cut in a manner similar to that seen on the horses in the Boston painting.
7. See *Guangchuan huaba,* juan 6, pp. 86a–b, in *WH,* juan 4.
8. See *Xixia wenwu,* pl. 75.
9. See Tuotuo, et al., juan 37, p. 441.
10. See Lawton, *CFP,* cat. 46; and Smith and Wan-go Weng, pp. 154–55.

11

Attributed to Fan Kuan (act. late 10th–early 11th century)
Winter Landscape with Temples and Travelers

Northern Song dynasty, 11th century
Hanging scroll; ink and light color on silk
182.4 x 103 cm
Chinese and Japanese Special Fund 14.52

As one of China's three great landscapists of the classical period (tenth–eleventh centuries), Fan Kuan was acclaimed for creating a unique style reflecting the mountainous scenery of his native Shaanxi province. The Northern Song poet Su Shi (1036–1101) considered Fan Kuan the only artist of his time whose style still preserved the *gufa* (ancient aesthetic) derived from the Tang model.[1] His style is known to us primarily through his reliably signed masterpiece: *Travelers among Streams and Mountains* (National Palace Museum, Taipei). Another large hanging scroll in the Tianjin Municipal Museum of Art bears a signature: "Fan Kuan."

Boston's monumental wintry landscape, on the other hand, is the best representative work of the Fan Kuan school in the West. Shanghai art historian Xie Zhiliu believes that the Boston Fan Kuan is comparable in quality to the Taipei work. Despite damage and the darkened surface of the silk, the monumentality and subtlety of the landscape scenery in the Boston scroll can still be observed.

The artist has used the *yudian cun* (raindrop texturing) technique to model the rock groups in the foreground and the mountains in the background. Trees, especially the cypress trees, are depicted in a more archaic manner than those in the Fan Kuan paintings in Taipei and Tianjin.[2] Unlike other Northern Song paintings, neither sharp contrast of light and dark nor cloud and mist elements were used in painting the Boston work.

The figures moving about in the foreground and middle ground are portrayed in great detail and, in typical Northern Song manner, are small in scale in relation to the landscape. In the left foreground, a roofed boat has just been moored. The fisherman seems to be trading with a buyer on shore. The buyer carries an umbrella to ward off the falling snow and the fisherman, having emerged from the

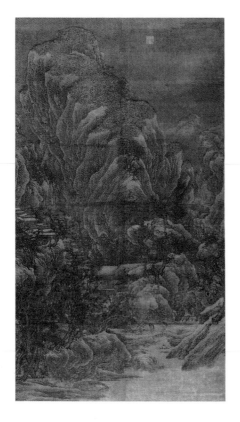

boat's warm compartment where his wife and child remain, protects his face with a sleeve. Behind the fish buyer, a mountain stream flows among a group of ancient cypress trees with wrinkled trunks, standing tall by a zigzagging path that leads toward the middle ground. These scenes—just like the team of donkeys and their escorts in the foreground of the Taipei scroll—are designed for intimate viewing. The scholar at the left, gazing up at the Buddhist temples from the window of a thatched house, serves the same function as the two monks crossing the bridge: All draw our attention toward the monastery complex further into the mountains. These figures are entirely different from those depicted in the Southern Song landscapes. By then, figures had come to be rendered in a sketchier, more abstract manner while they were shown in larger proportion relative to the surrounding landscape. The naturalism that had been practiced by the Northern Song landscapists was abandoned to explore the more surface-oriented elements of design and motifs.

The Boston composition presents an intricate spatial arrangement that heightens the sense of remarkable depth. Passageways opening up on either side of the central mountain range invite viewers to enter the landscape. A well-defined, slender, rapid waterfall leading to a narrow valley on the right is echoed by a remote waterfall to the mountain's left. A mountain path above the valley leads viewers to further exploration. Beyond the pass, peaks open up to allow a glimpse of yet more mountains beyond.

The blanket of repetitively drawn bare trees that covers the peaks demonstrates a distinct graphic invention originated by Fan Kuan, that also appears in his representative work in Taipei. At the lower right, the area where the water meets the edges of the rocks and the slopes of land is left undefined—another characteristic of Northern Song landscape painting. Later artists would always carefully delineate the shoreline.

The Taipei Fan Kuan radiates strength through its strong brushstrokes and masterful articulation of a number of large spatial units. The Boston scroll does not display such powerful verticality. Instead, a series of rhythmic repetitions of mountain contours create a sense of movement, which methodically entices the viewer to explore this intricate landscape world.

1. See Chen Gaohua, *Song Liao Jin huajia shiliao,* pp. 266–67.
2. See *ZMQ: huihuabian,* vol. 3, pls. 7 and 8.

12

Zhao Lingrang (act. late 11th–early 12th century)
Summer Mist along the Lake Shore

Northern Song dynasty, dated 1100
Handscroll; ink and color on silk
19.1 x 161.3 cm
Keith McLeod Fund 57.724

Of all the paintings attributed to Zhao Lingrang (*hao:* Danian), only three or four are now thought to be by his hand. The Boston handscroll, which is signed, dated, and accompanied by two seals of the artist, is considered the most reliable work among them. Usually Northern Song handscrolls are more monumental in both pictorial presentation and size; the small scale of this exquisite painting makes it unique among its contemporaries.

Description

In a lyrical manner, the composition cinematically reveals scenery along a lake shore during summer. The remarkable application of winding bands of mist that permeate the trees on the shore weaves the entire composition together. Like other Northern Song painters, Zhao Lingrang shows concern for spatial depth. The foreground is defined by three areas of land, at the beginning, middle, and end of the composition respectively.

The scroll begins with an inviting path provided for the viewer to stroll visually, over a narrow bridge and farther into the forest on the other side of the lake. A zigzagging stream, which enters the picture from afar, enhances a perspectival sense of great depth. Lotus leaves dot either side of the bank; birds and ducks, once brilliantly colored, swim or fly about. To suggest a rich, varied foliage, Zhao used a remarkably inventive technique, which was more individualistic than those of most of his contemporaries. Old masters like Fan Kuan (see cat. 11) tended to be more descriptive when representing foliage.

The middle foreground also provides a wooden bridge that connects the village to the other side of the lake. Unlike the first section, here a group of simply constructed houses are scattered in the woods. Zhao utilized the trees to convey a sense of front-to-back spatial relationship while he also repeated the bands of mist and lotus leaves, aquatic reeds, and waterfowl to amplify the horizontality of his composition. At the lower left foreground, three dark-trunked, beautifully shaped trees with sensitively executed leaves and branches spread like an open folding fan. Through the open spaces, between branches and leaves, the viewer can glimpse wild ducks in flight. The painting ends with a line of inscription in regular style by Zhao that reads "painted by Danian in the year *gengchen* of the Yuanfu era," a date corresponding to 1100. Two square seals of the artist are impressed over the inscription.

Interpretation

In early publications, Zhao Lingrang was praised for his lyrical style and elegant brushwork,[1] but was criticized for a lack of monumentality in his composition and a weakness in texturing landscape.[2] These works described Zhao Lingrang as a member of the imperial family who was fond of studying literature. His interest in painting began when he read the poems of the great Tang-dynasty bard Du Fu

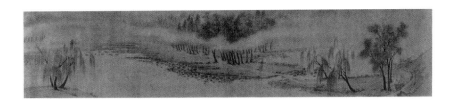

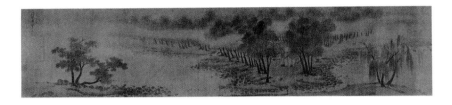

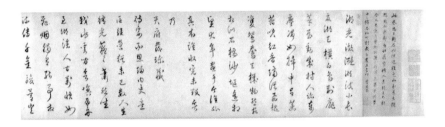

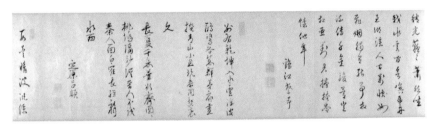

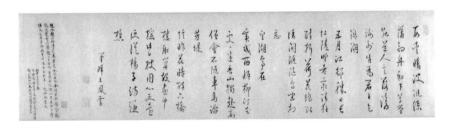

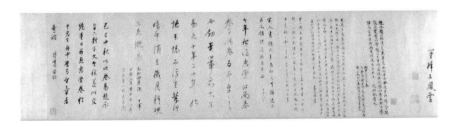

Northern Song, Zhao Lingrang developed a new landscape style that already reflected the theory of literati painting championed by his contemporaries Su Shi and Mi Fu (1051–1107). Later, Southern Song artists followed Zhao's way of avoiding monumentality in order to focus on a section of natural scenery, although these later artists preferred to use the intimate scale of a round-fan or album-leaf format. Possessed of an independent mind, Zhao appears to have broken away from the dominant styles of Fan Kuan, Guo Xi (ca. 1001–90) and Li Tang (1060–after 1150). Perhaps his closeness to literati scholars affected his style and aesthetic. He clearly inspired artists of succeeding generations who sought to avoid rigid, academic structures and styles in painting.

Provenance

The scroll bears the so-called *siyin* (half-seal) at the lower left corner. The *siyin* was impressed by early Ming officers who confiscated the Yuan imperial collection of paintings after overthrowing the Mongol rulers in 1368. The painting was once in the collection of the late-Ming literati artist Dong Qichang (1555–1636), who wrote many colophons on the painting. These colophons indicate a high regard for its literary quality, placing Zhao Lingrang in the same category as other literati painters. After the Manchu conquest of China, the painting entered the collection of Emperor Qianlong (r. 1736–95). Prior to its acquisition by the Boston Museum in 1957, the painting was in the collection of the modern painter Huang Junbi (1898–1991).

1. See Wang Tinggui, *Luxi xiansheng wenji,* cited in Chen Gaohua, *Song Liao Jin huajia shiliao,* pp. 413–14.
2. Ibid., pp. 409–10.
3. See *Shangu Bieji,* vol. 1, in Chen Gaohua, op. cit., pp. 411–12.

(712–70) that were inscribed on master paintings. Afterward, he began to collect early paintings and learn from them. In the third year of the Yuanyou era (1088), the scholar and art critic Huang Tingjian composed two poems inspired by Zhao's small landscape paintings, praising him for trying to be more inventive with each new composition.³ The Boston scroll

seems to confirm early records concerning the inventiveness of Zhao Lingrang's works. His refreshing presentation departs from the mainstream of Northern Song landscapes; Zhao's more individual approach polarized the opinions of critics, who either admired or disliked his more intimate observations of nature.

It is fair to say that, during the later

13

Emperor Huizong (r. 1101–25, d. 1135)

Five-Colored Parakeet on Blossoming Apricot Tree

Northern Song dynasty, datable to 1110s
Handscroll; ink and color on silk
53.3 x 125.1 cm
Maria Antoinette Evans Fund 33.364

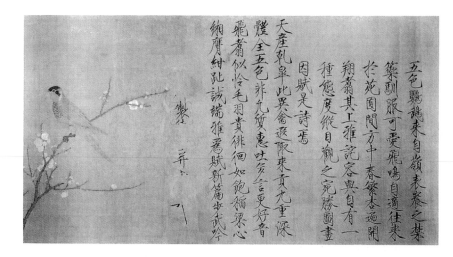

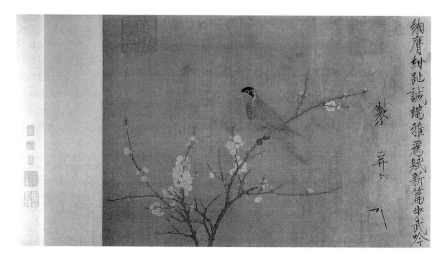

Although modern scholarship has questioned the authenticity of the landscape and figure paintings attributed to Emperor Huizong, his works in the *hua niao hua* (bird-and-flower) genre have been accepted more readily since he was known in history and literature as a specialist in this genre. The Boston Museum's *Five-Colored Parakeet on Blossoming Apricot Tree* is undoubtedly one of the most reliably attributed examples by this Northern Song emperor. According to Emperor Huizong's own inscription on the scroll, this painting was created to commemorate the arrival of a rare parakeet (recently identified as an Ornate Lorikeet) that was brought to his court as a tribute from "beyond the South" (Lingbiao).[1] When the emperor caught sight of the parakeet flying amidst the full blossoms of springtime apricot trees in the imperial garden, he personally painted (*yuhua*) the bird to record this event.

Description

The bird is depicted realistically, in profile, perching on an apricot tree with white flowers in various phases of blossoming. The painting strongly suggests a portrayal directly from nature. Unlike what would become the case for bird-and-flower paintings in the succeeding Southern Song period, little effort has been made here to create a dramatized composition or to embellish motifs for decorative effect. Despite some deterioration, the curved contours that form the beak (which are drawn in the iron-wire technique), show clearly that they were executed with precision, strength, and clarity. Even the faded colors—especially the yellow hue near the neck and encircling the eye—used to model and decorate the bird's body, feathers, and claws, have not lost their subtlety and richness entirely. X-ray examination by the Boston Museum's conservator recently confirmed that the bird was drawn with a free hand, without prior sketching.

The apricot branches and blossoms were rendered in pale ink, with short, sharp, slender lines, prior to being colored. A sense of archaic charm informs the arrangement of the branches. They are surprisingly symmetrical and idealized, like those depicted in such earlier bird-and-flower works as the *Seven Sparrows on Bare Branches* attributed to Cui Bai (act. 1068–77) in the Beijing Palace Museum, and *Pheasant and Sparrows by Thorny Brambles* attributed to Huang Jucai (tenth century) in the National Palace Museum, Taipei. By comparison, Huizong's *Finches and Bamboo* (Metropolitan Museum of Art, New York) appears more decorative and less lifelike in its execution and composition than the Boston *Parakeet* scroll. Very likely the New York painting was completed later than the Boston work.

The right half of the picture is occupied by a stylish calligraphy comprising eleven vertical lines of writing: From right to left, six lines are devoted to the inscription, four to poetry, and one to the signature. All were written by the emperor himself in his unique style known as *shoujin* (slender-gold) calligraphy. Huizong's signature line has been badly damaged, but the second character, *zhi* (to compose), the fourth character, *bing* (as well as), and a large part of the emperor's stylized *Tianxia yiren* (First Man under Heaven), remain intact.

Fortunately an identical line of a similar signature by Huizong has been preserved on his two other reliably attributed paintings—a handscroll entitled *Auspicious Cranes* (Liaoning Provincial Museum, Shenyang) and the *Propitious Dragon Rock* (Beijing Palace Museum). Huizong wrote and signed these two works in the same manner as he did for the Boston painting: *Yuzhi yuhua bing shu* (composed, painted, and written by the emperor). The damaged writing on the Boston scroll can be reconstructed accordingly. In all three paintings, a rectangular seal—*yushu* (imperial writing)—is impressed upon the second written character *zhi* (to compose) in the signature line.

Interpretation

In his *Huaji* (preface dated 1167), the art historian Deng Chun (act. mid-twelfth century) records that Emperor Huizong produced an album depicting rare birds, flowers, and precious objects, as well as auspicious events during the Zhenghe era (1111–18). It is conceivable that these three tall handscrolls were originally in the format of large album leaves, each of which depicted an unusual subject or event. If this is the case, the three hand-scrolls represent the earliest-known album leaves in Chinese-painting history, and Emperor Huizong as one of the earliest artists to combine the art forms of poetry, calligraphy, and painting into one work. As such, the emperor may be considered one of the pioneers of the influential literati painting tradition in China. Together with the Boston *Parakeet*, all three of the aforementioned works have similar measurements and elements in their format: a naturalistic painting, an inscription with a poem, and calligraphy by the emperor. In the Boston scroll, however, the arrangement of calligraphy and painting is the reverse of the other two works. This probably can be attributed to an error made during remounting.

Attribution, Dating, and Provenance

In the present composition, the line of the signature intrudes upon the pictorial section resulting in an awkward appear-ance. If the layout of the calligraphy and painting in the Boston scroll could be reversed (painting on the right and calligraphy on the left) as in the Beijing and Liaoning paintings, it would greatly enhance the overall rhythm and spacing of the composition. Not only would this position the signature line at the end of the scroll, which traditionally is the correct place for a signature, but it would reposition the imperial seal of the Yuan Emperor Wenzong to match the same seal location on the Beijing *Rock* painting.

On the Beijing *Rock* painting, the emperor recorded his profound interest in the strange appearance and artful shape of this dragonlike rock. Since no words could adequately describe its eccentric quality, he then "personally painted [the rock] on a piece of white silk" (*qin hui jiansu*). In the poem following the inscrip-tion, the emperor reiterates that he "per-sonally imitated and painted the rock

with color and brush" (*gu ping caibi qin moxie*). This important statement in Huizong's own words of his personal hand in creating the dragonlike rock pro-vides convincing evidence for the authen-ticity of Beijing's *Propitious Dragon Rock* and, consequently, the two other closely related paintings: Liaoning's *Cranes* and Boston's *Parakeet*.

Furthermore, the emperor's inscription on *Auspicious Cranes* precisely dates the event at sunset on the sixteenth day of the first moon of the year *renchen* in the Zhenghe era (a date corresponding to February 15, 1112). Apparently Huizong composed a poem right after he wit-nessed this rare sight and then painted the picture. The similarity in style, size, and format between the datable *Cranes* and the undated *Rock* and *Parakeet* paintings proves that the latter two were also paint-ed during the Zhenghe era. Additional lit-erary evidence further supports such dat-ing. The aforementioned *Huaji* records that in the fifth year of the Zhenghe era (1115), Emperor Huizong, upon seeing purple-colored mandarin ducks swim-ming in the imperial Pond of the Flying Dragon, decided to depict the scene and write a poem for inclusion in a collection of rare and auspicious events memorial-ized in his album. The *Huaji*'s description shows that this painting was similar in date, size, and content to the three scrolls discussed above.[2] Obviously the purple mandarin ducks, too, came from the same album as the paintings of the parakeet, the rock, and the cranes.

Prior to the acquisition of this painting for the Boston Museum by Tomita, it was in the collections of the Yuan Emperor Wenzong (r. 1329–32), collectors Dai Mingyue (act. 1625–74) and Song Lao (1634–1713), the Qing emperors Qian-long (r. 1736–95) and Jiaqing (r. 1796–1820), Prince Gong (d. May 29, 1898), and Yamamoto Teijirō (1867–1937).

1. According to ornithologists, this species most likely came from the Sulawesi area of what is today's Indone-sia. See Lindholm, pp. 22–27.
2. See Deng Chun, *Huaji*, juan 1, p. 2, in Yu Anlan, *HC*, vol. 1.

14

Attributed to Emperor Huizong
(r. 1101–25, d. 1135)
Court Ladies Preparing Newly Woven Silk

Northern Song dynasty, early 12th century
Handscroll; ink, color, and gold on silk
37 × 145.3 cm
Chinese and Japanese Special Fund 12.886

Introduction

In 1126, the Jurchens defeated the North-ern Song and captured Emperor Huizong and his son Emperor Qinzong (1100–61; r. 1126–27), and also took other Song palace personnel and art collections back to Manchuria. This famous scroll was part of the war booty removed from the Song capital. Its original title slip, which reads "Tianshui mo Zhang Xuan daolian tu" (Copied by Tianshui [Emperor Huizong] after Zhang Xuan's painting, Silk Beat-ing), follows the traditional Chinese prac-tice of naming a handscroll after the first scene it depicts. The English title *Court Ladies Preparing Newly Woven Silk* is intended to describe all the activities involved, however.[1] Previously, except to classify it as a Northern Song genre paint-ing, scholars focused on artistic aspects of this well-known handscroll rather than on the subject matter. However, certain anomalies in its sequence of scenes call for a more in-depth study of its purpose and subject as well as the underlying literary and historical sources.

Description

The Boston scroll shows three groups of well-dressed court ladies engaged in beat-ing, sewing, and ironing new silk. Two young maids assist the ladies by keeping the charcoal hot and the silk stretched; a little girl amuses herself by horsing around. It seems that the artist rendered these different activities in one composi-tion more for purposes of aesthetic arrangement than for a logically presented narrative sequence designed to detail how new silk was prepared during the Tang dynasty.

The scroll's three groups move sequen-tially from a vertical to a curvilinear and, last, to a horizontal presentation. Concern for aesthetic design rather than story-telling determined their order.

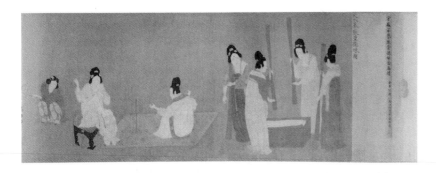

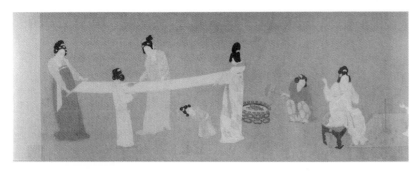

At the very beginning of the scroll, two ladies are seen, each of whom holds a heavy wooden pestle to pound the new silk on a stone block; another pair, holding the beams of their long pestles upright, are taking a break from the arduous task. Their idealized, handsome faces show no concern as to whether such work might ruin their make-up, hairdos, or luxurious apparel. The next scene shows a palace lady in profile, sitting on a mat in the traditional Chinese manner, trying to sort out a skein of silk thread. Her companion, concentrating on sewing, sits in the then newly fashionable Western style on a mother-of-pearl-inlaid lacquer stool. Unlike the previous group of ladies, both of these women appear to be at ease, unrushed by their duties. The last group is involved with the ironing of a long piece of white silk.

Even though all three groups portray aspects of the preparation of silk, the activities of beating, sewing, and ironing silk lack a sequential narrative relationship in the handscroll. The painting ends as abruptly as it begins. Apparently it was

not the painter's intention to inform viewers why such lavishly dressed palace ladies were beating the silk, or for what the newly ironed silk was intended.

Literary and Historical Sources

Some historical background may illuminate the painting's purpose. The first half of the eighth century, known as the High Tang period, was one of the most prosperous times in Chinese history. Women of high birth typically amused themselves by pursuing all sorts of pleasurable activities, from horseback riding to playing music or chess, as can be seen from the *Ladies Playing Double Sixes* (Freer Gallery, Washington, D.C.) and *Listening to the Music* (Nelson-Atkins Museum of Art, Kansas City), both attributed to Zhou Fang (ca. 740–800). To show off their wealth and beauty, the ladies also loved to parade on horseback through the capital city, Chang'an. Such scenes are depicted in *Lady Guoguo's Spring Outing* (Liaoning Provincial Museum, Shenyang), which was formerly attributed to Emperor

Huizong but, like the Boston scroll, is now considered to be a work by a copyist in the emperor's academy.[2] Given this cultural and social context, it seems puzzling that a Tang artist would portray a group of palace ladies engaged in work like beating silk, which was normally an occupation associated with the peasant class.

Why would such aristocratic women take upon themselves the hard labor of preparing silk? Two sources may shed some light on the question: One concerns the court tradition of *gongcan* (palace sericulture); the other derives from literary works on the subject of "beating silk" or "beating the clothes."

Gongcan was a symbolic imperial duty performed every spring by the empress. In this ritual, she would lead palace ladies in all stages of silk production, from raising the silkworms to making dresses from the newly woven material. This tradition may have had an ancient origin in China, although the earliest pictorial representation can be traced back only to the Southern Song court painter Liu Songnian (ca. 1150–after 1225)—about a century later than Boston's scroll. According to a literary reference, Liu Songnian's *Gongcan tu* was in collections throughout the Ming and Qing dynasties.[3] Unfortunately, that work only survives in a nineteenth-century Japanese copy. But the lost Liu Songnian work depicted, step-by-step, every aspect of palace sericulture. If *gongcan* were the subject matter of the Boston handscroll, then its three groups of women and their activities represent only a selection from a fully articulated sequence illustrating this imperial rite.

As for the literary theme of beating silk or beating the clothes, a text by the Jin-dynasty scholar Yuan Haowen (1150–1257) describes in great detail a painting by Zhang Xuan (act. 714–41), the leading eighth-century figure painter, that depicts activities of the palace ladies in each of the four seasons.[4] In the autumn section, Yuan Haowen describes the following scenes: palace ladies beating silk with pestles and measuring it; a young girl fanning the coals for ironing, a lady sewing, with one knee raised on a stool; another lady cutting and tailoring; two ladies stretching a length of white silk while another irons it; and a little girl playing beneath the extended fabric. This description is strikingly similar to scenes depicted in the Boston scroll.

The painting Yuan Haowen describes was most likely a pictorial rendering of the famous poem "Beating the Clothes," by Xie Huilian (397–433), which describes women preparing silk to make new clothes for their beloved ones fighting at the frontier. One extant work based on this poem is a handscroll by Mou Yi (act. third quarter of twelfth century) in the National Palace Museum, Taipei. Mou Yi's work is significant in two respects. First, from beginning to end, a logical narrative sequence underscores the central meaning of the poem and painting—the prepared silk would be made into clothes intended for soldiers at the front. Second, according to Mou Yi's own colophon on the scroll, his painting was based on a model by Zhou Fang, who had been a student of Zhang Xuan.[5] The sections of this painting that depict women beating new silk on a stone block and sewing a piece of cloth are directly related to two scenes in the Boston scroll. Although the Boston handscroll is less complete than Mou Yi's work, it follows the poetic intent of Xie Huilian's poem.

Interpretation

A Northern Song copyist may have imitated selectively a few sections from the more comprehensive original by Zhang Xuan, since it was a common practice in Huizong's imperial painting academy for painters to imitate old masters for the purpose of studying their composition and brushwork. Generally, a copyist would reproduce only a section of the original. An example of this practice is the painting Scholars of the Liuli Hall (Metropolitan Museum of Art, New York), a thirteenth-century copy after Zhou Wenju (act. ca. 900–75), and Literary Garden, an earlier, shorter copy in the Beijing Palace Museum of the same, now-lost prototype.[6] It is entirely possible that when Emperor Huizong ordered one of his academy students to copy Zhang Xuan's Beating Silk, the copyist, like many of his colleagues, copied only those sections that most interested him (or Huizong). The original Tang work could well have included other scenes showing the palace ladies engaged in measuring, cutting, sewing, and tailoring the newly prepared silk for shipment to the frontier as encouragement for patriotic soldiers, just as in the Mou Yi painting and its Zhou Fang prototype.

Furthermore, we know from literary evidence that Zhou Fang once created a composition illustrating the poem "Beating the Clothes."[7] Mou Yi's inscription on his version explains that he copied the Zhou Fang prototype for a second time in 1249 and added architectural background, trees, and ten more palace ladies to the original composition. A narrative scene without such elements certainly would be more consistent with an eighth-century presentation and would support the notion that Mou Yi was working from a Tang prototype.[8]

Even earlier than either Mou Yi or the copy of Zhou Wenju's Literary Garden, is another old copy after a Tang painting: Seven Sages of the Bamboo Grove by the eighth-century artist Sun Wei. The copy, now in the Beijing Palace Museum, is most likely a late-eleventh to early twelfth-century imitation. It bears Emperor Huizong's inscription and may actually have been carried out under his order. In this version, the artist copied only four of the seven sages. During Huizong's reign, such selective imitation was apparently a common practice in the imperial painting academy, which supports our contention that Boston's Court Ladies is yet another example of an "edited" imitation of a more elaborate original Tang work.

1. Ever since Okakura Kakuzo (Tenshin) (1862–1913) acquired this handscroll for the Boston Museum in 1912, it has been known in the West as Court Ladies Preparing Newly Woven Silk. That the Chinese title was written by the Jurchen Emperor Zhangzong (1168–1208) proves that it was part of the plundered imperial treasures. Silk Beating refers to a scroll by the Tang court painter Zhang Xuan that had once been in Emperor Huizong's collection. See Xuanhe Huapu, juan 5, p. 55, in Yu Anlan, HC, vol. 2.
2. See Wu Tung, "Zhangzong ti Tianshui mo Zhang Xuan Guoguo furen youchuntu xiaokao,"pp. 1–11.
3. See Midian zhulin shiqu baoji sanbian, vol. 3, p. 1495.
4. See Yuan Haowen, Yishan xiansheng ji, juan 34, pp. 7b–8a.
5. Emperor Huizong's catalogue records nine paintings by Zhou Fang with exactly the same titles as recorded works by his teacher Zhang Xuan.
6. It bears Huizong's attribution to the eighth-century artist Han Huang (723–787). However, the painting was apparently a study work produced by a member of Huizong's imperial painting academy.
7. The renowned collector and calligrapher Wang Shimao (zi: Jingmei; 1536–88) owned a Zhou Fang painting entitled Beating the Clothes, which the Ming connoisseur Wang Keyu (1587–ca. 1650) described as a work showing "four ladies beating or pounding clothes with one pestle." See Wang Keyu, Shanhuwang: hualu, juan 23, p. 46b.
8. See Richard Edwards, "Mou I's Colophon to His Pictorial Interpretation of 'Beating the Clothes,'" p. 7. A complete translation of Xie Huilian's poem appears in the article.

15

Anonymous (traditionally attributed to Hao Cheng, act. first half 10th century)
Horse and Groom

Northern Song dynasty, early 12th century
Square album leaf; ink and light color on silk
33.1 x 36 cm
Denman Waldo Ross Collection 17.741

Description

The artist of this large square album leaf departs from the convention of profile portraits of horses on a single plane and presents instead a relatively deep spatial composition. He uses a large, album-leaf format, markedly bigger than later albums of the Southern Song, to depict an imperial groom in uniform and official headgear, cautiously stepping forward as he extends his lure of fodder in an attempt to retrieve a wayward horse. The horse sees through the groom's intentions and draws back coyly, its head lowered, looking askance at the offering.

Style and Attribution

The work does not follow the monumental and stylized approach of the mainstream tradition for this subject matter, as represented by Night-Shining White, attributed to Han Gan (Metropolitan Museum of Art, New York),[1] and Li Gonglin's renowned handscroll Five Horses and Grooms (location unknown). The Boston album also lacks the idealized, exotic flavor of paintings depicting steppe ponies with their nomadic grooms, such as those often attributed to Hu Gui and Li Zanhua of the Five Dynasties period.

The seven-character inscription of Horse and Groom is written in Emperor Huizong's distinctive shoujin, or slender-gold, style of calligraphy, and reads: "The brush of Hao Cheng. Imperially recorded in the year dinghai [1107]." Immediately following is Huizong's Tianxia yiren (First Man under Heaven). An imperial square seal stamped over the inscription reads yushu (imperial writing). The style of calligraphy is similar to that on Literary Gathering, attributed to Han Huang (Beijing Palace Museum), and on Herding Horses, attributed to Han Gan (National Palace Museum, Taipei). Both of these paintings were inscribed in the year dinghai (1107),

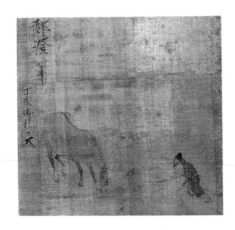

the first year of the Daguan era (1107–10). It also resembles the emperor's regular script in *Thousand Character Document* (Shanghai Museum), which was written in the *jiashen* year of the Chongning era (1104). Thus, the inscription of *Horse and Groom* can safely be attributed to the early years of Huizong's reign.[2]

In *Tuhua jianwenzhi* (Experiences in Painting), Guo Ruoxu, praised Hao Cheng as the leading figure painter of his time, an artist who excelled at making copies and specialized in Buddhist and Daoist works depicting ghost and spirit subject matter.[3] In *Shengchao minghua ping* (Commentary on Famous Paintings of the Northern Song Dynasty), Liu Daochun commented that, Hao Cheng was from a noble family and amused himself with painting. Liu placed the artist in the "capable" category.[4] The imperial catalog *Xuanhe huapu*, compiled ca. 1120, selected just thirty-three figure painters from the Three Kingdom period to the Northern Song dynasty—a period spanning some eight centuries. With high accolades, it ranks Hao Cheng between the Five Dynasties master Gu Hongzhong (tenth century) and the Northern Song's Li Gonglin. He is praised for being able to "capture the spirit and character beyond the form."[5]

But later Yuan literati, like the connoisseur and art critic Tang Hou (act. early fourteenth century) severely criticized Hao Cheng. In his *Gujin huajian* (Mirror of Painting), Tang Hou writes:

> Hao's paintings are very vulgar. I once saw a painting of a horse and groom [by him] that was no better than a craftsman's work. It was totally lacking in the spirit of antiquity [*guyi*]. The painting carries an inscription and seal of [Emperor] Xuanhe.[6]

Tang Hou's comment most likely refers to Boston's *Horse and Groom*. His disdain for works of this genre in an academic style is in keeping with the taste of Yuan literati, who preferred such paintings as *Sheep and Goat* by Zhao Mengfu (Freer Gallery, Washington, D.C.).[7]

Furthermore, Tang Hou may have been responding to inconsistencies in the quality of the brushwork. For instance, the line describing the horse's right hindquarters is less effective and the hoofs are flat and unconvincing. The artist's hand seems to have been unsure as he awkwardly painted the groom's right hand and unfinished foot. In contrast, the horse's spine and overall shape is powerful and solid, and the groom's facial features and garments are expressive and fluid. The artist succeeded in the difficult task of depicting a horse in three-quarter frontal view. The heightened tension between the horse's wary retreat and the groom's coaxing advance convincingly infers three-dimensional space.

In accordance with the emperor's directive to follow antiquity, paintings in the imperial collection were copied by academy students as a matter of regular practice and the quality of the copies was stringently judged by the emperor himself. According to the *Huaji,* completed in 1167, Emperor Huizong would

> ...have two boxes of painting scrolls brought out from the imperial collection, and would command his palace officials to deliver them personally to the academy to show students....The painters of the academy would strive to meet imperial standards....From time to time, the emperor would pay a personal visit. If he found even the slightest cause for dissatisfaction, he would have [the copies] destroyed.[8]

Clearly, *Horse and Groom* is a product of this environment, and Huizong's inscription serves as a record for inventory purposes as well as a mark of his approval of the copy.

It is possible to apply this argument to a corpus of works that carry convincing inscriptions by Huizong, the aforementioned *Literary Gathering* attributed to Han Huang and *Herding Horses* attributed to Han Gan possibly among them. In the latter, the forms and composition of the figures and horses possess a certain magnificence and elegance. However, the brushwork is thin and weak, and it succeeds only in conveying the outlines of the forms. Further, the folds of the drapery are overly elaborate and are articulated mainly through the "hook" brush-stroke. The horses' hooves are rigidly outlined, causing them to look scrawny and feeble, like the hooves in the Boston Museum's *Horse and Groom*. In fact, both paintings were done by academy painters in the early years of Huizong's reign and were later inscribed by Huizong in the year *dinghai*. Boston's *Horse and Groom* is the closest extant copy approximating Hao Cheng's painting style, and it may be the only such surviving example through which we can reliably assess Hao Cheng's work today.

1. Fong, *BR,* pp. 16–17, pl. 1.
2. The form and style of the so-called Huizong calligraphy on the painting *Peach and Turtledove* (Japanese private collection) is completely different from other works of the year *dinghai*; the inscription apparently was later appended to a Southern Song academy work.
3. See juan 3, p. 45, in Yu Anlan, *HC,* vol. 1.
4. See *WH,* juan 1, p. 18.
5. See juan 7, p. 73, in. Yu Anlan, *HC,* vol. 2.
6. We use Alexander C. Soper's discussion and translation of "*ku-i*" [*guyi*] as "spirit of antiquity." See his "The Relationship of Early Chinese Painting to Its Own Past," in Christian G. Murck, ed., *Artists and Traditions: Uses of the Past in Chinese Culture* (Princeton: Princeton University Press, 1976, p. 44). Soper uses a reprint of *Gujin huajian* published in *Meishu congkan.* See Ma Cai's annotated version in the *Xuehai leipian* ed. (Shanghai: Renmin meishu chubanshe, 1959, p. 31).
7. See Chu-tsing Li, "The Freer Sheep and Goat and Chao Meng-fu's Horse Painting," in *Artibus Asiae,* vol. 30, no. 4 (1968), pp. 279–326.
8. See juan 1, pp. 3–4, in Yu Anlan, *HC,* vol. 1.

16

Anonymous (traditionally attributed to Hu Gui, act. first half 10th century)

Khitan Falconer with Horse

Southern Song dynasty, 12th century
Round fan mounted as album leaf;
ink, color, and gold on silk
23.4 x 24.1 cm
Chinese and Japanese Special Fund 12.895

After years of war with the powerful nomads from the north, the Chinese were forced to try to understand the tribe known as the Khitan, who established the Liao dynasty. Beyond their mutual distrust and dislike, the Chinese and the Khitanese shared a certain curiosity about one another. From very early on, paintings by Khitan artists like Li Zanhua and Hu Gui were admired and acquired by the Song Chinese, including Emperor Huizong. These historical and cultural circumstances explain the body of Liao paintings, or Chinese imitations—for example, those by Chen Juzhong (early thirteenth century)—that accumulated in Song China. Some of these works have survived, including two rare hanging scrolls depicting deer in the autumn woods (National Palace Museum, Taipei).[1]

This fan painting in the Museum's collection is traditionally attributed to Hu Gui, a Khitan artist who lived in what today is known as Hebei province. Hu Gui specialized in depicting northern nomads. Although numerous paintings are attributed to him, Hu Gui used no seals, nor did he sign his work; hence, it is difficult to establish with certainty which paintings were really executed by him. For instance, the Boston fan differs in style and brushwork from two album leaves depicting Khitan hunting scenes (National Palace Museum, Taipei). A general idea of his style perhaps can be deduced from the available attributed pieces, which demonstrate an attention to minute detail in precise, linear depictions. They reflect Khitan characteristics, customs, and apparel in a nomadic environment. Such attributed works vary in artistic quality and originality, however. This Boston fan, with its exquisite brushwork and accurate characterization, is superior to the others.

1. *Gugong shuhua tulu,* vol 1, pp. 137–40.

17–20

Anonymous

Lady Wenji's Return to China

Introduction

The frontier story of the captivity by northern nomads, in A.D. 195, of Chinese scholar–poet Lady Wenji and of her eventual return to China twelve years later has been a favorite subject in Chinese genre and narrative paintings. Among them, the four album leaves in the Boston Museum depicting scenes from this historical and literary romance are unquestionably the earliest and the highest in artistic quality, but they represent less than one-fourth of the original handscroll from which they were cut, and all four leaves have lost the original texts that accompanied them. Fortunately, a copy with all eighteen texts and illustrations has been preserved (Metropolitan Museum of Art, New York) and another copy with the same eighteen scenes is in the collection of the Yamato Bunkakan Museum in Nara, Japan. These works offer useful points of comparison for considering their Boston prototype.

Judging from its style and brushwork, the New York scroll, *Eighteen Songs of a Nomad Flute,* may be dated to the late–Southern Song period. Because it retains the original borders now lost from the Boston leaves, the New York copy gives a better understanding of the overall compositional arrangement. Each of the four sections in Boston illustrates one of the eighteen texts that accompanied the original handscroll. *Encampment in the Desert* (cat. 17) represents a scene described in the third poem of the cycle; *Encampment by a Stream* (cat. 18) illustrates the fifth poem; *Parting from Nomad Husband and Children* (cat. 19), the thirteenth poem; and *Wenji Arriving Home* (cat. 20), the cycle's eighteenth and final text.

The Boston album leaves of *Lady Wenji's Return to China* are more than merely a set of illustrations to well-known poems by the Tang writer Liu Shang (act. ca. 773), however. They embody important characteristics of twelfth-century genre and history painting and also display exceptional brushwork, particularly in their depiction of different human and animal figures and the articulation of architectural structures. The figures in the last album leaf of the four are especially remarkable for their realistic display of urban life as represented in a panoply of professions and activities. Their sophistication and animation compare well with two Northern Song figure paintings in the Metropolitan Museum of Art, New York: *The Classic of Filial Piety* and *Duke Wen of Jin Recovering His State.* The quality of drawing in this last Boston leaf is on a par with the depiction of figures in *Qingming shanghe tu* (Qingming Festival along the River) by Zhang Zeduan (act. early twelfth century) and Li Tang's *Boyi and Shuqi Picking Herbs,* both in the Beijing Palace Museum.

Official histories of the Eastern Han dynasty identify the Huns (Xiongnu) as the nomads who captured Lady Wenji.[1] In this work, however, Khitan Tartars, who conquered parts of northern China and established the Liao dynasty more than nine hundred years later are depicted as her captors.[2] The types of human figures, costumes, ponies, and camel-drawn carts as well as the everyday accessories depicted in the four album leaves correspond to what is seen in archaeological evidence from Liao tombs and wall paintings. Depicting Khitan nomads as the historical Huns who had kidnapped a Chinese woman poet in ancient times may have had a hidden political purpose for whomever painted or commissioned the work. The painting could link the historical captivity of Lady Wenji with the contemporary capture of the mother of Emperor Gaozong by the Jurchens during the 1126 sack of the Northern Song capital, Kaifeng. After lengthy negotiations, Gaozong's mother, like Lady Wenji, was finally returned to China.

It is not immediately apparent whether the four leaves are the work of a late–Northern Song or early Southern Song painter, but their style strongly suggests a date from the second quarter of the twelfth century. An early Southern Song artist would have hesitated to depict openly the much-hated Jurchen Tartars as substitutes for the historical Huns since, at that time, the Jurchens presented the most immediate threat to the existence of Southern Song rulers. No one from the Southern Song painting academy would have taken such a political risk, especially since Emperor Gaozong supported the peace treaty with the Jurchens. By portraying Khitans as Lady Wenji's captors, the artist would avoid a direct reference to the Jurchens yet still suggest an indirect link between these two nomadic tribes from Manchuria. In fact, throughout the Southern Song period, painters like Chen Juzhong were always more fond of drawing Khitan Tartars than Jurchens. Since the Khitans were not defeated until 1125, the same reasoning could not apply to a late–Northern Song painter because artists of that time would have been equally concerned about both of these powerful nomadic tribes. For political reasons, therefore, it is unlikely that a Northern Song painter painted the Boston leaves.

1. See Fan Ye, *Hou Hanshu* (1739 edition), juan 114, pp. 16a–19a.
2. See Fontein and Wu Tung, *Unearthing China's Past.* Entry 118 discusses both the archaeological evidence as well as the significance of substituting Khitan for Xiongnu nomads.

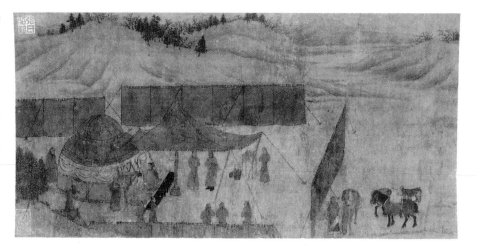

17

Anonymous
Encampment in the Desert

Southern Song dynasty, second quarter 12th century
Section of a handscroll mounted as album leaf; ink, color, and gold on silk
24.7 x 49.8 cm
Denman Waldo Ross Collection 28.62

Because of the extensive loss to the four edges of the original work, this painting appears more cramped than the Metropolitan Museum's late thirteenth-century copy. The latter has reserved generous space on the upper edge to show a sky above the hills. The trimmed Boston version centers attention around Lady Wenji and her nomad husband, both of whom are seated in front of a yurt under an erected tent, attended by Khitan servants. Four leather curtains surround this group on three sides. The trees at the lower-left corner have lost half of the original size. In the New York version, the copyist omitted all of the line drawings that, in the original work, represented the ropes with wooden pegs used to tie the curtains and the tent to the ground. On the right side of the New York painting, a groom attends three horses standing outside a curtain stretching diagonally from the bottom edge into the middle section. In the Boston original, serious damage and poor repainting have shortened this curtain. Although the New York painting is helpful for a better understanding of the original layout, its brushwork falls far short of that of the Boston original. For example, the trees on a distant hilltop in the Boston painting are strong and vibrant, while those in the New York ver-

sion appear mechanical and unrelated to the landscape.

This leaf illustrates the third poem and shows the early stage of Wenji's captivity. Her two children do not appear yet. It is significant that her nomad husband sits to her left in accordance with Chinese tradition. As can be seen in *Banquet Scene in a Khitan Camp* (Beijing Palace Museum), a handscroll attributed to Hu Gui, the nomadic tradition would have reserved the right-side seat for the husband. The Beijing handscroll also depicts Lady Wenji and her husband in a slightly earlier style than the Boston work, one that more accurately portrays a non-Chinese lifestyle. The Boston version is more likely by a Chinese artist who was knowledgeable about the Khitans in the north, but who could not help injecting some typically Chinese ideas into the painting.

18

Anonymous
Encampment by a Stream

Southern Song dynasty, second quarter 12th century
Section of a handscroll mounted as album leaf; ink, color, and gold on silk
25 x 46.6 cm
Denman Waldo Ross Collection 28.63

This leaf presents an unusual depiction of a stream, which winds straight down from the upper right edge of the composition then turns toward the center foreground through a lush, oasislike grassland. Such a presentation adds an exotic, non-Chinese flavor to the painting. The bushes here closely resemble those in the two Liao deer scrolls in the National Palace Muse-

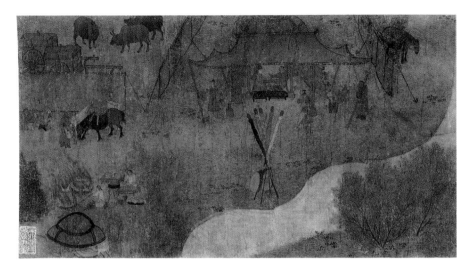

um, Taipei.[1] The stream and unconventionally rendered tall bushes in the foreground enhance the scene's nomadic setting. Unfortunately, the distinctly shaped river has been badly cut during remountings. Comparison with the New York copy reveals that the Boston illustration for the fifth poem has suffered extensive losses on all four sides.

As in the previous leaf, all the ropes fastening curtains and tents have been omitted in the New York copy. Such simplification occurs elsewhere as well. For example, the man kneeling in front of the cooking pots in the Boston scroll uses a stick to poke the firewood, but in the New York version he is empty-handed, making his function unclear. Despite the trimming, an unfailing display of artistic technique is in evidence in the Boston painting. For example, the burning flame amid smoke rising from underneath the two cooking pots, and the two cooks busily preparing a meal for the new couple are exceptionally well rendered. The unusual binding together of flags and drums displayed in front of the main tent is also shown in mural depictions from the recently discovered Liao tombs as well as in the handscroll *Emperor Gaozong's Auspicious Omens* (Municipal Museum of Art, Tianjin), attributed to the early Southern Song painter Xiao Zhao (act. ca. 1130–60).

1. See *Gugong shuhua hulu*, vol. 1, pp. 137–40.

19

Anonymous

Parting from Nomad Husband and Children

Southern Song dynasty, second quarter 12th century
Section of a handscroll mounted as album leaf; ink, color, and gold on silk
24.8 x 67.2 cm
Denman Waldo Ross Collection 28.64

This segment illustrates the moment of parting after Lady Wenji's nomad husband has received the ransom and agrees to return Lady Wenji to China after twelve years of captivity in the northern steppes. For a gifted scholar like Wenji, who was accomplished both in literature and music, to have been separated from her own culture for so many years was perhaps just as tragic as her leaving her two children and nomad husband. Lady Wenji seems torn between love for her newer nomadic family and for her old family in China.

In a panoramic view from right to left, we see first the empty tent, with all the unused eating utensils left on the low tables, while the approaching final moment of Wenji's departure saddens everybody. The parting must have taken quite a while as the escort of the chariot cannot help stretching his arms wide in a big yawn. The chieftain's horse with a fancy saddle stands quietly in the foreground. At the extreme left of the composition, just behind a low hill, a Chinese banner and an imperial tasseled staff are glimpsed; three soldiers dressed in Song-dynasty uniform stand ready to accompany this woman scholar on her homeward journey.

The Boston illustration to this thirteenth poem has lost a large section of its left edge, which, fortunately, consisted mainly of open landscape. The right side has been only slightly cut, but the loss of trees at the upper center of the leaf does significantly alter the picture's appearance.

In this scene, too, the New York version exhibits the characteristic simplifications of a copyist. Two, rather than the original three, horses with a groom are represented; the copyist has also changed the position of the grooms and horses at the lower center left, thereby making the foreground a more condensed area than that in the Boston version. Another omission occurs close to the center of the composition. To the right of two cooking pots and in front of a yurt, the Boston version depicts a Khitan servant bending forward to put utensils on a table in front of him. In the New York painting, this table is conspicuously absent, so the purpose of the servant's diligence is lost.

20

Anonymous

Wenji Arriving Home

Southern Song dynasty, second quarter 12th century
Section of a handscroll mounted as album leaf; ink, color, and gold on silk
25 x 55.8 cm
Denman Waldo Ross Collection 28.65

This illustration shows a bird's-eye view of a walled mansion adjacent to a busy street, which is a rare depiction in Song paintings. A running-roofed wall divides the composition in two diagonally. Inside the wall, Lady Wenji is tearfully welcomed to the main hall by her relatives, men and women, old and young, many covering their faces with their sleeves—
a traditional gesture when crying. More friends arrive through the corridor and courtyard. Others peek from behind a screen next to the main gate of the family mansion.

Servants carry her belongings to the quarters at the left of the mansion, and that this is her homecoming is apparent from the oxen-drawn chariot and escort outside of the wall. The artist must have observed street scenes with great attention in order to present so realistic an image of

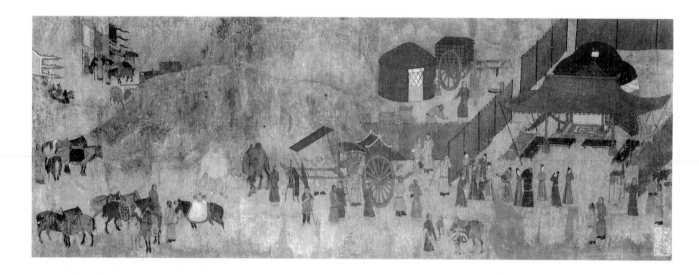

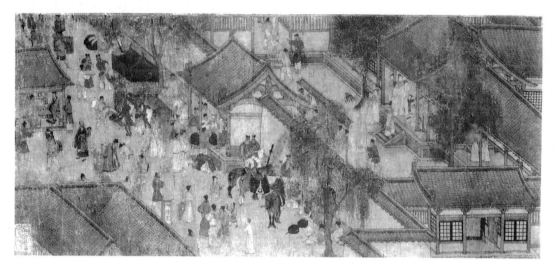

bustling city life. People from all walks of life are depicted in this small painting: monks, woodcutters, musicians, barbers, vendors, women, and children. Some are drinking tea in a shop; others are buying and selling buns on the street. Their noisy, animated activities sharply contrast with the sober, silent mood inside the wall of Lady Wenji's house.

This location was once incorrectly identified as the city of Chang'an. More likely, it is the southeastern suburb of the Northern Song capital, Kaifeng, called Chenliu, which was Lady Wenji's home-town. The bird's-eye view of houses at the busy T-shaped streets resembles buildings in the handscroll *Duke Wen of Jin Recovering His State* (Metropolitan Museum of Art, New York), attributed to Li Tang. The brushwork and execution of the figures is close in style to Li Tang's masterpiece *Boyi and Shuqi Picking Herbs* (Beijing Palace Museum). The line drawing of the drapery folds, characterized by heavy beginnings and sharp endings, resembles that work as well.

Compared with the New York copy, the Boston leaf has been trimmed on all sides at the cost of some important details. For instance, two figures and a courtyard at the lower-left corner have vanished; the wine shop at the upper-left edge has lost some furniture and its roof; the extensive depiction of the roofs, the wall, and willow trees have mostly disappeared along the top edge of the Boston album leaf. However, the copyist of the Metropolitan scroll not only omitted an entire vertical section along the right edge, which can still be seen in the original Boston composition, but he has also created a new courtyard that does not appear in the prototype. Apart from these obvious omissions and changes, this copy is helpful in reconstructing its much damaged counterpart in Boston.

In comparison with the other three illustrations in Boston, this leaf shows a dramatic change in presentation, especially in its rendering of the figures. Perhaps this is because the figures in the previous three leaves are dressed in nomadic cos-

tumes that would have been made of heavier materials. The figures seen in this illustration are wearing either silk or cotton garments, which would require more sensitive brush techniques for appropriate depiction. Aside from the different figure styles and brush techniques, the depiction of the horses, oxen, and chariots is exactly the same in all four leaves. It is safe to assume that they were all painted by the same hand, though the authorship has not yet been determined.

21–23

Anonymous (formerly attributed to Wu Daozi, act. 710–60)
Daoist Deity of Earth

Southern Song dynasty, first half 12th century
Hanging scroll mounted as panel; ink, color, and gold on silk
125.5 x 55.9 cm
Chinese and Japanese Special Fund 12.880

Daoist Deity of Heaven

Southern Song dynasty, first half 12th century
Hanging scroll mounted as panel; ink, color, and gold on silk
125.5 x 55.9 cm
Chinese and Japanese Special Fund 12.881

Daoist Deity of Water

Southern Song dynasty, first half 12th century
Hanging scroll mounted as panel; ink, color, and gold on silk
125.5 x 55.9 cm
Chinese and Japanese Special Fund 12.882

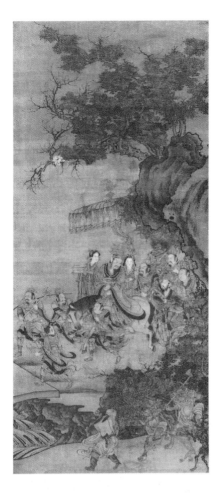

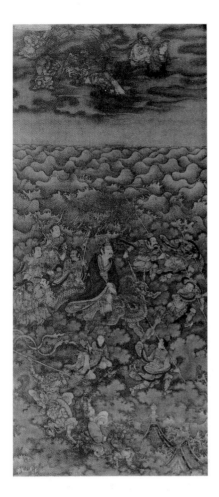

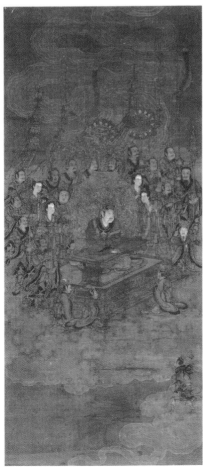

Daoist art has received less scholarly attention than has the philosophy and religion from which it stems. Nor has this art reached the same level of understanding and appreciation as Chinese Buddhist art. Daoism's emphasis on the joy of life, the dualities of mortality and immortality, of natural and supernatural phenomenon, are reflected in pictorial representations inspired by its thoughts and rituals. While Boston's *Daoist Deities* are emblematic examples of such expression, it is important to bear in mind that, by the twelfth century, all three of China's major religions and philosophies—Daoism, Buddhism, and Confucianism—had, in varying degrees, become less "pure" and distinct than they were in earlier periods. These three Boston panels display borrowings from elements, compositional style, and techniques of Buddhist art. Nonetheless, their overall purpose and message remain Daoist—in their conception of essential "elements" of nature, of the interaction between humans and immortals, and in their celebration of existence.

These three paintings are among the most outstanding examples of Daoist art from this period. They rival in importance and artistic quality the early eleventh-century *Daoist Pantheon in Procession* (C. C. Wang family collection, New York), attributed to Wu Zongyuan (d. 1050), and a short handscroll, *Daojun xiang* (The Supreme Daoist Master and Attendants; Wango H. C. Weng collection), by Liang Kai (act. early thirteenth century). The Boston set depicts the deities of heaven, earth, and water with their retinues. The Deity of Earth occupies the center and is flanked by the other two deities. The numerous Daoist figures depicted in the painting are portrayed with a sense of great movement and expression. Specific elements emphasize the nature of the particular deity represented in each panel. For instance, the Deity of Heaven is shown suspended in the air on a five-colored body of "auspicious clouds." The Deity of Water rides comfortably through waves on the back of a dragon. While the faces of the deities of heaven and water are depicted in an idealized manner, the Deity of Earth projects a portraitlike appearance rendered in a more realistic style. He is shown mounted on a white horse, inspecting his terrestrial realm and patrolling through a landscape painted in the style of Li-Guo. In addition to the entourage, a group of monsters are led by

the legendary demon-queller Zhong Kui, who impatiently awaits the deity's arrival on the other side of the mountain stream where he will submit a report of his charges' activities. A realistically drawn monkey and an imaginatively rendered tree monster apparently represent the evil spirits on earth. Ironically, the Daoist god seems to pay more attention to a nearby falcon than to Zhong Kui's urgent business.

The Deity of Heaven and the celestial beings surrounding him are the most tranquil of the three; except for their wind-blown sleeves and scarves, these figures appear motionless. The holy throne the deity occupies is elaborately represented. Its elevated platform is decorated with scroll designs in gold. Behind him is a delicate, engraved, gilded, dodecahedral dragon panel. The canopy above is lavishly decorated with jewels. In contrast to the stillness of the figures, the auspicious clouds are depicted in a circular manner, providing the only suggestion of movement in this painting.

Just opposite the heavenly group is the clamorous retinue of the Deity of Water, who rides on a four-clawed dragon. The restless waves parallel the equally animated figures. Flanking the Deity of Water, the gods of thunder and rain emerge from the mist above the water, while the monsters in the foreground, with mirrorlike devices on their backs, are in charge of the lightning. In this panel, the wave pattern is naturally rendered, without the stylization seen in most post-Song paintings. For example, the foam of breaking waves in the front and the middle ground reflects a twelfth-century interest in realism. Another early Southern Song characteristic apparent in this painting is the artist's attention to the high horizon line, in accord with the so-called *ping yuan* (level distance) concept for depicting figures in a natural setting.

The movement and animation of the water group perhaps explains the old attribution of the work to the great Tang painter Wu Daozi, who was known for his expressive figure-painting style. It is precisely for this reason that the *Daoist Pantheon in Procession* by Wu Zongyuan has traditionally also been considered as following Wu Daozi's style. But this stylistic connection aside, the three Boston paintings postdate Wu Zongyuan. The rendering of trees and rocks in this painting is imitative of the work of the eleventh-cen-

tury master Guo Xi, which makes it possible to date these rare Daoist paintings to the first half of the twelfth century.

In later Chinese paintings, the three Daoist deities are usually depicted together, but in works painted during the Tang and Song dynasties, they appear separately. For example, the Northern Song Emperor Huizong's painting catalogue records three scrolls representing the Daoist deities of heaven, earth and water by the ninth-century painter Fan Qiong.[1] Moreover, the Northern Song poet Su Shi and his father once saw a scroll of the Deity of Water said to be by the Tang court painter Yan Liben (see cat. 3). A poem by Su Shi's father details this composition, which includes the Deity of Water riding a dragon, followed by attendants as well as sea creatures. Above them are the gods of wind and thunder just as in the Boston composition. The Boston set of three Daoist deities clearly comes out of the same early pictorial tradition.[2]

1. *Xuanhe Huapu*, juan 2, p. 19, in Yu Anlan, *HC,* vol. 2.
2. See Chen Gaohua, *Sui Tang huajia shiliao* (Beijing: Wenwu chubanshe, 1987), pp. 49–50.

24

Attributed to Ma Hezhi (act. second half 12th century) and Emperor Gaozong (r. 1127–62, d. 1187)

Illustrations to Six Texts from the Xiaoya Section of the Book of Songs

Southern Song dynasty, datable to 1160s
Handscroll; ink and color on silk
27 x 383.8 cm
Marshall H. Gould Fund 51.698

Literary and Historical Sources

The *Shijing,* or *Book of Songs,* is an anthology of 305 songs said to have been compiled and edited by Confucius from more than 3,000 lyrics originating in various kingdoms.[1] As China's earliest literary work, this collection became part of the classical Confucian canon. Confucius told his disciples that the songs could be used "to enforce a point, to judge a man's character, to ease social intercourse, or to express a grievance."[2] The anthology was burned by the anti-Confucian tyrant Qin Shihuangdi in the third century B.C., but later Confucian scholars reconstructed it from memory, thus resulting in many versions. The orthodox edition known as *Mao Shih* was the work of scholar Mao Heng (second century B.C.) in the Western Han period. His version of the *Book of Songs* has been one of the most studied classical texts in China, whose rulers frequently cited and used it to advance and justify their political aims. One such ruler was the first Southern Song Emperor Gaozong. As the ninth son of the Emperor Huizong, Gaozong ascended the throne by chance rather than through legitimate succession. When the Jurchen army attacked Yangzhou in 1129, Gaozong fled to Hangzhou. Because of his cowardliness, tens of thousands of Yangzhou citizens were massacred by the Jurchens, and Gaozong was then dethroned by a rebellious army. Although he soon regained power, Gaozong was always at pains to legitimize his mandate. During his reign, he published many classic Confucian texts, and the *Mao Shih* was among his favorites. With the help of court calligraphers, Gaozong created a large number of calligraphic works based on *Shijing* texts. In so doing, he hoped to

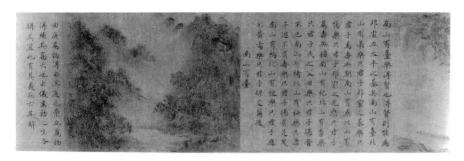

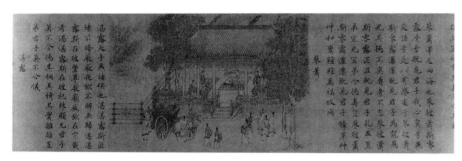

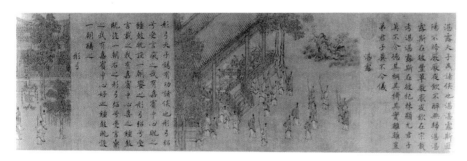

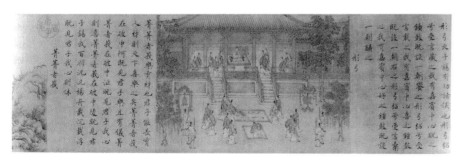

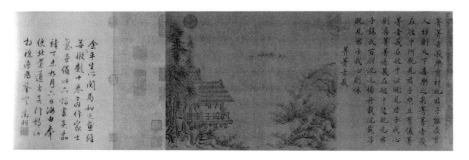

demonstrate his pro-Confucian stand to the people as a way to strengthen his rule.

Attribution

Although unsigned, based on their painting style and exceptional quality, the illustrations that accompany the texts of the Boston scroll can confidently be attributed to the court artist Ma Hezhi.[3] They combine the inventiveness and archaism associated with his paintings. The exact dates and details of the life of this court artist remain uncertain, and he is rarely cited in Southern Song literature. Two so-called Southern Song references state that he not only received the prestigious *Jinshi* degree during the Shaoxing era (1131–62), but later also served as a deputy in the Ministry of Works. However, these accounts come from much later reprinted publications whose credibility is open to question. No surviving documents verify his literary training or association with other literati. None of his paintings are mentioned in the 1199 publication *Nan Song zhongxing guange lu* or among the list of works recorded by the Yuan scholar Wang Yun in his *Yutang jiahua,* which documents the looting of the Southern Song imperial collection in 1276, after the Mongols sacked Hangzhou. Zhuang Su (act. late-thirteenth to early fourteenth century), in his 1298 work *Huaji buyi,* provides the first reference to Ma Hezhi's illustrations for the *Book of Songs* together with texts written by "Emperor Xiaozong." Ma Hezhi's figure-painting style is described as following the Tang-dynasty master Wu Daozi, with its "fluttering and spontaneous brushstrokes."[4] Zhuang's contemporary Zhou Mi (1232–1308) ranks Ma Hezhi among the ten greatest court artists, showing the high respect he was given during Emperor Gaozong's time.[5]

Ma Hezhi's involvement in the project of writing and illustrating the *Book of Songs* suggests that he must have been close to Emperor Gaozong. Based on reliable paintings, we know that he was still working with Gaozong after the emperor retired from the throne in 1162. For example, the Beijing Palace Museum has a handscroll by Ma Hezhi, *The Second Prose Poem of the Red Cliff,* the text for which was written in cursive style by Emperor Gaozong during his retirement.[6] (This would explain why literary references say that Ma Hezhi served both Emperor Gaozong and his son Emperor

Xiaozong (r. 1163–89, d. 1194), for Xiao-zong was already in power by the time of the creation of this handscroll.)

The Boston handscroll shows the inventiveness of Ma Hezhi in his painterly brushwork, which was applied in different layers with varying ink tonalities to define and model the motifs. Ma created an expressive rather than descriptive pictorial style that is unique among Southern Song painters. In landscape and riverscape compositions, he is more associated with the southern painting tradition. The two riverscapes in the Boston *Book of Songs* compare well with the above-mentioned *Red Cliff* in Beijing. The treatment of trees and grass and the relationship among boat, water, and human figures are similarly organized in the two scrolls. In its depiction of architecture and ceremonial scenes, the Boston painting is very close to the handscroll *Deer Call* (Beijing Palace Museum). The calligraphy on the Boston scroll, however, lacks the depth and strength of works reliably by Emperor Gaozong. None of his characteristic round and tight articulation is in evidence. Thus the calligraphy's traditional attribution to Emperor Gaozong is doubtful. More likely, it is by an academic calligrapher writing in Gaozong's style.

Description

The six illustrations follow the sequence of the second group of poems in the "Xiaoya" section of the *Book of Songs*. (This group originally contained thirteen poems. Three were lost before the Western Han period; the other four by 1547 when the Ming painter Wen Zhengming (1470–1559) wrote his colophon for this painting.) Ma Hezhi's illustrations rely heavily on the inherent symbolism of the texts. The first poem, "Nan you jiayu" (In the South There Are Fine Fish), suggests how good rulers seek able men to lead the country while talented people look for worthy rulers to serve.[7] The painting shows two fishermen catching fish with a net and a trap, illustrating the poem's metaphor for rulers recruiting good men. At the upper edge, five wood pigeons circle near a tree, while two others have already settled on a branch as if calling those still seeking a perch, thus symbolizing people with talents looking for the right position to occupy. Vines climb along the tree trunks and sweet gourds hang prominently from branches—sym-

bols of the good ruler who nurtures growth. The painting is executed in typical Ma Hezhi style, with curvy and varied brushstrokes executed in different ink tones. This impressionistic technique serves to build up the volume of a motif, especially the rocks and land slopes.

The second poem, "Nanshan you tai" (On the Southern Mountains Are the *Tai* Plants), likens the relationship between a ruler and able officers to that of a mountain and the trees and *tai* plants (sedges) that grow upon it.[8] In the painting, the lush, dense growth of the plants enriches the mountains. So, too, in the well-ordered state, trusted scholar–officials ensure the nation's prosperity. The illustration shows two mountain ranges, which represent the southern and northern mountains described in the poem. The mountains on the right are covered with layers of thick furry grasses, while those on the left are defined with masses of dots. The landscape style recalls the tradition developed in the lower Yangzi River area exemplified by paintings by Dong Yuan (act. tenth century). In style and technique, this illustration relates to a handscroll, *Golden Palace among Ten Thousand Pines,* attributed to Zhao Bosu (1124–82), in the Beijing Palace Museum.[9] The mountains in both works are decorated with delicate dots and washes that are further accentuated by mineral colors, while traditional usage of *cun* texturing for rocks and mountains is kept to a minimum. Neither work derives from the Li Tang style of structuring and execution.

The third poem is entitled "Lu xiao" (Tall *Xiao* Plants). The poem notes that heads of small states were supported like brothers by the king of the Zhou dynasty, just as *xiao* plants (smartweeds) are fed by drops of dew.[10] The painting shows a large guest hall in which the king and his guests are feasting. Separated from this scene by curtains and clouds is an area of profusely growing grass in the upper-left corner of the composition. There, what the poem calls "smartweed" symbolizes the minor states patronized and protected by the Zhou ruler.

"Zhan lu" (Heavy Dew), the fourth poem, describes how the king of the Zhou dynasty feasted with princes until late at night, just as the dew replenished grasses and buckthorns in the morning and evening. At the upper-right corner, are painted abundant grass and buck-

thorns. In response to the king's generosity, the princes formed a brotherhood represented by the *tong* and *yi* trees, which both yield plentiful fruit.[11] The scene depicts a banquet hall at night, illuminated by six large candles inside, while outside sixteen attendants hold burning torches in front of the court. Unlit torches indicate that the feast will continue well into the night. The text's message of brotherhood is emphasized by the intimacy of the king's animated gesture to the three princes at his right. Echoing the verse "unless intoxicated, do not depart," the three princes are in various stages of inebriation.

The fifth poem, "Tong gong" (Red-lacquered Bow), emphasizes how the king of the Zhou dynasty rewarded feudal princes who contributed to the kingdom. The ceremony of presenting red-lacquered bows was carried out with feasting and drinking accompanied by music from bells and drums.[12] In the illustration, the bow is centrally placed in the courtyard facing the king's palace. A prince who is about to be rewarded stands on a carpet and bows to the king seated in a palace erected on a platform. Symmetry and a certain rigidity in the depiction underscore the atmosphere of the formal court ceremony described in the poem. The architecture is rendered frontally and is the most elaborate structure among the three illustrations with palace scenes (the third, fourth, and fifth). The building's high foundation requires seven steps to reach the palace floor. The interior furnishings are also more lavish than those in the previous illustrations. For example, here the large, ornately framed screen behind the king is decorated with the *fu* axe, one of the twelve imperial symbols.

The sixth poem is entitled "Jing jing zhe e" (Luxuriant Are the *e* Plants). Metaphorically, the poem describes how these plants (aster-southernwood) can grow everywhere, just like talented people. But a good ruler has to cultivate and inspire them for a greater cause.[13] The illustration shows a riverscape, with scholars seated in a thatch-roofed water pavilion from which they enjoy the scenery. The three men in the pavilion, in fact, represent the rulers, while the aster-southernwood plants growing near the trees, by the waterfront, and in the hills, are the able subjects awaiting the ruler's cultivation and employment. The little boat on the far side of the water illustrates the

third stanza's last lines: When recognized and appreciated by rulers with material rewards ("I have seen my Lord, he has presented me with a hundred strings of cowries"), the talented person endures any difficulties to perform his duty, just as a boat laden with goods will overcome troubled waters. This illustration is unusually short and its left edge most likely has been trimmed.

Provenance

Following the texts and illustrations are two colophons, one written in 1547 by the Ming-dynasty literati artist Wen Zhengming and the other by Emperor Qianlong (r. 1736–95), dated in 1770. Wen Zhengming states that he had seen "several tens" of paintings for the *Book of Songs* by Ma Hezhi and "if one looks for the combined qualities of artistic skill and scholarly elegance, then these six illustrations have them all." This handscroll was later acquired by Liang Qingbiao (1620–91), then by Emperor Qianlong, who not only added a colophon but also named one of his palace buildings Xue Shi Tang (Hall of Learning the Book of Songs) to commemorate its acquisition.

1. Prior to the Han dynasty, the *Book of Songs* was referred to simply as *Songs* (Shi) or *Three Hundred Songs* (Shisanbai).
2. See Hawkes, p. 26.
3. Very few paintings attributed to Ma Hezhi are signed except for the two album leaves in the National Palace Museum, Taipei. See *Masterpieces of Chinese Painting in the National Palace Museum*, pl. 25. For discussion, see Julia Murray, *Ma Hezhi and the Illustration of the Book of Odes* (Cambridge: Cambridge University Press, 1993).
4. Ma Hezhi's close ties with Emperors Gaozong and Xiaozong must have provided more opportunities than extended to others to study works of earlier masters, such as Wu Daozi and Li Gonglin, in the imperial collection. See Zhuang Su, juan 1, p. 4.
5. See *Wulin jiushi*, juan 6, in *Yingyin Wenyuange sikuquanshu*, vol. 590 (Taipei: Shangwu yinshuguan, 1983), p. 253.
6. See *ZMQ, huihuabian,* vol. 4, pp. 38–39.
7. "Nan you jia yu," based largely on Tomita and Chiu's translation (as are the remaining five poems), is rendered as follows:
a. In the South there are fine fish,
 In great numbers caught in basket trap;
 The Lord has wine,
 Noble guests feast and rejoice.
b. In the South there are fine fish,
 In great numbers caught in wicker nets;
 The Lord has wine,
 Noble guests feast and are delighted.
c. In the South there are trees with drooping branches,
 The sweet gourds cling to them;
 The Lord has wine,
 Noble guests feast and comfort him.
d. Fluttering, fluttering, the wood-pigeons

In great numbers come;
 The Lord has wine,
 Noble guests feast and second him.
8. "Nanshan you tai" is translated as follows:
a. On the southern mountains are the *tai* plants,
 On the northern mountains the *lai* plants. Happy be the Lord!
 He is the foundation of the state; Happy be the Lord!
 May his years be without limit!
b. On the southern mountains are mulberry trees,
 On the northern mountains willow trees. Happy be the Lord!
 He is the light of the state; Happy be the Lord!
 May his years be without end!
c. On the southern mountains are medlar trees,
 On the northern mountains plum trees. Happy be the Lord!
 He is the father and mother of the people; Happy be the Lord!
 May his fair fame be everlasting!
d. On the southern mountains are the *kao* trees,
 On the northern mountains the *niu* trees. Happy be the Lord!
 May he have a vigorous old age! Happy be the Lord!
 May his fair fame ever flourish!
e. On the southern mountains are the *ju* trees,
 On the northern mountains the *yu* trees. Happy be the Lord!
 May he attain venerable age! Happy be the Lord!
 May his descendants be safe and contented!
9. See *ZMQ, huihuabian,* vol. 4, pl. 20, pp. 26–27.
10. "Lu xiao" is translated as follows:
a. Tall are the *xiao* plants,
 The fallen dew drenches them.
 I have seen my Lord,
 My heart is eased.
 Feasting, we laugh and converse.
 And we are joyous and tranquil.
b. Tall are the *xiao* plants,
 The fallen dew abundant.
 I have seen my Lord,
 He is full of grace and brightness.
 His virtue is faultless;
 May he live long and not be forgotten!
c. Tall are the *xiao* plants,
 The fallen dew soaks them.
 I have seen my Lord,
 Grandly we feast and are joyous and pleased;
 He sets an example to his brothers;
 May he always be virtuous and enjoy old age!
d. Tall are the *xiao* plants,
 The fallen dew is heavy.
 I have seen my Lord,
 His rein-ends jingling,
 His chariot-bells and bridle-bells chiming;
 In him all blessings meet.
11. "Zhan lu" is translated as follows:
a. Heavy is the dew;
 Without the sun it will not dry.
 Peacefully we drink in the night,
 Unless intoxicated, do not depart.
b. Heavy is the dew on the rich grass.
 Peacefully we drink in the night,
 In the ancestral hall we feast to the full.
c. Heavy is the dew on the medlar and buckthorn trees.
 Distinguished and faithful are the lords,
 None without virtue.
d. The *tong* trees, the *yi* trees,
 Their fruits hanging everywhere.

Joyous and pleasant are the lords,
 None without good behavior.
12. "Tong gong" is translated as follows:
a. The red-lacquered bow unbent,
 He who is given treasures it.
 I have fine guests,
 With all my heart I bestow [upon each a bow];
 The bell and drum have been set up;
 From morning I feast them.
b. The red-lacquered bow unbent,
 He who is given preserves it.
 I have fine guests,
 With all my heart I rejoice in them;
 The bell and drum have been set up;
 From morning I ply them.
c. The red-lacquered bow unbent,
 He who is given sheaths it.
 I have fine guests,
 With all my heart I adore them;
 The bell and drum have been set up;
 From morning I reward them.
13. "Jing jing zhe e" is translated as follows:
a. Luxuriant are the *e* plants,
 In the midst of the sloping hills.
 I have seen my Lord,
 I rejoice and enjoy his hospitality.
b. Luxuriant are the *e* plants,
 In the midst of the islet.
 I have seen my Lord,
 My heart is gladdened.
c. Luxuriant are the *e* plants,
 In the midst of the hill.
 I have seen my Lord,
 He has presented me with a hundred strings of cowries.
d. Floating on is the willow boat,
 Now dipping, now rising.
 I have seen my Lord,
 My heart is at rest.

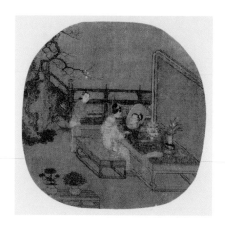

25

Su Hanchen (act. 1120s–1160s)

Lady at Her Dressing Table in a Garden

Southern Song dynasty, mid-12th century
Round fan mounted as album leaf;
ink, color, and gold on silk
25.2 x 26.7 cm
Denman Waldo Ross Collection 29.960

On a spring morning, a woman arranges her hairdo and make-up as she sits on a beautifully carved red-lacquer couch covered by a richly patterned textile. She is surrounded by a sumptuous array of furniture and art objects. Behind her is a low wooden stand with two contrasting miniature trees in typical Song ceramic pots.

Significantly, the artist presents two different views of the young lady—one from the back and the other, a deliberately enlarged three-quarter view of her face, is a reflection in the mirror. The mirror reveals a palace lady's inner mood, which would otherwise be concealed from the viewer (and the outside world). In Chinese-painting history, depictions of a woman seeing herself in a mirror date back to the handscroll *Admonitions of the Instructress to the Palace Ladies* (British Museum, London) attributed to Gu Kaizhi (ca. 344–ca. 406). What is remarkable in the Boston fan is the way Su Hanchen conveyed both his subject's material well-being, which is evident from the furnishings and surroundings, and her noble nature as suggested by the woman's reflection in the mirror. Her larger-than-life mirror image seems to be the artist's way of emphasizing her inner state, adding a psychological dimension to the painting. As if to enhance his charac-

terization of the palace lady, the artist has also added a flowering plum tree and a young bamboo in the left middle ground, and a vase filled with narcissi on the dressing table, to the right. Plum blossoms and bamboo traditionally symbolize purity of mind, while the narcissus refers specifically to a woman's lofty, noble character. Another possible meaning for the disposition of the plum blossom near the maid and the narcissi by the lady derives from the Song custom of naming a maid *xiang mei* (fragrant plum blossom), while the Chinese characters for narcissus, *shuixian,* literally mean an "immortal on the water."[1] In such a reading, the waves painted on the screen behind the flower further emphasize the noble beauty of the narcissi and, by implication, that of the seated lady.

This fan painting is filled with exquisitely depicted furniture and a variety of art objects including a porcelain vase and cup, a lacquer tray, a hardwood stand, tortoise-shell boxes, a bronze incense burner, a bronze mirror with a stand, textiles, and bonsai trees. From this fan painting, one can discern how different pieces of furniture were related to each other and how, in the warm climate of southern China, furniture was used in an outdoor setting. To the lower left is a partly damaged signature: Su Hanchen.

Su Hanchen entered the Song painting academy as early as the Emperor Huizong's time. After the fall of the Northern Song, he continued his career at the Southern Song court until the third quarter of the twelfth century under Emperor Xiaozong. This is one of two or three genuine signed works by Su Hanchen.

1. The phrase *lingbo xianzi* (female immortal gracefully moving on flowing waves) further connotes the idea of a noble, dignified beauty.

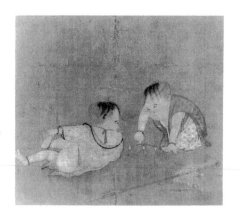

26

Attributed to Su Hanchen (act. 1120s–1160s)

Children Playing with a Balance Toy

Southern Song dynasty, 12th century
Square album leaf; ink and color on silk
22.7 x 25 cm
John W. Willard Fund 56.98

The Municipal Museum of Art in Tianjin, China, owns an album leaf with Su Hanchen's signature that shows a child holding a fan, about to assist his little playmate in capturing a white butterfly on top of a flowering plant.[1] The children portrayed in the Tianjin painting bear a striking resemblance to those in the Boston album leaf. They share similar hairstyles, which are tied with ribbons in the same manner. The children on the left in both paintings resemble each other in their facial features and expressions. The Su Hanchen signature on the Tianjin work closely resembles that on Boston's *Lady at Her Dressing Table in a Garden* (cat. 25). The family name, Su, is constructed similarly on both works, with a flaring lower part. In both cases, the second character, *han,* is written slightly smaller than the first character, and is positioned just below the right edge of the first character. On both leaves, the third character, *chen,* is too badly cut and retouched for useful comparison.

Since the Tianjin *Children* and Boston's *Lady* are accepted as Su Hanchen's genuine works, this Boston leaf of *Children Playing with a Balance Toy* can thus be accepted as authentic as well.

The tradition of depicting *yingxi* (playful children) became quite fashionable in Southern Song times. The image of a

robust, well-fed child reflected the ultimate fruits of a prosperous society and, from the court to merchant families, such works were commissioned as gifts that would impart good luck or purely for aesthetic enjoyment.

1. *Liangsong minghuace*, pl. 7.

27

Anonymous (formerly attributed to Fan Kuan, act. late 10th–early 11th century)
Winter Forest

Southern Song dynasty, mid-12th century
Round fan mounted as album leaf;
ink and light color on silk
23.8 x 24.9 cm
Chinese and Japanese Special Fund 14.53

Of this round fan, Max Loehr once wrote: "If Song painting were to vanish and this small work alone to remain, it would still testify to the greatness and profound insight in the art of that period."[1] Loehr's praise is understandable. The theme of the winter forest (*hanlin*) was treated by all three landscape masters of the tenth and eleventh centuries: Li Cheng (919–67), Fan Kuan, and Guo Xi. Of the existing winter-forest paintings, most are academic works emphasizing form and structure. But, as Loehr suggests, this artist's attempt to capture nature's infinite time and space reflects a deeper sensibility and spiritual quality.

Winter's severe cold has been subtly captured by the artist. The painting details one section of a wintry forest, as if the trees were an endless succession of "cold bones" (*hangu*) standing in the silence of a frozen land without any living leaves or birds. The roots of old trees mirror the barren twigs and branches, exposed and extending in all directions. As Richard Edwards observed: "There is one singular root-branch which plunges into the water, but at that point sends a new growth straight upward." This image had a lasting impact, and was incorporated into landscapes by later artists from the Song to the Ming (1368–1644).

The image of old trees stubbornly enduring a severe environment and of new growth emerging from a seemingly moribund Nature was an archetypal

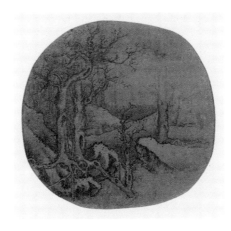

expression of Confucian virtue. The metaphorical connotations were echoed and developed throughout the history of Chinese culture, including works by later literati such as Qian Xuan (ca. 1235–after 1301), and Ni Zan whose *Six Scholars* (Shanghai Museum) depicts the virtuous scholars as six upright trees, as Huang Gongwang (1269–1354), the leading Yuan literati painter, commented on this allusion in Ni Zan's painting.[2]

The vibrant drawing of the twigs shows the artist's skillful brushwork and represents the victory of linear expression over purely formal and spatial concerns. This is also true for the snow-covered rocks and slopes. Despite some damage and poor retouching, the energy and expressive quality of the original drawing can still be observed. In mood and taste, the Boston work reflects a more archaic aesthetic as evidenced by the linear rendering of the motifs. It stands apart from the more realistic construction of academic works such as Ma Lin's *Fragrant Spring, Clearing Rain* (National Palace Museum, Taipei).[3] The simplified twelfth-century spatial arrangement presented in the Boston painting is a far cry from the symmetry, volume, and depth of space represented in the two eleventh-century hanging scrolls: Fan Kuan's *Travelers among Streams and Mountains* (National Palace Museum, Taipei) and Boston's *Winter Landscape with Temples and Travelers* by a follower of Fan Kuan (cat. 11).

1. Quoted in Barnhardt, *Wintry Trees, Old Forests*, p. 3.
2. See *ZMQ: huihuabian*, vol. 5, pl. 116, pp. 68–9.
3. See *ZMQ: huihuabian*, vol. 4, pp. 150–51.

28

Anonymous
(traditionally attributed to Li Di, act. 1163–1225)
Bamboo and Rock under an Old Tree

Southern Sung dynasty, second half 12th century
Square album leaf; ink and color on silk
24.2 x 25.7 cm
Chinese and Japanese Special Fund 17.186

This painting has traditionally been attributed to Li Di, a leading court artist who specialized in bird-and-flower paintings during the last quarter of the twelfth century.[1] Within a limited album-leaf space, the artist presents a strong composition with motifs inherited from the classical style established by the Northern Song master Cui Bai, whose work Li Di followed. For example, the round modeling and shading of the tree trunk and branches as well as the lively, large leaves, can all be traced back to Cui Bai's 1061 masterpiece *Hare and Jays* (Beijing Palace Museum). A similar type of large, heavy tree appears in both Li Di's grand hanging scroll of 1196, *Hawk and Pheasant* (Beijing Palace Museum) and in *Birds in a Tree above a Cataract* (Cleveland Museum of Art). The round, rough rocks juxtaposed with sharp but smooth, green bamboo leaves in the Boston painting again follow the more classical style. Bamboo leaves are arranged and precisely executed in a refined line drawing. Weight and volume in the rock formation are suggested by means of a combination of thick outline, subtle washes, and careful texturing. The arching tree branch echoes the curved contour of the rocks below. A dialogue between the bamboo leaves and the leaves of the tree, between its branches and the rocks is implied in the artist's design. Even the unpainted spaces defined by the painted motifs play a role in the overall effect of the Boston composition.

The Boston album leaf has a strong right-side orientation and no background. The blank ground embodies a more archaic aesthetic than the Beijing and Cleveland works—both of which emphasize spatial depth—suggesting a slightly earlier date for the Boston album leaf. A Southern Song court painter in the second half of the twelfth century could very

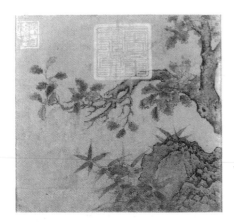

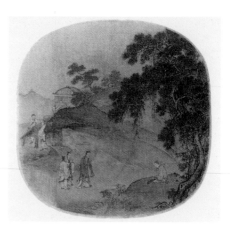

29

Anonymous (formerly attributed to Ma Yuan, act. 1190–1235)
Confucius' Encounter with the Hermit Rong Qiqi

Southern Song dynasty, second half 12th century
Round fan mounted as album leaf;
ink and light color on silk
24.8 x 25.3 cm
Chinese and Japanese Special Fund 14.63

well have produced this remarkable work.

A two-character signature appears at the lower-right corner of the painting, but its calligraphy is hesitant and weak, and the ink tone is inconsistent with other painted areas in the work, which makes it more likely to have been a later addition. Two important imperial seals indicate that this album leaf was in the court collections of the Southern Song and Yuan dynasties. The Southern Song imperial seal, *Ruisi dongge zhi yin,* was used during the second half of the twelfth century. Over the left corner is a Yuan imperial seal, *Dusheng shuhua zhi yin,* which was used in the mid-fourteenth century.

1. For a detailed study of this artist, see Edwards, *Li Di.*

Tomita's 1933 *Portfolio* identified this fan's subject matter as a musical gathering between the scholar–musician Xiao Sihua (406–55) and Wendi (r. 424–53), emperor of the Song State during the period of Southern dynasties. However, judging from his distinct appearance, the standing figure on the left can only be the Chinese philosopher Confucius. The iconography, manner, and dress employed in this idealized portrait of the philosopher are consistent with other known surviving depictions.[1] The philosopher wears a courtly robe with a long sword on his left. Bowing slightly, his folded hands inside his sleeves, it appears as if he is paying respect to the musician at the right. The rendering of Confucius' face aptly portrays a personality of kindness and intelligence. Accompanying him are two young disciples in simpler apparel. Further back, half obscured behind a large rock, stands a canopied horse-drawn chariot with three attendants, who probably comprise the traveling entourage. Opposite from Confucius' group, under a tall pine tree surrounded by bamboo bushes, a hermit sits on a cushion placed over a flat rock, the musical instrument known as the *qin* in his lap. The hermit's profiled head has been partially retouched to repair damage.

The painting actually illustrates a legendary encounter between Confucius and the ninety-year-old musician–hermit Rong Qiqi. The story is based on a legend recorded in pre-Tang texts. They recount how, one day, the renowned moral philosopher was passing by Mount Tai in his native Shandong province, when he heard someone singing and playing the *qin.* Through the music, Confucius recognized the contented state of the musician's mind and inquired as to its cause. Rong Qiqi replied that there were three worldly joys in a successful life: to

be a human being, to be a man, and to enjoy longevity. He was blessed with all three.

Throughout Chinese history, the image of Confucius was appropriated to reflect distinct political and cultural trends. For example, this perhaps-legendary encounter appears as a decorative motif on many bronze mirrors from the High Tang period, a time when China prospered from its foreign trade and its cosmopolitan ruling class included many non-Chinese, who led a society in which material pleasures were celebrated. The Boston fan, however, is the only surviving painted example illustrating the story that dates from the Southern Song, a time when the anecdote would have evoked quite different readings and associations.[2] Unlike the High Tang, the prosperity of the Southern Song came with a price: the controversial 1165 peace treaty with the Jurchen nomads who threatened China from the north. The treaty was opposed by one of the leading philosophers of the time, Zhu Xi (1130–1200), founder of the Neo-Confucianist school, who found himself in direct confrontation with the imperial court. This strict moralist attacked many of the literati of his day for promoting a decadent lifestyle that embraced precisely the sort of pleasures embodied by Rong Qiqi in this fan painting. The painting, on the other hand, conspicuously promotes the aristocratic point of view of the Southern Song rulers—one that avoided the issues posed by standing up to an enemy and fighting for a principle. In the painting, Rong Qiqi and his "three joys" represent a more Daoist view of human conduct—one opposed to the Neo-Confucianists but not unlike that of Emperor Gaozong, who favored Daoism, especially during the period of his retirement in the third quarter of the twelfth century. At a time

of enormous political, moral, and military pressure, Gaozong established himself at Hangzhou where his court embodied the good life that flourished, albeit precariously, in the south. The painter of this work has used the authoritative figure of Confucius to justify that philosophy of life.

This work was traditionally attributed to Ma Yuan, but it lacks any of the features of his typically one-cornered compositional style. Nor do the rock forms reflect his more angular presentation. The type and style of the figures are quite different from those in *Scholars Conversing Beneath Blossoming Plum Tree* (cat. 69). Here they are drawn with a careful but forceful outline that shows special attention to structure and expression.

Stylistically the painting should predate Ma Yuan; it more closely follows a style derived from Li Tang, as seen in such works as *Duke Wen of Jin Recovering His State* (Metropolitan Museum of Art, New York).[3] For instance, the figures and chariot in the Boston fan are similar to, though slightly more conventionalized than, those in the Metropolitan scroll, and the bowing pose of Confucius resembles a key figure in the *Duke Wen* scroll. It is possible that the Boston fan was created by a follower of the Li Tang style in the second half of the twelfth century.

1. See *ZMQ: huihuabian,* vol. 4, pl. 33, p. 50; and pl. 63, p. 91.
2. A painting with the same subject matter, attributed to the sixth-century painter Lu Tanwei, is recorded by Zhang Yanyuan in his ninth-century text *Lidai minghua ji,* juan 6, p. 77, in Yu Anlan, *HC,* vol. 1.
3. Fong, *BR,* pp. 196–203, pls. 27a–h.

30

Attributed to Zhu Rui (act. first half 12th century)
Bullock Carts Traveling over Rivers and Mountains

Southern Song dynasty, 12th century
Hanging scroll; ink and light color on silk
104.2 x 51.4 cm
James Fund 08.115

Chinese genre painting reached its height during the Song period. Commercial success and new-found wealth led to a different taste in paintings—a phenomenon not unlike the rise of genre painting five hundred years later in seventeenth-century Japan and Holland. Affluent Chinese merchants preferred paintings that were neither too scholarly nor too religious or political, hence the popularity of genre paintings. Southern Song genre paintings differ from their prototypes in one major respect. Pre-Song works often served a didactic, Confucian purpose, recording events in order to preach political and moral ideology instead of simply describing everyday life. Perhaps the finest example of the new genre painting is the famous handscroll *Qingming shanghe tu* (Qingming Festival along the River) by Zhang Zeduan (Beijing Palace Museum), which depicts life in and around Kaifeng, the capital of the Northern Song dynasty until 1126, when the Jurchen nomads conquered and sacked it.

Comparison with Northern Song works shows the dramatic shift that occurred during the Southern Song period. In this hanging scroll, *Bullock Carts Traveling over Rivers and Mountains,* the artist delights in detailing and depicting the difficult journey undertaken by the traders with their heavily laden carts. Unlike such Northern Song paintings as *Travelers at the Mountain Pass* (National Palace Museum, Taipei) attributed to Guan Tong (act. tenth century), in which the travelers are dwarfed by the overwhelming presence of the landscape, in this work the activities surrounding the oxcarts provide the focal point.

In the foreground, its driver half-visible in his seat, one bullock cart is drawn by three oxen strenuously trudging through the river. Two merchants on horseback follow their cargo closely to ensure its safety. In the middle ground,

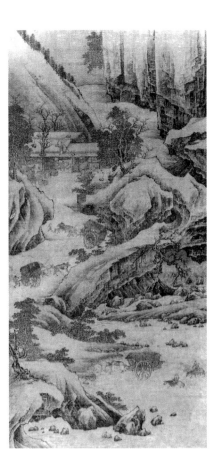

another oxcart scales an uphill path with one man pushing from behind, another helping at the wheel, and a third whipping the oxen to move on. The third cart, which has successfully made it up the hill, approaches a thatch-roofed inn in the upper left. In front of the inn, travelers are busily rearranging their cargoes, feeding the camels, and enjoying a well-deserved meal. One customer dozes off at the dining table. The mountainous-landscape setting and inclusion of the camels in the picture signals that the scene takes place in northern China rather than around Hangzhou, the capital of the Southern Song dynasty. The texturing of the cliffs and the rocks relates to the Li Tang school, although the trees are reminiscent of an even earlier style.

Bullock carts traveling through mountain paths were a popular subject for artists of the Southern Song, perhaps because of their exotic nature. A related, slightly later painting, bearing the same title as Boston's work, is in the collection of the Beijing Palace Museum. This anonymous hanging scroll, comparable in size (109 x 49.5 cm), is executed in ink and light color on silk.[1] In both the Boston and Beijing scrolls, similar overhanging plateaus are tipped upward in the middle ground. The section depicting the

country inn and the activities around it are also similar—each has a "wine flag" hanging outside on a pole to indicate the nature of the services; camels and cargoes appear in front of both inns, and, interestingly, a tree grows through the roof of each inn.

In terms of spatial arrangement, the Beijing *Bullock Cart* is more concentrated in the upper part of the composition. With towering peaks above, it is confined within a more closed space. On the other hand, the mountain path in the Boston scroll stretches beyond the inn, leading the viewer visually farther into a distant, open space. The Boston painting follows the compositional design that is characteristic of the early Southern Song period, while the Beijing work agrees with that of the mid-thirteenth century.

An inscription at the lower left corner of the Boston painting reads: "chen Zhu Rui gonghua" (respectfully painted by officer Zhu Rui). Neither the calligraphic style nor the wording of the inscription is consistent with other known Southern Song examples. Nevertheless, Zhu Rui was known as a specialist in such subjects, and the painting is possibly the work of one of his followers.

1. See *ZMQ: huihuabian*, vol. 4, pl. 6, p. 6.

31

Attributed to Jiang Shen (ca. 1090–1138)
Evening Mist over a Valley

Southern Sung dynasty, late 12th century
Round fan mounted as album leaf; ink on silk
24.2 x 26.2 cm
Denman Waldo Ross Collection 28.838a

This unusual ink landscape from the early Southern Song period diverges from the landscape-painting mainstream dominated by the influence of Li Tang and his followers. Clearly a work of high quality, it finds no close comparisons to other Southern Song works by artists either inside or outside the painting academy.

The artist seems to have been inspired by the landscape style of the early eleventh-century master Guo Xi, of whom Jiang Shen was a follower. Even though the scale has been reduced from

Guo Xi's typically monumental designs, and the composition is concentrated more on one side than Guo Xi's symmetrical arrangements, still it evokes the sense of profound distance characteristic of that master's works. Guo Xi's powerful brushwork has been translated here into softer, rounder, and wet shapes, reflecting the new aesthetic concerns of the Southern Song. The full moon, subtly defined by slight ink washes, appears near the cliff and provides just enough illumination for a fisherman carrying equipment over his shoulder to cross a shaky bridge on his way home. Such deliberate elaboration of the watery southern atmosphere and the specific reference to evening further relates this ink landscape to such other Southern Song works as the well-known, late-twelfth-century handscroll *Xiao and Xiang Rivers in a Dream* (National Museum, Tokyo).

The painting's facing fan (cat. 32), attributed to Emperor Gaozong, bears a quatrain written in the cursive calligraphy style. If the painting and calligraphy indeed belong to the same round fan, the landscape would likely have been produced during the later years of Gaozong's retirement.

32

Attributed to Emperor Gaozong (r. 1127–62, d. 1187)
Calligraphy of a Quatrain in Cursive Style

Southern Song dynasty, ca. 1163–87
Round fan mounted as album leaf; ink on silk
24 x 25.3 cm
Denman Waldo Ross Collection 28.838b

Scholars consider Emperor Gaozong to have been the finest and most influential calligrapher among the Southern Song rulers. Gaozong retired from the throne in 1162, after which he was able to devote himself to the art of calligraphy for a quarter century. Of the various styles he practiced, the cursive and the semi-cursive scripts were his favorites. The better-known examples include a calligraphy of Su Shi's *Second Prose Poem on the Red Cliff* and Gaozong's writings on two twelfth-century landscape fans (both in the Beijing Palace Museum). A quatrain written on a round fan in the Metropolitan Museum of Art, New York, bears a seal impressed at the left edge that reads "Deshou xianren" (Idle Man of Virtue and Longevity [Palace]). Gaozong used this seal during his retirement exclusively, and the New York fan is generally regarded as a masterpiece of his later style.

The Boston fan is unsigned and less-well known; nevertheless, the grounds for accepting its traditional attribution to Emperor Gaozong are ample. In brushwork and structure, it is distinctly similar to the above-mentioned works. The typical right-to-left, looping turn of such characters as *xiao* (diagram) and *zhang* (ten feet) in the New York fan is also evi-

dent in the Boston fan's character *zhi* (branch).[1] The same heavy, horizontal finishing strokes in the *jin* (near), *hua* (flower), and *bian* (side) of the New York work appear in the character *chi* (late) in the Boston fan. So, too, the characters *xijiu* (to bring wine), *ming* (bright), *feng* (wind), and *you* (to have) resemble their counterparts on the *Second Prose Poem on the Red Cliff* handscroll.[2] Moreover, both the Boston fan and the Beijing handscroll display a round seal with a design of a coiled dragon in red at the end of the writing. These elements make it clear that the Boston fan is closely related to Emperor Gaozong's late, retirement-period works.

Richard Edwards translates the text of the quatrain as:

> Searching flowers at the mountain
> temple
> spring already late
> Behind the cliff are branches
> only two or three;
> In brightening dawn we carry wine
> our drinking on and on
> To tell the spring wind:
> hold back that dawn!

1. Fong, *BR,* p. 230 and pl. 32.
2. Xu Bangda, *Gu shuhua wei'e kaobian,* vol. 2: *tuban bufen,* pp. 6–7.

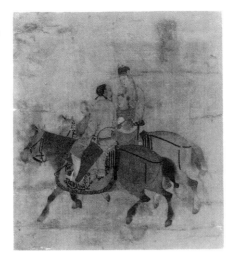

33

Anonymous (formerly attributed to Gu Deqian, act. second half 10th century)
Wenji and Her Family

Southern Song dynasty, late 12th–early 13th century
Square album leaf; ink and color on silk
24.4 x 22.2 cm
Chinese and Japanese Special Fund 12.898

The unusual relationship between the celebrated woman scholar Lady Wenji and the leader of the Southern Xiongnu nomads has inspired and fascinated generations of Chinese poets and artists. Episodes from her tragic life are illustrated in painted versions of the group of poems known as *Eighteen Songs of a Nomad Flute* (see cat. 17–20). But several other paintings show Lady Wenji and her family engaged in activities that are not among those included in the poetic texts traditionally ascribed to the Tang poet Liu Shang.[1] The scene portrayed here is one of them.

The Boston album leaf evokes an intimate atmosphere between Lady Wenji and her nomad husband. Not only has the artist painted Wenji and the chieftain looking at each other as if in the middle of a conversation, but he has also positioned their two young children to enhance the impression of a close family. The side-by-side movement of the two horses, their eight hooves rhythmically synchronized, also adds a bright and harmonious tone to the four riders on horseback. Specifically, this album leaf projects a happier moment in the life of Lady Wenji, who is remembered more for the suffering and despair she endured during her captivity.

The artist replaced the original Xiongnu chieftain with a Khitan Tartar and dressed Lady Wenji in Tartar costume. The type of horses and saddles depicted are frequently seen in murals discovered in recent excavations of Liao-dynasty tombs. The artist's more sympathetic attitude toward the interracial relationship between Wenji and her non-Chinese husband differs remarkably from the strong nationalism and patriotism expressed by earlier painters who depicted similar subject matter from the *Eighteen Songs.* Perhaps the more relaxed rendering here reflects the economic prosperity and flourishing foreign trade in thirteenth-century China, a resurgence that prompted an artistic reevaluation of the historical events and literary themes alluded to in this work.

1. For a detailed discussion, see Rorex and Fong, *Eighteen Songs of a Nomad Flute.*

34–43

Zhou Jichang and Lin Tinggui (both act. second half 12th century)

Ten Lohan Paintings from Daitoku-ji, Kyoto

Introduction

In December 1894, Ernest Fenollosa (1853–1908) arranged an exhibition of forty-four rare Chinese Buddhist paintings at the Museum of Fine Arts, Boston. These scrolls, dating from the early Southern Song dynasty, had been kept for centuries in Kyoto's renowned Zen temple, Daitoku-ji. After the exhibit, for which Fenollosa wrote the catalogue, ten of these paintings were acquired for the Boston Museum, a transaction that marked the beginning of the museum's collection of early Chinese paintings.[1] Two more paintings from this set were acquired by Charles L. Freer (1856–1919) and are now in the collection of the Freer Gallery in Washington, D.C.

The contemporary importance of Fenollosa's special exhibition in Boston can be judged from what art connoisseur Bernard Berenson (1865–1959) wrote upon viewing these paintings at the show:

> They had composition of figures and groups as perfect and simple as the best we Europeans have ever done. . . . I was prostrate. Fenollosa shivered as he looked. I thought I should die, and even Denman Ross who looked dumpy Anglo-Saxon was jumping up and down. We had to poke and pinch each other's necks and wept. No, decidedly I never had such an art experience.[2]

The forty-four Chinese Lohan paintings in Fenellosa's exhibition were part of a set of one hundred scrolls that had been preserved as a set in Daitoku-ji since the late sixteenth century. According to Kōjirō Tomita, the set

> was taken to Japan in the thirteenth century and was deposited at the temple Jufukuji at Kamakura. Subsequently it was transferred to Sōun-ji in Hakone by the powerful Hōjō family who supported that monastery. Again the set was removed by Toyotomi Hideyoshi (1536–98) in 1590 to Kyoto and was presented to Hōkō-ji, a temple founded by him. Later the paintings became the property of Daitokuji in the same city.[3]

As noted by Fenollosa in his catalogue,

during the late Meiji period the temple Daitoku-ji was badly in need of repair. The decision by the Japanese government to allow the first Western exhibition of these forty-four paintings was prompted in part by the need to restore the temple. But the sale of twelve of the temple's Lohan scrolls was something the Japanese have regretted ever since. In 1897, Morimoto Kōchō (1847–1905), director of the imperial museums in Kyoto and Nara, inscribed on one of the twelve scrolls he copied to replace those sold from the Daitoku-ji set: ". . . recently the paintings were sold to a foreign country, the foreigners acquired 12 scrolls. . . . I regret the loss."

Of the ten paintings Fenollosa acquired for the Boston Museum, only one carries a colophon. Partially damaged, dated 1178, it was written by the priest Yishao of the Huianyuan temple in Ningbo, Zhejiang province. The other nine scrolls either have no writing on them at all or the inscriptions are too damaged to read. Possibly those without inscriptions or with damage were less expensive than the perfectly inscribed ones, including *Lohan Laundering* and *The Rock Bridge at Mount Tiantai,* the two acquired by Freer, both dated 1178.

According to James Cahill's *Index of Early Chinese Painters and Paintings,* the two painters Zhou Jichang and Lin Tinggui produced the set of one hundred scrolls between 1178 and 1188. Cahill's *Index* lists the ten Boston scrolls as dated by inscription, but a thorough examination can only confirm what Tomita already stated in the 1933 *Portfolio:* Only *Lohans Feeding a Hungry Spirit* (cat. 43) bears such an inscription, which is in gold ink "though much obliterated," while *Pilgrims Offering Treasures to Lohans* (cat. 34), reveals "traces of the inscription." But even the weak "traces" of what Tomita took to be an inscription on the latter scroll cannot be confirmed today.

Zhou Jichang and Lin Tinggui obviously were professional artists specializing in Buddhist and Daoist works in Ningbo, the leading port for trade with other Asian countries of the time. Neither painter is mentioned in Chinese literature and no other works by them are known to exist. Judging from these works, both artists were skilled in brushwork and creative in their composition. Although Fenollosa thought they belonged to the school of Li Gonglin, such a connection

seems unlikely in view of Li Gonglin's preference for, and emphasis on, the refinement of ink drawing. A more plausible stylistic source for the two artists would be the court painter Liu Songnian, who was almost their contemporary and came from Hangzhou, the capital of the Southern Song dynasty, which was located northwest of Ningbo. Three Lohan paintings by him, all dating from 1207, are in the collection of the National Palace Museum, Taipei. If these works by Liu represent the most mature and sophisticated court style of Buddhist painting in the Southern Song, then the Daitoku-ji Lohan paintings provide their nonimperial parallel.

In 1385, the famous Japanese monk painter Minchō (1352–1431) recreated a set of fifty Lohan paintings based on those by Zhou Jichang and Lin Tinggui. Minchō creatively rearranged them to include ten Lohans on each of the fifty scrolls, making a total of five hundred Lohans. The paintings in Minchō's set— each of which is painted in ink and color on silk and measures 159.5 cm in height by 90.5 cm in width—are considerably larger in size than those in the Daitoku-ji set. They are now in the possession of Engaku-ji in Kamakura City.[4] As noted in Tomita's 1933 *Portfolio,* of the original one hundred Lohans, six paintings from the Daitoku-ji set were lost centuries ago and were replaced by copies painted by the seventeenth-century artist Kano Tokuō.

The cult of Lohan worship began in China much earlier than in other Asian countries. Chinese painters also were the first to depict Lohan images and activities, beginning with a set of sixteen Lohans in the early sixth century;[5] which later grew to eighteen, and then, in the Song dynasty, to five hundred. The Daitoku-ji set is apparently the earliest to depict five hundred Lohans, and these are a far cry from the Indian or Central Asian types shown in earlier paintings like the sixteen Lohans attributed to Guanxiu (act. tenth century) now in the Japanese imperial collection.[6] The basically austere ink drawing of Guanxiu's *Sixteen Lohans* gives way to the vividly colored, often naturalistic settings of the Daitoku-ji scrolls, a dramatic stylistic shift that reflects the change in Lohan worship in China. While the former were meant for more meditative viewing and purposes, the latter, with their often dra-

matic content, were intended to attract and impress large groups of worshippers and cult followers.

1. Five of the ten scrolls were acquired through the Museum's General Fund while, at the recommendation of Fenollosa, Dr. Denman Waldo Ross, a trustee and benefactor, acquired another five that he donated to the museum later.
2. See Fontein, "A Brief History of the Collections," pp. 9–10.
3. See *Portfolio*, p. 12.
4. All fifty scrolls are illustrated in Suzuki, *CICCP*, vol. 4, pp. 44–48.
5. In Emperor Huizong's imperial catalogue, *Xuanhe huapu*, a work depicting sixteen Lohans is among the paintings attributed to Zhang Sengyou.
6. See Loehr, p. 56.

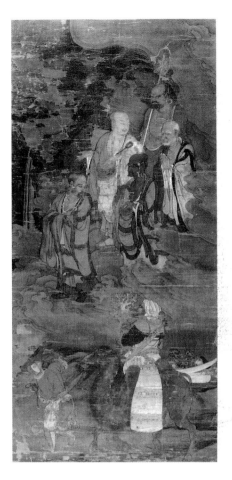

34

Zhou Jichang
Pilgrims Offering Treasures to Lohans

Southern Song dynasty, ca. 1178
Hanging scroll mounted as panel; ink and color on silk
111.5 x 53.1 cm
General Fund 95.2

Derived from early Buddhist texts, the Lohan cult reached its apogee in China during the Southern Song period, when it became a popular subject for both amateur and professional painters. *Lohan,* or *Aluohan,* is the Chinese transliteration of the Sanskrit *Arhat*—an enlightened disciple of the Buddha, freed from worldly desire and pain, who becomes a sage through hearing the teachings of the Buddha and in turn enables believers to attain the reward of Enlightenment.

Two dark-skinned, non-Chinese figures, possibly from Central Asia or the Near East, are in the foreground. One leads a two-humped Bactrian camel and the other offers a large coral tree (see cat.

37 and 58)[1] to the five Lohans riding on clouds in midair. The pilgrims have brought other rare goods such as elephant tusks, a black rhinoceros horn, and peculiar tree roots, all of which lie on the ground awaiting presentation. Such offerings reflect similar rituals and devotional practices in medieval China. But the appearance of the camel and worshippers from afar is here adapted by the artist more for exotic effect.

Despite some damage, the rich mineral colors applied to the motifs are still brilliant. The painting is close to the Freer's Zhou Jichang, *The Rock Bridge at Mount Tiantai.* Their resemblances include: the depiction of clouds, pine tree, and waterfall as well as the Lohans and their robes. While no inscription appears on the Boston painting, the Freer scroll fortunately has a two-line dedication written along the center, right border, in gold ink in regular script, which gives a date of 1178 and identifies the painter as Zhou Jichang.[2] Given the stylistic similarities and provenance, it is clear that this Boston painting, as well as eight others, were all done by the same hand at about the same time for the same purpose, though they might have been commissioned by different families.

1. Some Buddhist sūtras include the coral tree as one of the Seven Treasures.
2. See Fong, *The Lohans and a Bridge to Heaven,* pl. 1.

35

Zhou Jichang
The Transfiguration of a Lohan

Southern Song dynasty, ca. 1178
Hanging scroll mounted as panel;
ink, color, and gold on silk
111.5 x 53.1 cm
General Fund 95.3

This painting shows a mystical epiphany, the moment when one of the five Lohans manifests himself in the image of the Buddha in a meditative pose. This Lohan–Buddha has a large halo behind his head and upper torso whence his spiritual energy ascends like smoke into the air before it is dispersed in three directions. Surrounding the Lohan–Buddha and his halo are articulations of swirling flames and clouds. Below this

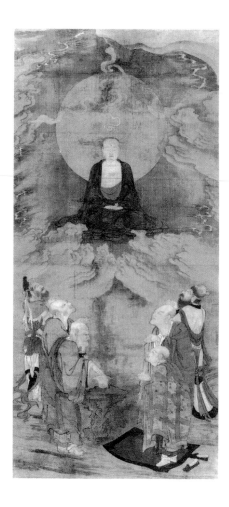

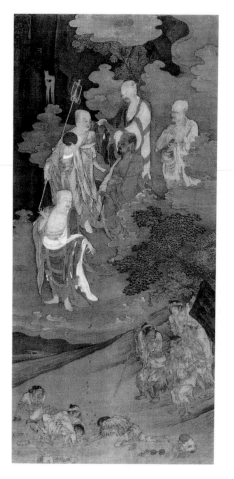

scene, the other four Lohans and two so-called "barbarian kings" stand on the ground in a symmetrical arrangement, praying for the success of this transfiguration.

While the painting bears no written inscription, it is closely related to the Zhou Jichang in the Freer, and therefore can be dated and attributed accordingly.

36

Zhou Jichang
Lohans Bestowing Alms on Suffering Human Beings

Southern Song dynasty, ca. 1178
Hanging scroll mounted as panel; ink and color on silk
111.5 x 53.1 cm
General Fund 95.4

In his 1894 catalogue entry, Fenollosa writes that "the broken nervousness of this artist's touch has enabled him to render the squalid rags and emaciated limbs with an intensity that nothing in early Italian frescos equals."[1] The contrast between the destitution of the threadbare beggars in the foreground and the five well-fed Lohans in brilliantly colored robes high above them in the sky is a striking pictorial juxtaposition that may have had a certain political and sociological implication regarding "haves and have-nots" in the urban centers of the prosperous Southern Song dynasty. The underprivileged usually were not portrayed, either by court painters or professional artists of the Southern Song. But

as a professional painter and artisan, Zhou Jichang might have felt some sympathy for the marginalized classes that were neglected by the rulers of his day.

The artist's ability to unify the two opposite groups of figures in one painting is most impressive. Even the landscape background performs a useful purpose. Behind the clouds in which the Lohans stand, a waterfall pours down through rocky cliffs, suggesting the heavenly beneficence of the Lohans and defining a spatial distance between the celestial clouds and the landscape of the earthly world below. Trees and rocks in the foreground provide a transition to the bedraggled, careworn beggars who emerge into the scene to receive alms dropped by their heavenly protectors.

There is no inscription on this painting but it is stylistically close to the Freer's Zhou Jichang.

1. Fenollosa, p.28.

37

Zhou Jichang
Lohans in a Bamboo Grove Receiving Offerings

Southern Song dynasty, ca. 1178
Hanging scroll mounted as panel;
ink, color, and gold on silk
111.5 x 53.1 cm
General Fund 95.5

The landscape elements of this painting, especially the rock formations, are not as well articulated as similar elements in other works by Zhou Jichang. While they do enhance a sense of space and depth, the rocky areas are out of proportion with the Lohans and obscure the clarity of pictorial presentation. On the other hand, the depiction of the five Lohans and the two offering-bearers is consistent with the style of the Freer Zhou Jichang. The standing figure in the left foreground, possibly a Central Asian, is especially revealing, with his fixed gaze and gray beard. The beard mirrors the whisk held in the hand of a Lohan in the middle ground. The coral-tree gift, regarded by Buddhists as one of the Seven Treasures, is similar to the one pre-

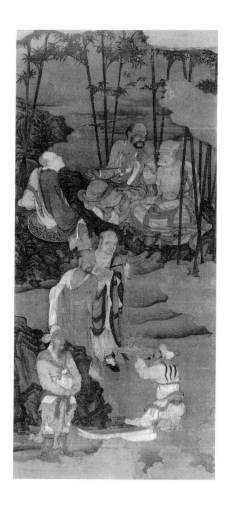

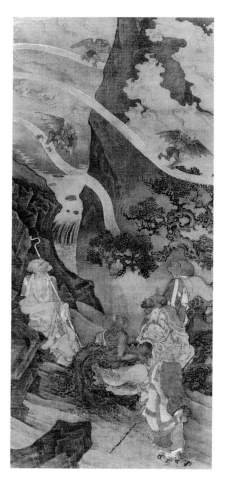

sented in *Pilgrims Offering Treasures to Lohans* (cat. 34).

Apart from damage in the lower part and losses on the upper edge, the painting is in good condition; the mineral-colored robes of the five Lohans and the costumes of the two offering-bearers are well-preserved.

38

Zhou Jichang
Lohans Watching the Distribution of Relics

Southern Song dynasty, ca. 1178
Hanging scroll mounted as panel; ink and color on silk
111.5 x 53.1 cm
General Fund 95.6

The dramatic compositional arrangement of this work places it among the best Daitoku-ji Lohan paintings in Boston. The artist has set the five holy Lohans in the foreground of an eerie landscape where they anxiously watch three small, winged creatures, each bearing a miniature stūpa in its hands, riding in three separate directions on what Fenollosa calls "light-like paths." Each of the relic-bearing monsters wears a uniform of red shorts.

This supernatural drama is enhanced by a fantastically shaped pine tree. Its dragonlike form emerges from the central foreground and stretches forcefully toward the right edge, extending beyond the pic-

torial space and reentering the picture to display clawlike branches. Its trunk provides an amusing support for three Lohans to lean upon. The landscape's spatial depth is rendered in a three-layered manner: the foreground's dark rock forms and slope are set against a steep, lighter-colored cliff in the middle ground which, in turn, provides an accentuated front edge before the light ink wash of the waterway in the far distance. The clouds, too, with their many demonic forms, heighten the landscape's otherworldly atmosphere.

Although of outstanding artistic quality, this painting carries no encomium by the priest Yishao, who originally commissioned the Lohan scrolls. Its style and brushwork strongly suggest that it is a work by Zhou Jichang produced around the same time as the Freer's *Rock Bridge at Mount Tiantai,* which bears a date of 1178.

39

Zhou Jichang
Lohan in Meditation Attended by a Serpent

Southern Song dynasty, ca. 1178
Hanging scroll mounted as panel;
ink and color on silk
111.5 x 53.1 cm
Denman Waldo Ross Collection 06.288

The painting depicts a Lohan deep in meditation, seated motionless just in front of the entrance to a cave, amidst a turbulent underground stream that emerges in the foreground. The Lohan is indifferent to the inundating water while a large serpent lies around him in a protective gesture. This giant serpent has been misidentified as a dragon but it has neither the four legs nor the claws and scales traditionally associated with the Chinese mythical creature called *long,* or dragon. Instead, it has a snake's body with a single horn in its forehead. The creature depicted here may have been the painter's misunderstanding of the role a *nāga* serpent played in early Buddhist art and narratives from India.

Above the cave, carried by auspicious, reddish clouds, four other Lohans watch and pray for the one meditating on the water. A green-colored guardian king in full armor stands behind the four Lohans

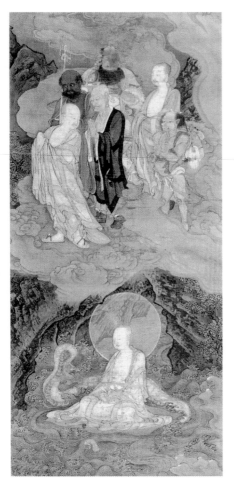

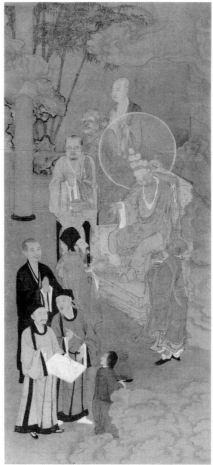

providing protection for the entire group as he carries their belongings, including a water vessel called a *kuṇḍika,* a fly whisk, and scrolls with sacred images and scriptures.

These figure types and landscape details are typical of Zhou Jichang's work. Unfortunately, this painting has no inscription.

40

Zhou Jichang
Lohan Manifesting Himself as an Eleven-Headed Guanyin

Southern Song dynasty, ca. 1178
Hanging scroll mounted as panel; ink and color on silk
111.5 x 53.1 cm
Denman Waldo Ross Collection 06.289

Of the ten Lohan scrolls Ernest Fenollosa acquired for the Boston Museum, this painting displays the highest artistic quality and the most interesting content. It presents a dramatic moment of transformation: One of the five Lohans is either in the process of putting on a mask of an eleven-headed Guanyin or, as Fenollosa noted, the Lohan actually "has pulled aside the bronze skin of his face, as if it were a mask, and revealed beneath the luminous features of the eleven-headed Kannon."[1]

Description

The other four Lohans, three on the far side of the chair, are shown praying. The one standing next to an incense burner has his eyes fixed on the magical moment. Apart from this group, another four figures appear in the left foreground with a boy servant. In front of two praying priests are two figures dressed as laymen, the younger of whom wears a yellow robe and ornate shoes and holds a sketch of a painting in his left hand while gesturing authoritatively with his right hand as if to express an opinion about the work. His elder companion, with a graying beard and wearing plain white shoes, holds a brush in his right hand as if he had just finished the sketch and is trying to tell the other person about it. The praying priest in the black robe is quite possibly Yishao, the monk of the Huianyuan temple who wrote many dedicatory inscriptions in gold ink on paintings in the Daitoku-ji set, although no writing is found on this particular work. The gentleman with a brush is most likely the artist of this painting. Since this painting is stylistically related to known works by Zhou Jichang, it could be his self-portrait. The younger one, dressed more lavishly, is probably the donor who commissioned the work. The donor's identity is unknown since no inscription has been found on this painting.

The painting's color arrangement favors cinnabar red and mineral blue as the two dominating hues. Opaque red is used for the architectural elements as well as the garments of the two Lohans on either side of the chair. The blue color is applied to the fantastically shaped garden rock, the Lohan manifesting himself, the worshipper with a black, tall hat, and a red-and-gray *kaṣāya* (mantle), as well as the handheld incense burner. Besides these two colors, black ink also plays an important role in the picture. Although both Tomita and Cahill attributed this painting to Lin Tinggui, neither provided explanations for that attribution. Judging from the style and brushwork, it is undoubtedly the work of Zhou Jichang. Further evidence of this stems from the fact that the three portraits in the composition agree with similar figures from two other scrolls in the set that were painted by Zhou Jichang.[2]

Interpretation

To return to the image of the masked Lohan, the monk Nianchang recounts in his 1341 publication *Fozu tongzai* (juan 9) that the renowned figure painter Zhang Sengyou was commissioned by the Southern Liang Emperor Wudi (r. 502–49) to paint a portrait of the Buddhist priest Baozhi (d. 514), who was said to possess magical powers. Just before sitting for the portrait, this eccentric priest suddenly scratched his face with his fingernails to manifest an appearance of the "twelve-faced Guanyin." We do not know if Zhang Sengyou actually completed such a work or if its iconography had an impact on the work of later artists, but a Tang-dynasty text—*Zhenguan gongsi huashi* by Pei Xiaoyuan (act. early seventh century), published in 639—records that the author saw a copy made by court artists of the Sui dynasty from a portrait by Zhang Sengyou of Baozhi.[3] It is interesting to note that the Lohan in the Boston painting is the only one of the five depicted with long, sharp fingernails. Also, a group of wrinkle-free faces with smooth, fresh skin emerges from the otherwise old, dark body of this seated Lohan's original face. The total number of faces (or heads) on this Boston Lohan may either be eleven or twelve, depending on how they are tallied. If twelve is the correct number, it would support the connection of the painting to the Baozhi story. The intriguing connection of the work to the Baozhi legend merits further investigation.

1. Fenollosa, pp. 17–18. *Kannon* represents the Japanese pronunciation of the Chinese characters *Guanyin*.
2. See Suzuki, *CICCP*, vol. 4, p. 17, fig. 42; p. 18, fig. 49; and p. 21, fig. 90.
3. Yang Jialuo, p. 20.

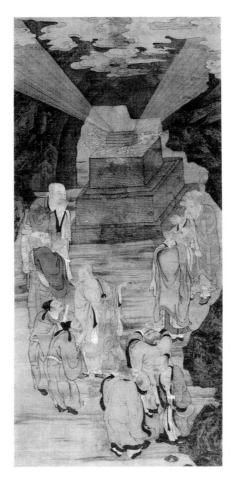

41

Zhou Jichang
Lohan Demonstrating the Power of Buddhist Sūtras to Daoists

Southern Song dynasty, ca. 1178
Hanging scroll mounted as panel; ink and color on silk
111.5 x 53.1 cm
Denman Waldo Ross Collection 06.290

During Emperor Huizong's reign, Daoism was greatly promoted at the expense of Buddhism. When Gaozong and Xiaozong, the first two emperors of the Southern Song period, ascended the throne, the struggle for dominance between the two religions was still intense. Even though Emperor Xiaozong (1127–94, r. 1162–89) was more inclined toward Buddhism, the Buddhists were still being challenged by Daoists. This constant tension between native Daoist and imported Buddhist beliefs in Chinese history is amply illustrated in this painting.

Four Lohans, pride and joy shown in their faces, witness a magical epiphany of Buddhist supremacy. Painted in the center of the picture is a group of twelve scrolls of Buddhist sūtras, neatly tied together and displayed atop a three-tiered pedestal constructed of tiles and bricks. The scrolls radiate a powerful blue and red lightning that shoots out of a sacred cave into the clouds above. Flames burst from beneath the bundle of holy Buddhist scrolls, where, interestingly, a number of half-burned rolls of paper—apparently Daoist writings—are about to be immolated.

A fifth Lohan steps forward, gesturing to two men dressed in official robes and headgear, each with an official tablet held in his hands. This Lohan, wearing a serious facial expression, seems to be admonishing the government officers, symbols of the imperial court, who are, on the other hand, showing their obeisance by bowing slightly and looking up in awe at the magic of the sūtra.

What the fifth Lohan is saying to the government officers perhaps can be understood through the frenzied reaction of a group of three Daoist priests in the foreground. Two of them cannot hide their state of worry and shock. They scramble for a solution to the Lohan's magic and—even worse—to the apparent conversion of the court officers to Buddhism.

The third Daoist is also being won over by Buddhism. He is depicted from the back, his head thrown all the way back and his hands together held high in a gesture displaying his utmost respect for Buddhism. The rather unusual and somewhat humorous posture of this instantly converted Daoist is obviously a sarcastic treatment aimed at Daoism by a professional artist who is either a Buddhist believer himself, or is simply trying to please the Buddhist clients who commissioned the work for the Huianyuan temple in Ningbo.

Clearly the painting is more notable as religious propaganda than for its aesthetic quality. Its artistic style and brushwork, nonetheless, relate closely to the known paintings by Zhou Jichang in the Daitoku-ji set. Although no inscription by the priest Yishao has been found on the present work, scholars have not hesitated to attribute it to Zhou Jichang.

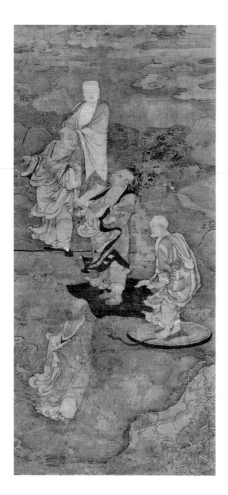

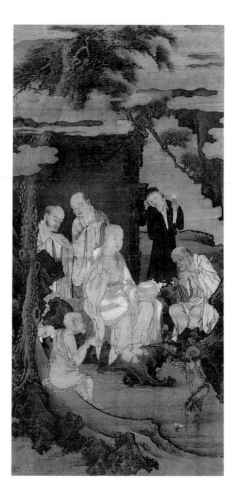

to whether the traditional title, *Lohans Crossing the Sea,* is accurate, especially if we consider that the red-robed, dark-skinned Lohan in this painting is very likely reenacting Bodhidharma's legendary crossing of the Yangzi River. Such historical symbolism would be more appropriate for the Huianyuan temple, whereas an ocean journey would have unavoidably been associated with the equally famous sea-crossing by the Eight Daoist Immortals.

Although this painting has suffered damage in several places, the individual characterizations of the five Lohans remain most successful. Their facial expressions and hand gestures are just as animated as the wind-blown robes and restless waves. To contrast this lively scene, the artist has juxtaposed the Lohan in the background, whose expression is as calm as the priestly garment that adorns his body. This Lohan is a more Chinese-looking figure than the other four—a further reference to the sinicization of Indian Buddhism, especially in the Chan Buddhist sect.

There is no inscription or date by the priest Yishao on the painting.

42

Zhou Jichang

Lohans Crossing the River

Southern Song dynasty, ca. 1178
Hanging scroll mounted as panel; ink and color on silk
111.5 x 53.1 cm
Denman Waldo Ross Collection 06.291

This painting shows five Lohans standing on water, each with a different means of transportation. It reminds viewers instantly of the well-known legend of Bodhidharma, founder of Chan Buddhism, who crossed the Yangzi River on a reed. In fact, the Lohan in a red garment, standing on a reed in the foreground, closely resembles him. Of the other four, one stands on his upside-down bamboo hat, another on a piece of carpet, one on a staff, and the final one, seen in the background, stands on a tree root.

The five Lohans are sandwiched between a group of clouds above and a slope with reeds and grass in the foreground. Such a setting raises a question as

43

Lin Tinggui

Lohans Feeding a Hungry Spirit

Southern Song dynasty, datable to 1178
Hanging scroll mounted as panel; ink, color, and gold on silk
111.5 x 53.1 cm
Denman Waldo Ross Collection 06.292

It is unclear why Ernest Fenollosa selected nine Zhou Jichang paintings and only one by Lin Tinggui for the Boston Museum. Perhaps it was because there were fewer works by Lin Tinggui among the original set of one hundred and even fewer in the forty-four selected for the 1894 Boston exhibition. This painting provides an opportunity to examine the stylistic relationship between these two collaborators for this important set of paintings.

Description and Style

In this work, Lin Tinggui demonstrates a much more forceful and painterly manner of treating trees and rocks than his

colleague Zhou Jichang. Lin Tinggui's brushwork is heavier, bolder, and more angular as well. The outlines of trees and rocks are frequently executed with a deliberate effort to create a rough and rugged appearance. The texturing of the rock surface emphasizes contrasting light-and-dark relationships, producing a more three-dimensional effect. The pine tree rises from the lower left all the way to the top where it is surrounded by the clouds, lending a strong sense of verticality to the painting. All seven figures stand parallel to both the tree in front of them and the cliffs behind them. The figures are brightly colored; the brushwork for the drapery shows the same bold, sharp angularity as the trees and the rocks, even though the drapery lines are more refined and restrained.

One particular type of face that is not seen among Zhou Jichang's works appears in this painting as well as in the Freer's Lin Tinggui: the face of the Lohan standing right behind the pine tree and the rock. He is a less idealized figure, with eyebrows rendered as curved lines, and a short chin and thickened lips that provide him with a more human look. Such individualization also occurs in the Lohan

standing next to him and in the boy attendant who holds a gold-colored bell in one hand and a metal rod in the other. These three figures contrast dramatically with the grotesque faces not only of the hungry spirit in the foreground but also of the two Lohans flanking this spirit. These two Lohans appear to be as hungry for rice as the unfortunate *preta*. In the center of this world of contrasts is a very handsome Lohan of the Chinese type, seated on a piece of carpet spread over the surface of a rock. In his left hand he holds a large bowl of cooked rice and in his right a spoonful of the white rice he is about to bestow upon the deprived being.

Lin Tinggui has provided lavish details for some of the designs: the cloudlike pattern on the outer wall of the rice bowl, perhaps simulating the vessel's wood grain, and the semitranslucent, pale-green garment the central Lohan wears under his pinkish outer robe.

The bell held by the young boy has probably been sounded by the Lohans as a summons to deprived beings, either in this world or the underworld, calling them forth for Buddhist salvation. This strong religious message distinguishes the Boston Lin Tinggui from the Freer's *Lohan Laundering,* in which five Lohans occupy themselves with a most mundane task—washing their own clothes in a mountain stream. The tree branches have been well utilized by these Buddhist sages either as laundry lines or to help wring out the water. The Lohan wringing his cloth has a curve connecting his eyebrows exactly like his counterpart in the Boston painting. The treatment of the rocks and the drapery lines are identical in the Boston and the Freer scrolls, and both works display the artist's interest in achieving surface richness, in sharp contrast to Zhou Jichang's concern for spatial depth.

Attribution and Dating

The valuable inscription on the lower right corner on the Freer Lin Tinggui was analyzed by Wen Fong.[1] In it, the priest Yishao of the Huianyuan temple identifies the artist as Lin Tinggui. In the case of Boston's Lin Tinggui, although the half-damaged writing by Yishao has left out the name of the painter, it is still possible to identify this painting as his work based upon Wen Fong's research. The Boston inscription appears in four lines of regular script in gold ink at the lower-left corner. It gives the *xiang* (village) name as Wanling and the name of the *li* (district) as Chicheng. The donor is a woman from the Zhang family who donated money to have the painting executed as a permanent offering to the Huianyuan temple. The inscription bears a date in the eighth moon of the fifth year of the Chunxi era (1174–89) during Emperor Xiaozong's reign, corresponding to 1178. Although the name of the priest Yishao can only vaguely be discerned, the name of Lin Tinggui is illegible to the naked eye, even under high magnification.

Two discrepancies arise among the inscription on the Boston scroll, those on the two at the Freer, and another one published by *Kokka.*[2] First, in the Boston Lin Tinggui, the woman donor is referred to by the priest Yishao as *nüdizi* (female devotee); on the other three examples, each woman is merely attached to her husband's name. Second, the Boston version provides the "eighth moon of the fifth year" as the precise time for the donation; on the other three examples, only the year is mentioned. It is significant, perhaps, that all four published inscriptions by Yishao are dated in the fifth year of Chunxi, which means the paintings were made no later than this year, although theoretically they could have been made slightly earlier.

According to Thomas Lawton, the entire set of one hundred paintings "was commissioned in 1175 by Abbot I-shao of the Hui-an yüan in Ning-po, Chekiang. The paintings were completed in 1178."[3] It is unclear what reference the 1175 date is based upon. Other scholars seem to have different readings; James Cahill, for example, has dated three of the Boston group in 1180, 1184, and 1188, all later than the year 1178 when the set was supposed to have been completed.[4]

1. Fong, *The Lohans and a Bridge to Heaven,* p. 2 and pls. 2 and 3.
2. *Kokka,* vol. 238 (March 1910), p. 239.
3. See Lawton, *CFP,* p. 97.
4. Cahill, *Index,* p. 78.

44–47

Jin chushi (act. late 12th–13th century)

Four of the Ten Kings of Hell

Introduction

In China, long before the arrival of Buddhism, traditional beliefs about the afterlife developed through shamanism, native ancestor cults, and Daoist religion. Buddhist teaching, with its doctrines of karma, reincarnation, and salvation, introduced new understandings of the realms of the living and dead, past and future lives, heaven and hell. These ideas were richly represented in Chinese Buddhist art. During the Tang dynasty, artists like Wu Daozi were famous for their often frightening depictions of the afterlife. According to *Tangchao minghua lu* (Famous Paintings of the Tang Dynasty) by Zhu Jingxuan (act. early ninth century), when Wu Daozi painted a mural of hell scenes at the Jingyunsi temple in the capital city of Chang'an, local butchers became so terrified at seeing the brutal punishments meted out to those who killed animals that they changed their profession.[1]

By the late Tang, many such pictorial representations of retribution in the underworld for sins committed in this life were produced. The Buddhist notion of hell was based upon a text known in Chinese only as the *Shiwangjing—The Sūtra of the Ten Kings of Hell.*

One of the earliest images of these kings appears in a handscroll from Dunhuang depicting the Bodhisattva Kṣitigarbha (Dizang) and ten kings of hell (British Museum, London), whose duties and punitive measures are detailed in Chinese characters.[2] Compared with a late-sixth-century Central Asian hell scene from Kizil, also in the British Museum, the iconography changed radically. We can see that the simple, symbolic style at Kizil developed into the elaborately descriptive and realistic style in China. The art historian Guo Ruoxu recorded that, later, in the Five Dynasties period, an artist of religious paintings named Wang Qiaoshi (act. tenth century) painted more than one hundred works on the subject of the ten kings of hell and the Bodhisattva Kṣitigarbha.[3]

A fascinating aspect of the iconography of these Buddhist hells is the manner in which they became thoroughly sinicized. The hell courts were all organized according to the legal and bureaucratic system familiar to the contemporary Confucianist society. By the twelfth century, the scenes and the hierarchy of kings presiding over the ten great hells had evolved into sets of lavishly colored images. As Korea and Japan started to accept this much-sinicized image of hell, the demand for such pictorial reminders geared to Buddhist worshipers grew, and Ningbo, China's major trading port for other Asian countries, soon became a center for producing religious art for export, with many flourishing workshops of professional painters. Of the existing Chinese hell paintings, a majority have been carefully preserved in Japan since the Southern Song dynasty.

From the late-twelfth century onward, Ningbo workshops set the standard and style for such export paintings with religious themes. Most likely, the leading artist was Lu Xinzhong (act. late twelfth–early thirteenth century), a name little known in his native country, but highly regarded in Japan. Even less-well known was Jin Dashou, who is thought by American scholars to be the same as Jin chushi (Jin the Recluse). Scholars in Japan are reluctant to assume that the two names belong to the same artist.[4] No works by this artist are known to exist in China. However, in the early twentieth century, nine paintings from a set of ten kings of hell were sold to the Museum of Fine Arts, Boston, and the Metropolitan Museum of Art, New York.[5] The rich colors and animated portrayals in these nine scrolls bear many similarities to the works of the other leading Ningbo professional painter, Lu Xinzhong. Commercial competition rather than religious zeal may have inspired each of the workshops to surpass the other in order to win commissions from abroad. If one had a new creative idea, the others would not hesitate to borrow from it immediately.

Boston acquired two of these hell paintings in 1906 and two more the following year. None of the four kings is identified by any original inscription and Tomita gave no reasons for the titles he assigned to the four kings in his 1933 Portfolio. Based on comparison with available sets in Japan, however, it is now possible to propose the following new identi-

fications:[6] 1—formerly King Ch'u-chiang Hearing a Protest, can be identified as the first king of hell, Qinguangwang (cat. 44); 2—formerly King Tsung-ti Revering a Sūtra, can be identified as the tenth king of hell, Wudaolunzhuanwang (cat. 45); 3—formerly King Pien-ch'eng Listening to a Plea, can be identified as the ninth king of hell, Dushiwang (cat. 47); and 4—formerly King Tu-shih Writing a Judgment, can tentatively be identified as the sixth king of hell, Bianchengwang (cat. 46). Damage to this scroll and a lack of comparable motifs or torture scenes makes the identity of this king more problematic, however.

1. See Yang Jialuo, Nanchao Tang Wudai ren huaxue lunzhu, p. 16.
2. See Weidner, p. 133, fig. 37.
3. See Guo Ruoxu, Tuhua jianwen zhi. juan 2, p. 23, in Yu Anlan, HC, vol. 1.
4. For centuries Jin Dashou was incorrectly identified as "Xijin jushi" by collectors. Modern Japanese scholars have determined that this was based on a misreading of original Chinese inscriptions. Nobuyuki Minato of the Tokyo National Museum called my attention to the set of Lohan paintings signed by Jin Dashou in his museum's collection. They differ in style from the Kings of Hell by Jin chushi in Boston and New York. See Buddhist Images of East Asia, exhib. cat. (Nara: Nara National Museum, 1996), pp. 162–63 and 270.
Concerning English-language references to Jin Dashou, Jin chushi, and "Xijin jushi," see Cahill, Index, p. 77, and Fong, BR, p. 375, n. 18. The term chushi (recluse) is associated with a number of Chinese painters. See Xia Wenyuan, Tuhua baojian: buyi (1366), in Yu Anlan, HC, vol. 2, pp. 144 and 146.
5. According to Cahill, the tenth is still in a private collection in Japan. See his Index, p. 77. Of the five companion pieces from this set in the Metropolitan Museum of Art, New York, only Yama, the fifth king, has been identified. The motif of the karmic mirror showing the past misdeeds of the deceased makes this identification reliable. See Fong, BR, pl. 74a, p. 336.
6. See illustrations of various kings of hell in Nihon no Bijutsu, no. 313 (June 1992).

44

Jin chushi

First King of Hell: Qinguangwang

Southern Song dynasty, late 12th century
Hanging scroll mounted as panel;
ink, color, and gold on silk
107.5 x 47.4 cm
Denman Waldo Ross Collection 06.317

Based on comparisons with Lu Xinzhong's Ten Kings paintings and their original identifications in the Eigen-ji (Shiga prefecture) collection, it is possible

to identify this king as the First King of Hell, Qinguangwang.[1] According to the Ten Kings Sūtra, this king is charged with making a preliminary judgment that separates good souls from evil ones right after the deceased arrive at the first hell. In this scroll, the two figures in the middle ground appear to argue with the presiding king, perhaps over the judgment or the severity of the sentence. In the left foreground, a deceased mortal is tied to a post to enable a ferocious demon to extract his tongue with a large pliers. On the lower right, amidst a snake and a cloud of flames, a deceased mortal lies prone on a low table while a demon wielding a butcher's knife (or axe) high in his right hand prepares to mutilate the poor soul.

1. See Suzuki, CICCP, JT-108-001 pl. 1/11.

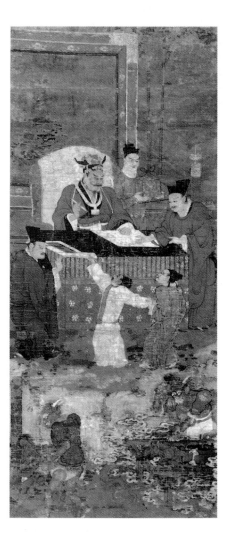

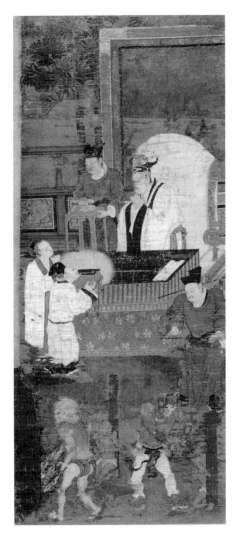

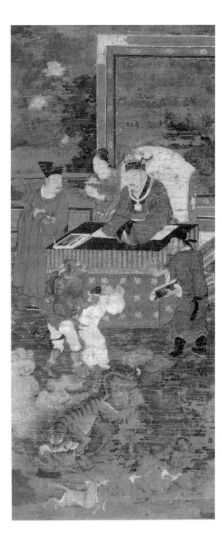

deeds. Even the hell clerk at the king's side is unusually friendly toward the two penitents, who will soon depart for a better incarnation. In sharp contrast, the foreground displays a typical hell torture reserved for the less fortunate. Behind the king, an attractive garden is half seen beyond the landscape screen.

In other paintings showing this particularly moving scene (where the infernal bureaucracy and sinners have a less painful exchange), the deity is usually identified as the tenth king of hell with the title Wudaolunzhuanwang.[1] It should be noted that in some examples, this presiding deity is identified as a different hell king. The inconsistency may result from different traditions of arranging the roles and sequence of the ten. Jin chushi and Lu Xinzhong, though contemporaries and both leading Ningbo professional artists, appear to have developed their own respective variations.

1. See Suzuki, *CICCP*, vol. 3, p. 73, JM4–001/10. The tenth king of hell by Lu Xinzhong is identified by the original title written in the upper-right corner. The set is in the collection of the Agency for Cultural Affairs, Tokyo.

45

Jin chushi
Tenth King of Hell: Wudaolunzhuanwang

Southern Song dynasty, late 12th century
Hanging scroll mounted as panel;
ink, color, and gold on silk
107.5 x 47.4 cm
Denman Waldo Ross Collection 06.318

This king decides whether a deceased soul is to be dispatched to paradise, reborn as a human being or, as shown in the foreground, put to further punishment before returning in a less favorable incarnation. Kings of hell, understandably, should appear fearful and authoritative. This king, however, is depicted as being not only merciful, but compassionate. The king is shown standing next to his desk with hands clasped in a praying gesture. In front of him, two pardoned souls hold their hands high with the shining sūtras just given to them in reward for good

46

Jin chushi
Sixth King of Hell: Bianchengwang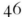

Southern Song dynasty, late 12th century
Hanging scroll mounted as panel;
ink, color, and gold on silk
107.5 x 47.4 cm
Denman Waldo Ross Collection 07.2

Damage to this scroll makes it uncertain what torture scene is depicted in the foreground. Two jumping goats appear in the center, and judging from the threatening gesture of the demon who grasps the deceased by the hair, it is possible that his sin derives from some harm inflicted on the goats. The scene itself offers few clues to which hell king presides here, and there is no corresponding torture scene among the sets with cartouches by Lu Xingzhong. In two such sets, however (one in the collection of Honen-ji, Kagawa prefecture; another in Eigen-ji), only the sixth king is shown in the act of writing (rather than simply holding a brush).[1] In both sets, that king is identi-

fied in Lu Xingzhong's cartouches as Bianchengwang. The king in the Boston scroll is similarly depicted.

1. See Suzuki, *CICCP*, vol. 4, pp. 80 and 107.

47

Jin chushi
Ninth King of Hell: Dushiwang

Southern Song dynasty, late 12th century
Hanging scroll mounted as panel;
ink, color, and gold on silk
107.5 x 47.4 cm
Denman Waldo Ross Collection 07.1

This painting consists of two parts: First, the foreground, as usual, displays a scene of torture in which a deceased soul is chased and devoured by wild beasts. Second, separated by the motif of clouds, the upper half of the painting shows the king, in the company of two clerks and a servant, who presides over a case. The costumes, furniture, and flower garden are all

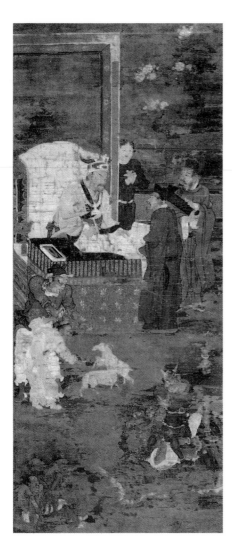

typical accouterments of a well-to-do lifestyle that would have been found around Hangzhou and Ningbo during the Southern Song. The two important elements in the painting—the devouring tiger and the demon grasping the deceased from the back—come close to Lu Xinzhong's rendition of the ninth king in the collection of Eigen-ji in Japan.[1] This may be an example in which Jin chushi adopted a design by his chief competitor in Ningbo.

Jin chushi displays a broad repertoire of subjects he has mastered: realistic and imaginative figures, animals, flowers, and textile designs. Bright and thick colors generally decorate the motifs, which are skillfully outlined in ink to define the detail. An ink landscape adorns the surface of a large screen behind the king. It is noteworthy that both of Ningbo's leading Buddhist artists have incorporated tranquil ink landscapes in their otherwise gruesome hell paintings. Such landscapes originated in southeastern China and became popular with Chan Buddhist and literati

painters during the Southern Song period.

1. See Suzuki, *CICCP*, JT-108-001, pl. 9/11.

48–62

Lu Xinzhong (act. late 12th-early 13th century)
Sixteen Lohans

Introduction

Pictorial representations of groups of sixteen Lohans appear early in China. The first Chinese artist recorded as creating such works is Zhang Sengyou of the Southern Liang dynasty (502–57).[1] Unfortunately, apart from the title, nothing else is known about Zhang Sengyou's *Sixteen Lohans.* In terms of compositional style, figure types, and brush technique, these early Lohans undoubtedly would be quite different from those sets created seven hundred years later by Ningbo artists during the Southern Song dynasty. If the *Sixteen Lohans* attributed to the tenth-century monk–painter Guanxiu (Imperial Household Collection, Tokyo), is any indication, Guanxiu's style is probably much closer to Zhang Sengyou's than it is to Lu Xinzhong's vivid, colorful renditions. For example, among Lu Xinzhong's Lohans in the Boston set, at least nine look distinctly Chinese and all are busy performing miracles—a clear reference to the impact of the native Daoism on Indian Buddhism. On the other hand, Guanxiu's Lohans all have a non-Chinese appearance and none are involved in supernatural activities.

The tradition of painting sixteen Lohans continued to flourish in the Southern Song and beyond, even as the depiction of new and larger groups of Lohans—eighteen or, indeed, five hundred—became fashionable. Lu Xinzhong's version differs in two major respects from the five hundred Lohans depicted by Zhou Jichang and Lin Tinggui in the Daitoku-ji set (cat. 34–43). Lu's figure type is considerably more rigid and heavy than Zhou and Lin's curvilinear, lyrical portrayals. Further, Lu's bulky, shortened figure-forms show little motion and appear as though carved from blocks of wood. By contrast, a key characteristic of the Daitoku-ji group is the Lohans' great animation and fluidity.

Of the sixteen Lohans in this set, fifteen are original Southern Song works and one, the tenth Lohan, is a copy by an anonymous fifteenth-century Japanese artist, which was substituted as a replacement and therefore not included here. Unmentioned in Chinese publications, the artist Lu Xinzhong is recorded in the fifteenth-century Japanese publication *Kundaikan Sōchōki* by Noami (1397–1471).

Lu Xinzhong was said to have been active during the late-twelfth to the early thirteenth century and had a workshop in the commercial quarter of Ningbo, where he and his apprentices collaborated to produce sets of religious paintings. Almost all extant works attributed to him are in Japan, or came from former Japanese collections. Directly related to the Boston set of Lohans is another *Sixteen Lohans* of larger size by Lu Xinzhong (Shōkoku-ji collection, Kyoto).[2]

In comparison with the Shōkoku-ji set, the Boston paintings have a simpler, more focused structure with extensive open space in their compositions. These works concentrate on elaborate depictions of figures. Decorative details of architecture and textiles, executed in gold and bright colors, are also selectively depicted to accompany the Buddhist figures. The Shōkoku-ji set, on the other hand, is clearly a much more lavish and developed production, finished with more ornate compositions.

Based on its generally more archaic style, the Boston set probably pre-dates that in the Shōkoku-ji. Further evidence of an earlier date for the Boston paintings is found in the inscriptions. The twelfth and the thirteenth Lohans in the Boston set have similar inscriptions by the artist: "Painted by Lu Xinzhong at Stone Slate Lane [*Shibanxiang*], Chariot Bridge [*Cheqiao*], in Siming." All sixteen works at Shōkoku-ji are inscribed: "Painted by Lu Xinzhong at Stone Slate Lane, Chariot Bridge, in Qingyuanfu." Siming and Qingyuanfu are both old names for the city of Ningbo. Siming, or Mingzhou, was used in the Southern Song dynasty until the first year of the Qingyuan era (1195), when the name was changed to Qingyuanfu. Therefore, the Boston set must have been created before that date, while the Shōkoku-ji set was made after 1195, possibly in the first half of the thirteenth century and certainly before 1276, when the Mongol rulers changed the

name to Qingyuanlu. Ebine Toshirō found the exact location of Cheqiao and Shibanxiang and discovered that the area of Lu Xinzhong's original workshop is still a commercial district today.[3]

Each of the scrolls in the Boston set of Lohans originally bore the name of what is now thought to be a Japanese temple, Manju-ji, on Minakami mountain, but some of them were later trimmed and many of the original artist's inscriptions on the Boston works were also cut away during remounting. The transliterated Sanskrit names of the Lohans are written in regular Chinese script on white cartouches with a red border. For unknown reasons, several Lohan names were abbreviated further and it is these names that have been adopted for the Chinese titles in the entries that follow. The cartouches are decorated top and bottom with lotus leaves and blossoms in a manner similar to other Song and Yuan Buddhist paintings. The Shōkoku-ji set, however, bears no cartouches.

1. See *Xuanhe huapu,* juan 1, p. 5, in Yu Anlan, *HC,* vol. 2.

2. All of the Shōkoku-ji Lohans are illustrated in Suzuki, *CICCP,* vol. 4, pp. 4–5, figs. JT 3–001. However, except for the fifth Lohan, the sequence used for the *Sixteen Lohans* is entirely different from Boston's.

3. Ebine, pp. 60–66.

48

Lu Xinzhong
The First Lohan Piṇḍolabharadvāja

Southern Song dynasty, late 12th century
Hanging scroll mounted as panel;
ink, color, and gold on silk
80 x 41.5 cm
William Sturgis Bigelow Collection 11.6123

A young attendant with buck-teeth, having just ignited a brand, safeguards the flame from the wind with his hand in order to provide the illumination by which the Lohan reads the sūtra unrolled on top of a black-lacquer table. The elderly Lohan sits in profile in an exotic chair that is unrelated to the typical Chinese black-lacquer furniture in the painting. Two young Chinese monks, one in a praying gesture, the other holding a box, echo the two Chinese tables in the picture. The fanciful railing, the strangely

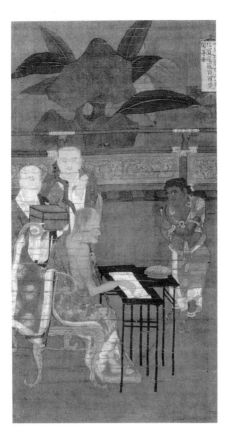

shaped rock, and a plantain tree form a garden setting typical of the area around Hangzhou and Ningbo, Lu Xinzhong's home.

The artist's attention to detail is well demonstrated by the rendering of the wood-grain on the box, the blue-green and gold peony design on the railings, and the rug with a chrysanthemum design covering the Lohan's chair. The seemingly abstract patterns on the cover of a box on the black-lacquer table are actually two double-outline Chinese characters—*bao dian,* the term for Buddhist halls.

Although this painting no longer has the artist's inscription, two other writings appear on it: The cartouche contains the Chinese transliteration of the Lohan's Sanskrit name and his residence; "Manju-ji," the name of the Japanese temple that once owned the set, is written just below the cartouche. In the Shōkoku-ji version of this painting, the Lohan sits in a black-lacquer chair. Many more details were added to the Shōkoku-ji composition, including a vase of lotus blossoms placed on a stand, and a low platform upon which the Lohan's chair and tables are placed. Apparently the Boston version depicts the most essential elements of the composition with few embellishments, unlike the busy style of the Shōkoku-ji painting.

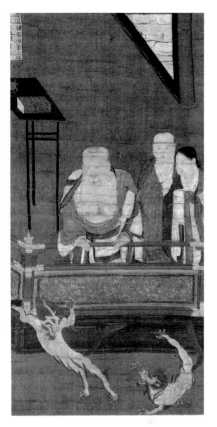

49

Lu Xinzhong
The Second Lohan Kanakavatsa

Southern Song dynasty, late 12th century
Hanging scroll mounted as panel;
ink, color, and gold on silk
80 x 41.5 cm
William Sturgis Bigelow Collection 11.6132

The Lohan Kanakavatsa (Chinese: Jianuo-jiabacuo) and his two acolytes are thoroughly absorbed by watching two fantastic beasts playfully fighting in a courtyard. Behind the Lohan, possibly added by a lesser artist from Lu Xinzhong's workshop, is a black-lacquer table with volumes of sūtras and an incense burner, as well as fragments of a wall and a column in front. Perhaps the artist meant to suggest that the scene takes place in a Buddhist building or a temple. The Shōkoku-ji version gives a much more thorough indication of the interior and its furnishings. The white beasts probably represent the Chinese idea of what lions might look like. Lu Xinzhong's inscription is no longer preserved on the Boston painting; only the name of the Manju-ji temple appears in the upper-right corner.

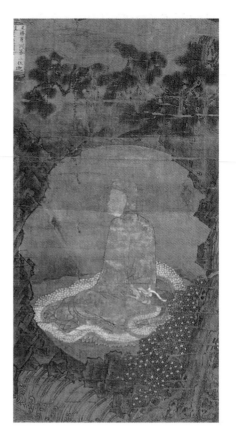

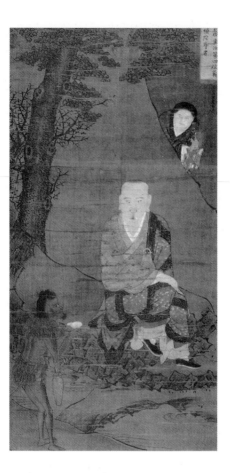

50

Lu Xinzhong
*The Third Lohan
Kanakabharadvāja*

Southern Song dynasty, late 12th century
Hanging scroll mounted as panel;
ink, color, and gold on silk
80 x 41.5 cm
William Sturgis Bigelow Collection 11.6127

The inscription in the cartouche at the top left reads, "Jiabaliduoshe," which is short for the more common Chinese transliteration "Jianuojiabaliduoshe." The third Lohan appears seated in profile, with closed eyes and tight lips, deep in meditation by a waterfall. In contrast, his protector, the serpent encircling him, is quite alert, its eyes and mouth wide open. The Lohan radiates a circle of magical light that encompasses himself and the serpent. He is seated in a womblike cave, surrounded by craggy rocks and gushing water. The artist depicted the Lohan with finely detailed line drawing, while freely applying his brush to depict the rugged environment with expressive strokes. He is less successful in convying a sense of depth. The artist employs an iconography often associated with Bodhidharma, the

South Indian prince who, according to legend, arrived in China at the age of 150 and was recognized by Chinese as the founder of Chan Buddhism. This is part of an accepted symbolic vocabulary that conveys the idea of an appropriate environment for Buddhist meditation. Such a setting serves to remind the viewer of the difficulties involved in attaining Enlightenment. The artist juxtaposes the enduring rocks and pine with the ever-changing clouds and water. In addition, the flowering vegetation and waterfall perhaps symbolize the fragrance and purity of the Lohan's enlightened mind.

51

Lu Xinzhong
The Fourth Lohan Suvinda

Southern Song dynasty, late 12th century
Hanging scroll mounted as panel;
ink, color, and gold on silk
80 x 41.5 cm
William Sturgis Bigelow Collection 11.6130

In contrast to his dramatic facial expression, the Lohan Suvinda (Chinese: Supintuo) sits motionless on a rock. His robe displays an interesting design motif of mountains and waves. Across from a small stream, an exotic-looking man wearing tree leaves over his shoulders and waist offers two peaches, their leaves still intact, to the Lohan. This Daoist gesture wishing longevity to the Lohan is, in fact, an example of the kind of syncretism that often appears in the Chinese art of the two rival religions, Buddhism and Daoism. Behind the Lohan, a young attendant brings out a shining, gilt stūpa. The landscape is simplified to such a point that a mere section of a tree and some suggestion of rocks are all that is presented. But this simple composition is pervaded by a sense that profound dialogue is taking place among the Lohan, his attendant, and the Daoist, all of which is subtly conveyed through facial expressions, especially in the figures' eyes.

There is no inscription by Lu Xinzhong, but the names of the Lohan and the Japanese temple, Manju-ji, are written in Chinese characters at the upper right. The characters *man* and *ju* are written in an abbreviated style, similar to the *tōyō kanji* script used in Japan today.

This painting's Shōkoku-ji counterpart provides the Lohan with a more complicated landscape background. In addition to the three figures, another monk stands behind the Lohan, and the small stream that separates the Boston Lohan from the corresponding leaf-clad man has been transformed into a sizable pond in the Shōkoku-ji example.

52

Lu Xinzhong
The Fifth Lohan Nakula

Southern Song dynasty, late 12th century
Hanging scroll mounted as panel;
ink, color, and gold on silk
80 x 41.5 cm
William Sturgis Bigelow Collection 11.6126

Holding a censer with both hands, the fifth Lohan sits in a meditation chair in front of a three-fold screen that is decorated with ink landscape paintings. On either side of him, two pairs of monks pray. In front of the Lohan a pair of flower vases and a candlestand have been placed on top of a small, black-lacquered table. The flowering branches in the vases

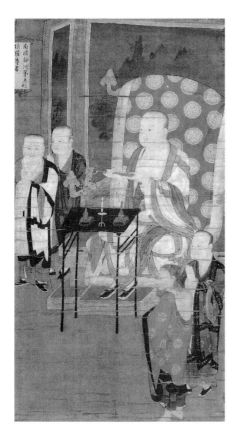

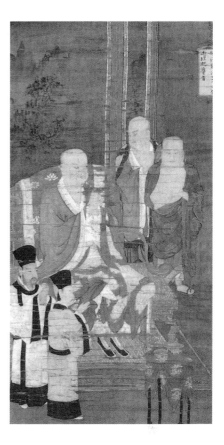

instead of flanking the Lohan, two monks stand in front of the platform and two more are behind it. A minor but noteworthy difference between the two versions is the shapes of the two vases, which indicates that the paintings were executed at different dates. The vases in the Shōkoku-ji painting are of the so-called *yuhuchun* (pear shape), a form fashionable in the thirteenth century. In the Boston version, the vase shapes are of an earlier, long-necked type.

1. See Siren, vol. 3, pl. 209.

53

Lu Xinzhong
The Sixth Lohan Kārika

Southern Song dynasty, late 12th century
Hanging scroll mounted as panel;
ink, color, and gold on silk
80 x 41.5 cm
William Sturgis Bigelow Collection 11.6135

This Lohan is identified by his transliterated Chinese name as the sixth Lohan Jialijia zunzhe. However, according to Buddhist sūtras, particularly the *Fazhuji* (A Record of the Abiding of the Dharma Spoken by the Great Arhat [Lohan] Nandimitra), this Lohan should instead be the seventh.[1] Such an unusual misidentification may reflect the degree of sincization of Buddhism in China by the late-twelfth century, when Chinese artists were less concerned about the Indian origin of these Lohans. Such an attitude may also explain two other inaccuracies in this and other sets of Lohan paintings: (1) At least nine of the Boston Lohans have Chinese features rather than those of the their native South or Central Asian regions; and (2) four of the Lohans' transliterated Chinese names were carelessly abbreviated in the artist's Ningbo workshop, without concern for the original Buddhist literature.[2]

The Lohan Kārika sits in a meditative pose on an elaborate chair before a three-fold landscape screen. He is flanked on one side by two monks and on the other by two devotees, all of whom hold their hands in a gesture of prayer. In front of this group, an exquisitely shaped celadon incense burner and its companion incense box are placed on top of a black-lacquer

stand, which is covered with a piece of red brocade. An even more elaborate brocade with lotus motif covers the back of the Lohan's chair, on the surface of which the artist has applied very fine gold hatching to create a realistic appearance of woven material. The two ink landscapes on the screen are freely rendered in the style of the eleventh-century master Guo Xi. The trees in the foreground of the larger one are executed in the so-called "crab's claw" technique, with all their branches painted in a curvilinear manner. The distant mountain in ink wash also relates to a later development of the Guo Xi school. This painting style is comparable with two album leaves of the same school in the Boston Museum (cat. 126 and 127). The screen painting should originally have included a third side panel, which would presumably have been decorated with an ink landscape as well, but it has been cropped from the scroll.

Despite the artist's ability to execute elaborate designs and apply bright colors, he delighted in presenting the figures in blocklike shapes, which are short, heavy, stiff, and archaic. The landscape decorating the screen in the Shōkoku-ji version is in color. It is closer to the realistic style of the Southern Song academy and, as such, corresponds well with the overall landscape elements shown on the Shōkoku-ji

cannot be seen fully because of damage to the work, but the smoke of the incense from the censer and the red flame from the white candle are clearly visible. A reddish textile with floral-medallion designs serves as a cover for the back of the Lohan's chair. The two landscape paintings, although only partially visible, are in the same style as the ones painted on the screen for the sixth Lohan (cat. 53).

The artist's attention to minute detail appears in such unexpected areas as the side panel beneath the right armrest of the Lohan's chair, where, surprisingly, another ink landscape painting appears. The depiction of the Lohan in a high-backed chair, with its colorful textile cover, recall the many portrait paintings of Chan Buddhist masters executed in the Southern Song period.[1]

Neither a signature of the artist nor the name of the Japanese temple Manju-ji appears on the scroll. The Chinese name of the Lohan Nakula, abbreviated from three characters to only two—*Juluo*—is written at the upper-left edge.

The Shōkoku-ji version differs from the one in Boston in both composition and details. The former places the Lohan on a high-rise platform, an arched stairway in front of him. No screen is depicted behind the platform; rather, a canopy hangs over the Lohan's head. Moreover,

set. No artist's inscription is found except the name of the Japanese Manju-ji temple and the Chinese name for this Lohan.

1. For discussion of the scriptural sources and imagery of the Lohan cult in China, see Richard K. Kent, "Depictions of the Guardians of the Law: Lohan Painting in China," in Weidner, pp. 184–88 and 206 n. 2–3.
2. The same lack of fidelity to the canonical Buddhist sūtras is reflected in the inconsistent identifications of the ten kings of hell in scrolls produced by Southern Song artists in Ningbo workshops. See introduction to cat. 44–47 and cat. entries 46 and 47.

54

Lu Xinzhong
The Seventh Lohan Bhadra

Southern Song dynasty, late 12th century
Hanging scroll mounted as panel;
ink, color, and gold on silk
80 x 41.5 cm
William Sturgis Bigelow Collection 11.6136

A catlike tiger responds to the call of the seventh Lohan, Bhadra (Chinese: Batuoluo). It raises its head all the way up to look at the Lohan, who sits sideways, looking toward the right while turning his body toward the left. With his right hand he supports himself on the rock, and with the left hand he reaches out, beckoning to the tiger. The crossing of the Lohan's two hands is echoed by the crossing of the two pine trees behind him. A boy attendant is shown peeking out from behind the tree.

At the upper-left edge, the remaining half of the Chinese name for the seventh Lohan appears; however, in the original Buddhist sūtra Bhadra is identified as the sixth rather than the seventh Lohan.[1] There is no artist's inscription, but the name of the Japanese temple Manju-ji is written in Chinese characters in the upper-right corner, among the pine needles. The Shōkoku-ji counterpart of this painting includes an elaborate landscape setting. In addition to the two pine trees, it shows dramatic rock formations with waterfalls running down from the upper left.

1. See discussion for previous Lohan scroll, cat. 53.

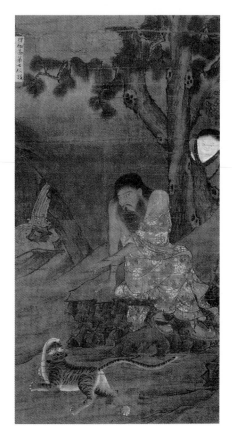

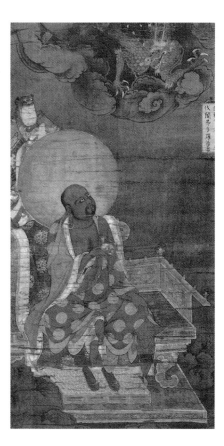

55

Lu Xinzhong
The Eighth Lohan Vajraputra

Southern Song dynasty, late 12th century
Hanging scroll mounted as panel;
ink, color, and gold on silk
80 x 41.5 cm
William Sturgis Bigelow Collection 11.6124

From his seat on a throne, the eighth Lohan enlists the magical power of his jewel to summon a dragon. Mists emerge from the base of the throne while a body of moving clouds accompanies the arrival of the dragon from the sky. The dragon, painted in red and accentuated in white, differs from the traditional Chinese Daoist version, which is normally blue. Such subtle differences suggest the artist's desire to borrow a non-Chinese red dragon to go with a non-Chinese Indian Lohan. This Lohan's brownish skin and his red robe with gold design perfectly echo the colors of the dragon. A guardian king in Chinese armor witnesses this miracle from behind the Lohan. The basic structure of the Lohan's meditation throne is related to, but more ornate than, the imperial throne depicted in the anonymous painting *Portrait of Emperor Taizu of Song* (National Palace Museum, Taipei).[1] The imperial throne with straight legs and red-lacquer surface depicted in the Taizu portrait is typically Chinese, while this one with curved legs, carved floral design, and ornamental jewels around its rails is evidence of the artist's effort to add to its exotic, non-Chinese appearance.

Two inscriptions are found at the upper-right edge. The first, in small characters, reads "Shuishangshan Wanshousi." Tomita speculated that it may be the name of a temple in Ningbo, but Japanese scholars are either unsure about its location or have identified the temple as one in Japan.[2] Judging from the calligraphical style and the name of the mountain Shuishangshan (Japanese: Minakami), it is more likely the Japanese temple Manju-ji. The second inscription contains the transliterated Chinese name (Fashefo-duoluo) of the Arhat known in Sanskrit as Vajraputra. This inscription is written in two lines of regular script within a red-lined boundary that is decorated with lotus leaves and blossoms at top and bottom. This writing is consistent with the

date of the painting.

The larger version of this Lohan in the Shōkoku-ji collection is compositionally related to Boston's but differs in many details. For instance, the Shōkoku-ji painting is filled with cloud motifs. Its dragon appears almost in its entirety, and the Lohan wears a simpler robe and no sandals. The basic form of the throne is more Chinese than that in Boston's scroll. Most likely, the Boston painting has been cropped on all four sides and its original size was probably closer to the Shōkoku-ji version.

1. See Smith and Wan-go Weng, p. 158.
2. See the introduction to these Lohan entries on pages 170–71, and Ide Seinosuke, p. 89 *n.* 1.

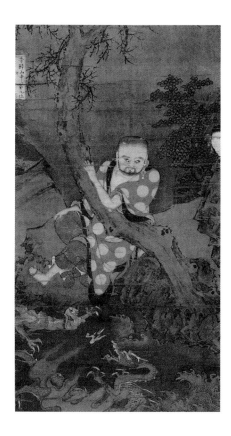

56

Lu Xinzhong
The Ninth Lohan Jīvaka

Southern Song dynasty, late 12th century
Hanging scroll mounted as panel;
ink, color, and gold on silk
80 x 41.5 cm
William Sturgis Bigelow Collection 11.6138

The painting shows the ninth Lohan Jīvaka (Chinese: Xubojia) sitting at the edge of a cliff, where he leans against a tree trunk that forms a cross with his reclining body. The Lohan intently watches two dragons vigorously chasing a flaming jewel in the water. His colorful robe contrasts with the ink-painted trunk of the bare tree with leafless branches circling down its trunk. The Lohan's attendant is shown hiding behind a tree as if in fear of the battle between the dragons. The artist has dramatized the combat by depicting flames and high waves.

The Lohan's name is written at the upper-left edge. No additional inscriptions identify Lu Xinzhong or the Japanese temple Manju-ji. In the Shōkoku-ji version, the scene of the dragon fight takes up one third of the composition. The bare tree in the Boston painting becomes a pine tree lush with needles in the Shōkoku-ji scroll.

57

Lu Xinzhong
The Eleventh Lohan Rāhula

Southern Song dynasty, late 12th century
Hanging scroll mounted as panel;
ink, color, and gold on silk
80 x 41.5 cm
William Sturgis Bigelow Collection 11.6125

The Lohan sits on a chair inside a pavilion and leans against a railing to watch two deer in the courtyard, each of which holds a flower in its mouth. The deer must have been enlightened by the Lohan's preaching and therefore have come forth to offer flowers to the Lohan—an auspicious omen. Behind the Lohan are two young attendants, one of whom holds a stack of sūtras while the other, having just retrieved incense from the white porcelain box on the black-lacquer table, puts it in a celadon incense burner. The artist painted minute designs on small objects, such as the porcelain box and the incense burner, but he also decorated the pavilion with lavish design. A red-lacquer column stands on a carved base and the inside faces of the railings are constructed of beautifully grained wood. The outsides of the railings, which are partially lacquered in red and have gold reinforcement at the joints, are decorated

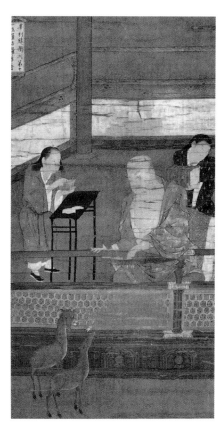

with panels of brocadelike designs.

This painting has neither the artist's signature nor the name of the Japanese temple Manju-ji. But in the upper-left corner, the Lohan's Chinese name Luohuluo is written on a cartouche decorated with a lotus blossom and leaf. The Shōkoku-ji version of this painting is more highly decorated. The addition of a large tree in the courtyard and in front of the Lohan plus the bamboo grove outside the pavilion make the Shōkoku-ji version appear to be much more complete than the one in Boston.

58

Lu Xinzhong
The Twelfth Lohan Nagasena

Southern Song dynasty, late 12th century
Hanging scroll mounted as panel
ink, color and gold on silk
80 x 41.5 cm
William Sturgis Bigelow Collection 11.6131

The weighty Lohan Nagasena sits on a rock before two attending monks. Their eyes are fixed upon a dwarf's offering of treasures, which include a rare coral tree that grows shining pearls at the tip of

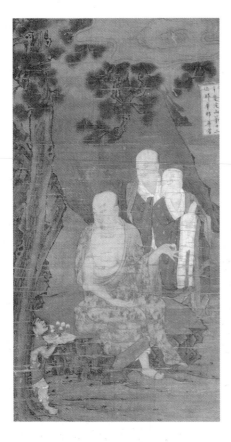

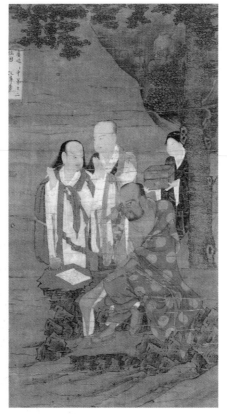

60

Lu Xinzhong
The Fourteenth Lohan Vanavāsi

Southern Song dynasty, late 12th century
Hanging scroll mounted as panel;
ink, color, and gold on silk
80 x 41.5 cm
William Sturgis Bigelow Collection 11.6129

This contemplative Lohan, whose Chinese name is Fanaposi, appears before a pond in which a pair of mandarin ducks playfully swim among the colorful lotus leaves and blossoms. The Lohan, who looks more Chinese than Indian or Central Asian, wears an elaborately decorated robe that echoes the colorful lotus pond nearby. A large, shady willow tree separates him from a servant who brings a tray of boxes made of tortoise shell. The simplistic composition is enlivened by the Lohan's vivid expression and the lotus pond. The style and rendering of the mandarin ducks, lotus, and water vegetation resemble many Southern Song academic paintings.

each branch. One of the pearls is already held in the Lohan's left hand. The Lohan wears a garment decorated with golden-cloud and blue-brown mountain motifs. Throughout the painting, outlines are drawn in a rather expressive, calligraphic manner, as can be seen from the tree trunk, the rocks, and the cliff contours. But the artist gives little evidence of interest in showing the kind of spatial depth common in Southern Song paintings, including Lohan paintings by contemporary artists such as Zhou Jichang and Lin Tinggui (see cat. 34–43). On the lower trunk of an imposing pine tree at the left edge of the picture, a line inscribed by the artist reads "Siming Cheqiao Shibanxiang Lu Xinzhong bi" (Painted by Lu Xinzhong of the Stone Slate Lane, Chariot Bridge, in Siming). The Chinese name of this twelfth Lohan was originally transliterated as Najiaxina but here has been abbreviated to Naxina.

Differences in execution and composition between the Boston version and its counterpart in the Shōkoku-ji collection are obvious. The latter places the Lohan and his attendants in a crowded landscape with more motifs and details.

59

Lu Xinzhong
The Thirteenth Lohan Iṅgada

Southern Song dynasty, late 12th century
Hanging scroll mounted as panel;
ink, color, and gold on silk
80 x 41.5 cm
William Sturgis Bigelow Collection 11.6128

The Indian Lohan Iṅgada (Chinese: Yin-jietuo) is shown reading a sūtra scroll placed next to an incense burner in front of him. Behind him stand two young monks in prayer and a boy attendant who holds a sūtra box. Away from this group of four brightly colored and well-rendered Buddhist figures, semihidden in the dark behind a tree, are two horned, demonic beings, grinning as if in fear. The landscape setting is much simpler than the Shōkoku-ji version. Toward the middle of the right edge and near the tree root, an eleven-character inscription written in regular script reads "Siming Cheqiao Shibanxiang Lu Xinzhong bi" (Painted by Lu Xinzhong of the Stone Slate Lane, Chariot Bridge, in Siming). This artist's inscription is one of two in the Boston set of Lohan paintings that can still be read. In the upper right, another line of

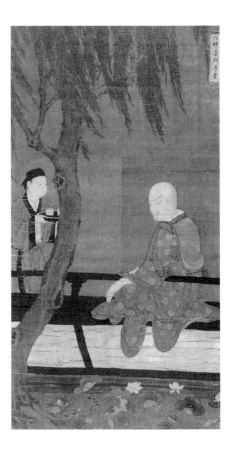

The Shōkoku-ji version of this painting is much more crowded. Its Lohan and attendant are set in an architectural environment that gives the painting greater spatial depth. The Boston painting has been cropped on all sides, especially at the top and the bottom. The transliterated name of the Lohan, written in the cartouche at the upper-right corner, has lost half of its original text.

railing is a large garden rock and blossoming tree.

Adiduo, the name of the fifteenth Lohan, is written in Chinese characters on a cartouche. At the middle-right edge of the scroll, close to a leg of the the black-lacquer table, is the name of the Japanese temple, Manju-ji. The Shōkoku-ji version is basically the same, except that it is more elaborately detailed.

haired demon even carries a staff with a white banner hanging from it. The relationship among the four figures is unclear; however, the painter has placed them all on the left half of the composition. The right half of the painting is taken up by the waterfall, a deep mountain gorge, and the vase with magic light.

No artist's signature or inscription naming the Japanese temple Manju-ji is found. Although the writing on the whitened cartouche has been trimmed almost in half, the Chinese name for the sixteenth Lohan has been preserved. The Shōkoku-ji version of this Lohan scroll includes an additional attendant holding a Khakkhara staff, which appears behind the tree and the rock. The rocks in the Shōkoku-ji version lack the originality and calligraphic quality of those in the Boston version.

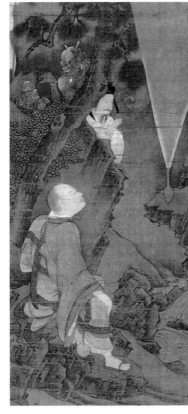

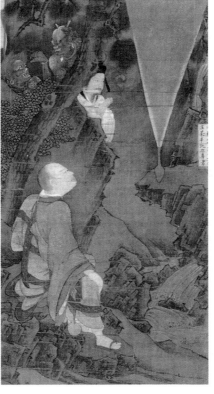

61

Lu Xinzhong
The Fifteenth Lohan Ajita

Southern Song dynasty, late 12th century
Hanging scroll mounted as panel; ink, color, and gold on silk
80 x 41.5 cm
William Sturgis Bigelow Collection 11.6134

The Lohan Ajita sits casually on a fancy couch, a writing brush and a plantain leaf next to him, while a boy servant grinds ink on an ink stone in front of the Lohan. Two lay believers wait to witness the Lohan practicing calligraphy. Behind them and in front of the garden railing, an incense burner and saucer are placed on top of a black-lacquer stand. Outside the

62

Lu Xinzhong
The Sixteenth Lohan Cūḍapanthaka

Southern Song dynasty, late 12th century
Hanging scroll mounted as panel;
ink, color, and gold on silk
80 x 41.5 cm
William Sturgis Bigelow Collection 11.6137

The sixteenth Lohan, Cūḍapanthaka (Chinese: Zhutubantuojia), watches intently as magical light shoots out of a vase placed on a cliff above a mountain stream opposite him. A worshipper in a gesture of prayer, and two lavishly dressed demons actively engaged in debate occupy the same side as the Lohan. The red-

63

Xia Gui (act. late 12th–early 13th century)
Sailboat in Rainstorm

Southern Song dynasty, about 1189–94
Round fan mounted as album leaf;
ink and light color on silk
23.9 x 25.1 cm
Chinese and Japanese Special Fund 12.891

As early as the mid-thirteenth century, the scholar and connoisseur Zhou Mi had already identified Xia Gui as one of the ten masters serving in the Southern Song painting academy. As a contemporary of Ma Yuan, Xia Gui has rarely been thought of as active during Emperor Xiaozong's lifetime, yet a couplet by Xiaozong (cat.

64) has been a companion to this Xia Gui landscape since at least the fifteenth century. The poetic text and pictorial image of these two round fans complement one another extremely well. If the calligraphy accompanied this Xia Gui landscape from its inception, it would suggest that Xia Gui entered the academy earlier than previously believed.

Xia Gui's ink landscapes tend to be condensed compositions, executed with more spontaneous brushwork than paintings by other Southern Song academy painters. For instance, the work of Ma Yuan, the other leading landscapist of the academy, is full of meticulously rendered settings with a strongly individualistic approach. Ma Yuan's landscapes entice the viewer into the scenery through their intricate presentation. Xia Gui beckons one to look beyond, emphasizing the vast extension of the landscape.

Three major developments characterize Xia Gui's landscape painting. The earliest phase can be represented by a fan painting entitled *Watching the Waterfall* (National Palace Museum, Taipei.)[1] Judging from its tense structure and strong rendering, this early painting shows how much Xia Gui was inspired and driven by the style of the master Li Tang and, perhaps indirectly, by Fan Kuan, Li Tang's mentor. The simplicity and inventiveness characteristic of his late style is demonstrated in the handscroll *Twelve Views of Landscape* (Nelson-Atkins Museum of Art, Kansas City). Between these two phases, an interim style appeared during Xia Gui's mature years, exemplified by the long ink landscape entitled *Pure and Remote View of Streams and Mountains* (National Palace Museum, Taipei). The work, largely based upon a Li Tang–type compositional structure, reveals Xia Gui's technical mastery in the complete control of forms, textures, and space rendered by a display of his sweeping brushwork. This masterpiece was most likely a work completed before the emergence of Xia Gui's late style when he broke free from the influence of the earlier masters.

Stylistically and technically, the Boston fan painting falls somewhere between Xia Gui's early and mature periods. Although it does not exhibit the freedom of the painting in the Nelson-Atkins Museum, it amply demonstrates Xia Gui's familiarity with the watery scenery around his native Hangzhou and the atmosphere of the lower Yangzi River region where lakes,

rivers, and canals abound. Xia Gui's adept handling of ink gradations conveys a realistic yet lyrical sense of a watery "Jiangnan" environment. In terms of atmosphere and ink play, Xia Gui uncannily echoes the southern-landscape tradition, depicting the same watery scenery that was started by the tenth-century master Dong Yuan.

The northern painter Li Tang knew, and was profoundly inspired by, northern China's dominant scenery of monumental mountains. His stylistic influence arguably comprised the most important Northern Song artistic legacy for Southern Song landscape painting, especially that from the 1130s to the end of the thirteenth century. Li Tang had been a member of Emperor Huizong's painting academy before he fled to the south and settled in the lake city of Hangzhou, around the 1130s. There he was rehabilitated to a leading position in the new painting academy revived by Emperor Gaozong. Li Tang's mountain landscapes had a lasting impact for three generations of Southern Song artists. Both the descendants of northern immigrants, such as Ma Yuan, and natives of the south, like Xia Gui, followed and transformed Li Tang's style. If Xia Gui's handscroll in Taipei is a most compelling example of how a southerner skillfully adopted and interpreted the landscape art of Li Tang, then his works in Boston and Kansas City represent his inspiration for the new movement toward minimalist landscape that arose in the mid-thirteenth century. That influence can be seen in the Boston album leaf *Boating Near Lakeshore with Reeds* (cat. 105) and such Ma Lin works as *Reclining Scholar Enjoying the View of the Clouds* (Cleveland Museum of Art) and *Swallows Skimming over the River at Sunset* (Nezu Museum, Tokyo).

Scholars have questioned whether Xia Gui's signature at the lower right of the painting is a later addition. A recent analysis by the Boston Museum's research laboratory has revealed that the ink tone of the signature is consistent with that of the painting. Under high magnification, the distinctive way in which the ink adheres to the surface of the silk is identical in the painted and signed areas. This evidence supports the view that the signature was written when the painting was created.

1. For an in-depth discussion of this early landscape fan by Xia Gui, see Edwards, *The World Around the Chinese Artist*, pp. 12–53.

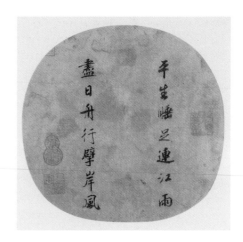

64

Emperor Xiaozong
(r. 1163–89, d. 1194)
Calligraphy of Poem by Su Shi in Semi-Cursive and Regular Scripts

Southern Song dynasty, ca. 1189–94
Round fan mounted as album leaf; ink on silk
23.9 x 25.1 cm
Chinese and Japanese Special Fund 12.892

The couplet, taken from a poem composed by Su Shi, is written in a calligraphic style combining both regular and semi-cursive scripts. It reads:

> The ceaseless river rain always lulls me to sleep,
> Winds beat the cliffs all day to move my boat along.

As indicated by his colophon and seals, this fan was in the collection of Ruan Yuan (1764-1849), who attributed it to Emperor Gaozong (1107–87; r. 1127–62). Kōjirō Tomita, in the 1933 *Portfolio*, challenged Ruan Yuan's attribution and published it instead as the work of Emperor Xiaozong, Gaozong's adopted son and successor. Later, on stylistic grounds, Tseng Yu-ho Ecke concurred with Tomita's reattribution to Xiaozong characterizing it as "thoughtful, rather brooding and conservative, with a mature and balanced control."[1]

Zhu Huiliang's recent research has firmly established a number of writings as authentic calligraphic works by the Emperor Xiaozong.[2] They generally share the same characteristics with this Boston fan. For example, the calligraphy of a poem written by Emperor Xiaozong on a Southern Song album painting, *Fisherman Awakening in His Boat* (National Palace

Museum, Taipei), closely relates to the Boston fan in its structure and the brush movement of the characters. Both exhibit Xiaozong's tendency to construct elongated characters that end abruptly. Unlike the brushstrokes characteristic of his father's writing, Xiaozong's brush tends to be uneven and hesitant, resulting in contrasts between adjacent thick and thin strokes, as seen on the Museum's fan in the characters *zhou* (boat) and *shui* (sleep). Since the calligraphy on the Taipei album can be safely dated to Xiaozong's retirement period (1189–94), the Boston fan should then also be regarded as a late work of the emperor. These same characteristics can also be seen in the beautiful fan calligraphy of *Quatrain on Fishermen* (Metropolitan Museum of Art, New York).[3] Though long attributed to Emperor Gaozong, the shape and structure of the characters as well as the brush technique all resemble that of the Taipei album leaf and the Boston fan. Accordingly, the New York fan should be reconsidered as a work by Emperor Xiaozong that was executed during his retirement.

Based on seals impressed on fans by the Mu family, the couplet has been mounted together with Xia Gui's *Sailboat in Rainstorm* (cat. 63) since at least the fifteenth century and, most likely, even earlier. The painting gives visual form to the poetic meaning expressed in the couplet. The wet ink and reduced brushwork used to paint the foreground contrasts well with the light ink and fine-line brush technique applied to the background. The gourd-shaped seal on the calligraphy appears painted, rather than impressed. The unsteady red-ink drawing follows a faint charcoal underdrawing. It imitates a well-known gourd seal originally used by Emperors Huizong and Gaozong, grandfather and father, respectively, of Xiaozong.

1. Ecke, cat. 24.
2. Zhu Huiliang, pp. 17-52.
3. Fong, *BR*, pl. 31.

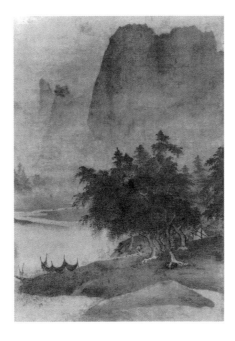

65

Attributed to Xia Gui
(act. late 12th–early 13th century)
A Fisherman's Abode after Rain

Southern Song dynasty, end of 12th century
Hanging scroll; ink and light color on silk
44.3 × 101.2 cm
Chinese and Japanese Special Fund 14.54

After a day's work, a fisherman seems to long for a dry, firm place to rest. He hardly notices the serene beauty of the picturesque lakeside scenery that surrounds him. Judging from the scroll's size, it may originally have adorned a large freestanding screen. Such an imposing composition could have been displayed in the main hall of a palace or a temple for viewing by large groups of visitors.

Despite damage and repairs, this hanging scroll has retained its monumental strength. This type of rendering with a fisherman coming ashore and going through the woods to return to his dwelling is a subject frequently associated with either Xia Gui or his followers. The painting depicts trees on a windy, rainy day, not unlike the scenery of the museum's small round fan painting *Sailboat in Rainstorm* by the same artist (cat. 63).

Xia Gui characteristics in Boston's *Fisherman's Abode after Rain* include such details as heavily outlined tree trunks, roots dancing out of the ground, massing of ink leaves, and features like the sunken ridge-line of the rustic house (with or without ridge weights to stabilize it), which is also found in Xia Gui's well-known *Pure and Remote View of Streams and Mountains* (National Palace Museum, Taipei).[1]

Perhaps due to a restorer's misunderstanding, the spatial relationship between the large mountain in the middle ground and the two distant peaks, which are supposed to be behind it, has been obscured. One suspects that the entire surface of this mountain mass has been smoothed with a light ink wash by restorers. The lower-left edge of the mountain, for unknown reasons, has been broadened to the present shape, hence its awkward appearance.

The style of this large hanging scroll is a softer, rounder manifestation of the earlier tall-mountain landscapes, which were animated in the foreground by trees and human figures. By the middle of the Southern Song period, motifs had come to be compressed to one side as a way of creating the illusion of space and distance. This landscape displays a further development from such tight, compressed compositions as Xiao Zhao's large painting *Landscape with Tall Cliffs and Temples* (National Palace Museum, Taipei).[2] Xiao Zhao was Li Tang's pupil, making him part of the lineage that secured an aesthetic ideal placing Xia Gui, along with Ma Yuan, as heirs to the Li Tang style, which they, in turn, transformed into their own unique vision.

1. *Three Hundred Masterpieces of Chinese Painting in the Palace Museum,* vol. 3, no. 115(4).
2. Ibid., no. 103.

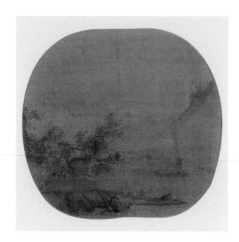

66

Anonymous (formerly attributed to Li Tang, 1060s–after 1150)
Sailboat on an Autumn Lake

Southern Song dynasty, late 12th century
Round fan mounted as album leaf; ink and light color on silk
24 x 26.3 cm
Chinese and Japanese Special Fund 14.56

As in many Southern Song academy paintings, this work conveys a sense of time, season, and weather in a simple yet profound manner. The economy of brushwork and compositional structure enhance the feeling of a lone scholar boating along a river on a windy day. It is late autumn, as half the leaves have parted from the branches and the others are in the process of falling. In the foreground, on the shore, the rather twisted appearance of four trees with exposed roots implies the constant blowing of a strong wind from the river. These semibare trees soon will lose their last leaves, as the artist suggestively depicts them drifting away. It is a sentimental metaphor as if seen through the eyes of the scholar in the boat. The unavoidable change from brilliant autumn to severe winter will soon occur. For poets and artists of the prosperous Southern Song, living in a time and environment constantly threatened by invasion from the north, the passage of time and changing seasons were reminders of the ephemeral nature of security and happiness in life.

The composition and brushwork resemble works attributed to the brothers Yan Ciping (act. 1164–81) and Yan Ciyu (act. late-twelfth century) who were followers of Li Tang. The painting was most

likely executed before the rise of the Ma Yuan and Xia Gui styles since it shows neither their expressive brushwork nor the extreme one-corner composition characteristic of their influence.

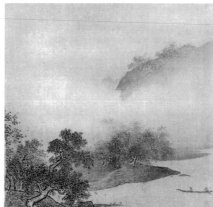

67

Anonymous (formerly attributed to Li Tang, 1060s–after 1150)
Autumn Foliage along a River

Southern Song dynasty, late 12th century
Square album leaf; ink and light color on silk
26.7 x 28 cm
Denman Waldo Ross Collection 29.2

This painting presents an autumn scene from the perspective of a scholar in a boat, approaching a shore on which the autumn foliage is in full array. The artist conveys a sense of both the season and the blustery weather by means of the leaves scattering, falling, and flying in the air and on the river. The surface of the river undulates in the autumn breeze, as suggested by the gentle waves around the boat and the nearby riverbank. The foreground is dominated by an impressive maple with brilliant red foliage. At the edge of the painting, a crisply outlined slope with smaller rocks and a sandy band lie beyond. The foreground tree holds tightly to the rocky surface, its exposed roots shaped like powerful claws. The flatness of the rock's surface is offset by a soft bluish green wash that contrasts well with the red foliage. In the middle ground, more trees appear with a reddish hue, half hidden by a rising mist that has engulfed the foot of a distant mountain in the upper right. Beyond it, the artist has

added light-blue washes that suggest another, more distant, peak; they echo the green of the foreground in the lower-left corner as well.

The painting style reflects Li Tang's influence and seems to date slightly earlier than Ma Yuan or Xia Gui. Neither the tree types nor the spatial arrangement is related to works like the two Ma Yuan (cat. 68 and 69) or the two Xia Gui (cat. 63 and 65) in the Boston collection. The traditional attribution to Li Tang probably arises from the painting's stylistic connection to that master.

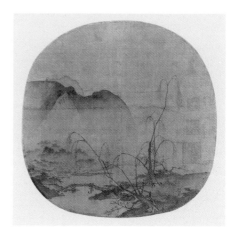

68

Ma Yuan (act. 1190–1235)
Bare Willows and Distant Mountains

Southern Song dynasty, end 12th century
Round fan mounted as album leaf; ink and light color on silk
23.8 x 24.2 cm
Chinese and Japanese Special Fund 14.61

Ma Yuan, like his contemporary Xia Gui, is recorded as one of the ten masters of the imperial painting academy in the Southern Song capital of Hangzhou. A pair of well-known landscape fans in the Boston collection—this one and *Scholars Conversing Beneath Blossoming Plum Tree* (cat. 69)—represent two distinct painting styles and phases in his work. *Bare Willows and Distant Mountains* is the rarer, earlier type. In this composition, Ma Yuan gives a full account of the scenery of eastern, coastal China. It evokes the landscape surrounding the lake city of Hangzhou, where Ma Yuan's grandfather settled after

fleeing the Northern Song capital Kaifeng during the invasion of the Jurchen nomads in 1126. Born and brought up in Hangzhou, Ma Yuan was naturally accustomed to a landscape of rivers, lakes, and canals, but he also carried on his family tradition of painting the more mountainous scenery of northern China. Clearly Ma Yuan needed to find a pictorial solution to merge these two worlds: the landscape of his immediate surroundings and that of the north, which he preserved as a legacy of his family's past. What resulted was a hybrid landscape style. Its formative stage is exemplified by this fan, *Bare Willows and Distant Mountains,* which he painted toward the end of the twelfth century. The later phase of Ma Yuan's work can be seen in *Scholars Conversing Beneath Blossoming Plum Tree,* which dates from the early thirteenth century.

In contrast to the latter, this earlier work presents nature as an organic whole. Different elements of nature correspond with, complement, and balance one another. The twin willows, with their long, slim, but vigorous branches, extend to various corners of the picture in a connecting web, while the narrow bridge unites the two banks of a lake. The lower-right foreground not only echoes the mountains in the distance but also balances the village shrouded in mist on the other side of the water where two figures look out from a waterfront pavilion, as if expecting visitors.

A lone servant carrying a pole over his shoulder has just emerged from behind the bamboo bushes, walking from the lower-right corner toward the bridge. A large damaged area is just in front of him. Judging from the two travelers in the foreground of *Mountain Market in Clearing Mist* (Freer Gallery, Washington, D.C.), an album leaf by Yan Ciyu,[1] one cannot help wondering whether the large damaged area might not have been the logical place for Ma Yuan to have painted a mounted scholar. The presence of a horse or donkey rider in the foreground would not only explain the purpose of the solitary servant but would also be consistent with the duality of two willows and two plum trees in the surrounding area. The presence of a scholar would have unified this elaborate and elegant landscape, as is evident from other similar Southern Song compositions.

The painting is signed by Ma Yuan at the lower-right edge, but the second

character of the signature has been badly damaged.

1. See Fong, *BR,* p. 258, fig. 110.

69

Ma Yuan (act. 1190–1235)
Scholars Conversing Beneath Blossoming Plum Tree

Southern Song dynasty, early 13th century
Round fan mounted as album leaf; ink and light color on silk
23.4 x 25.2 cm
Chinese and Japanese Special Fund 14.62

Unlike the panoramic view presented in Ma Yuan's earlier landscapes, such as *Bare Willows and Distant Mountains* (cat. 68), his later paintings frequently show close-ups of particular subjects. Here Ma Yuan depicts two scholars engaged in a conversation, with the senior scholar on the left side seated on a cushion on top of a flat rock, facing the viewer. A young servant holding the master's staff stands behind him. A magnificent blossoming plum tree reaches out from behind the master, while nearby a mountain stream flows from left to right underneath a simple bridge. In the lower-right corner of the composition sits the other scholar, depicted in profile with his head slightly lowered as if listening with respect. The animated, outstretched branches of the plum tree complement the dialogue in progress by symbolically filling the void between the figures at left and right. While the two scholars are immersed in serious discourse, the young servant appears bored by the elders' conversation and looks the other way.

Traditionally plum blossoms signify spiritual purity. However, not all blossoming plum trees are treated in the same symbolic, philosophical manner as the one in this fan painting. For example, in Ma Yuan's celebrated album leaf from the Crawford collection, *Viewing Plum Blossoms by Moonlight* (Metropolitan Museum of Art, New York),[1] the trees serve a much more decorative function. The branches and twigs in that work are added merely for the sake of ornamentation. The beauty of calligraphic lines and

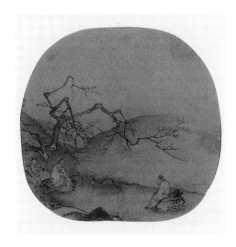

realistic depiction has been compromised in favor of enriched graphic design in the New York leaf.

1. Fong, *BR,* p. 270, pl. 50.

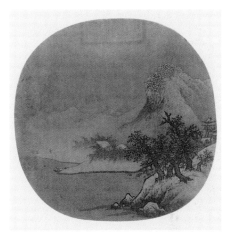

70

Anonymous (traditionally attributed to Fan Kuan, act. late 10th–early 11th century)
Temple among Snowy Hills

Southern Song dynasty, early 13th century
Round fan mounted as album leaf; ink and light color on silk
24.7 x 25.5 cm
Chinese and Japanese Special Fund 12.889

Although the Southern Song academy painters were influenced by many earlier masters, the landscape genre was predominantly inspired by the Northern Song painter Li Tang, who fled from Kaifeng to Hangzhou after the Jurchen conquest in 1126. Several generations of landscape

painters such as Xiao Zhao, Liu Songnian, the Yan brothers, the Ma family, and Xia Gui established themselves as new masters in the south largely based on Li Tang's inspiration. To a lesser degree, the landscape tradition of the northern master Fan Kuan also survived in the Southern Song. As noted by the Yuan painter Ni Zan, this was because Li Tang himself had also been a follower of Fan Kuan.

Style

This fan's traditional attribution to Fan Kuan perhaps derives both from the snowscape subject matter and such Fan Kuan motifs as the wintry trees in the foreground and the stylized woods decorating the top of the snow-covered mountain peak. Apart from its Fan Kuan connection, the painting is surprisingly free from the influence of the contemporary Ma–Xia style. Outlines and texturing are executed with slower speed, sometimes with a drier brush. Except for the architectural rendition of the temple, the typically angular forms of Ma-Xia landscapes have been replaced by those that are rounded, softened, and more restrained. From right to left: The rigid temple structure behind stiff trees contrasts with the more spontaneously depicted peasants' dwellings amidst lush bamboo groves; dotted twigs of the bare trees in the foreground contrast with highly stylized distant trees on the mountains. This counterpoint between motifs helps create an illusion of a vast space receding diagonally from the lower right into the upper-left edge. The painter's delight in design is a stylistic departure from the realism and naturalism typical of the Northern Song masters. While Northern Song artists detailed human activity just as vividly as trees, rocks, mountains, and water, in Southern Song paintings human figures assume a symbolic role.

Attribution and Provenance

While the Boston hanging scroll *Winter Landscape with Temples and Travelers* attributed to Fan Kuan (cat. 11) is closely associated with the Northern Song tradition, this snowscape fan is likely a Southern Song interpretation of his style. *Winter Landscape with Two Riders* by Liang Kai (National Museum, Tokyo) represents yet a further transformation of the Fan Kuan style in the south.

The remaining lower part of a Yuan imperial seal that reads "Tianli zhi bao" (Treasures of the Tianli Era) can be seen at the upper middle of the fan painting. It indicates that the painting was originally added to the emperor's collection during the period between 1328 and 1330. Seals of the late-Ming collectors Xiang Yuanbian (1525-1590) and Zhang Zezhi (act. early seventeenth century) have also been impressed upon this painting. At the right is the seal of the Manchu collector Wanyan Jingxian (late nineteenth–early twentieth century), from whom Okakura Kakuzō (Tenshin) acquired this fan. Since the early Qing dynasty, a calligraphy fan of a quatrain (cat. 71) written in regular script by Emperor Lizong (r. 1225–64) has been mounted together with this snowscape as a companion piece.

71

Emperor Lizong (r. 1225–64)
Calligraphy of a Poem by Huangfu Ran in Regular Script

Southern Song dynasty, second quarter 13th century
Round fan mounted as album leaf; ink and light color on silk
24 x 25.6 cm
Chinese and Japanese Special Fund 12.890

Since the text of this quatrain describes the pictorial scenery on the facing fan (cat. 70), it is possible that the painting and the calligraphy were created as a pair during the Southern Song period. The text may be translated as follows:[1]

> Still I yearn to see my parents in every crowd.
> Here, white clouds always touch the eastern mountains.
> Sitting alone, I burn incense and recite sūtras.
> The mountain is deep; the temple, ancient; and snow, everywhere.

In the facing fan, one sees mountains, a temple, and snow. The tradition of combining poetry and pictorial representations originated in Emperor Huizong's academy and was carried on throughout the Southern Song period.

Formerly attributed to Emperor Ningzong (1168–1224; r. 1195–1224), this round fan can now be identified on stylistic grounds as a work by his son, Emperor Lizong, whose calligraphic style is more individualistic and less influenced by Emperor Gaozong than that of most other rulers of the Southern Song dynasty.

Comparison with four round fans by Emperor Lizong (all in the collection of the Metropolitan Museum of Art, New York) related to this work supports this attribution. The calligraphy on one of them, a couplet from a Han Hong poem, is dated by the emperor's seal to 1261; its structure and the brushwork of the characters closely resemble those on the Boston fan.[2] For instance, the characters *shan* (mountain) and *shen* (deep) on both fans are equal in proportion, shape, and execution. Although the Boston fan was considered to be an early work by Emperor Lizong, its stylistic closeness to Lizong's fan dated 1261 suggests a date in his later years.[3]

1. The poem by Huangfu Ran (ca. 717–ca. 770) was written for the Buddhist monk Zhen of the Wu'ai temple.
2. See Fong, *BR*, p. 236, pl. 37.
3. Zhu Huilang, "Imperial Calligraphy of the Southern Song," p. 310.

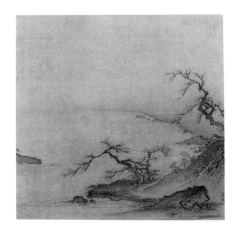

72

Ma Lin (act. 1220s–1260s)
Lake View with a Palace Lady Riding a Deer

Southern Song dynasty, second quarter 13th century
Square album leaf; ink and color on silk
25.2 x 26.3 cm
Denman Waldo Ross Collection 28.837a

This Ma Lin album leaf has a companion piece of calligraphy (cat. 73) by Emperor Lizong, both of which are square in shape. Sets of painting and calligraphy in the form of round fans by these two artists are also found in the Cleveland Museum of Art and the Nezu Museum in Tokyo.[1] The Boston Ma Lin and Lizong pair is not dated and its original function remains uncertain. It may have been part of a decorative ensemble for interior furniture, such as those seen in the handscroll painting *Han Xizai's Night Revels* attributed to the tenth-century artist Gu Hongzhong (Beijing Palace Museum).

Stylistically, the Boston pair seems earlier than the sets in the Nezu and Cleveland museums. Ma Lin's landscapes from the 1250s had achieved a great degree of abstraction and simplicity. The calligraphic works of Emperor Lizong are also much more assertive in brushwork and inventive in style. Yet in the Boston painting, Ma Lin is still bound to the stylistic inspiration and landscape vocabulary of his father, Ma Yuan. For instance, motifs such as rocks, pines, buildings, and figures are freely borrowed from the elder Ma. While Ma Yuan's rocks are executed with a convincing three-dimensional effect, Ma Lin's foreground rock, though similar in form to his father's work, is painted with a flat,

unmodulated brush. The impressive economy of composition and brushwork evident in Ma Lin's later paintings was not yet in evidence at the time he painted the Boston example.

Equally significant is Ma Lin's distinct approach to translating an abstract poetic meaning into a pictorial representation. In both the Cleveland and Nezu examples, he achieved an abstract beauty to mirror that of the accompanying couplets and created a landscape that matches in subtlety and immediacy the poetic expression. In the Cleveland Ma Lin, the composition consists of a limited foreground and a magical, lyrical background, visualizing the text of Lizong's calligraphy. Even the lone hermit is constructed more like characters.

For these reasons, the Boston Ma Lin should be dated to a more formative period in this artist's work, around the 1230s. Even the style of Ma Lin's signature differs from that in his later paintings. Interestingly, however, it is nearly identical in style and structure to the signature on an earlier work by him: *Landscape with Great Pine* (Metropolitan Museum of Art, New York).[2]

1. The Cleveland pair originally comprised the front and back of a single round fan. An imperial seal dates its calligraphy to 1256, eight years prior to Emperor Lizong's death. A seal on the Nezu calligraphy dates that work to 1254.
2. Fong, *BR*, p. 300, pl. 65.

73

Emperor Lizong (r. 1225–64)
Calligraphy of a Quatrain in Semi-Cursive and Regular Scripts

Southern Song dynasty, second quarter 13th century
Square album leaf; ink on silk
25 x 25.8 cm
Denman Waldo Ross Collection 28.837b

The poetic meaning of *Quatrain on Autumn Landscape in Regular Script* directly complements the facing landscape by Ma Lin (cat. 72) even more closely than the other calligraphy fan by Emperor Lizong in Boston's collection (cat. 71). Richard Edwards translates the text of the poem as follows:

> Riding a dragon, a double jade,
> crossing stream's source
> Red leaves return the spring,
> blue waters flow
> You may in a wine-pot
> see heaven and earth,
> But heaven and earth in the pot
> no match for autumn.

The first half of the text is depicted in the Ma Lin landscape: amidst spring blossoms, two young palace women (the "double jade") appear by a path along a stream. One rides a deer; the other carries a palace fan decorated with a stylized dragon in gold against a vermillion ground. Perhaps, by representing the poem through pictorial means, the artist sought to realize the poet's longing for eternity, which is expressed in the second half of the poem.

In this fan, Emperor Lizong generally adhered to the style of balanced structures and squarish shapes characteristic of his regular script. Nevertheless, he intermittently places a more cursive character to break the predominant regularity. For instance, the character *yu* (jade) is written in the semi-cursive style in the first vertical line on the right; two others, *chun* (spring) and *shui* (water), are interspersed in the second line. The third line has just one semi-cursive character, while the last three characters of the final line, on the extreme left, are all rendered in the cursive manner. This subtle mixture of two calligraphic styles in one work demonstrates Emperor Lizong's sensitivity as a serious and creative calligrapher.

Three dated works by Emperor Lizong are in the collections of the Metropolitan Museum of Art, New York, the Cleveland Museum of Art, and the Nezu Museum, Tokyo. The New York fan, dated 1261, is executed in regular script; the fans in Cleveland (dated 1256) and the Nezu (1254), are both written in semi-cursive style. In the New York fan, departing from

the constraints of his earlier regular script, Emperor Lizong shows a far freer, more expressive hand than is seen in this Boston fan. By comparison, the Boston calligraphy would therefore predate all three works.

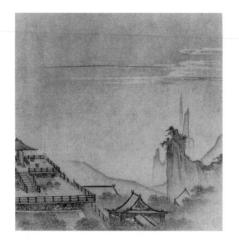

74

Attributed to Ma Yuan
(act. 1190–1235)

Viewing Sunset from a Palace Terrace

Southern Song dynasty, ca. 1200
Square album leaf; ink, color and gold on silk
25.2 x 24.5 cm
Maria Antoinette Evans Fund 28.850

Depictions of sunsets are rare among works of this period or in later times. The artist has used the texture and color of the unpainted white silk to reveal cloud bands against a sky delicately washed in light blue. Touches of gold and red have been applied to further accentuate the cloud formations at a darkening time of approaching evening. Beneath this colorful dusk, a palace complex topped by a bi-level terrace is shown from a bird's-eye perspective. Its foundations and other palace buildings are semihidden by a sea of foliage. A lone scholar stands against the railing on the upper terrace, deeply absorbed by the spectacle of the sunset above and the hints of a world beyond. Two maids pass by large pots of blossoming chrysanthemums as they bring drinks to their master. Strongly vertical hills at the far right echo the three elongated figures on the terrace.

The composition of this album leaf has been skillfully divided between the sky

above and the human world below. The artist's depiction recalls the Chinese tradition of climbing to a high place on the ninth day of the ninth moon each year during the season of chrysanthemum blossoms.[1] The great Tang poets Du Fu (712–70) and Wang Wei (699–759) composed well-known poems for this festival occasion, which may well have provided the original inspiration for this painting.

The brushwork in the Boston painting is generally delicate and subtle. It is a highly stylized version of the Ma Yuan tradition from the later Southern Song period.

1. In the Chinese lunar calendar, this festival is known as Chongjiu (double nine).

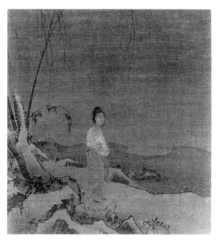

75

Anonymous (formerly attributed to Ma Lin, act. 1220s–1260s)

Snowscape with a Standing Woman

Southern Song dynasty, 13th century
Square album leaf; ink and light color on silk
24.5 x 25.6 cm
Chinese and Japanese Special Fund 05.204

The protagonist of this painting has traditionally been identified as Pang Lingzhao, the filial daughter of Pang Yun (*zi*-name Daoyuan, act. late eighth–early ninth century), a renowned disciple of the Chan Buddhist priest Mazu Daoyi (709–88). According to legend Pang Lingzhao supported her aging parents by selling baskets she had woven. Although she was poor, as

suggested by her tattered garment, she was revered for generations as an ideal female role model, combining the virtues of both Buddhist faith and Confucian piety.[1] The woman in this painting suggests the destitution and bearing of Pang Lingzhao, but her identity is uncertain; nor can we be sure if she is holding the baskets traditionally associated with her piety, as that part of the album leaf has suffered from damage and repainting.

Buddhist subject matter is not uncommon in paintings by Southern Song academic artists. Works like *Yaoshan Conversing with Li Ao* (Nanzen-ji, Kyoto), by Ma Gongxian (act. second half of thirteenth century) along with Ma Yuan's *Dongshan Wading a Stream* and Liang Kai's *Śākyamuni Coming out of the Mountains* (both National Museum, Tokyo), all represent Buddhist figures in different landscape settings.[2] The old, tall, snow-covered willow tree and the lone young woman convey a symbolism that is both poetic and religious. Despite severe cold, the old willow has new, vigorous branches issuing from its dying trunk—a metaphor of the renewal of life or faith, even under unfavorable circumstances. If the young woman is indeed the daughter of Pang Yun, then her faith in Buddhism and devotion to her parents would be strong enough for her to endure the hardships brought about by the snow and the poverty in her life.

Apart from its possible Buddhist connotation, this painting is a perfect example of Southern Song academic work. Its one-corner composition and angular, linear brushwork are characteristic of thirteenth-century paintings. The artist focuses attention on the foreground of the composition, thereby imparting a sense of vast emptiness to the rest. The types of trees and rocks depicted as well as the outlines and texturing strokes are closely related to works by Ma Yuan and his son Ma Lin. It is, therefore, no surprise that for centuries previous Japanese owners of this album leaf always attributed it to Ma Yuan. In his 1933 *Portfolio*, based on a seal at the lower-left corner that reads "Ma Lin," Tomita reattributed the painting to Ma Lin. This seal's authenticity is, however, questionable.

1. See Rosenfield and Shimada, p. 354.
2. See Fontein and Hickman, cat. 4; and Fong, *BR*, p. 268, fig. 112, and p. 287, fig. 126.

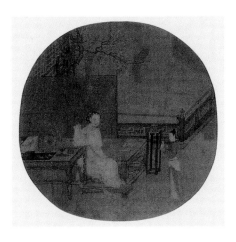

76

Anonymous (formerly attributed to Wang Juzheng, act. early 11th century)

Lady Watching a Maid with a Parrot

Southern Song dynasty, early 13th century
Round fan mounted as album leaf; ink and color on silk
23.4 x 24.2 cm
Harriet Otis Cruft Fund 37.302

Little is known about paintings by Wang Juzheng, to whom this fan was formerly attributed, except that he was active in the early eleventh century and specialized in painting women. According to literary records, he closely followed the figure-painting style of the Tang master Zhou Fang. Wang Juzheng's father, Wang Zhuo, was a leading master of religious painting during the reign of the Northern Song Emperor Zhenzong (r. 997–1022).[1] The only other work attributed to Wang Juzheng is a fine genre painting, the handscroll *Woman Spinning Thread* (Beijing Palace Museum). No stylistic connection between the Beijing handscroll and this round fan exists. A more meaningful comparison can be made between this fan painting and Su Hanchen's *Lady at Her Dressing Table in a Garden,* also in the Boston collection (cat. 25). Both works depict the same topic: the sensuality and lifestyle of a woman in high society. In Su Hanchen's work, the subject is preoccupied with her make-up, concerned with the passing of time or her age. The lady shown on this fan, taking a break from reading, summons her maid to bring forth her beloved parrot. Like Su Hanchen, this anonymous artist has placed the elegant lady on a garden terrace and surrounded her with sumptuous furniture and art objects, including a bronze mirror with a stand, a bronze vessel, a bronze incense burner, lacquer boxes wrapped inside a piece of thin, reddish silk, a black-lacquer tray with writing tools, and a few other decorative objects.

What distinguishes this fan from that by Su Hanchen is the addition of many volumes of books neatly stacked together on her table, while another has been left lying next to a handscroll on her couch. Such emphasis, showing a young courtly woman's interest in learning and her ability to do calligraphy, is quite exceptional. Possibly the influence upon Southern Song women of the learned scholar and great poetess Li Qingzhao (1084–after 1151) can be inferred from paintings such as this Boston fan.

1. See Guo Ruoxo, *Tuhua jianwen zhi,* juan 3, p. 45, in Yu Anlan, *HC,* vol. 1.

77

Anonymous (traditionally attributed to Zhang Sigong, act. 12th century)

The Planet Deity Chenxing (Mercury) Attended by a Monkey

Southern Song dynasty, early 13th century
Hanging scroll mounted as panel; ink, color, and gold on silk
121.4 x 55.9 cm
William Sturgis Bigelow Collection 11.6121

Description

The deity sits casually with her left leg resting on the couch and her right foot on the floor. Significantly, in her hands she holds a roll of paper and a writing brush, while a monkey stands obediently by her side, holding high an inkstone, as if assisting the deity in her writing. She wears an elaborate garment and a pleated skirt seen under her long robe. Her head-piece, equally as elaborate as her dress, resembles the kind of crown that would have been worn by a Song-dynasty empress.

Iconography and Dating

When the painting was purchased by William Sturgis Bigelow in Japan in the late-nineteenth century, it was labeled as a bodhisattva by Zhang Sigong. In fact, the ensemble of such indigenous Chinese writing equipment as brush, paper, and inkstone, together with a monkey is most unusual and can only be identified as the Planet Deity Chenxing (Mercury) who represents the north and is one of the five planet deities in ancient-Chinese astrology. Mercury was later associated with the Buddha of Blazing Light (Tejaprabha Buddha) in esoteric Buddhism. According to the *Tang shu* (Official History of the Tang Dynasty), the connection between this Chinese astrological deity and Buddhism probably came about in 718, when the Tang court translated an Indian solar calendar and determined that this deity, Mercury (*shuixing*), would be called Chenxing. This Tang manuscript survives only from Japanese copies, of which the Boston Museum owns a Kamakura copy entitled *Kuyō Hiryaku* (Nine Stellar Dieties, Sacred Calendar; 11.6204) that is dated 1224.[1]

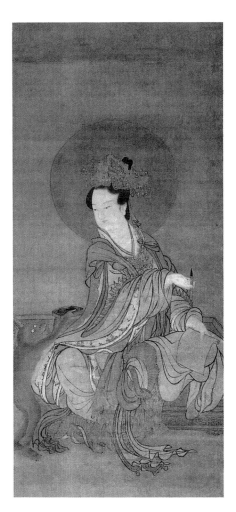

According to Chinese literature, early painters such as Zhang Sengyou and He Changshou (seventh century) had already painted the planet deity "Chenxing." The handscroll *The Five Planets and the Twenty-eight Constellations* attributed to Zhang Sengyou (Osaka Municipal Museum) provides the earliest prototype of this deity in existence. The fifth figure shown in the scroll is identified by an accompanying inscription as Chenxing—a standing young woman with brush and paper in her hands, wearing a headpiece in the shape of a monkey head. The inscription indicates that the deity is in charge of documents and writings as well as law and morality "under the heaven." This explains why brush and paper are always part of this deity's iconography. A later evolution of the representation of this deity can be seen in an 897 painting from Dunhuang, *The Tejaprabha Buddha and the Five Planets* (British Museum, London).[2] There, she is adorned in a dress typical of the late-Tang period, but still holds the brush and paper in her hands; however, the earlier monkey head has developed into a small monkey squatting atop the deity's hairdo.

For the Boston painting, the artist has added an ink stone with newly ground ink, giving the large monkey the role of ink-stone holder. Such additional details and the animated body posture apparently influenced by Southern Song Buddhist sculpture confirm a later date for the painting. The Boston *Mercury* is currently the only known Southern Song painting of this deity in existence.[3]

Attribution

The artist Zhang Sigong is not mentioned in Chinese publications. But the fifteenth-century Japanese catalogue by Noami, *Kundaikan Sōchōki* (entry 14), recorded Zhang as a follower of Li Gonglin of the Northern Song period, and noted that he specialized in painting Buddhist figures.

1. See *Exhibition of Japanese Paintings from the Collection of the Museum of Fine Arts, Boston*, cat. 18.
2. See Whitfield, vol. 1, pl. 27.
3. The Museum of Fine Arts, Boston, owns an anonymous painting, *The Buddha of Blazing Light and Stellar Deities* (11.4001) that also includes the Deity Mercury. However, judging from its style and composition, this is more likely a Korean Buddhist painting from the Koryŏ period than a Chinese one as originally thought.

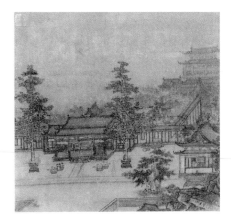

78

Anonymous
Palaces with a Garden

Southern Song dynasty, early 13th century
Square album leaf; ink and color on silk
23.3 x 24.9 cm
Denman Waldo Ross Collection 29.1

Inspired by the sophisticated life in and around the prosperous city of Hangzhou, Southern Song academy painters frequently depicted luxurious residences and attractive gardens. According to Emperor Huizong, this subject matter did not become sophisticated until the Five Dynasties period.[1] Whereas earlier depictions generally favored panoramic views of an entire palace complex, Southern Song artists tended to focus on sections.

This square painting was probably trimmed in the past. Its darkened appearance heightens the feeling of evening time. A section of a palace complex is ingeniously divided into horizontals and diagonals, with the trees and a three-story tower providing additional verticality. The high tower looms in the background almost like a distant hill in a landscape. In front of it is the pointed roof of a pavilion situated at the end of a closed corridor with windows. The front end of the pavilion is revealed by the opening door of a horizontal building from which two young maids, only partially visible, have just emerged. In the center of this building, a lobby is connected with the guest hall, where lacquered furniture, colored with cinnabar red and black ink, is still visible. Because it has been worn away, only three pigmented, slim women are now visible at the center of the entrance. They stand as if expecting visitors; two are dressed in white and, between them, a

third wears red. Four pots of lotus, still showing red and white blossoms, are placed on either side of the entrance. The large front courtyard is decorated symmetrically with potted trees and blossoms. On the right side of the composition is located another palace building, inside which figures can be seen. It is situated away from the main gate but close to a corner of the landscaped garden and a pond. The buildings are connected by a tile-paved, T-shaped path. The large, empty space beyond the main guest hall and the tower is left entirely clear. The drawing of the architecture and trees as well as the garden rocks is heavy and solid, recalling a style associated with the *Landscapes of the Four Seasons* attributed to Liu Songnian (Beijing Palace Museum).[2]

1. See *Xuanhe huapu*, juan 8, pp. 81–90, in Yu Anlan, *HC*, vol. 2.
2. See *ZMQ: huihuabian* vol. 4, pl. 55.

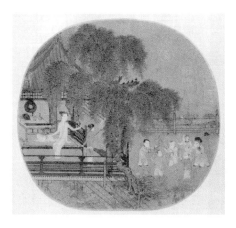

79

Anonymous (formerly attributed to Wang Qihan, act. 961–75)
Women and Children by Lotus Pond

Southern Song dynasty, first half 13th century
Round fan mounted as album leaf; ink and color on silk
23.9 x 25.8 cm
Denman Waldo Ross Collection 28.842a

On a summer day—with green willows in the courtyard, pink lotus blossoms in a pond, and a maid waving a long fan— seven small children are totally preoccupied by their outdoor games. A young mother, inside a pavilion built over the lotus pond, is at once comforting her

baby while gesturing to the maid to watch the youngsters outside. The artist has used a leafy weeping willow as a natural device to divide the composition in two halves, in both of which he has successfully portrayed engaging scenes. As they look toward the children on the right half, the turned heads of the mother, the maid, and even the baby subtly link these otherwise separate spheres of activity.

This thirteenth-century genre painting accurately records the lifestyle in the Southern Song capital of Hangzhou. For example, the two women wear contemporary Southern Song dress and hairdos, which differ markedly from the antiquated clothing and hairstyles borrowed from earlier periods, which are seen in two other paintings in the Boston Museum's collection (see cat. 25 and 76). The rendering of the baby and children also differs from those of the earlier type, which are generally rounder and heavier.[1]

The artist is equally at home in painting human figures, architecture, and furniture of the time. The small pavilion holds a variety of furniture and objects depicted in a logical sequence, without seeming overly crowded. The objects surrounding the mother suggest she is a Southern Song woman, educated in music and literature with an antiquarian's taste for fine art. On her black-lacquer table are three scrolls of painting or calligraphy, a stack of books, a lacquer box containing writing tools, a bronze vessel known as a *touhu,* an incense burner, and the musical instrument known as *qin.* A small standing screen is at one end of the couch and an unidentified round object hangs on the wall.

The artist's interest in physical details is impressive. This is an extremely skilled and careful rendition of contemporary elegance and prosperity from the Southern Song period. A fan with calligraphy of a poem (unrelated to the image here) has traditionally accompanied this painting (cat. 80).

1. Fong *BR,* pp. 22–23, pl 2.

80

Anonymous

Calligraphy of a Quatrain in Semi-Cursive Script

Southern Song dynasty, late 12th century
Round fan mounted as album leaf; ink on silk
24.3 x 23.8 cm
Denman Waldo Ross Collection 28.842b

Although this calligraphy is the companion leaf to *Women and Children by Lotus Pond* (cat. 79), the meaning of the poem is unrelated to what is depicted in the painting. The text is translated by Richard Edwards as follows:

> Across the stream I seem to hear a trace of sound
> Idle the light fades, day already late
> No egret comes to settle at the river-sand's mouth
> Here the breeze, the moon—yet who's to know?

Quite possibly a mismatch occured some time ago in the Boston Museum. The poem describes a solitary moment in a quiet landscape not frequented by people. The poetic expression would be much better suited to a painting such as *Cranes under an Overhanging Pine Tree* (cat. 83). The calligraphy style is generally related to a group of works by twelfth-century Southern Song nobility. The seal, with two characters *shan ya* (virtue and elegance), impressed at the left edge is engraved in a style similar to the two-character seal that reads *shan qing* (virtue and celebration) on the well-known *Swallows and Willow Tree* by Mao Yi (act. 1165–74) now in the collection of the Freer Gallery, Washington, D.C.

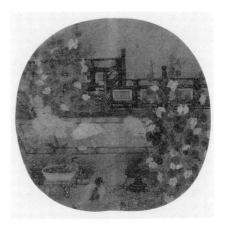

81

Anonymous (formerly attributed to Zhou Wenju, act. ca. 900–75)

Child with His Pets in a Flower Garden

Southern Song dynasty, 13th century
Round fan mounted as album leaf; ink and color on silk
24.5 x 25.7 cm
Chinese and Japanese Special Fund 12.897

The peace treaty with the Jurchen Tartars in northern China, which was agreed upon in the mid-twelfth century, and a flourishing economy in the south allowed the people of the newly established Southern Song dynasty to enjoy a much richer life and a more sophisticated culture than before. Paintings produced by Southern Song artists faithfully reflect the prosperity of this new society. This lovely, quite naturalistic fan painting depicts a well-maintained garden with colorful flowers, fantastically shaped garden rocks, lavish garden railings, and a variety of potted plants. It also offers a rare glimpse of the lifestyle of a young boy in thirteenth-century China. He is shown surrounded by his toys and his pets—a native white cat and a Siamese. The child has been provided with a piece of handsome carpet upon which he and his white cat are taking a break, perhaps after having played some game.

The composition is at once colorful and complex. Within the orderly confines of the garden railings, the artist has created a world of dazzling colors and varied forms. His effort to provide varied colors even extends to the designs of the carpet and the four potted plants. The composition is built around a complex design of horizontal, vertical, diagonal, and curvilin-

ear lines. The artist thoughtfully positioned the reclining child with his head turned inward so as to form a triangle with the two cats, which in turn subtly offsets the horizontality of the railings and the carpet. He also emphasizes a number of round and oval shapes ranging from cymbals, a little drum, the pots containing dwarfed plants, miniature rocks, and the repeated round pattern at the edges of the carpet.

Zhou Wenju has been credited for several paintings of children, such as the fan painting *Palace Ladies Bathing Children* (Freer Gallery, Washington, D.C.) and a short handscroll, *Playing with Children* (Metropolitan Museum of Art, New York), which was incorrectly attributed to the eighth-century painter Zhou Fang. It is doubtful that the Boston fan is a work by Zhou Wenju. More plausibly, it is by a follower of the twelfth-century master Su Hanchen, who also specialized in painting children.[1] The removal of the original handle from the fan has resulted in an imbalance between the more pronounced horizontality and the reduced verticality. It also has left the center of the fan without any motif except the modern seal of an inconsiderate collector.

1. See cat. 26 and *Two Children at Play in a Garden* (National Palace Museum, Taipei).

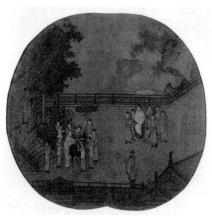

82

Anonymous
Yang Guifei Mounting a Horse

Southern Song dynasty, first half 13th century
Round fan mounted as album leaf; ink and color on silk
25 x 26.3 cm
Chinese and Japanese Special Fund 12.896

The romance of the Tang Emperor Xuanzong (r. 712–56) and his favorite concubine Yang Guifei (or Yang Yuhuan, 719–56), who was regarded as the most striking beauty of her time, has always been a favorite subject for poets and painters in China, Japan, and Korea. This painting shows the emperor and his entourage patiently waiting for Yang Guifei to mount a black stallion, while a group of ten attendants help her. In the crowd of nineteen people and two horses depicted on this small fan, all seem frozen in space except the beautiful lady struggling to mount the horse. With her elaborate hairstyle and fanciful dress, Yang Guifei is the center of everyone's attention. The courtyard setting is rigidly defined by railings and buildings. Even the trees in the picture appear motionless. The stiffness of the figures and rigidity of the architectural elements drawn with the help of a ruler (*jiehua*), detract from the romantic passion associated with the celebrated love affair between the most powerful emperor in eighth-century Asia and the most beautiful woman in the Central Kingdom.

It is useful to compare this academy work with a handscroll by Qian Xuan that depicts the same subject matter (Freer Gallery, Washington, D.C.).[1] Qian Xuan's treatment represents a renewed interest in pre-Song figure styles, which is in direct contrast to the conventionalized repetition of academic works produced during the Southern Song period. Qian Xuan's neoclassicism in figure painting reintroduces a long-neglected elegance and refinement of brushwork as well as the archaic charm of a composition free from the interruption of a background setting. As a learned scholar, poet, and calligrapher, Qian Xuan was possessed of a literati aesthetic view that differed from that of the professional painters who served in the court.

1. Lawton, *CFP*, no. 43.

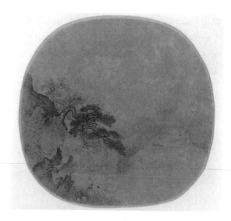

83

Anonymous (formerly attributed to Liu Songnian, ca. 1150–after 1225)
Cranes under an Overhanging Pine Tree

Southern Song dynasty, first half 13th century
Round fan mounted as album leaf; ink and light color on silk
23.3 x 24.8 cm
Chinese and Japanese Special Fund 14.57

A pair of delicately drawn cranes appear in a marsh. Nearby, an oddly shaped rocky cliff provides a foundation for overhanging trees whose branches reach downward and shade the cranes below. The composition in this exquisite painting is truly one-cornered. With the exception of the lightly painted, small, short reeds that vaguely define the edge of the pond, all the major motifs are concentrated in the left corner, leaving a vast void of mist to the right.

This painting was previously attributed to the twelfth-century court painter Liu Songnian. However, Liu Songnian's compositions never display such one-cornered arrangements. The compositional features of this painting, in fact, do closely resemble those of the Yan brothers, in which the foreground frequently is compressed into one corner, thus leaving the rest of the painting to void areas of space. Such rendering typifies later styles of the Southern Song landscape tradition. Since both the pine tree and the crane are traditional symbols of longevity, the artist may have created this work to be an auspicious gift, one by which he extends to its owner his wishes for a long life.

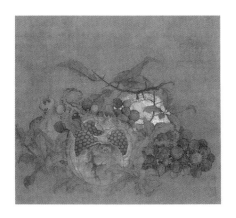

84

Lu Zonggui (act. 13th century)

Orange, Grapes, and Pomegranates

Southern Song dynasty, 13th century
Square album leaf; ink and color on silk
24 x 25.8 cm
Charles Bain Hoyt Collection 50.1454

This rare "still life" among Chinese paintings, a delightful and colorful presentation of a selection of three different fruits, was created to serve as a traditional auspicious gift. The grapes and pomegranates symbolize the wish for many descendants. The mandarin oranges, on the other hand, symbolize good luck, since the Chinese pronunciation for orange—*ju*—sounds like *ji,* the word for auspicious. The presentation of these motifs may have been exaggerated to create a stronger visual impression, but the tightly articulated composition and the rather realistically rendered, rich colors of the fruits and their animated leaves are typical of a thirteenth-century Southern Song pictorial treatment. The small, broken twig from which the orange grows suggests that the fruits were freshly and purposely gathered for presentation. They imbue the painting with worldly charm and expectation. One can easily understand that, during this time, well-to-do families, even the royal household, would be eager to acquire art works that both delighted the eye and heightened the owner's expectations for prosperity.

A small signature reading "Lu Zonggui" appears in regular script at the left side on the surface of a green leaf, next to the left pomegranate. Few paintings attributed to this artist are signed, thus the signature here provides a valuable document. Judging from literary references, the

artist was a member of the imperial painting academy and was known for his still-life works. The seals of three collectors are found on the album leaf: The one at the upper-right corner is that of Mu Lin (act. fifteenth century); the two at the lower right belong to Li Zaixian (nineteenth century); and in the lower left are two seals of Wang Beiyuan (twentieth century).

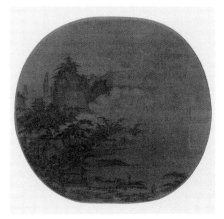

85

Attributed to Ma Kui
(act. late 12th–early 13th century)

Landscape with Temples and Figures

Southern Song dynasty, mid-13th century
Round fan mounted as album leaf; ink and light color on silk
23.8 x 26.3 cm
Chinese and Japanese Special Fund 14.58

In brushwork and composition, this fan is close to that of *Viewing the Tidal Bore on the Qiantang River* (cat. 87) and both may be by the same hand. The composition of this fan may have been based on a scenic spot around the West Lake in Hangzhou, the capital of the Southern Song dynasty, just as *Viewing the Tidal Bore* is based on the celebrated tidal waves of Qiantang River near Hangzhou. This fan shows a scholar carrying a cane, who is about to walk over a stone bridge en route to a temple complex. A tall peak crowned with shapely trees pushes up behind a band of rising mist. Beyond the peak are distant mountains painted with a light ink wash. At the foot of the mountain, in the middle ground of the composition, bamboo groves can be seen along the shore.

The whole painting is executed with a blunt brush (*dunbi*), resulting in thicker lines that articulate the motifs. Two pines are surprisingly similar to the pair in *Viewing the Tidal Bore:* Not only are their trunks outlined with thick strokes further enhanced by a series of dottings, but the pine needles in both fans are also drawn with sets of short, heavy strokes; the hanging vines are done in the same manner as well. Painted next to the trees in each work are similar architectural structures executed freely, without a ruler. The compositions of each fan are also related: In both, a corner of the foreground is crowded with motifs, then either tidal waves or the lively rising mist contrasts with the busy, solid rendering of buildings and trees.

The traditional attribution of this round fan painting to Ma Yuan's older brother Ma Kui is difficult to confirm since no work definitely known to be by Ma Kui has survived. However, the painting clearly shows Ma Yuan's influence and was likely the work of a painter close to him. Comparison of this album leaf with an early painting by Ma Lin, *Landscape with Great Pine* (Metropolitan Museum of Art, New York),[1] shows some similarity in the drawing of buildings, the Ma Yuan–type of pine trees with creepers hanging from the branches, and the way motifs crowded into one area display little space or depth. But the Boston painting emphasizes details rather than the pictorial unity that is characteristic of Ma Lin's works.

1. Fong, *BR*, p. 300, pl. 65.

86

Anonymous
Travelers at Dusk

Southern Song dynasty, mid-13th century
Round fan mounted as album leaf; ink and light color on silk
22.8 x 25.3 cm
Chinese and Japanese Special Fund 14.59

This composition is dominated by horizontal elements. At the middle of the painting, distant mountains, trees, and land form an intricate band that extends from the extreme left of the composition all the way to its right. This emphasis is so

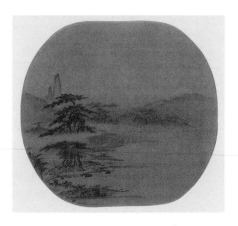

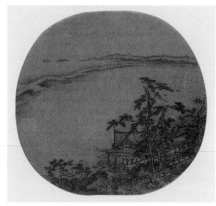

pervasive that even the five tall pine trees in the foreground have been "cut" by misty horizontal zones. It is as if the upper reaches of the pine trees were more integral to the left-to-right movement than to the verticality one normally would attribute to the trees themselves. Such strong left-to-right compositional blocking is deliberately enhanced by other suggestions of horizontality in the sand banks, slopes, and movement of the travelers in the foreground.

The acute sense of spatial depth, attention to atmospheric depiction, and clarity in articulating the travelers' approach from the foreground to the temple complex in the far distance are characteristic of the late-Southern Song period. The softer, less forceful brushwork is consistent with the academy style of that period but it hasn't been subject to the oversimplification seen in many such works. Stylistically, the painter of this composition is indebted to the influential new landscape painting movement started by the sons and the followers of Ma Yuan and Xia Gui about the middle of the thirteenth century.

87

Anonymous (formerly attributed to Xu Daoning, 11th century)

Viewing the Tidal Bore on the Qiantang River

Southern Song dynasty, mid-13th century
Round fan mounted as album leaf; ink and light color on silk
23.7 x 25.4 cm
Denman Waldo Ross Collection 17.733

When the Southern Song court made Hangzhou its new capital, the natural phenomenon of the massive tidal bore in the nearby Qiantang River became one of the favorite topics for poets and painters of the time. The fan painting of the same subject matter, attributed to Li Song (act. 1190–1230), in the collection of the National Palace Museum, Taipei, is an idealized presentation of the subject.[1] Li Song's viewpoint is from the terrace of a luxurious imperial palace complex; the architecture and point in the Qiantang River where the tidal waves emerge are meticulously rendered with a delicate, pointed brush and the aid of a ruler. The artist even provides the viewer with a full moon to enhance the atmosphere.

The Boston fan, on the other hand, is painted from a more mundane perspective. The viewer is right at the edge of a balcony in the waterfront pavilion. Instead of the moon hanging high in the sky, as in Li Song's composition, here the artist focuses on showing the natural force that rushes the tidal waves toward the shore. Capturing an instant in time, the artist includes a few detached pine needles to indicate the strong wind accompanying the tide. A blunt brush (*dunbi*) touched the silk's surface quickly and lightly to form groups of rocks and bushes in the foreground, topped by two angularly shaped pine trees. A few anchored boats emerge from behind the foliage. The architecture here is painted with a free hand rather than relying on a ruler and, hence, creates a more spontaneous flavor. The artist of this fan departs from Li Song's one-cornered composition, opting for a more intimate spatial relationship. He avoids showing the dramatic contrast between solid and void, instead making the distant mountains and the moving tidal waves more apparent in the composition.

At the extreme right of the fan, two characters that may be interpreted as "Daoning" are written on a rock. These two characters are the same first name as the eleventh-century artist Xu Daoning who created the masterpiece *Fishermen* (Nelson-Atkins Museum of Art, Kansas City). Although the first name is the same, there is no reason to consider the Boston fan his work. *A Scholar Carrying a Staff under Pine Trees,* a fan painting from the National Palace Museum, Taipei, bears the same two-character inscription as the Boston work.[2] But the style of the Taipei fan is much closer to Liu Songnian than Xu Daoning. The signatures on both works are probably later additions.

1. *Chinese Art Treasures,* cat. 51.
2. *National Palace Museum Monthly of Chinese Art,* no. 147 (June 1995), front cover and pp. 84–85.

88

Anonymous (formerly attributed to Dai Song, 8th century)

Herd-Boy Mounting a Water Buffalo

Southern Song dynasty, 13th century
Round fan mounted as album leaf; ink on silk
24.1 x 25.2 cm
Denman Waldo Ross Collection 29.961

This fan depicts a playful little boy doing his best to climb on the back of a friendly water buffalo in a conventional manner—from the head to the neck and onward to the animal's back. With its head lowered and legs spread, the water buffalo eyes the boy skeptically. Its open mouth seems to cry out with instruction to the struggling boy. By depicting the buffalo frontally, and the boy from behind, the artist has produced a delightfully amusing drama.

Unlike the realistically detailed presentation of the herd-boy and water buffalo on the right, a clump of bamboo is freely

painted in ink on the left half of the fan. The plants' leaves are executed with speed and energy. Such spontaneity is more commonly found in ink bamboo drawings by literati and Buddhist painters of the thirteenth and fourteenth centuries. The difference in this Southern Song fan is that its painter adheres more to the natural shapes of the whole bamboo and also uses different ink tonalities that lend visual depth to the leaves. In order to echo the bamboo grove on the left, the artist added some bamboo leaves on the far right, resulting in a composition more typical of Song rendition. The abstraction of the bamboo and the realism of the figures on this fan have created an unusual, contrasting ensemble.

89

Anonymous

Illustrations to Tao Qian's Prose Poem "Home Coming"

Southern Song dynasty, 13th century
Handscroll; ink and color on silk
30 x 438.6 cm
Chinese and Japanese Special Fund 20.757

Chinese classical literature, whether poems, prose poems, or essays, has long inspired painters not only in China, but in Korea and Japan as well. For centuries it was a common practice of Chinese artists to translate literary imagery into pictorial presentations. Paintings illustrating the classical prose poem "Home Coming" by Tao Qian (*zi*-name: Yuanming, 365–427) are typical examples of that tradition. This handscroll embodies the unique Chinese aesthetic concept of combining literature, calligraphy, and painting into a single art form, a synthesis of what Chinese called the Three Perfections.

Literary Themes and Sources

The poem and painting in the Boston scroll represent one of the quintessential paradigms of Chinese art: the theme of the scholar–official or literatus who retreats from public life to affirm the transcendental values of nature over bureaucratic order. Tao Qian's poem is one of the earliest examples in a lineage that includes figures like the Tang poet and prototypical literatus Wang Wei as well as the Song literatus Mi Fu. Tao Qian's

poem captivated artists for centuries, in part because of the Daoist philosophy and lifestyle he expressed. Unlike Confucianists, who throughout their lives sought participation in court politics, philosophical Daoists like Tao Qian renounced such entanglements and preferred, instead, to pursue individuality and self-cultivation.

The poet Tao Qian composed this prose-poem in 405, when he was forty-one years old, after he had served as a district magistrate for a little over eighty days. In the preface he writes that the reason he entered government service was to support his family; but he soon realized that bureaucratic conduct was against his nature, and thus decided to resign and return home. In the prose poem, Tao Qian envisioned the life of joy and spirituality that he would lead after his home-coming—a life he would live in complete harmony with his own Daoist philosophy.

Description

The Boston handscroll contains a portrait of the poet Tao Qian and five illustrations of varying lengths to accompany corresponding calligraphic texts of "Home Coming." Unfortunately, it lacks Tao Qian's original preface and final paragraph as well as their companion illustrations. It may have been the painter's intention for the idealized portrait of the poet that begins the *Home Coming* scroll serve as a pictorial preface instead. The portrait, executed in the *baimiao* (ink line drawing) style, resembles the image of Tao Qian seen in the hanging scroll *Scholar of the Eastern Fence* (National Palace Museum, Taipei), an early work by the individualist painter Liang Kai. In fact, the pose and the costume of the *baimiao*-style portrait in Boston suggest a stronger antiquarian appearance than the one by Liang Kai and may have been inspired by a prototype in the Northern Song dynasty or earlier. A handscroll entitled *Illustrations to the Life of Tao Yuanming* (Freer Gallery, Washington, D.C.), attributed to Zhu Derun (1294–1365), depicts the poet with similar headgear, a loose robe, sandals, and staff; a young servant carrying a wine jar on his back follows a few steps behind.[1] This idealized image of Tao Yuanming probably derived from Li Gonglin and was repeated by many Song and Yuan painters. In the Boston handscroll, the portrait of Tao Qian at the beginning may originally have included a similar young attendant carrying a wine jar. Wine drinking not

only suggests the poet's personality but it would also represent his more carefree, Daoist attitude toward existence.

The illustration to the first paragraph of "Home Coming" depicts the poet anxiously standing at the bow of the boat as he waits for it to anchor. On shore, a lively welcoming party busily prepares for his arrival: A young boy rushes out of the gateway with an adult to welcome the returning poet; behind the gate inside the courtyard, a dog runs alongside a woman, perhaps the poet's wife, who hurries to the door while still fixing her hair; a maid follows her mistress carrying a lacquer tray with a cup of greeting wine. The painted scenery, with a large pine tree and chrysanthemums by the gate, the thatched roof and fence woven with bamboo skin, all closely follow the description in Tao's prose poem.

The illustration that follows the second paragraph of the text describes the situation after Tao Qian's arrival—how the poet enjoyed food and drink with his wife and children in an austere-looking hall while servants shuttle back and forth between the kitchen and dining hall with food or empty plates. Outside the kitchen, a rooster perches on the roof while two hens appear sitting on their eggs in baskets. Gourds, hoes, ladles, and fruit are suspended from the beam. To the left of the kitchen, a large jar receives water from a mountain stream under a trellis covered with green gourds. The poet and his family sit in an archaic manner on the floor, rather than on contemporary chairs. The wine container and drinking vessels are also shaped like ancient ritual bronzes. Two trees growing outside the house have both been meticulously modeled with drawings and shadings to show the rough texture of their trunks and the spatial relationship among their branches.

The third paragraph of the text expresses the poet's longing for nature when he observes the mists floating casually away from the hills and birds returning to the woods after a long flight. The calligraphy is written in cursive script modeled after the style of Emperor Gaozong. The forty-eight characters of this paragraph are symmetrically arranged, not unlike the calligraphy of Buddhist and Daoist sūtras. The third illustration in the painting depicts a garden situated between two streams. A stairway leads to the top of the manmade hill, painted in green and

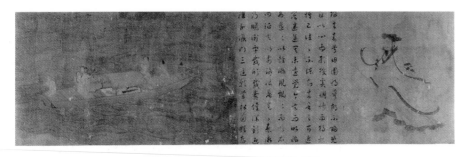

decorated with a group of garden rocks, where the poet stands under a lone pine tree.

The fourth paragraph of the text conveys the poet's decision to withdraw from society and public life and to befriend only a few learned hermits who share the same philosophy and lifestyle. On the right, the picture illustrates his great enjoyment in sharing with his friends the joy of composing poetry amidst good wine and food. Tao Qian and his three guests all sit on floor mats, again without the kind of Western-influenced furniture popular in the Northern and Southern Song periods. The poet in his typical loose-robed outfit leans slightly toward the left as if listening to his guests' views on his writings, which are unrolled in front of him on the mat. Nearby, we see the display of a group of handscrolls, a *qin,* and a round ink stone, just as the prose poem describes.

A servant next to the tightly closed gate seems to be gesturing to the people outside to go away. These callers have arrived by means of either horses or oxen. The two horse grooms are obviously tired of waiting; one yawns while the other is taking a nap; two young cowherds occupy themselves with a game. The servants dressed in uniform with official headgear accompany a distinguished-looking gentleman, perhaps a district magistrate. One, carrying a "portfolio" of official documents, knocks on the door; while the other, standing behind this official, holds a package, perhaps a gift. Just around the corner of the slope, another officer, newly arrived, is in the process of dismounting. They represent the court's efforts to lure the disillusioned Daoist poet back to the establishment.

In the next paragraph, the poet expresses his awareness of the limitlessness of nature and the limitations of human life. Accordingly, he desires to abandon himself to nature, exploring the beauty of mountains and rivers by means of boat or ox-drawn cart. The scroll shows a landscape with the poet riding such a cart in the foreground and boating on the river at the upper left. In the foreground scene, he is accompanied by three servants who carry a wine jar, scrolls, and food—a few worldly pleasures Tao Yuanming still enjoys. An exquisitely depicted portable picnic cabinet, the prototype of furniture that became popular in the late Ming, is also among his belongings. The device of

representing Tao Yuanming simultaneously in two distinct settings suggests a Daoist transcendental theme long associated with this poet. Here, the triumph of the poet's imagination over actuality allows him to be literally and metaphysically in two places at once. It also shows the painter's effort to represent synchronous events in time and space that transcend a purely linear "reading" of the narrative in the handscroll format.

The two missing sections from the Boston scroll can only be reconstructed according to what is still preserved in the Freer handscroll *Tao Yuanming Returning to Seclusion*.[2] The section illustrating the sixth paragraph of the text shows the poet squatting in a rice field, balancing himself by tightly holding onto a staff. The last paragraph and illustration in the Freer repeat the approach of the fifth section, allowing the image of the poet to appear more than once in the same pictorial composition. Here Tao Qian is shown standing both on top of a hill, whistling with joy while, at the bottom, he is shown sitting on the bank of the river with his feet in the water, trying to compose a poem; a servant stands by him with a wine jar on his back and a cup of wine in his hands, just in case the poet needs inspiration.

Style and Dating

The Boston *Home Coming* scroll must have been based on the same original as the Freer version, and both scrolls should be studied together for a better understanding of their history and style. The Freer version has a colophon by Li Peng (act. early twelfth century), dated to the fifth day of the third moon in the fourth year of the Daguan era (March 26, 1110). The poetic text of the Freer's *Tao Yuanming Returning to Seclusion* is not signed, but the calligraphic style of the colophon and that of the poem are precisely the same, which has led scholars like Fu Shen to date the texts to 1110.[3] All of the illustrations in the scroll appear to be early Southern Song, however.

In terms of the brushwork and compositional rendering, the Boston painting has a stronger antiquarian quality than the example in the Freer. Motifs are firmly defined and described in a more linear fashion; spatial depth is minimized to emphasize the more intriguing forms and colors. Its calligraphy follows the writing style of Emperor Gaozong, the most influential calligrapher prior to the emergence of Zhao Mengfu 150 years later. It may have been written by a late-Southern Song calligrapher familiar with Gaozong's hand. The Freer version is more concerned with brushwork and space. This is especially clear in its third and the fifth illustrations, where the background landscape recedes into the distance—just the opposite of the blue-and-green mountain ranges in the Boston scroll. However, the exact relationship of the two scrolls requires further study.

1. See *Toso Genmin meiga taikan*, vol. 3, pl. 2.
2. See Lawton, *CFP*, cat. 4, pp. 38–41.
3. See Nakata and Fu Shen, p. 143.

90

Anonymous (formerly attributed to Dong Yuan, act. tenth century) *Clear Weather in the Valley*

Jin or Yuan dynasty, 13th century
Handscroll; ink and light color on paper
37.5 x 150.8 cm
Chinese and Japanese Special Fund 12.903

Description

The composition of this tall handscroll comprises a mountainous first half followed by a vast riverscape that imparts a strong rhythmic movement from right to left. A vertical structure within the horizontal movement repeatedly invites the viewer to look deep into its pictorial space. Subtly shaped land contours and hills with a distant mountain range in a light blue wash demarcate the opposite side of the river. The composition ends at a wine shop—which would be recognizable to travelers from its outdoor wine flag—at the scroll's lower-left corner.

Style

In general, this work retains the taste and mode of Northern Song landscapes in which vertical, imposing mountain ranges frequently dominate the composition. Here, spatial depth has been treated more conventionally than it would have been in original works by Northern Song masters like Guo Xi and Fan Kuan. Instead, the painter was more interested in simplifying the earlier idealized style for the sake of more descriptive, atmospheric presentation. The three valleys among the peaks in the first half of the scroll are clearly described so that the viewer easily grasps the sense of depth implied in the landscape. The repetitive mountain peaks have the visual effect of a fan unfolding. The application of mists at the foot of the mountains, deep in the valleys, and across the river with the faraway land and hills, produces a soft, light, and intimate landscape image. The mists follow the twelfth- or thirteenth-century tradition of enhancing and defining pictorial space. Equally straightforward is the foreground woods, whose trees are aligned in a horizontal procession. A typically northern-Chinese architecture, complete with a heated brick couch known as a *kang*, is visible inside a thatched house. Beyond this dwelling, deep in the valley, the rooftops of a temple complex can be seen as they rise out of the mist. At the juncture where the mountain mass merges with the open water, an easy transition has been made by the deliberate placement of two groups of travelers moving in opposite directions— one toward the house and the other awaiting a ferry's arrival. The miniature size and strategic placement of travelers and boats highlight a sense of time and space in the painting. The wine shop— another Northern Song motif adapted by the artist—is empty of customers, as if the group aboard the ferry had just left.

The composition, with both lower corners occupied by triangulated land forms and two contrasting elements (mountain versus water), closely follows the northern linear tradition of *The Red Cliff* handscroll by the Jin painter Wu Yuanzhi (act. late-twelfth century) in the National Palace Museum, Taipei. This distinctive northern style can be seen in another Jin painter's work, the handscroll *Wind and Snow in the Firpines* by Li Shan (act. early thirteenth century) in the Freer Gallery. The landscape mural excavated in the tomb of the Daoist priest Feng Daozhen (d. 1265), from the northern province of Shaanxi, also displays this stylistic feature.

The Boston handscroll differs from representative works of the more painterly southern tradition: for example, the *Dream Journey on the Xiao and Xiang Rivers* by a Master Li of Shucheng (National Museum, Tokyo). Throughout the work, the artist combines wet-ink washes to model the motifs with relatively heavy and strong outlines to articulate tree trunks

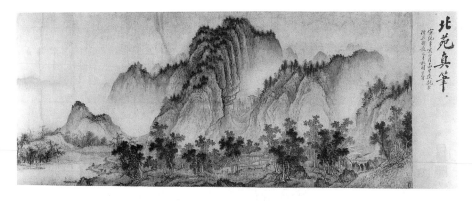

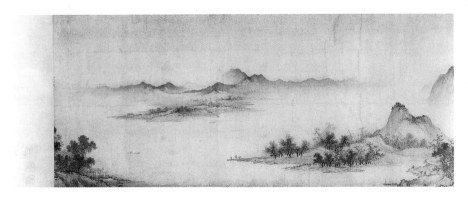

lower-right corner of the picture was once thought to be that of Dong Yuan. In fact, this sign manual (or cipher) was a traditional practice of collectors, and sometimes of artists themselves, to register a painting or a piece of calligraphy in their collection with such a marking. It seems highly unlikely in this case: The character(s) remain indecipherable, and neither the calligraphic style nor structure relate in any way to a period as early as that of Dong Yuan's. The mark resembles a Jurchen (*nüzhen*) character of the thirteenth century.

1. Dong Qichang's attribution is echoed in a 1911 colophon by Zheng Xiaoxu (1860–1938), written at the request of the prominent Manchu collector Wanyan Jingxian just before the owner sold this work to the Museum of Fine Arts, Boston.

91

Anonymous (formerly attributed to Zhang Dunli, act. late 12th century)
The Nine Songs of Qu Yuan

Southern Song or Jin dynasty, second quarter 13th century
Handscroll; ink and color on silk
24.7 x 608.5 cm
Archibald Cary Coolidge Fund 34.1460

Literary and Historical Sources

The poet Qu Yuan (real name: Qu Ping, 343–ca. 277 B.C.), a noble of the Chu State in the south of China, was a learned and faithful minister, entrusted with state and diplomatic affairs by King Huaiwang of Chu (328–299 B.C.). Jealous of his talents, rival court officials slandered and maligned him. Despite his loyalty to the king, the poet was eventually banished. While Qu Yuan was in exile, the Chu State was invaded and King Huaiwang later died in the land of the Qin invaders. In despair, the poet drowned himself in the Miluo River. Ever since, the Chinese people have honored him as a patriot. Annual dragon-boat festivals commemorate his tragic death on the fifth day of the fifth moon.

Qu Yuan's *Nine Songs* were compiled while he was in exile in the area of the Yuan and Xiang rivers, south of the Chu state. The spirituality of local shamanistic rituals and their sacrificial songs moved

and mountain contours. Such wet-ink and bold drawing as well as the northern-style residential architecture identify the painter as either a late-Jin or early Yuan artist who followed the landscape tradition developed in northern China.

Attribution

The former attribution to Dong Yuan, a leading landscape master of the Jiangnan (southern) school in the Southern Tang dynasty, was based not on style but on the Dong Qichang colophon attached to this scroll.[1] The writing "sign-manual" at the

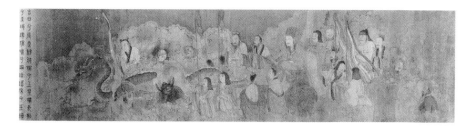

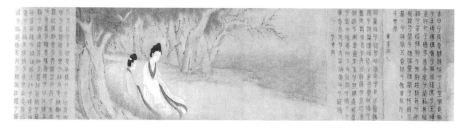

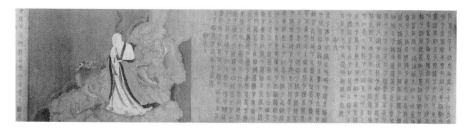

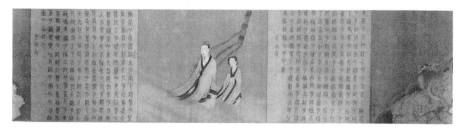

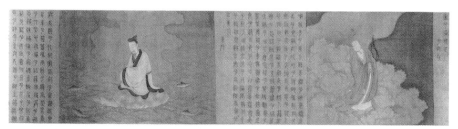

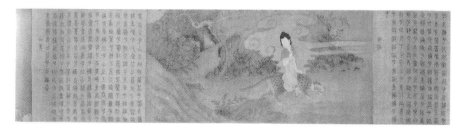

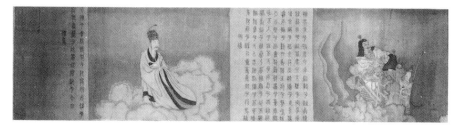

him. Qu Yuan refined and edited them into the text known today as the *Nine Songs*. His literary masterpiece and tragic life inspired many later painters to illustrate the poems. Of the two distinct traditions that developed in China for such illustrations, the better known derives from the eleventh-century literatus Li Gonglin, who is said to have created a version of *Nine Songs* relying solely on ink line drawing. Paintings in this tradition usually follow the *baimiao* (ink line drawing) style, with the text written in either clerical style[1] or regular script.[2] The Li Gonglin tradition was popular among Chinese literati due to their preference for the purity, simplicity, and elegance of ink monochrome presentations.[3] The Boston version, in contrast to the *baimiao* style, represents the lesser-known coloristic tradition.[4] Moreover, the texts that accompany its illustrations are written in archaic seal script.[5]

Two sections are missing: the second ("The Lord in the Clouds") and third ("The God of the Xiang River") songs and their illustrations. The remaining nine are entitled: (1) "The Great Unity, the Sovereign of the East"; (4) "The Ladies of the Xiang River"; (5) "The Senior Arbiter of Fate"; (6) "The Junior Arbiter of Fate"; (7) "The Lord of the East"; (8) "The River Deity"; (9) "The Mountain Spirit"; (10) "The Patriots Died in Wars"; and (11) "The Rites for the Dead."[6]

Description

The text of the first song describes the Chu shamans worshipping the Sovereign of the East with music and dance; in the painting, however, the artist portrays the Sovereign of the East, the celestial king, riding above the clouds in a dragon-drawn chariot, as if responding to the call of the shamans below. The deity is accompanied by a large entourage that includes the demon-queller Zhong Kui, Daoist deities, and civil and military officers. The artist adds a little drama to this otherwise serious parade: At the rear, a guardian king tries to prevent a lesser deity from submitting a report to the Sovereign of the East. To accentuate the procession, the artist has darkened the sky around the outline of the clouds. A mighty, four-clawed dragon is solidly drawn and shaded with color and ink to create a voluminous appearance, which differs from the types created by southern painters such as Chen Rong (cat. 92) or Lu Xinzhong

(cat. 56). A humorous touch can be seen in the facial expressions of three of the colorful monsters next to the dragon. The iconography of the Sovereign of the East resembles the deities in the Boston *Daoist Deities* (cat. 21, 22, and 23). On the other hand, they differ from the type depicted in the painting, *Illustration to the Daoist Huangting Sūtra* (Wango H. C. Weng collection, New Hampshire) by the Southern Song academic painter Liang Kai.[7]

The horizontal narrative scenes of the first song relate closely to religious murals developed in the north in the twelfth and thirteenth centuries. This northern style is quite different in execution and composition from southern, Ningbo-school works (see cat. 34–43 and 48–62).

The illustration to the fourth song, *Ladies of the Xiang River*, is the best-known section of the Boston handscroll. It shows the legendary King Shun's two wives, both of whom died in Dongting Lake and became goddesses of the Xiang River. This illustration portrays the moment when the shamans call upon the goddesses to appear at the lakeshore. One stands in three-quarter view, the other in profile, at the edge of the woods, their heads lowered. They stare at a vast body of water. Along the lake shore, the leaves, grass, and the ladies' garments are all wind-blown, and waves are visible in the water. The picture conveys a deliberate archaism. In general, the tree trunks relate to the handscroll *Secluded Bamboo and Weathered Tree* by Wang Tingyun (1151–1202) of the Jin dynasty, now in Tokyo's Fujii Yurinkan Museum;[8] or to the ink painting, *The Sixteen Arhats,* attributed to the priest Fanlong (Freer Gallery, Washington, D.C.).[9] The composition captures the poetic meaning of the poem's famous verse: "gently, the wind of autumn whispers; on the waves of the Dongting Lake the leaves are falling."

The motifs, including the waves, the two types of grass (on the slope and ground), and the structure of the pine trees are all reminiscent of earlier painting styles. Although the two female figures are comparable to other thirteenth-century works, the gentle and reserved brushwork here produces a visual effect entirely distinct from contemporaneous academic paintings.

The illustration of the fifth song, "The Senior Arbiter of Fate," portrays the deity who decides about the life and death of human beings. It shows an elderly man holding a staff in both hands, riding clouds flying from right to left. He is accompanied by a dragon that closely resembles the one illustrating the first song. The clouds are divided into two types—the light clouds in front have been painted with shading and washes, while the darker ones in the background result from a mixture of color and ink, leaving a lighter edge as an outline. These two layers of clouds are further enhanced by a pale-blue wash for the sky. So lively an approach to rendering clouds is rarely seen in thirteenth-century works.

The subject of the sixth song, "The Junior Arbiter of Fate," is a deity responsible for the life and death of children. The painting shows him as a middle-aged man in Daoist dress and headgear. He is followed by a young female attendant who carries a tasseled staff. The two move from right to left on top of a rainbow, shown with subtle, light-red and blue washes.

The Lord of the East, subject of the seventh song, was regarded by the Chu people as the deity of the sun. The picture shows a young archer clad in a blue robe, holding a bow and two arrows. The deity rides clouds that seem to have made a sudden left turn, animating the composition.

The Chu people started to worship the deity of the Yellow River after the Spring and Autumn period (770–476 B.C.), when the state of Chu had expanded its territory south of the Yellow River. The eighth song is dedicated to the River Deity. The illustration shows the deity sitting on the back of a huge, light-colored tortoise surrounded by four, orderly positioned, leaping fish. This illustration follows the verses: "riding a white turtle he chases the spotted fishes. Let me play with you among the river's islets." The waves, turtle, and fish are all derived from earlier prototypes.

The illustration of the ninth song, "The Mountain Spirit," is another well-known section of the Boston scroll. It depicts a young, attractive female deity riding on the back of a leopard and holding a branch of blossoms in her delicate fingers, which signifies her purity and beauty. The deity appears against a landscape with a mountain slope in the foreground and cliffs with trees and bamboo in the background. Again, this type of landscape is entirely different from typical Southern Song academic works. It is painted in linear style with added texturing and shading in light color and ink. The illustration follows the text it accompanies, including the head of a small animal identified in Tomita's translation as a wild cat.

The tenth song is dedicated to the patriots who died in wars. Two warriors in arms and armor, one in a three-quarter view, the other with his back to the viewer, are shown standing proudly on the clouds. These fallen heroes who died for their country evoke the defeat of the Chu people at the hands of Qin invaders.

Modern scholarship has confirmed an earlier theory that the purpose of the final text, "The Rites for the Dead," was to bid farewell to the deities who were summoned by the shamans. It was meant to be sung as a kind of coda to the previous ten songs. Other illustrated versions, such as the album attributed to Zhao Mengfu or the so-called "Li Gonglin" album,[10] have no illustration for this text, which even the Nanjing copy lacks.[11]

Dating

The Boston scroll stands apart from the mainstream of Song figure painting. The many northern-style compositional characteristics as well as the painting's archaic motifs would support a thirteenth-century dating in the Southern Song or Jin dynasties.

1. See the 1361 ink drawing *Nine Songs* by Zhang Wu (act. ca. 1336–ca. 1364) in S. Lee and Wai-kam Ho, cat. 187.

2. See the 1305 album *The Nine Songs,* attributed to Zhao Mengfu, formerly in the Chang Dai-chien collection. Also see *Dafengtang cang Zhao Wenmin Jiuge shuhuace.*

3. No genuine *Nine Songs* by Li Gonglin is extant. The paintings attributed to Zhang Wu and Zhao Mengfu cited in notes 1 and 2 reflect the fourteenth-century interpretation of the Li Gonglin tradition.

4. The only other known *Nine Songs* painting in color on silk is an album attributed to Li Gonglin now in Berlin's Museum für Ostasiatische Kunst. See Suzuki, *CICCP,* vol. 2, pp. 240–42. The museum of Nanjing University owns an anonymous copy of the Boston handscroll, but it is painted in ink on paper and measures both longer (850.2 cm) and higher (34.9 cm) than Boston's. See *Illustrated Catalogue of Selected Works of Ancient Chinese Painting and Calligraphy,* vol. 6, pp. 305–306.

5. Seal script was not as fashionable as the regular clerical style in Song paintings. The type of seal script on the Boston scroll appears to be of an earlier style than other Southern Song examples.

6. For a complete translation of the text, see Hawkes, pp. 95–122.

7. See Cahill, *The Art of Southern Sung China,* cat. 30.

8. See Cahill, *Chinese Painting,* p. 96.

9. Ibid., p. 94.

10. See note 4.

11. See note 5.

92

Chen Rong (act. first half 13th century)
Nine Dragons

Southern Song dynasty, dated 1244
Handscroll; ink and touches of red on paper
46.3 x 1,096.4 cm
Francis Gardner Curtis Fund 17.1697

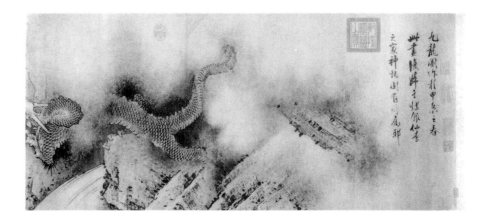

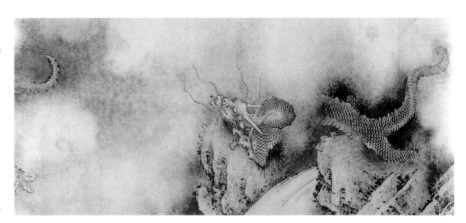

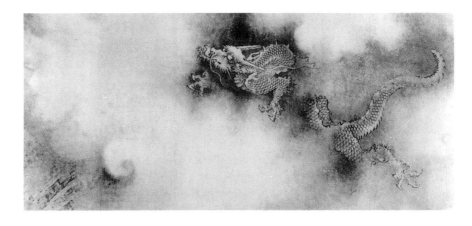

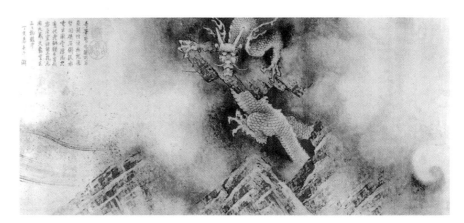

Introduction

Of the many Daoist subjects rendered by Chinese artists, none is more emblematic of the religion's spirit and philosophy than the divine, mythological creature called *long,* or dragon as it is better known in the West. Recent archaeological discoveries confirm its association with Chinese culture for at least six thousand years. From the late-second to early first millennium B.C., dragon references appear prominently in such early philosophical texts as the *I Ching,* or *Book of Changes,* as well as in the images of popular shamanistic worship. Ever since Liu Bang (r. 206–195 B.C.), the founding emperor of the Western Han dynasty proclaimed himself a son of the divine *long,* this creature has been part of the imperial symbolism of China. For Chinese, *long* had distinct cultural associations predating those that developed in the West through Christian iconography and such Biblical dragon images as those in the Book of Revelations.

In China, the importance of dragon painting was recorded by the ninth-century connoisseur Zhang Yanyuan in his work *Lidai minghua ji.* He cites dragon masterpieces by Cao Buxing (act. early third century) and Zhang Sengyou as examples. In the early twelfth century, Emperor Huizong devoted a chapter in *Xuanhe huapu,* the catalogue of his imperial collection, to dragon paintings. Among the extant Chinese dragon paintings today, the Boston scroll is the oldest and the finest in quality.[1]

According to the artist's poem and inscription written at the end of the painting, this *Nine Dragons* was inspired by a *Nine Horses* by the eighth-century painter Cao Ba and a *Nine Deer* attributed to Huichong (ca. 965–1017). Chen Rong was determined to create not only a painting that would match the quality of these legendary works, but also a com-

panion text describing its creation. His poem recounts how he was able to paint the dragons while he was in an intoxicated state of mind. The creative process recorded in both text and image reflect certain mind-altering experiences and insights long associated with Daoist transcendental practices.

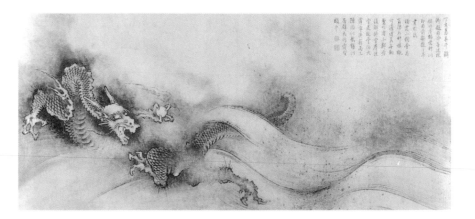

Description

Chen Rong portrayed the first dragon at the beginning of the handscroll as if it had just flown out from the midst of the deep gorges and steep cliffs at a place known as Longmen (Dragon Gate) amidst the waves and clouds. The next dragon has just emerged from Tianchi (Heavenly Pond), ascending through its mists and clouds. Like the Greek demigod Prometheus, the third dragon appears condemned by Heaven, for it was "arrested" at a dark cliff created by the magic power of the Thunder God. Grinding its teeth and stretching its claws, the dragon tears at the slippery cliff as if struggling to free itself. Amidst the uncertainty and confusion of inundating waves and shifting clouds, the fourth dragon has just grasped the pearl of wisdom. With its wide-open eyes and smiling face, this dragon appears exuberant, as if it had just plucked the moon from the sky.

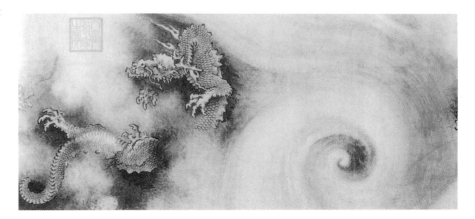

Chen Rong called the "fifth" dragon the oldest in his painting. It is trying to educate its offspring above the clouds. A slight discrepancy between poem and painting occurs with this and the next dragon. Perhaps to dramatize the composition, the oldest (fifth) dragon in Chen Rong's text appears in the painting as the sixth, while the "youngster" receiving instruction precedes him. In the picture, the "oldest dragon" is depicted with missing teeth, a thin, white mane, and a sagacious expression.

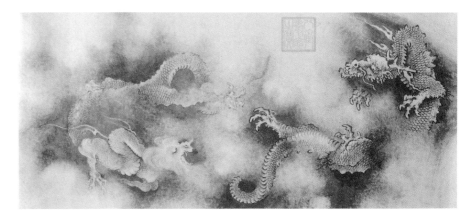

The seventh dragon battles the great waves at Yumen (Gate of Yu), a feat few dragons had ever before dared. The eighth dragon has a gray beard, reddish mane, and a tail "burning with fire." The last dragon reclines atop a solid rock, lofty as the great statesman—the Duke of Shu (Zhuge Liang, 181–234), who retreated from politics to wait for the right moment to save his hungry people from misfortune.

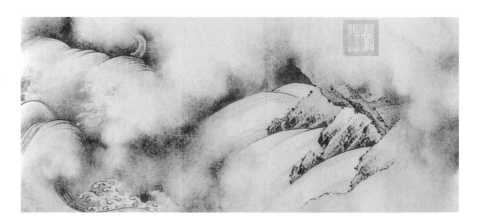

Pleased by the artistic quality of his *Nine Dragons*, Chen Rong declares at the end of the poem:

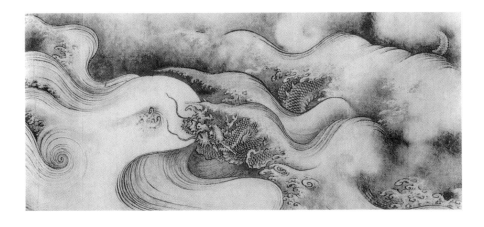

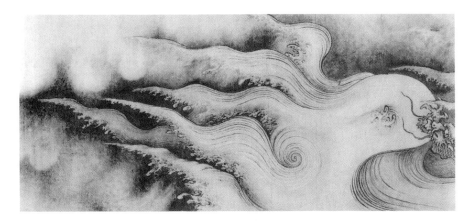

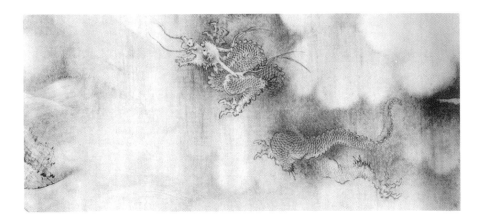

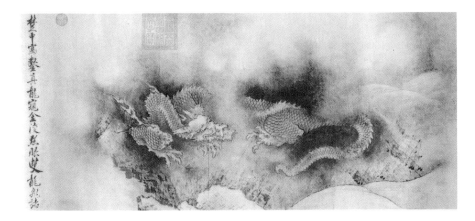

I have painted the picture of nine dragons, and the greatness that emerged from the tip of my brush cannot be found elsewhere in the world. At a distance, one feels as if the clouds and the waves were flying and moving. Viewed closely, one suspects that only god could have painted these dragons.

Interpretation

The varied expressions of the dragons, their movements and interplay with different elements in nature—cliffs, clouds, mists, and waves—are manifestations of the *Dao*. The contrasting nature of the solid rock and cliff on the one hand, and the fluid, everchanging waves and clouds on the other accord with the fundamental Daoist concept of life as the interaction of two forces: *yin* (the negative, receptive, or feminine principle) and *yang* (the positive, creative, or masculine principle).

The nine dragons in the scroll may also be interpreted as one entity experiencing nine transformations in shape, emotion, age, and wisdom. The first dragon charges out of the deep gorges, ascending the celestial heights. But any upward motion must always be followed by a fall, represented here by the agony of the third dragon, which is condemned by heaven to a rocky cliff. In the next transformation, the fourth dragon exalts in achieving life's most difficult task—catching the pearl of wisdom. Then, midway in the composition, the artist ingeniously employs a giant whirlpool to embody the primary Daoist symbolism of *yin* and *yang,* as well as to provide an image for the transmission of knowledge from the older (the sixth dragon in the painting) to the younger (the fifth dragon) generation. In its triumph over the seemingly uncontrollable forces of nature, the seventh dragon, as the embodiment of growth and maturity, once again ascends toward the heavens. At the end of the cycle, the dragon is finally able to reflect and relax on a solid, rocky foundation.

Artist and Colophons

Chen Rong was a learned, ambitious, but impoverished scholar from the southeast coast of China. By the time he earned the prestigious *Jinshi* degree, in the second year of *duanping* (1235), under Emperor Lizong, he was already a middle-aged man. Unfortunately, this did not bring him prosperity. Instead, he ended up a district officer at Putian in his native

Fujian province. According to one of his friends, even at the age of fifty Chen Rong was still poor.

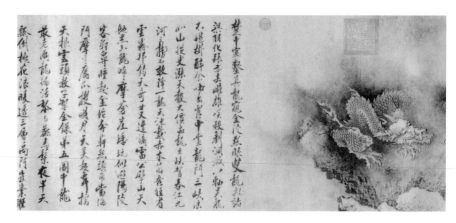

But being a proud scholar, his poverty and political setbacks never interfered with his desire to be a poet, calligrapher, and painter. He expressed his frustration with politics by painting angry dragons. Of the existing paintings by or attributed to him, the Boston scroll is the only work with two lengthy inscriptions by the artist. The evocative poem at the end of his dragon painting is the only original written work composed by the painter in existence today.

Following the pictorial section of the scroll, several historically prominent Daoist scholars and priests, all active in the first half of the fourteenth century, added colophons. Among them is a 1306 colophon by Dong Sixue (act. early fourteenth century), a contemporary of the artist, who left government to become a Daoist priest after the Mongol conquest. Zhang Sicheng (act. first half of fourteenth century), "the Heavenly Teacher" of Daoism, wrote a long poem praising this painting in 1331. Wu Quanjie (1269–1346), another major figure in the Daoist hierarchy of the Yuan dynasty, contributed a colophon in the form of a poem. He believes that the dragon symbolizes Laozi, the founder of Daoism, and that the number nine represents the masculine element of *yang*. In his colophon, the court historian Zhang Zhu (1287–1368) recalls that when a Daoist collector brought this scroll to his attention, he was overwhelmed by the dynamism and divine quality of the dragons. At the end of his poem, Zhang Zhu writes:

> Alas, how heroic is your expression. The conduct of a great man should be just like a dragon. Whenever it appears, it sweeps away all the mediocre ones. How could a great painter be satisfied with just pretty colors, or casually waste his effort in depicting grass and insects?

Provenance

Prior to its acquisition by the Boston Museum, the painting belonged to Geng Zhaozhong (1644-86). It subsequently entered the imperial collection of Emperor Qianlong and then that of the Manchu Prince Gong.

1. For a detailed discussion of the brushwork and other stylistic innovations of the scroll, see Tseng Hsien-chi. Without examining the Boston scroll, Su Gengchun of the Guandong Provincial Museum has compared it to another dragon scroll in that museum and concludes that *Nine Dragons* is a later copy. See *Wenwu* no. 12 (1978), pl. 8 and p. 81.

Anonymous
Four Dragons in Mists and Clouds

Southern Song dynasty, mid-13th century
Handscroll; ink and a touch of color on paper
44.8 x 254.8 cm
Chinese and Japanese Special Fund and James
Fund 14.50 and 14.423

Scholars consider this section of four
dragons to be part of the same handscroll
that originally comprised a section con-
taining two dragons (44.4 x 191.8 cm) in
the Metropolitan Museum of Art in New
York[1] and a section with five dragons
(45.3 x 375 cm) originally in the posses-
sion of the Tokyo collector Masao Suzuki.
This assumption is based on recurrence of
a number of similar motifs and on the
dragons' expressions in the three sections.
Moreover, the rocks are all rendered with
angular brushwork that is further
enhanced by ink washes. The trees, waves,
and waterfalls are consistently depicted in
the same style among the three. However,
a lack of direct continuity among the
three sections suggests that other inter-
vening portions were either cut from the
original handscroll or lost due to damage.

A tentative reconstruction of the three
extant sections would start from the Met-
ropolitan's, with Boston's as the second
and the Suzuki portion at the end. If this
sequence is correct, then the original
composition began rather dramatically
with a group of animated trees whose
twisted trunks, branches, and exposed
roots evoke the bodies, legs, and grasping
claws of dragons tightly clinging to rocky
cliffs amidst clouds and waves. Just after
two circled dragons emerge from behind
the rocks, the New York section abruptly
ends. The Boston section does not contin-
ue the New York layout directly. Altogeth-
er, four dragons spread out in the Boston
scroll, whose heavy ink washes, whirling
clouds, and powerful mountain torrent
create a distinct atmosphere. Once again,
an apparent gap interrupts the presumed
progression from the Boston composition
to the one in Japan. The Suzuki section
brings the ensemble to a dramatic climax
by presenting four playful but tightly
intertwined dragons, with a fifth peeking
out from underneath a rock.

An anonymous colophon written in

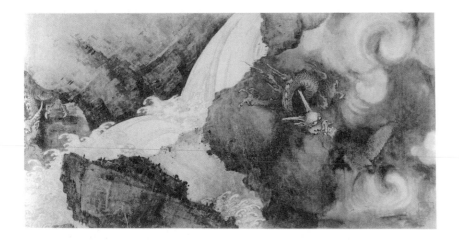

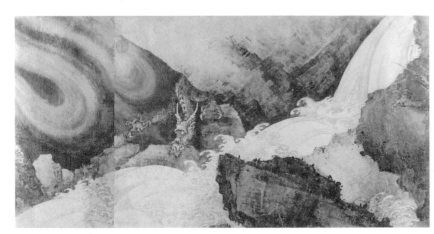

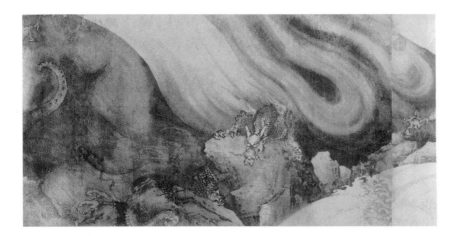

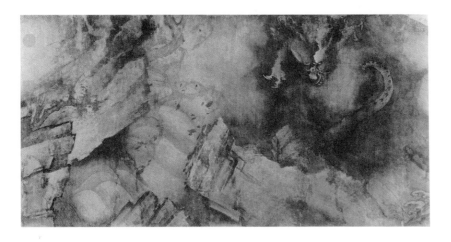

cursive style, probably by a Southern Song monk, is attached to the Suzuki section. On both the Boston and New York scrolls, questionable Qianlong seals are impressed on the composition whereas a dubious Chen Rong seal reading "Suoweng" is stamped at the lower-left edge on Suzuki's. Despite incompleteness and damage, the existing three sections of the eleven dragons together comprise one of the finest extant dragon scrolls. We do not know whether Chen Rong is the painter, but the quality of the original scroll of eleven or more dragons was certainly on a par with his *Nine Dragons* (cat. 92) in the Boston Museum. Tomita believed the scroll had been cut into sections, perhaps around the time of China's 1911 revolution.

1. S. Lee and Wai-kam Ho, cat. 212.

94

Anonymous (formerly attributed to Zhao Lingrang, act. late 11th–early 12th century)
Lake Retreat among Willow Trees

Southern Song dynasty, mid-13th century
Round fan mounted as album leaf; ink and light color on silk
22.2 x 24.6 cm
Chinese and Japanese Special Fund 28.840

The composition of the painting is densely clustered on the left side, leaving an open space to the water. This intimate lake village with a countryside retreat among willows is vividly depicted in a manner typical of the Southern Song. The retreat's open balcony faces the scenic lake

and is flanked by two gently weeping willows. Beneath them, two scholars are at ease, either playing chess or enjoying the view. Damage at the lower right obscures the original scenery. It would have been a common practice of the time to include an additional figure in the foreground so that the light blue wash of the distant mountain and the rice paddy in the middle ground would be more meaningful. The willow tree and rock formations are painted in a light, sketchy manner, indicating a style developed after Ma Yuan and Xia Gui.

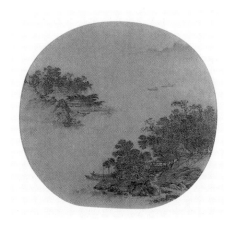

95

Anonymous (formerly attributed to Liu Songnian, act. late 11th–early 12th century)
Lakeside Village in Autumn

Southern Song dynasty, second half 13th century
Round fan mounted as album leaf; ink and light color on silk
24.2 x 26.4 cm
Maria Antoinette Evans Fund 28.849

The composition of this landscape fan is typical of the Southern Song academy style, displaying clarity in spatial relationships and attention to details. In the foreground, amidst autumn trees, stands a waterfront lodge approachable by a hillside path. A man looks out a window at two boats that have just pulled up to the rocky shore. Scattered autumn leaves have fallen on the ground and the reeds as well as on the waves. Further to the left, in the middle ground, a village of several thatched houses in front of a bamboo

grove is visible. Still further toward the background, two small boats sailing briskly toward the distant mountains have been rendered with light-blue washes.

Despite its Southern Song construction, the brushwork tends to be somewhat harsh and rigid. For instance, the texturing of the land and rocks is too loose for convincing definition of those shapes and forms. The motifs in this fan no longer carry the kind of crispness and intensity commonly seen among Song album leaves. Instead, a sense of flatness prevails, especially in the foreground. The richly patterned autumn foliage lacks the tightly woven appearance characteristic of most Song paintings. The artist has been more successful with the foreground where two tree branches with dotted ink leaves, rising higher than the rest, are painted with impressive calligraphic skill. A similar display of brushwork appears in the group of trees on the hilltop in the middle ground. This fan is most likely a late-Southern Song copy after an original work by Liu Songnian.

96

Zhao Qiong (act. 13th century)
The Second Lohan Kanakavatsa of Kasmira

Southern Song dynasty, mid-13th century
Hanging scroll; ink, color, and gold on silk
47.5 x 85.6 cm
Keith McLeod Fund 54.1423

Originally this scroll belonged to a set of sixteen Lohans by Zhao Qiong in the collection of Hokkekyō-ji in Chiba, Japan. The temple still owns twelve original Lohans from the set plus four later replacements that were mounted as two screens. Like others from the group, the Boston Lohan painting bears two inscriptions. One, at the upper-right corner, is the Chinese transliteration of the Lohan's Sanskrit name and place of residence. The other is the artist's signature, which appears at the lower-right edge, near the rock, and reads "Painted by Zhao Qiong from Xiantang, in Siming [prefecture]." Siming is in today's Ningbo district; during the Southern Song period, Xiantang (Brackish Pond) was a street close to Chariot Bridge, where professional artists who specialized in religious paintings had

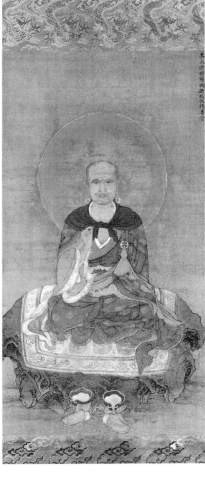

their workshops.

As Ningbo-school Buddhist paintings were mainly exported to Japan, the artists of this school are usually little known in China. The creativity and mastery of these Ningbo painters occupy a unique position in Chinese-painting history, and the effort to collect and preserve their works in Japan was of vital importance to an understanding and appreciation of a painting school that had vanished in its native country. Like other Ningbo painters, the painter Zhao Qiong was not recorded in any premodern Chinese publication.

The bright colors and rich decoration of the Boston Lohan are characteristics shared by other Ningbo-school paintings. A noteworthy Buddhist painting in the collection of Kyoto's Mangan-ji temple has recently been confirmed as a work by Zhao Qiong. It displays figure types, decorative motifs, coloring, and a drawing style that are similar to those Lohans in Chiba and Boston.

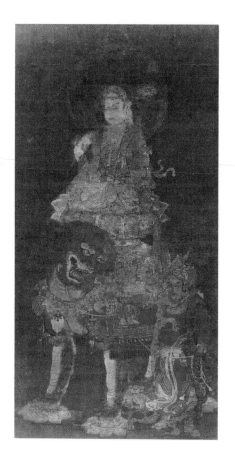

97

Anonymous (formerly attributed to Zhang Sigong, act. 12th century)
Mañjuśrī on a Lion with an Attendant

Southern Song dynasty, 13th century
Hanging scroll mounted as panel; ink, color, and gold on silk
104 x 54 cm
Gift of Mrs. W. Scott Fitz 08.145

The worship of the bodhisattva Mañjuśrī began long before pictorial presentations of this deity became popularized during the Tang dynasty.[1] Early paintings of this important bodhisattva were found in both murals and scrolls at the cave temples of Dunhuang. The center for the Mañjuśrī cult was Mount Wutai (originally Qingliang shan) in Shaanxi province, and a tenth-century wall painting in cave 61 at Dunhuang vividly shows the spiritual relationship between that Chinese sacred mountain and the bodhisattva.[2] Late-Tang paintings of Mañjuśrī in the British Museum attest to the importance and special attention Chinese artists gave to the deity.[3]

This Boston scroll depicts the bod-

hisattva in a serene, formal manifestation, holding the sword of wisdom in his right hand and seated, legs folded, on a lotus blossom. He is borne by a fierce lion who is supported, in turn, by four lotus blossoms. A groom in Central Asian armor accompanies them. The painting, dating from the thirteenth century, differs both in form and style from a Yuan-dynasty Mañjuśrī also in the Museum's collection (cat. 112). The formality of this Southern Song work contrasts with the animation and intimacy of the latter, a fourteenth-century hanging scroll. (For example, the verticality of the lion's and the groom's legs in this painting is just the opposite of the wide-spread legs of those figures in the Yuan version.) The deity's left leg hangs down alongside the lion in the later work, and this more relaxed pose of the figures further demonstrates the Yuan artist's interest in conveying an illusion of movement on the pictorial surface. The spatial depth and motionless figures in this painting, on the other hand, are consistent with Song tradition. The former Japanese owners of this Boston Mañjuśrī attributed it to the hand of Zhang Sigong, a Southern Song artist recorded in Japanese literature as a specialist in Buddhist painting but little known in his native country.

1. The ninth-century connoisseur Zhang Yanyuan recorded that a painter and sculptor named Dai Kui (d. 395) painted a Mañjuśrī image preserved in the main hall of Zhejiang's Ganlusi Temple even after the Tang-dynasty Emperor Wuzong's anti-Buddhist campaign in 845. See Zhang Yanyuan, *Lidai minghua ji*, juan 3 (Reprint ed. Taipei: Shijie shuju, 1962), p. 142.
2. Dunhuang Institute, *Chūgoku no sekkutsu: Tonkō Mogōkutsu*, vol. 5 (Tokyo: Heibonsha, 1980), pls. 55–64.
3. Whitfield, pls. 14-1 and 17.

98

Anonymous (formerly attributed to Huang Jucai, 10th century)
Parrot and Insect among Pear Blossoms

Southern Song or Yuan dynasty, second half 13th century
Square album leaf; ink and color on silk
27.6 x 27.6 cm
Denman Waldo Ross Collection 30.461

The painter's keen attempt to capture a fleeting natural event recalls the aesthetic concerns of earlier Song artists such as Emperor Huizong (cat. 13). However, the

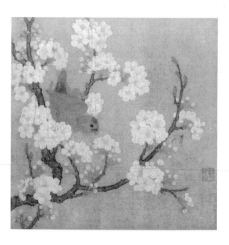

earlier Song interest in selective realism and a precise positioning of motifs has here been replaced by a fanciful atmosphere and an emphasis on filling the pictorial surface. Similarly, this artist is less concerned with articulating spatial depth. Instead, he delights in fully describing every element in the painting, whether the trunk of the pear tree with its delicately shaped blossoms, or the contrast of the bold coloration of the bird with the wasp's fragile appearance. Such concerns signal an important transition in Chinese bird-and-flower painting from the restrained, unified Song pictorial structure to a more relaxed world crowded with vivid details. Here, no hierarchy of spatial relationships is in evidence; every motif is equally detailed to evoke a beautiful design. On stylistic grounds, the painting should be dated to the late-thirteenth century.[1]

1. Traditionally this leaf has been attributed to the tenth-century bird-and-flower master Huang Jucai. James Cahill considers it a possible Ming work while Tomita dated it as early thirteenth century.

99

Anonymous
The Daoist Immortal Lü Dongbin Crossing Lake Dongting

Southern Song dynasty, mid-13th century
Round fan mounted as album leaf; ink and light color on silk
23.1 x 22.6 cm
Chinese and Japanese Special Fund 17.185

The fierce rivalry between Buddhism and Daoism is sometimes seen in the syncretic iconography and borrowings displayed in

their art works. Here the legendary story of Bodhidharma, founder of Chan Buddhism, crossing the Yangzi River on a reed has been surpassed in a similar magical feat attributed to the Daoist immortal named Lü Dongbin (Lü Yan), who is said to have crossed the vast Lake Dongting with no support at all.

This round fan provides a simplistic, austere presentation of one of Daoism's most colorful sages. Lü Dongbin, according to tradition, was a native of Yonglezhen in Shanxi province. During the Huichang era (841–46), he twice failed governmental exams for the prestigious *Jinshi* degree. At that time, he was over sixty years old. One day, in a wine shop, he encountered a Daoist immortal named Zhongli Quan, who converted him to Daoism. Lü Dongbin learned Daoist philosophy, sūtras, and magical swordsmanship to become one of the eight Daoist immortals. In the third year of the Zhongtong era (1262) during the Yuan period, a large Daoist temple dedicated to his worship was erected in Yonglezhen. Lü Dongbin was said to have visited the famous scenic tower Yueyang many times by crossing Lake Dongting but, unfortunately, no one recognized him as an immortal. Out of disappointment, he composed a poem, which he wrote on the tower wall.[1]

This fan shows him standing on waves. The flow of his long robe, scarf, and beard convey a clear sense of movement. He is positioned on the left of the fan rather than in the center because a handle originally obstructed the center of the fan. The figure's slender eyes and full cheeks, and the fine rendering of the beard are all characteristic of the Southern Song tradition. It differs from the more animated approach of the fourteenth century as represented in the hanging scroll *Portrait of the Daoist Immortal Lü Dongbin* (Nelson-

Atkins Museum of Art, Kansas City). The artist of the Nelson-Atkins work has taken a more descriptive approach including such pictorial elements as the turning of the head, the moving of the waistbelt, the gourd hanging from his belt, and the tip of his sword emerging from his right sleeve. None of these details were depicted in the Boston fan which, with simpler definition, was executed in the mid-thirteenth century, prior to the Yuan dynasty when the cult of Lü Dongbin became popular and he was immortalized.

1. Richard Edwards has noted similarities in the pose and drapery of the Boston Lü Dongbin and a miniature image of him in a fan in the Metropolitan Museum of Art, New York. See Fong, *BR,* p. 292, pl. 61.

100

Anonymous (formerly attributed to Li Tang, 1060s–after 1150)
Returning from a Village Feast

Southern Song dynasty, second half 13th century
Square album leaf; ink and color on silk
25.7 x 27.2 cm
Chinese and Japanese Special Fund 12.893

The tradition of genre painting started early in China. Art historical records show that during the Tang dynasty the depiction of scenes of daily life in cities and countryside was already popular.[1] The present album leaf presents an attractive scene of an old villager being helped onto the back of a water buffalo. He is quite intoxicated, his eyes half closed, as he grabs for support; a young man walking alongside tries to keep him from falling off. A barefooted herd-boy indifferently

holds the rope to lead the buffalo home while still finding time to eat the snack in his right hand.

The artist has subtly represented the facial color and expression of a drunken, elderly man. His silver-white beard and hair accentuate the pink complexion that has resulted from his drinking wine. The elder is dressed in two loose robes as if someone, worried about the effect of the evening chill, had thoughtfully covered him with an additional white coat. The drunken old man wears headgear with peonylike blossoms that suggest his participation in a joyful village festival, maybe as a guest of honor. With parted lips and open eyes, the young helper struggles to keep the intoxicated farmer steady by placing his left arm around his back.

Only the water buffalo, with its finely textured hide, looks directly at the viewer. The others are too preoccupied with their own immediate concerns; the herd-boy with his food barely notices the old man's inebriated condition, and the trio seem not to be aware of the moonlit lake-side scenery they travel through, somewhere in the eastern coastal area of China. The beautifully textured, colored leaves of two large willow trees move gracefully in the evening breeze, a movement complemented by the gentle waves in the nearby lake. The thin, dancing lines of the water recede in the distance. A design triangle of natural motifs— willows, waves, and bamboo, all animated by an invisible wind—frame the clumsy human trio. This subtle contrast enhances the realism and atmosphere of this scene from life in the countryside.

The painting's relaxed, gently satiric mood is enhanced by a soft, bluish green color scheme. The artist has skillfully utilized the technique of *shuanggou* (outlined in ink) to depict the bamboo leaves, in contrast to the grass, which is painted with the *mogu,* or "boneless," technique (color drawing without ink). The contours of the rocks, slope of the land, and the tree trunks as well as the drapery on the three figures are drawn with a sense of leisure and elegance. Most likely the painting is of a late-Southern Song or slightly later date. Not enough evidence is available to link this painting directly to the master Li Tang or his school, as formerly attributed, even though Li Tang is known as a painter of figures, water buffaloes, and genre works.

The Beijing Palace Museum has a

short handscroll by an anonymous painter treating the same subject; it varies slightly from the Boston version by its depiction of an ox instead of a water buffalo, a government officer instead of a farmer, and pine trees instead of willows.[2] The Beijing Palace Museum dates its handscroll correctly to the late-Southern Song dynasty (mid-thirteenth century). Its version may have been copied from a Northern Song scroll since the figures are closer to Northern Song prototypes than are those of Boston's. In contrast, the Boston leaf should be considered an academic painting executed during the second half of the thirteenth century. The seal of Mu Cheng (fifteenth century), impressed in the upper right, reads *qianningwang zizi sunsun yongbaozhi* (Treasured by Prince Qianning and his Posterity), also lends support to the Southern Song attribution.

1. Zhang Yanyuan, *Lidai minghua ji*, juan 6, pp. 77–83, in Yu Anlan, *HC*, vol. 1.
2. *ZMQ: huihuabian*, vol. 4, pl. 85.

101

Anonymous (traditionally attributed to Li Cheng, 919–67)
Winter Landscape with Travelers

Southern Song dynasty, late 12th century
Hanging scroll; ink and light color on silk
93.3 x 37 cm
Chinese and Japanese Special Fund 12.879

Based on an inscription written at the upper-right corner, this hanging scroll has traditionally been attributed to Li Cheng, the great master of early Chinese landscape painting, and was so published in the 1933 *Portfolio*.[1] Tomita accepted the inscription as the calligraphy of Emperor Huizong whose imperial catalogue listed some 159 works under Li Cheng's name. But neither the structure of the characters nor the brushstrokes is consistent with reliably accepted calligraphy by Emperor Huizong, such as his writings on the Boston Museum's *Five-Colored Parakeet on Blossoming Apricot Tree* (cat. 13) and *Horse and Groom* (cat. 15). The inscription here is most likely a later imitation of Huizong's hand.

The painting itself is executed in a profoundly delicate and articulated style. It simultaneously presents two spatial

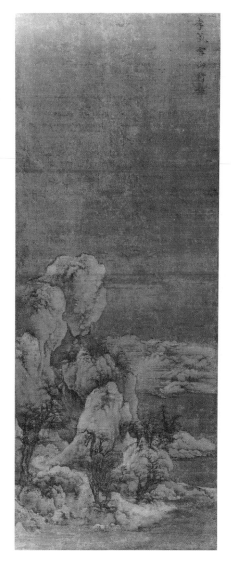

arrangements. On the left, a towering mountain range is depicted in what is known as *gao yuan* (high view), as described by Li Cheng's follower, the landscapist Guo Xi. On the right side, the land with rolling hills stretching into the distance is shown in *ping yuan* (level view). This same compositional approach can be seen in other mid-twelfth-century paintings such as Xiao Zhao's *Tall Cliffs by the River with Temples* (National Palace Museum, Taipei).[2] However, the stylistic tradition reflected in this Boston scroll is entirely different from that seen in works by Xiao Zhao, who was a student of Li Tang. It displays none of the angular, forceful, or sharp brushstrokes typical of Xiao Zhao. On the contrary, the Boston painting is constructed with delicate, curvilinear drawing, further softened by the snow scene. The painter here is less interested in a dominant physical landscape form, but, rather, in the poetic display of an intricate composition that draws the viewer into the painted space. A

viewer's eye is guided by a group of three travelers in the foreground along a winding mountain path leading toward a monastery deep and high up in the mountains. This soft, round, feminine mountain form also contrasts with works from the Fan Kuan tradition (see cat. 11). It is closer to Guo Xi's 1072 work *Early Spring* (National Palace Museum, Taipei).[3] What differentiates them is the use of pictorial space. In *Early Spring*, Guo Xi's landscape takes up almost the entire composition whereas the upper half of Boston's scroll is left void. The half-void, half-solid treatment and its delicate rendering of motifs create an intimate atmosphere that is entirely absent in *Early Spring*, the Boston Fan Kuan, or the Xiao Zhao painting in Taipei.

Very few, if any, extant Li Cheng works can be attributed reliably to this Five Dynasties master. Despite the classical appearance of the composition—like Guo Xi's *Early Spring*, it does not rely on mists, clouds, and waterfalls—the Boston hanging scroll is most likely a late-twelfth-century work in the Li Cheng tradition.

The repetition of similar tree types in the foreground and the little dots accentuating tops of rocks, mountains, and hills recall a post-Northern Song style. So, too, the spatial arrangement of the distant horizon (represented by low hills stretching from the right edge all the way to where the temples stand) suggests a later kind of treatment than what appears in works by Xiao Zhao.

The intimacy and elegant brushwork of this Boston landscape bears an affinity to two landscapes attributed to Emperor Huizong: *Streams and Mountains in Autumn Hues* (National Palace Museum, Taipei) and *Returning Fishing Boats on a Snowy River* (Beijing Palace Museum). The void upper half in the composition later became a fashionable formula for Yuan landscapes, which was subsequently borrowed by ink painters of the Muromachi period in Japan.

1. *Portfolio*, cat. 32, p. 7.
2. *Gugong shuhua tulu*, vol. 2, p. 49.
3. Ibid., vol. 1, p. 213.

102

Anonymous
Flock of Birds Returning to Wintry Woods

Southern Song dynasty, 13th century
Round fan mounted as album leaf; ink on silk
23.2 x 25 cm
Chinese and Japanese Special Fund 20.754

This fan painting, originally in the personal collection of Okakura Kakuzō (Tenshin), was acquired by the Boston Museum after his death. It suffered damage and was heavily retouched. Nonetheless, the original painting still shows its high quality. The artist has the ability to choreograph a large group of flying birds, perhaps crows, into a unique pattern as they return to the woods. Except for the bamboo bush, the trees are all bare and display a complex network of branches and twigs. Some of the birds, whether perched or still looking for a place to land, dot the trees as if they were the leaves. A simple, thatched hut is nestled tranquilly among the trees beneath the busy and noisy birds. A faint wash of a distant mountain divides the composition in two horizontally, while the birds appear like an inscription of poetic verse, offsetting the detailed lower half.

James Cahill has proposed Sheng Mou (act. 1310–60) as a possible creator of this work.[1] Existing paintings by Sheng Mou date exclusively from the 1340s to the 1350s. Little is known about his earlier style, and there does not seem to be any connection between the Boston fan and the dated later works by Sheng Mou. However, the Boston painting can be considered to be a continuation of the Southern Song academy modes into the Yuan period. A Yuan artist in Hangzhou

might well have been influenced by such developments.

1. Cahill suggests it may be "early Sheng Mou or slightly earlier work in same stylistic lineage?" Cahill, *Index*, p. 326.

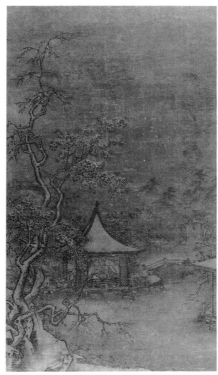

103

Anonymous (formerly attributed to Ma Yuan, act. 1190–1235)
Pavilions by a Stream in Winter

Southern Song dynasty, second half 13th century
Hanging scroll; ink and light color on silk
91 x 54.3 cm
Chinese and Japanese Special Fund 15.909

At first glance, the trees in this hanging scroll seem to borrow from the Ma Yuan vocabulary: with spread, fingerlike twigs and branches, heavy outlines of tree trunks, and rock surfaces with so-called *da fupi* (big ax-cut) texturing. But these resemble the form, not the substance of Ma Yuan's style. Their effective use, especially in the spatial arrangement, can be contrasted with such representative works as *Bare Willows and Distant Mountains* (cat. 68) and *Scholars Conversing Beneath Blossoming Plum Tree* (cat. 69). In this scroll, the two tall trees in the left foreground have been grouped in an almost parallel man-

ner; they lack the elegance of the bare willow trees of the former small fan painting.

The corner of another house glimpsed at the right edge has suffered from a severe trimming during remounting. The architecture of the main pavilion remains firmly in the Ma Yuan tradition, however. It presents delightful details such as a scholar sitting near the window behind a curtain and a rolled bamboo blind that is, in turn, behind grated panels. Across the table from where the scholar sits, a boy servant brings a vase of orchids. Around the pavilion, groves of bamboo bend under the weight of the snow.

For a long time this painting was attributed to Ma Yuan because it resembled his typical style of drawing rocks, trees, and architecture. However, this hanging scroll lacks the kind of tight compositional arrangement and tense brushwork found in the accepted works of Ma Yuan. It is more likely to be from the hand of an early follower active in the late Southern Song.

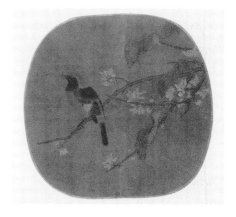

104

Anonymous
Bird on a Flowering Branch

Southern Song dynasty, 13th century
Round fan mounted as album leaf; ink and color on silk
23.2 x 24.8 cm
Chinese and Japanese Special Fund 14.55

In profile, a well-rendered bird, perhaps a Daurian redstart, is perched on a flowering branch of a magnolia tree. The branch bends downward as if to suggest the weight of the bird. The entire composi-

tion is divided in two: the left half is dominated by the redstart, while the other half shows colorful blossoms and leaves issuing from a network of branches. The ensemble gives the viewer a sense of leftward movement. The care taken to depict the three and a half leaves is revealed in the subtle differentiation of different hues of green for their fronts and backs, especially where the veins have been highlighted all the way to the junction with the branch. Adding brown wash and deep brown spots to the edges of the leaves vividly conveys their deteriorating condition. The flowers have been painstakingly drawn to show each of the petals, which are whitened at the edges to contrast nicely with the red color at the heart of the blossoms. The artist has also patiently and quite accurately depicted calyxes and their orientation with respect to the branches. Only the branches are painted in a simply outlined manner, which leaves them surprisingly devoid of further modeling and texturing.

The painting does not have the same tightness and physical accuracy typical of bird-and-flower paintings created in the twelfth century. Instead, what survive are the general compositional layout, forms, and colors of earlier Southern Song academic paintings. Despite the decorative effect of the image, this fan betrays the less sophisticated effort of a later, Song academy artist from the thirteenth century.

105

Anonymous (formerly attributed to Ma Yuan, act. 1190–1235)
Boating Near Lake Shore with Reeds

Southern Song dynasty, mid-13th century
Square album leaf; ink and color on silk
23.8 x 24.1 cm
Denman Waldo Ross Collection 29.963

This painting's most noteworthy qualities are its great economy in brushwork and the simplicity of its composition. Such a minimalist approach is similar in taste and mode to the late works of Ma Lin. But in its sparse display of the essence of the physical world, this work moves even beyond Ma Lin. A few quick, sketchy ink washes in rich black ink have shaped a stylized sandy bank in the foreground. A white-colored scholarly figure reclines in a simply drawn skiff beyond a screen of dancing reeds bent by a river wind toward the end of the sand bank at the lower left. The rest of the vast space has been deliberately left empty, save for two light washes at the upper left that suggest distant mountains emerging from the river mists.

The arresting brevity of this landscape depiction departs from the complex and colorful approach of earlier masters and represents a significant achievement by this unknown painter. The reduction of elements in this new style might have been inspired by the growing influence of such painters as the Buddhist monk Muqi Fachang (ca. 1200–70) and other literati artists. The album leaf has an old attribution to Ma Yuan as well as a seal that reads "Xia Gui" on its lower-right corner. Both are problematic.

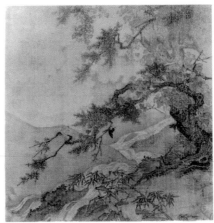

106

Anonymous (traditionally attributed to Li Song, act. 1190–1230)
Autumn Landscape with Butterflies

Southern Song dynasty or slightly later, second half 13th century
Square album leaf; ink and color on silk
26.2 x 26 cm
Gift of Paul and Helen Bernat 1984.457

Before World War II, the Yamanaka Company in Japan handled many Song and Yuan paintings for clients in the West through their New York branch. This previously unknown album leaf was among them.[1] Later it was acquired by benefactor Paul Bernat, who donated it to the Museum's Department of Asiatic Art.

The painting bears a two-character signature that reads "Li Song" in the lower-right corner. The signature appears old, but it differs from the accepted ones. The work shows an old cypress tree growing at the right side of the composition with two branches stretching diagonally from right to left. A mountain stream runs parallel to the branches above it. In typical Southern Song fashion, the upper-left quarter of the pictorial space has been left empty with only hints of a mist permeating the air. The bright-green leaves of a vine festoon the tree, echoing the color of the bamboo leaves seen in the foreground. However, the mineral-green color looks peculiarly fresh and poorly applied, which suggests it was added by a later hand.

Mysteriously, two butterflies painted in black ink, one in profile, the other seen from the back, have appeared in this otherwise typical Southern Song landscape.

Song butterflies were most frequently painted with birds and flowers. Occasionally we see paintings of young ladies or small children trying to capture them, but it is rare to encounter butterflies in a landscape setting such as this. In Chinese poetry and prose, butterflies commonly symbolize romance or the loss of a loved one, but the true meaning of this leaf remains obscure. The answer may lie in an accompanying poetic couplet or a quatrain, now lost.

1. A black-and-white photograph of this painting, marked on its label as in the collection of Yamanaka, New York, is preserved in Harvard University's Fine Arts Library.

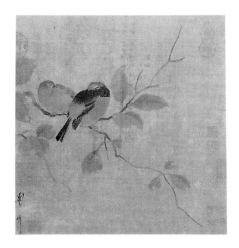

107

Anonymous (traditionally attributed to Ma Lin, act. first half 13th century)
Pair of Redstarts with Autumn Leaves

Yuan dynasty, late 13th–early 14th century
Square album leaf; ink and light color on silk
22.8 x 22.6 cm
Denman Waldo Ross Collection 28.841

This delightful album leaf has traditionally been attributed to Ma Lin because of a signature in the lower-left corner. However, its calligraphic style differs from most of the accepted signatures. The painter used the *mogu*, or boneless, technique in which motifs are freely drawn without the benefit of carefully defined ink outlining. Except for the bird on the right, which was sketchily outlined prior to coloring, other motifs are spontaneously drawn in color.

The positioning of this pair of freely brushed male and female redstarts is remarkably similar to those depicted in *Winter Birds after Evening Snow* (National Palace Museum, Taipei), also attributed to Ma Lin.[1] The theme of flat, simply defined birds on branches was popular even outside of the academy, and the same subject (with different birds) can also be seen in *Two Birds on a Branch with Bamboo*, attributed to the Buddhist monk Muqi Fachang (Nezu Museum, Tokyo).[2]

Simplicity of technique does not prevent the painter of the Boston album leaf from expressing subtle sentiments. The two birds contrast in pose, color, and expression—the more colorful male is depicted with lowered head and closed eyes, while its companion is alert, with eyes open wide. The positioning of the branches and leaves accompanying the birds gives the picture a sense of textile design. It lacks the intensity of the Taipei Ma Lin or the Nezu's Muqi, but it shares with them the same interest in depicting contrasting elements.

The painting was once in the collection of the well-known Ming connoisseur Huang Lin (late fifteenth–early sixteenth century) whose seals appear in the lower-right corner.

1. *Masterpieces of Chinese Painting in the National Palace Museum*, pl. 12.
2. Suzuki, *CICCP*, vol. 3, JM 12-043.

108

Anonymous (formerly attributed to Chen Rong, act. first half 13th century)
Dragon and Tiger Embracing

Southern Song dynasty, second half 13th century
Hanging scroll; ink on silk
William Sturgis Bigelow Collection 11.6162

Dragons and tigers have traditionally played a central role in Daoist iconography. According to Daoist thinking, the dragon has the nature of wood, and since wood produces fire, dragons are associated with that element. The tiger, on the other hand, has the nature of gold, which comes from water; hence the tiger is associated with water. Their importance in Daoism is reflected in the name of the most

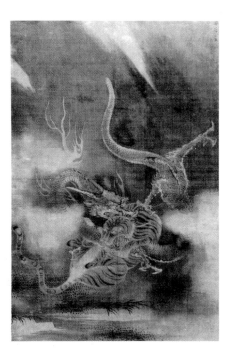

sacred Daoist mountain—Longhushan (Dragon and Tiger Mountain) in Guixi county, Jiangxi province. According to legend, Zhang Daolin, the founder of the Daoist religion, practiced Daoist alchemy there. When he finally succeeded in transmuting the divine elixir, a tiger and a dragon suddenly emerged out of nowhere. In addition to Longhushan, a Daoist text is also named the *Dragon and Tiger Sūtra*.

This large composition is a rare representation dealing with Daoist alchemy. According to the Daoist text *Xingming guizhi*, the dragon is the visual embodiment of *yang*, or the primordial masculine element, whereas the tiger embodies the *yin*, or feminine element. A central purpose of the alchemical process is to tame the contrasting *yin* and *yang* elements so that they complement rather than oppose each other. In Daoist belief, such harmonization of two opposite elements would eventually bring forth the fruit of divine elixir, the ultimate goal in the practice of Daoist alchemy. For Daoist practitioners, this abstract concept is not always easy to grasp. Paintings, therefore, served to help followers visualize and comprehend.

On the surface, the artist has created a lively representation of two rival, ferocious beasts in combat. However, to Daoist adepts, the image clearly embodies the idea of *shuihuo xiangji* (water as tiger and fire as dragon complement each other). At its upper-right corner, the scroll bears a damaged three-character signature that reads "Suoweng hua," (painted by Suoweng [Chen Rong]). An as-yet

unidentified seal follows the signature. Compared with the Boston Museum's *Nine Dragons* handscroll (cat. 92) and other reliable dragon paintings by Chen Rong, this hanging scroll displays a different style and imagery. The beasts are modeled with less linear drawing but more colorful ink washes, just the opposite of the *Nine Dragons* handscroll. The distinctive style is also apparent in the application of wet ink over the depiction of the land and vegetation.

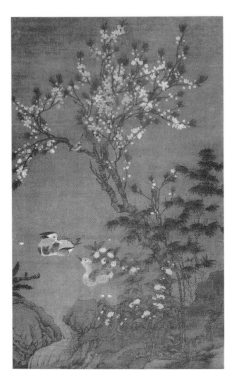

109

Anonymous (traditionally attributed to Wang Yuan, ca. 1280–after 1349)

Mandarin Ducks under Peach Blossoms

Yuan Dynasty, mid-14th century
Hanging scroll, ink and color on silk
176.2 x 109.5 cm
Chinese and Japanese Special Fund 15.906

This painting has been attributed to Wang Yuan, a Yuan master of the bird-and-flower genre, ever since its acquisition from China in 1915. However, the decorative nature and academic style of this scroll departs from Wang Yuan's usual preference for literati taste and his typical use

of ink. Recently this painting has been compared with *Two Ducks on a River in Autumn* (Shanghai Museum), a bird-and-flower painting by Ren Renfa (1255–1328) the leading horse painter.[1] But the Ren Renfa work displays a distinctive manner in its treatment of motifs. For example, the more angular structure and texturing of its rocks are the opposite of the smooth, curvilinear approach apparent in the Boston scroll. The Shanghai painting's animated depiction of the interplay between ducks and water, and between the birds and blossoming trees also differ from the Boston scroll, in which rich surface colors, forms, and an overall pleasant appearance are emphasized.

A more plausible comparison to this Boston scroll is *Mandarin Ducks under Apricot Blossoms* (Shanghai Museum), a large bird-and-flower painting by an unknown artist. That painting exhibits similar brushwork and the same decorative interest and quality.[2] Another related painting, though more in accord with Song taste, is Boston's album leaf *Parrot and Insect among Pear Blossoms* (cat. 98).

By the eighth century, the so-called *hua niao hua* (bird-and-flower painting) had become popular for decorating interiors and it came to be regarded as an independent genre in the Tang dynasty. Not only did some painters specialize in this genre, but even those better known for figure paintings, such as the eighth-century master Zhang Xuan, also painted *hua niao hua*. The recently excavated Tang bird-and-flower painting on a six-fold paper screen from Astana in western China further confirms its popularity.[3]

Emperor Huizong's personal interest in this genre and his insistence on realistic portrayal elevated it to new heights in the early twelfth century (see cat. 13). During the Yuan dynasty, however, professional painters of *hua niao hua* departed from the realism of the Song academies and instead concentrated more on its practical purpose as a decorative and auspicious art form. Only the literati painters, occasionally joined by some professional artists, pursued a different course, one where the subject matter was frequently rendered in ink monochrome and accompanied by inscriptions for a presentation that was intellectually, or politically, more challenging.

1. See Barnhardt, *Painters of the Great Ming*, p. 48, cat. 14.
2. See *ZMQ: huihuabian*, vol. 5, pl. 139.
3. See Jin Weinuo, pp. 17–18.

110

Anonymous (traditionally attributed to Qian Xuan, ca. 1235–after 1301)

Dragonfly on a Bamboo Spray

Yuan dynasty, 14th century
Hanging scroll; ink and color on silk
37.2 x 27.5 cm
William Sturgis Bigelow Collection 11.6146

Originally an album leaf, this small hanging scroll was remounted in Japan for tea ceremonies. It displays a subject often seen in Southern Song academy paintings. A blackish dragonfly gently touches the tip of an upright bamboo spray. The artist tried to capture the very moment of contact between the moving dragonfly and swaying bamboo, both suddenly frozen in time and space for the viewer's enhanced perception. The depiction of a seemingly insignificant natural event is elaborated by the rest of the bamboo leaves and twigs. In contrast to the upright bamboo spray, most of the leaves hang downward, except for a single bare branch that accompanies the spray and dragonfly. The sensuous green color applied to the bamboo leaves and the subtle touch of white and brown at their tips contrast with the dragonfly's black wings, which also have white ends.

The painting is unsigned, but two square seals at the upper-right edge bear the name of Qian Xuan, a leading literati master of the early Yuan period, known for his archaistic style and aesthetic interest in *fu gu*. Based on their style and

structure, neither of the two seals can be confirmed as authentic. Nor does the painting exhibit the brushwork, composition, or concepts characteristic of reliable works by Qian Xuan. It more likely derives from a group of Southern Song academy fans and leaves.

One such painting, *Bamboo and Insects,* a round fan by Wu Bing (act. end of the twelfth century) in the Cleveland Museum of Art, clearly shows the origin of the Boston work in regard to its composition.[1] The stylistic connection between these two paintings derives from the Piling tradition in the Jiangsu area and a genre known as "insects and grass." Another related Southern Song work is *Insects and Bamboo* (Cleveland Museum of Art, Kelvin Smith collection), an album leaf depicting a dragonfly and bamboo leaves.[2] Howard Rogers has suggested that the same thirteenth-century Piling artist painted both the Boston and Smith album leaves. While the traditional Qian Xuan attribution appears quite dubious (as is evident from their carving style, the seals are most likely later additions by Japanese collectors), it is difficult to accept this attribution. The Boston work is a much more simplified composition that gives no evidence of the artist having any interest in the variety of insects (grasshoppers, wasps) parading amidst vegetation that is so familiar to Piling paintings. Nor does it show the varied directions of movements, as in the Wu Bing fan.

The Boston artist takes even less interest in the contrast and drama between the dragonfly and grasshopper that may be seen in the Smith album leaf.[3] The mood and focus of this painting are quite different from the other two Southern Song works in Cleveland. It portrays a lone dragonfly against a mass of drooping bamboo leaves, perhaps drenched from an afternoon shower, and focuses on the insect's solo performance. The Cleveland works reflect their artists' concern with multiplicity, while the Boston work shows the more simplified, unitary focus demonstrated by Yuan painters. Finally, the brushwork displays little of the precise, tight, and careful execution characteristic of Southern Song artists. While derived from the Piling tradition, the Boston dragonfly should be dated to the early Yuan period.

1. *Eight Dynasties,* cat. 32, p. 51.
2. Ibid., cat. 33, p. 52.
3. Similar subject matter appears in a painting attributed

to the Northern Song artist Zhao Chang (ca. 960–ca. 1016), in the collection of the Tokugawa Museum, Nagoya. See Suzuki, *CICCP,* vol. 3, JM 16-010, p. 283.

III

Anonymous (formerly attributed to Su Hanchen, act. 1120s–1160s) *Sweetmeat Vendor and a Child*

Yuan dynasty, 14th century
Hanging scroll; ink, color, and gold on silk
101.4 x 66.3 cm
Charles Bain Hoyt Collection 50.1458

Paintings of sweetmeat vendors were popular during the Southern Song period, a sign of China's resurgent prosperity. Hangzhou, the Southern Song capital, was a lively center of commerce and culture, and genre paintings such as this Boston scroll were prized by members of the newly rich merchant class. The joy and playfulness of a child acquiring sweets from the vendor is portrayed here with feeling and humor. The reasons such distinctly Chinese subject matter survived in the Yuan period, when the country was no longer under Chinese control were threefold: a nostalgia for more secure and prosperous times; a certain tolerance, if not acceptance, on the part of China's new Mongol rulers for some native traditions; and the nonpolitical nature of such subject matter, which rendered it innocuous.

The scroll exemplifies the stylistic change from Song realism to the more decorative, mannered approach characteristic of the Yuan period. It has apparently lost its right side where the child's mother and, perhaps, other children would have appeared. The cropping would explain why both the vendor and child gesture to the right as if they were communicating with the now-missing figures. Despite its incomplete composition, the painting's refined brushwork and delicate depiction of the intricate motifs are impressive. The vendor is presented in profile. His figure type and apparel are based on Southern Song prototypes originated by such masters as Su Hanchen and Li Song.[1] In this work, nonetheless, the figure is more generalized and less articulated. Yet the enticing display of the varied items he sells on a small portable stand shows the painter's imaginative mastery of the subject matter.

1. See *ZMQ: huihuabian,* vol. 4, pl. 59.

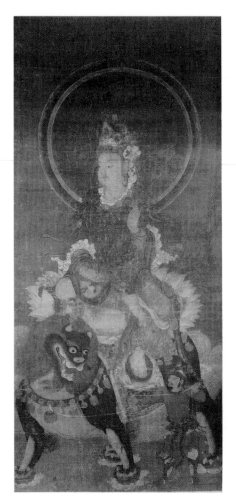

112

Anonymous

Mañjuśrī on a Blue Lion with a Groom

Yuan dynasty, early 14th century
Hanging scroll mounted as panel; ink and
color on silk
128 x 57.8 cm
Fenollosa-Weld Collection 11.4002

In murals and textile art, Mongol nobles
are sometimes portrayed by Yuan artists as
devoted Buddhists.[1] This is a rare example
of such portraiture in the form of a hang-
ing scroll mounted as a panel. The groom
standing at the lower right, just under the
left foot of the Bodhisattva Mañjuśrī, has
pronounced Mongolian facial features
evident in the high cheekbones and nose
bridge. He also wears Mongolian-style fur
headgear and a red hunting outfit. The
groom was likely a Mongolian noble who
wished to be portrayed as a Buddhist
devotee.

The panel's high artistic quality is evi-
dent in the exquisite brushwork and col-

oring. Delicate shading and so-called
iron-wire line drawing model the sini-
cized features of Mañjuśrī's face and
emphasize the divine attributes of this
cult figure who was highly popular
among Chinese under Mongol control.

1. For further discussion, see Wen C. Fong and Maxwell
K. Hearn, "Imperial Portraits of the Yuan Court," in
Wen C. Fong and James Watt, eds. *Possessing the Past*
(New York: Metropolitan Museum of Art, 1996), pp.
263–67.

113

Wang Zhenpeng (ca. 1270s–after 1330)

Mahāprajāpatī Nursing the Infant Buddha

Yuan dynasty, early 14th century
Handscroll; ink on silk
31.9 x 94.4 cm
Chinese and Japanese Special Fund 12.902

This short handscroll is executed in the
jiehua (ruler-aided painting) technique by
Wang Zhenpeng, a Yuan master of this
style. Wang, also recognized as a master of
early fourteenth-century figure painting,
was favored by the Mongolian emperors
Renzong (r. 1311–20) and Wenzong as
well as the powerful Princess Xianggelaji
(ca. 1283–1331).

To serve as a background for the fig-
ures, an imaginative and sinicized Indian
interior scene is portrayed, lavishly deco-
rated with ornate vessels, furniture, and

carpets. In this palace hall, after the death
of his mother, Queen Māyā, the infant
Buddha—Prince Siddhārtha—is nursed
by the Buddha's aunt Mahāprajāpatī. The
baby Nanda, half-brother of the Buddha,
watches enviously from beside his own
mother and the Buddha. The sinicization
has gone so far that the two infants and
the Indian women all have a distinct Chi-
nese appearances. The infant Buddha is
shown reaching up with his right hand to
grasp a peach held by Mahāprajāpatī.
Peaches are typically Chinese Daoist, not
Buddhist, longevity symbols.

It is also interesting that Wang Zhen-
peng added a fantastically shaped Chinese
scholar's rock together with a Daoist
magic fungus inside a typical Buddhist
container shaped like a lotus blossom.
Such rocks and fungi are also associated
with Daoist immortality cults. On the
opposite side from the rock is a playful
but sinicized Indian lion. Despite these
Daoist interpolations, Wang Zhenpeng
may actually have had some knowledge of
Indian motifs newly introduced to China
through Tibetan and Nepalese Buddhist
art sponsored by Mongol rulers during
the Yuan dynasty. Except for the two
infants, the other six figures were ren-
dered in a manner consistent with sculp-
ture of the period. Mahāprajāpatī resem-
bles a sculpted Guanyin, especially the
Guanyin portrayed as a protector of chil-
dren. The two infants look almost as if
they had just walked out of a Song or
Yuan album leaf (see cat. 26 and 79).

The entire painting is executed with
refined, firm line drawing and careful

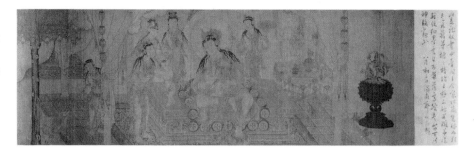

shading applied to model the folds of the robes, tree, rock surfaces, and the rounded vessels. Throughout the picture, jewelry ornaments are hung in a manner that would have lent a certain exoticism to the painting for Chinese viewers. Two tiny Chinese characters written in very dark ink on the lower part of the tree trunk toward the end of the handscroll read "zhen peng," but the authenticity of the artist's signature is uncertain. In brushwork and style, the Boston painting is close to a 1308 handscroll, *Vimalakīrti and the Doctrine of Nonduality,* by Wang Zhenpeng (Metropolitan Museum of Art, New York).[1]

The artist's interest in Buddhist painting probably derived from his family's strong Buddhist background; his older brother was a monk named Shanji. However, Wang Zhenpeng's figure paintings were not limited to religious subjects. His most celebrated secular work is the *Dragon Boat Regatta on the Jinming Lake* (Tianjin Municipal Museum of Art) a composition preserved in many versions in various collections. Even these nonreligious paintings share the same rigidly controlled brushwork and meticulous attention to detail evidenced in the Mahāprajāpatī scroll.

In contrast to Wang's flatter, less expressive Buddhist works, a more individualistic style is evident in his *Hermit Musician Boya Performing Qin for His Friend Zhong Ziqi* (Beijing Palace Museum).[2] Its brushwork is vivid and fluid, and each of the five figures in the picture is individualized with a distinct expression. Even a sense of spatial depth is subtly suggested by positioning the figures and motifs on different pictorial planes.

At the Boston handscroll's lower left, a square seal with four characters reads "Zhang Zhongju yin," a seal of the Yuan-dynasty scholar Zhang Zhu (1287–1368), whose *zi*-name is Zhongju. In the 1330s, Zhang Zhu was appointed as a court historian and compiled official histories of the Song, Liao, and Jin dynasties. His interest in painting is evident from his colophon for the *Nine Dragons* handscroll by Chen Rong (cat. 92). Since Wang Zhenpeng and Zhang Zhu were both Chinese who collaborated with the Mongol rulers in the early fourteenth century, it is not surprising that Zhang Zhu was the original owner of this scroll.

1. See Fong, *BR,* pp. 332–33.
2. See *ZMQ: huihuabian,* vol. 5, pl. 54.

114

Attributed to Wang Zhenpeng (ca. 1270s–after 1330)
A Grand Dragon Boat

Yuan dynasty, early 14th century
Round fan mounted as album leaf; ink, color, and gold on silk
25.5 x 26.5 cm
Chinese and Japanese Special Fund 12.899

A meticulously drawn dragon boat, shown in profile, fits tightly into the space of a round fan. The original colors and gold highlights have now faded considerably. This fanciful boat consists of a large, round dragon head; an S-shaped neck; and a tall, curled tail as well as a body that supports a complex structure of three viewing towers. On the deck, facing the viewer, a court officer with four attendants waits in front of the main tower while a crew of twelve rowers is busily at work. Another tall oarsman, who looks out at the viewer from the other side of the boat, is peculiarly positioned in the narrow opening between the dragon's lower jaw and neck. Just above the dragon boat, a two-character inscription written in the regular style by an unknown calligrapher reads "miao pin" (exquisite quality). To the left of the inscription is the Yuan Emperor Wenzong's seal, *Tianli zhi bao* (Treasure of the Tianli Era), in use from 1328 to 1332.

No seal or signature of the artist appears on the painting. A colophon by the collector Ruan Yuan (1764–1849) is inscribed on the right side of the mounting. It attributes the work to Wang Zhenpeng.

According to Song literary references like *Dongjing menghua lu* by Meng Yuanlao

(act. first half of twelfth century), dragon-boat festivals began during the late Northern Song period in the Chongning era (1102–1106). But dragon-boat paintings with Northern Song dates are rarely seen. Only two dragon-boat examples date from the Song period: one large, square album leaf, *Dragon Boat Race on the Jinming Lake* (Tianjin Municipal Museum of Art) was once attributed to the Northern Song painter Zhang Zeduan, and the National Palace Museum, Taipei, owns another album leaf, *Dragon Boat,* attributed to Li Song.

These two paintings show two entirely different types of dragon boats. The Tianjin *Dragon Boat Race* depicts a distinctly elongated body with a long dragon head and tail as well as more realistically constructed viewing towers in typical Song architectural style. This large album leaf is rightly accepted by scholars as an academic work of the Southern Song period, perhaps from the end of the twelfth century. On the other hand, the so-called Li Song *Dragon Boat* in Taipei is of a fundamentally different type from the Tianjin example. It carries a roof structure unknown in the Song period, but typical of most Yuan architecture paintings. Moreover, the dragon head of the Taipei painting is a type unknown in any art work before the fourteenth century. Rather, it is closely related to the type of dragon boats originated by the fourteenth-century master Wang Zhenpeng. The Taipei album leaf can only be dated as a Yuan-dynasty work, and, therefore, the Li Song signature is questionable.

This Taipei boat shows an almost identical shape and structure to those of Boston's painting, with a similarly large and round dragon head in the front and a tail raising high and curled inward at the end. Their similarities suggest that the Yuan dragon boat derives from Wang Zhenpeng's design, which appears in the many versions of *Dragon Boat Regatta* under his name, including one in the Metropolitan Museum of Art, New York. This new type of Yuan dragon boat bears no resemblance to the Song prototype as represented by the Tianjin album leaf. Also noteworthy are the varying perspectives and angles used to depict these three Yuan dragon boats. The Taipei example is seen from the front in three-quarter view, New York's is depicted in three-quarter view from the rear, while Boston's appears in profile.

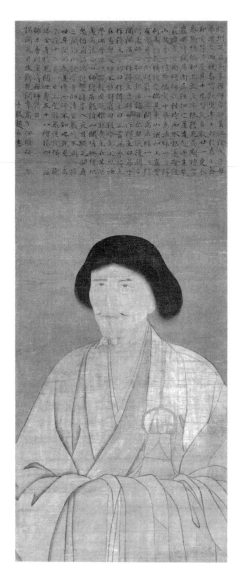

style is consistent with other genuine works by the artist. However, the precise relationship between the calligraphy and the portrait is difficult to discern. Zhao Yong, the second son of the early Yuan master Zhao Mengfu, is known through literature and surviving works to have been skilled in figure painting (see the middle section of *Grooms and Horses,* in Metropolitan Museum of Art, New York).[2]

The facial structure is rendered with remarkably disciplined line drawing. The hairstyle of master Gaofeng Yuanmiao is both long and thick, with intermittent gray hairs. It corresponds well with the master's age of fifty-eight, when he died. The once richly colored garment has now deteriorated. The drapery lines describing the garment are all drawn firmly and consistently, having the quality and strength one would expect from a good calligrapher. The drawing style is close to a 1301 portrait painting by Zhao Mengfu of the poet Su Shi.[3]

Compared with other Chinese figure paintings of the fourteenth century, the drawing of Gaofeng Yuanmiao is more elegant and restrained.[4] The bright colors that originally adorned the robe of Gaofeng Yuanmiao contrast directly with several austere Yuan ink portraits. The bright hues are reminiscent of the coloristic tradition of Southern Song Zen portraits such as the anonymous portrait of the priest Wuzhun Shifan (1177–1249) in Kyoto's Tōfuku-ji and the portrait of the priest Zhongfeng Minben (1264–1325) now in the collection of Senbutsu-ji, Kyoto.[5] Zhongfeng Minben was the most famous disciple of master Gaofeng Yuanmiao. Both priests not only had a large following in China but also attracted many Japanese monks, who traveled there to study with them.

1. See Brinker, pp. 8–29 and figs. 24–28.
2. See Fong, *BR,* pl. 200, pp. 432–33.
3. Brinker, p. 16, fig. 15.
4. For examples of the more expressive, exaggerated style, see S. Lee and Wai-kam Ho, cat. 186: *Portrait of Duke Fengguo;* cat. 191: *Portrait of Lü Dongbin;* and cat. 197: *Portrait of Priest Zhongfeng Minben.*
5. See Fontein and Hickman, cat. 15, pp. 40–42.

115

Attributed to Zhao Yong (ca. 1289–ca. 1362)

Portrait of the Chan Master Gaofeng Yuanmiao (1238–95)

Yuan dynasty, early 14th century
Hanging scroll; ink and color on silk
114.7 x 46.7 cm
Denman Waldo Ross Collection 28.355

If this scroll is indeed by the hand of Zhao Yong, then it is the sole example of a portrait by the artist. The only other portrait attributed to him (now in the collection of Tennei-ji in Takushiyama, Japan) has rightly been questioned by scholars.[1] The Boston scroll has a long inscription on the life of the priest Gaofeng Yuanmiao, a leading Chan master of the Yuan period. The inscription bears Zhao Yong's signature and seal and its

116

Anonymous (traditionally attributed to Yan Hui, act. late 13th–early 14th century)

The Chan Master Niaoke

Yuan dynasty, 14th century
Hanging scroll mounted as panel; ink, color, and gold on silk
80.3 x 38 cm
Fenollosa-Weld Collection 11.4003

This painting was originally attributed to the Yuan figure painter Yan Hui. Although the bold ink drawing of the drapery on this worn and darkened image is somewhat related to *Hanshan* and *Shide,* a pair of well-known hanging scrolls by Yan Hui in the Tokyo National Museum, the Boston painting represents an entirely different style, executed in a more painterly manner than the tight, angular calligraphical lines of the Tokyo paintings.

The subject was thought by its previous owner in Japan to represent the Chinese Chan monk Niaoke because the monk is meditating atop a pine tree. Two

historical texts refer to such a monk as a native of China. According to one Buddhist chronicle, the monk Daolin was the son of a family named Pan from Hangzhou.[1] Daolin later lived at the top of a tall pine tree, together with magpies, in the Qinwang mountains; hence, people named him Niaoke (bird's nest). During the Yuanhe era (806–20), the famous poet Bai Juyi (772-846) befriended Daolin, who died in 824 at the age of 84. A different biographical collection mentions another Tang-dynasty monk named Yuanxiu from Fujian, with virtually the same background, nickname, and history but under different Chan teachers, who died in 833.[2] It is uncertain whether or not these two monks were actually the same person, but clearly a historical record exists for a native-born Chinese monk known as Niaoke.

But the subject of the Boston painting has features suggesting a monk of foreign origin. The thick eyebrows, beard, and chest hair are characteristics only befitting a non-Chinese Lohan rather than a Chan priest of Chinese origin. The large gold earring in his left ear makes it further unlikely that he is a Chinese monk. A comparison between this monk and portraits of Chinese Chan master Wuzhun Shifan (collection of the Tōfuku-ji, Kyoto) or of master Gaofeng Yuanmiao by Zhao Yong in the Boston Museum (cat. 115) would demonstrate that this Boston painting possesses more foreign features far removed from any Chinese Chan monks known to us.

The handscroll *Eight Great Monks* by Liang Kai (Shanghai Museum) also includes a depiction of the priest Niaoke. He is shown dwelling in a pine tree and conversing with the poet Bai Juyi. The facial characteristics clearly indicate that he is an elderly Chinese monk, who does not have the hairy chest and eyebrows, or the earring and beard on the Boston Niaoke. Consequently, the image of the Boston monk is open to question. In any case, the image is probably not of the Chinese monk Niaoke. His identity is more likely related to Bodhidharma or an Indian Arhat.

1. See Mingfu, "Chuandeng Lu," in *Zhongguo foxue renming cidian,* entry 3387, p. 424.
2. Ibid.

117

Anonymous

Guanyin of Mount Putuo with Shancai and the Dragon

Yuan dynasty, early 14th century
Hanging scroll mounted as panel; ink and color on silk
105 x 51 cm
Gift of Miss Ella G. Parker 10.82

Various publications and catalogues have identified this particular Guanyin as a Japanese work, but their reasons have not always been clearly and convincingly explained. Scholars in Japan dated this Guanyin painting to the fourteenth century, arguing that the artist had been influenced by Buddhist paintings of the Yuan dynasty.[1] They interpreted the important colophon written on this painting by the Chinese monk Yishan Yining (1247-1317) as one of the earliest after 1299, when he migrated to Japan, where he remained until his death. Japanese scholars assumed that what they thought of as a Japanese painting of Kannon was seen by the newly arrived Chinese monk Yishan Yining, who probably was impressed by its religious and artistic quality, and therefore wrote a colophon for it.

Such argument seems to overlook the painting's strong Chinese iconographical and compositional characteristics. Contrary to the generally sweet, youthful appearance and expression of many Japanese images of Kannon, this Guanyin is portrayed as both serene and serious. In comparison with the flatness of Japanese Buddhist figures, this Guanyin presents a stronger suggestion of three-dimensionality. The ink drawing for Guanyin's drapery and the designs in gold lines are firm, solid, and forceful and thus correspond to Yuan-Chinese calligraphic brushwork. The volume and weight of the Chinese Guanyin is emphasized by his posture in the rock seat. Despite its modest size, this Guanyin manifests a sense of monumentality.

The painting's drapery lines masterfully describe and define the anatomy of the deity. In comparison, a painting of Nyoirin Kannon by the fourteenth-century Japanese painter Ryōzen uses ink and gold lines mainly to decorate the surface rather than to define the form and

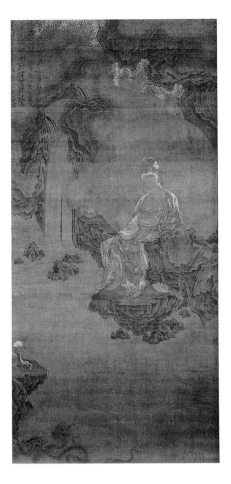

volume of the body.[2] Overall, Ryōzen's brushwork is much freer and more relaxed than its Chinese counterpart. The landscape in Ryōzen's work contrasts with the Chinese treatment of space and serves as little more than a decorative backdrop.

Moreover, in the Boston Museum painting, the rock formation and waterfall are depicted in a strongly naturalistic manner. The painter provides a complete rendering to describe the waterfall. It gushes from the top of the distant mountain and changes its course five times before finally reaching the Southern Sea. The rocks are carefully outlined first, then textured and shaded with ink wash to enhance their structure and spatial arrangement. Both the style of the rocks and the depiction of the waterfall have direct links to the Buddhist painting tradition developed in Ningbo in the late-twelfth and thirteenth centuries (see the Daitoku-ji Lohan paintings by Zhou Jichang and Lin Tinggui, entries 34–43). Furthermore, the depiction of the four-clawed Dragon King of the Sea (one of Guanyin's twenty-eight retainers) in the foreground is quite different from any Japanese dragons of this period, which are always of the three-clawed type. So, too,

the spatial depth in this painting is distinctly Chinese, developed through a series of receding images: from the dragon in the lower-left corner to the boy worshipper Shancai[3] kneeling on a rock, then across the vast Southern Sea to the magnificent Guanyin in the middle ground and, finally, to the mighty waterfall in the background.

Contrary to the Boston *Guanyin*, Ryōzen's *Nyoirin Kannon* depicts every element in the picture, including the Kannon, on the same pictorial plane. Despite the beauty of the richly worked surface, there is an apparent lack of interest in spatial depth. Ryōzen's waterfall in the foreground is meant to be more symbolic and decorative than naturalistic. Similarly, Ryōzen's rock formation is an idealized version that merely serves as a companion for the main deity.

1. See, for example, *Exhibition of Japanese Paintings from the Museum of Fine Arts,* cat. 25.
2. See *Art of the Muromachi Period,* cat. 290, pp. 191 and 320
3. Shancai is the Chinese name for the Indian prototype Sudhānaśresthi-dāraka—the Boy of Good Wealth. He first heard the law of the Buddha from the Bodhisattva Mañjuśrī. Chinese were the first to associate Sancai with Guanyin.

118

Anonymous
Guanyin with Fish Basket

Yuan dynasty, late 13th–early 14th century
Hanging scroll; ink and color on silk
85.1 x 37 cm
Chinese and Japanese Special Fund 05.199

The imagery of a barefooted Guanyin with a fish basket is a Chinese invention that is not found in representations of the Indian or Central Asian prototypes. Chinese Buddhists of the Tang dynasty created this particular iconography for the purpose of delivering followers from the sin of lust. Guanyin is said to have appeared in a river village at Jinshatan (Golden Sand Bay) in today's northern Shaanxi province as a beautiful young woman carrying a basket of fish. She offered herself in marriage to anyone who could memorize the sūtra that frees souls from the damnation of lust.

No written references to this manifestation of Guanyin earlier than the Southern Song period exist. The cult of the

"Yulan Guanyin" (Fish-basket Guanyin) soon spread throughout China, but particularly in eastern coastal areas. In the fourteenth century, this cult probably reached Korea and Japan where native artists produced their own versions of this sinicized manifestation of the deity.

In the Boston painting, Guanyin stands in the foreground, on the shore, against an empty background. Because of the figure's flatly colored face and chest, and the gold designs on her garment, some scholars have considered it possibly to be a fourteenth-century Korean work. However, the deity's facial features and the depiction of her voluminous robes are much closer to Chinese figure paintings of the late-thirteenth to fourteenth centuries than Buddhist figure paintings from Korea. The ink outline for the drapery, too, shows the more Chinese calligraphic concern. The calligraphy of a poem later added by priest Mu'an on the upper portion of the composition bears a Yuan-dynasty date written in the year *wuwu* during the Yanyou era (1314–19), which corresponds to 1318.

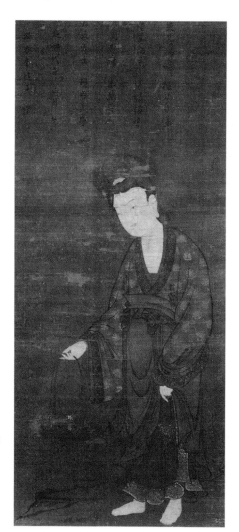

119

Anonymous
Two Carp Leaping among Waves

Yuan dynasty, late 13th century
Hanging scroll; ink, light color, and gold on silk
202 x 199.3 cm
Chinese and Japanese Special Fund
15.908

In China, legend predicts that if a carp succeeds in swimming upstream in the Yellow River to leap over a place named Longmen (Dragon Gate), it will instantly be transformed into an almighty dragon. Therefore, a carp leaping out of waves is a traditional subject that symbolizes good wishes for someone's success. Such a subject has also been popular in other countries where the influence of Confucianism is considerable. Since the Song period, Chinese painters have produced such paintings for a variety of purposes, including wishing someone success in taking the civil service examinations.

The enormous scale of the Boston carp painting indicates that the work originally adorned the surface of a freestanding screen. Such a large screen painting probably was designed for a main hall in an official building for cultural or educational activities. The majestic, large carp in this painting has leapt completely out of the torrential waves, revealing its entire form and imparting a powerful visual impression. The strength of this leap must have been incredibly forceful for its body makes a turn in midair, from the right side of the painting upward toward the left, to show its head in exact profile. The downcast eye of the fish is perfectly posi-

tioned in the upper middle of the overall composition. Its rhythmically rendered scales and back fin are subtly shaded in ink and further enhanced with touches of gold. These golden scales resemble those of a dragon; thus, the artist seems to suggest the carp's imminent magical transformation.

The large carp's downcast eye directs our attention to a young carp nearby whose body, still half in the waves, looks up to the great carp with apparent envy and respect. The youngster seems to be taking note of its elder's glory as it awaits the time when, one day, it will have its turn. Even the violent whirls and waves in this painting seem to celebrate the carp's epiphany as it leaps from the watery world into a new, higher space.

Tomita dated this painting to the Song dynasty. The depiction of the scales, fins of the fish, and the movement of the waves is marked by a strong sense of design. The type of naturalism shown in Ma Yuan's renderings of water in the album *Twelve Scenes of Water* (Beijing Palace Museum) is, however, distinct from the stylized, exaggerated water patterns of the Boston carp scroll.[1] But it has yet to become as stylized as early Ming works would. The body of inundating water is more like several Daoist paintings of Immortals dated to the Yuan dynasty. Therefore, this piece is now more widely accepted as an outstanding masterpiece of the same period.

1. *Song Ma Yuan shui tu.*

120

Attributed to the Priest Laian (ca. 14th century)
Fish among Water Plants

Yuan dynasty, 14th century
Hanging scroll; ink on silk
89.6 x 48.3 cm
William Sturgis Bigelow Collection 11.6170

The priest Laian rarely appears in Chinese reference works, but he is recorded as a Yuan artist in the important fifteenth-century Japanese catalogue *Kundaikan Sōchōki* (no. 67). Chinese fish paintings formerly in Japanese collections are often attributed to Laian.

Fish in Yuan paintings are frequently

given their own personalities. The fish in the Boston painting, with its wide-open mouth and piercing stare, has assumed an almost human expression. Similarly, in the well-known *Fish and Water Grass* (Nelson-Atkins Museum of Art, Kansas City), the fish wears a smile on its face.[1] In both, the subjects are depicted moving quickly through the water plants. In this scroll, the fish dominates its entire pictorial space and immediately arrests the viewer's attention, as if it had just made a turn and suddenly come face-to-face with the viewer. The artist attempts to be both precise, as seen in the fine pattern of scales, and to add a sense of movement, as the turn of the tail and the swaying reeds demonstrate. Such characterizations were more common during the Yuan dynasty than at any previous time. They mark a departure from the preoccupation with form, color, and realism of the Southern Song period—for instance, Zhou Dongqing's *Pleasures of Fish,* an early Yuan scroll dated 1291 (Metropolitan Museum of Art, New York)—in favor of the new awareness of spirituality and individuality of the fourteenth century.

1. See S. Lee and Wai-kam Ho, cat. 213.

121

Anonymous
Six Fish

Yuan dynasty, early 14th century
Hanging scroll; ink and touches of light color on silk
49 x 101.5 cm
Frederick L. Jack Fund 1984.408

Six realistically portrayed fish dangle from two branches of bamboo. They must just have been caught because their tails appear to be moving still. The artist's strong interest in realism can be seen in his elaborate and meticulous detailing of the subjects. He shows minute differences among the six fish: four carp, one predator with an open mouth, and a sixth fish with especially fine scales. The bamboo leaves and branches are also painted in the so-called *shuanggou* (outlined) style. A rope hanging from above the picture plane ties together the two bamboo branches. The stark symmetrical arrangement of the subject matter and the fantastic way of hanging the fish creates an unusual visual effect.

In Chinese culture, the number six

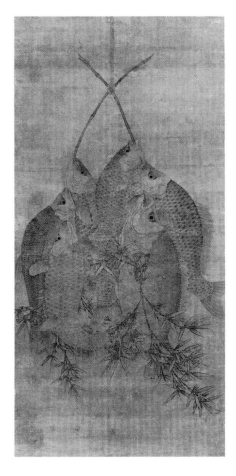

(*liu*) can have various meanings: it can refer to the earth, or *yin,* element in the *yin-yang* polarity. In Daoism, the number six may refer to the cosmos, as in *liuhe,* which means heaven, earth, and the four directions, or all the combined seasons. In Chinese Buddhism, the term *liuru* (the six "likes") symbolizes the everchanging world of illusory phenomena. In Confucianism, the term *liujing* refers to the most important six classics, and *liufa* are the six aesthetic criteria for quality in painting.[1] In addition, the fish subject has traditionally been used to symbolize abundance because *yu,* the Chinese word for fish, is a homonym for the word meaning surplus. The combination of fish with bamboo, which symbolizes peace, signifies an auspicious omen in a work created or presented as a wish for good fortune.

1. See E. Zürcher, "Recent Studies on Chinese Painting," in *T'oung Pao,* vol. 51 (1964), pp. 377–422.

122

Anonymous
Hawk on Pine Tree

Yuan dynasty, second half 14th century
Hanging scroll; ink and light color on silk
145.8 x 75.8 cm
Marshall H. Gould Fund, Frederick Jack Fund, and Asiatic Curator's Fund 1996.2

For Chinese artists, the identity and symbolism of the hawk changed according to political and cultural circumstances, as can be seen by comparing works from the prosperous Southern Song dynasty with those produced by Yuan painters, after China had fallen to the Mongols. In *Hawk,* a large Southern Song painting by the court artist Li Di (act. 1163-1225) dated 1196 (Beijing Palace Museum), the hawk is given a heroic cast, poised to attack a helpless pheasant below.[1] By elevating the hawk so high in the composition, the painter forcefully portrays its power and ferocity. In the fourteenth century, however, with China under Mongol rule, the image of the hawk often conveys a sense of threat and oppression with distinct political overtones.

In this hanging scroll, a majestic hawk perched on top of a pine tree dominates the composition. With its magnificently depicted back toward the viewer, the

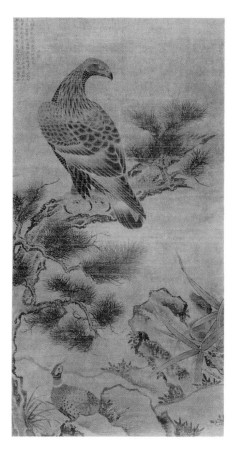

hawk turns its head and looks straight into the distance, ignoring the existence of a pheasant and wild boar below. Interestingly, the pheasant is not shown running for shelter, as is the case of the Boston fan painting *Wintry Scene with Hawks and Quails* (cat. 123), or in the above-mentioned work by Li Di. The attitude of this hawk, (or the message of this anonymous artist) resembles that seen in a work by Zhang Shunzi (act. second quarter of fourteenth century) in the Shandong Provincial Museum.[2] According to Zhang's own poem written on the painting, he wanted to show that his hawk was unlike others, which would surrender freedom for easy food. Both Zhang's and Boston's paintings display proud hawks standing tall atop trees in the wilderness. With turned heads, they look away from the world below, as if expecting something extraordinary. In the Boston example, the hawk seems to ignore and disdain the readily available pheasant and wild boar. The allusion, of course, is to those Chinese scholars who refused to serve the Mongol rulers, even though such service would provide an easy living.

The artist positioned the three creatures roughly in a triangle. While the pheasant and wild boar are colored, the hawk is depicted only in ink mono-

chrome, a further indication that it represents the integrity of a principled Chinese Confucian scholar. With subtle gradations of ink wash and line drawing, the artist achieves an attractive, rhythmic design for the hawk's feathers and wings. Contrary to the depiction of the birds and boar, the execution of brushwork in the rendering of the trees and rocks is much freer and more expressive. The drawing of the pine needles, which are neatly interwoven yet retain great clarity, has the same graphic beauty displayed in the hawk's feathers. The vibrant outline defining the rock contours and trees invigorate the painting as well. In general, the composition is more crowded than Song works like Li Di's *Hawk.* A more crowded composition is characteristic of Yuan paintings.

In accordance with literati painting style, where poetry often forms an important part of the pictorial presentation, a long poem accompanies this painting. However, it is written from left to right, an uncommon practice usually adopted by Buddhist monks. The poem is signed by one "Muxuan," followed by two unidentified seals. It is uncertain whether this Muxuan is only the author of the poem or the artist of the painting as well. Judging from the calligraphic style, it accords well with other writings from the second half of the fourteenth century and is rather close to the calligraphy of Zhang Shunzi.[3]

Unlike the colorful image and contented expression of the noble goshawk chained to a lavishly decorated stand (cat. 124), the present bird is free in a natural environment as well as free from the application of sweet, pleasing colors.

1. *ZMQ: huihuabian,* vol. 4, pp. 64–65, pl. 43.
2. *ZMQ: huihuabian,* vol. 5, p. 112, pl. 76.
3. Barnhardt, *Painters of the Great Ming,* cat. 13, p. 48.

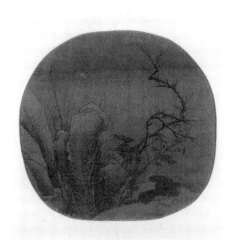

123

Anonymous

Wintry Scene with Hawks and Quails

Yuan dynasty, early 14th century
Round fan mounted as album leaf; ink and light color on silk
23.8 x 23.8 cm
Chinese and Japanese Special Fund 14.64

Executed in a deliberately rigid, linear manner, the painter candidly portrays the fate of a group of quail struggling for survival in a severe environment. The bare, harsh appearance of the surroundings is clearly indicated. The rocks, plants, and bamboo are all depicted with a dry, pointed brushwork and spare coloring. The surface of the rocks is modeled with hard, short texturing strokes that resonate with the bareness of the trees and the thinness of the bamboo leaves and blades of grass. Against the backdrop of these stiff forms, the artist represents a drama of life and death. The victory is clearly on the side of the powerful hawks, and the only safety for the quails is to hide or to escape.

The work displays little of the Southern Song naturalistic or realistic approach to motifs and the spatial relationships among them. Instead, the rocks, birds, and trees are all staged on a flat plane in the foreground. The fan embodies an emergent Yuan aesthetic of implication, one that invites the viewer to engage other interpretive possibilities of a symbolic or allegorical nature. There are many examples of political allegories in the art of the Yuan period, when the native Chinese were subjugated by nomadic invaders. For example, 27 years after the Mongol con-

quest, the scholar–artist Zheng Sixiao (1239–1361) painted an orchid suspended in air, with no support from the earth—a metaphor for the loss of the motherland to the Mongols.[1] If the artist of the Boston work intended a similar political allusion, then the symbolism here could reflect the tension between the Chinese people and their Mongolian rulers, with the latter portrayed as menacing hawks preying on the vulnerable quails below. Such sentiments are expressed in a well-known poem by Du Yuncheng inscribed on the hanging scroll *Hawk Chasing Thrush* by Wang Yuan (ca. 1280–after 1349) in the National Palace Museum, Taipei.[2] The poem describes the impending attack of a nomad's hawk (*hu ying*) on a small bird:

> In autumn, a nomad's hawk hovers
> above its prey
> Hurriedly, birds huddle beneath a tree
> for safety
> If smart birds know how to hide
> themselves
> How can men not see the danger?

1. See S. Lee and Wai-kam Ho, cat. 236.
2. *Gugong shuhua tulu*, vol. 4, pp. 241–42.

124

Attributed to Xu Ze (act. second half 14th century)

Goshawk Standing on a Perch

Yuan dynasty, second half 14th century
Hanging scroll; ink, color and gold on silk
54.2 x 98.1 cm
William Sturgis Bigelow Collection 11.6164

The artist Xu Ze, to whom this painting was attributed by its previous Japanese collector, is almost unknown in Chinese publications. In 1474, Noami's *Kundaikan Sōchōki* described him as a native of Yunjian (the present Songjiang, near Shanghai), who was active during the Yuan dynasty. Xu Ze is said to have specialized in painting landscapes, hawks, buffaloes, birds, and flowers. The only other painting of a hawk attributed to Xu Ze is in a private collection in Japan.[1]

The Boston goshawk is depicted in a stationary stance, against an empty background, its back turned toward the viewer to reveal the beauty of its feathers. Its head, turned to the left, presents the bird

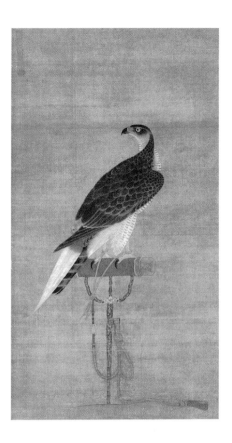

in portraitlike profile. The goshawk has a jingling bell and a red-and-white feather tied to its tail; leather strips fasten its feet to a magnificently designed stand consisting of a short, horizontal perch and a forklike support. The perch is lacquered in red, with floral designs visible on one end. The support is decorated with scrollwork in gold and silver. At the juncture of the fork, two heads of *makaras* (Indian mythological creatures) are painted in gold. The shape and design are identical with late fourteenth–century implements produced in China for ritual use in esoteric Buddhism.[2]

The high degree of realism in the depiction of this goshawk and its stand suggest that the Boston painting was commissioned by the owner to serve as a portrait. In the Yuan dynasty, under Mongol rule, the sport of falconry again became fashionable. Paintings of hawks executed in an elegantly controlled manner differed from more traditional Chinese depictions, which generally showed the birds in the wilderness, their habitat, and thus commonly served as symbols of justice, righteousness, and courage.[3] The pose of the Boston hawk may bear similarities in its fierce stare and heroic pose, but it reflects its domestication and enjoys luxurious palace accommodations.

Two hawks in the more traditional Chinese mode are found in the Beijing

Palace Museum and Shandong Provincial Museum. The latter was painted by the Chinese artist Zhang Shunzi (act. ca. 1330–50). The Beijing hawk is the work of Zhang Shunzi's friend Xuejieweng (act. fourteenth century), an otherwise unknown painter who here shows great skill. Both hawks are depicted with their heads held high and free of any restraint. For an artist like Zhang Shunzi from Hangzhou, the capital of the defeated Southern Song dynasty, the symbolism of the hawk seems clear. In contrast to the Boston painting, it represents the Chinese intellectual who refuses to be a captive under hostile foreign rule.[4]

The Boston painting has no signature or inscription by the artist. The owner of a set of six seals impressed in the upper left cannot be identified, but the style of the seals dates them to the late-fourteenth to early fifteenth century.

1. See *Kokka*, vol. 1022, pp. 2–3.
2. See *Selected Masterpieces of Asian Art*, cat. 124–25.
3. See *ZMQ: huihuabian*, vol. 5, pls. 75–76.
4. See *Wintry Scene with Hawks and Quails* (cat. 123).

125

Anonymous (formerly attributed to Mao Yi, act. 1165–74)
Hound Walking

Yuan dynasty, 14th century
Square album leaf; ink and light color on silk
28.4 x 27.1 cm
William Sturgis Bigelow Collection 11.6143

Despite the former attribution of this hound to the Southern Song academic painter Mao Yi, Tomita, in the 1961 *Portfo-lio*, correctly noted that it should be dated as a Yuan-dynasty work. In terms of quality and style, the old attribution is without foundation. The execution clearly departs from Song realism in the more simplistic form and detailing of the hound. A similar work by Li Di, dated 1197, in the Beijing Palace Museum collection shows how a Song artist treats the same subject, drawn from life. Occupying the entire lower half of the pictorial space, the Beijing hound is shown walking diagonally from the left toward the lower right in a three-quarter view. Each part of the hound's body is carefully observed and meticulously executed by the artist. The collar is depicted and colored so realistically that it conveys a textural sense of the leather material buckled around the dog's neck.

By comparison, the artist of the Boston version is far less interested in physical and anatomical precision or accuracy. Rather, he represents the hound in a more generalized, impressionistic manner. The leather collar here is reduced to a thin red line, symbolically applied around the neck. Similarly, the furry tail of the Beijing hound has been playfully added to the body of this dog in thin, delicate line drawing that does not convey its volume or substance. The same tendency is evident in the Boston hound's hair. In addition, unlike the Beijing hound, which is placed in the foreground, close to the viewer, the Boston animal is positioned in the middle ground, as though the artist did not intend his subject to be closely observed. The lack of interest in realism and articulation evident in the Boston version suggests that it was a study piece created in a period during which artistic concern for surface decoration and general form had superseded clarity and substance in representation.

126

Anonymous (formerly attributed to Guo Xi, ca. 1001–ca. 1090)
Riverscape with Figures

Yuan dynasty, late 13th century
Square album leaf; ink and light color on silk
25.6 x 24.5 cm
Denman Waldo Ross Collection 28.839

This painting and a companion leaf, *Land-scape with Fishermen* (cat. 127), are works by the same artist, most likely a late-thirteenth century Yuan follower of Guo Xi's style. Since the two leaves are compositionally related, they may be surviving sections from a longer handscroll. While *Landscape with Fishermen* emphasizes a vertical composition with lofty mountain peaks, this composition is predominantly horizontal. From the perspective of the tiny travelers depicted in this painting, a vast distance stretches from the lower left to the far right. Both works display Guo Xi-like trees but in this work they are much simplified, with patterned leaves on the cliff and along the bank of the river, while the land in the foreground contrasts with the flat hills in the distance. The use of such a zigzag arrangement to convey a sense of distance is quite characteristic of Northern Song landscapes in general and those by Guo Xi in particular.

These two square leaves are stylistically related to such masterpieces of the Li–Guo school as Guo Xi's *Early Spring* (National Palace Museum, Taipei) and *A Solitary Temple amid Clearing Peaks,* attributed to Li Cheng (Nelson-Atkins Museum of Art, Kansas City).[1] Certain motifs in the Boston album leaves—for instance, the short, vertical lines resembling distant

trees that decorate the top of the peaks—are reminiscent of those in the aforementioned works. By the Yuan dynasty, the long-established Guo Xi tradition had turned toward a more conventionalized, suggestive mode, as seen in the light touch, dreamlike rendering, and simplification of motifs apparent in these two Boston leaves. *Travelers in Autumn Mountains* (National Palace Museum, Taipei), copied after Guo Xi by the Yuan artist Tang Di (1296–1364) displays very similar characteristics to the two works in the Boston collection.[2]

A square seal in the foreground reads "Zhang Duan zhi ji" (seal of Zhang Duan). Judging from the style of the seal script and carving technique, the seal should date from the fourteenth or early fifteenth century. Another seal on the lower-left corner, repeated on the companion leaf as well, reads "Xu Gu." Whether it belongs to the famous monk painter Xugu (1821–96) is uncertain, but its carving style is that of the late-nineteenth century.

1. *ZMQ: huihuabian*, vol. 3, pls. 6 and 28.
2. *Masterpieces of Chinese Painting in the National Palace Museum*, pl. 18.

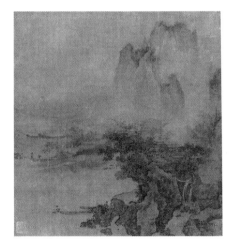

127

Anonymous (formerly attributed to Guo Xi, ca. 1001–ca. 1090)
Landscape with Fishermen

Yuan dynasty, late 13th century
Square album leaf; ink and light color on silk
25.5 x 24.4 cm
Denman Waldo Ross Collection 28.863

This album leaf is closely related to the previous entry *Riverscape with Figures* (cat. 126). Judging from the compositional relationship, this leaf is intended to be placed at the left of the two. They may have been cut from a long handscroll. The style originally derives from the Northern Song master Guo Xi. The modeling of the rocks, with their curving, shifting contours; the Guo Xi-type motifs of trees, a waterfall, and figures; as well as the architecture and the spatial arrangement all point to this tradition.

The Boston companion leaves do not exhibit any of the weight and dynamism of Guo Xi's hanging scroll, *Early Spring* (National Palace Museum, Taipei). Instead, the artist treats the motifs in a more playful manner. Like other Southern Song painters who followed the style of an earlier master, this artist, too, merely wants to give a general interpretation of Guo Xi's style while filling in details to suit his own taste. For example, the origin of the descending waterfall is only shaped symbolically like a "loop," and the fisherman's boat has been conveniently extended into a platform from which he can fish.

To articulate spatial depth, the artist appropriates Guo Xi's landscape vocabulary. This is evident in the positioning of the three figures in the foreground and the two in the left middle ground, by which he both creates an illusion of distance and animates the landscape with human activities. In terms of its structure, the style of the Boston leaf would certainly predate such Yuan followers of Guo Xi as Tang Di[1] or Zhu Derun (1294–1365); it is likely to have been created in the late-thirteenth century.

1. See *Gugong shuhua tulu*, vol. 4, pp. 227–28.

128

Yao Yanqing (act. early 14th century)
Winter Landscape

Yuan dynasty, ca. 1340
Hanging scroll; ink and light color on silk
159.2 x 48.2 cm
Chinese and Japanese Special Fund 15.902

The Li Cheng–Guo Xi tradition of the early Northern Song period continued to flourish after the Mongol conquest of

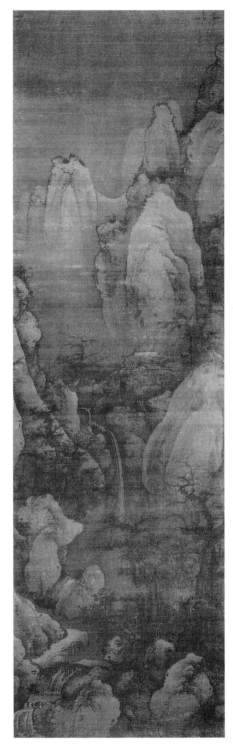

China in the late-thirteenth century. Artists like Yao Yanqing, Tang Di, and Zhu Derun were the leading Yuan-dynasty masters of this tradition. Yao Yanqing, however, is a relatively lesser-known follower of the Li–Guo school since few of his works have survived.

This painting closely adopts Guo Xi's compositional style and motifs (the architecture and waterfall in the middle ground, for example). The spatial depth and intricate arrangement of Guo Xi's mountains and valleys have been faithfully

followed here as well. Because of the close resemblance between this work and Guo Xi's extant paintings, the possibility does exist that Yao Yanqing was actually copying an existing work by this early Song master. Perhaps that is why the Boston painting differs so significantly from the recently published Yao Yanqing handscroll, *Fisherman in a Wintry Riverscape* (Beijing Palace Museum).[1] In the Beijing handscroll, rendered in ink on paper, the composition is divided simply into a foreground filled with bare trees and a background of snow-capped hills. The presentation is open and direct, reflecting the impact of Yuan literati aesthetic taste. Less attention is paid to the atmospheric effect and the antiquarian flavor so apparent in the Boston hanging scroll has been avoided. Yet the same types of trees, rock formations, and even the same two seals of Yao Yanqing are found on both paintings. (The Boston painting also has one additional signature.)

In addition to these two genuine Yao Yanqing paintings, *Leisure Enough to Spare* (Cleveland Museum of Art), a handscroll painted in the literati manner, is signed "Yao Tingmei" instead of Yao Yanqing. The Cleveland painting depicts a hermit sitting on rocks in front of his thatched hut, where he enjoys the view of a mountain stream gently flowing by him. The composition is also constructed with an eye for simplicity and clarity. Toward the end of this Cleveland painting, the artist composed a poem, thus demonstrating an even greater interest in the literati approach than is evident in the one in Beijing.

The form and the texturing of the rock groups in the Beijing and Cleveland paintings are strikingly similar, and the distant mountains in both works resemble each other. Even the mountain streams of both works are positioned alike—at the lower left foreground—and, interestingly, arise out of nowhere. The Cleveland work apparently has a closer relationship with the Beijing Yao Yanqing than with the one in Boston, while the handscroll in the Beijing collection bridges the gap between the Boston and Cleveland paintings.

It is now clear that the two names Yao Yanqing and Yao Tingmei belong to the same artist.[2] Based on the 1360 inscription by Yao Tingmei and the attached 1359 essay by the calligrapher Yang Weizhen (1296–1370) on the Cleveland

scroll, we know that Yao was not only a painter but also a calligrapher and poet, who moved with ease in the literati circles.

1. See *ZMQ: huihuabian,* vol. 5, pl. 91.
2. See R. Barnhardt, "Yao Yen-ch'ing, T'ing-mei, of Wuhsing," in *Artibus Asiae,* vol. 39, no. 2 (1977), pp. 105–23; and Cahill, *Index,* p. 356.

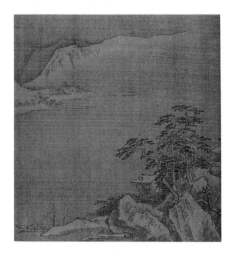

129

Anonymous (traditionally attributed to Xia Gui, act. late 12th–early 13th century)

Winter Riverscape

Yuan dynasty, late 13th–early 14th century
Square album leaf; ink on silk
22.5 x 21.2 cm
Denman Waldo Ross Collection 17.734

Although this painting relates stylistically to the compositional ideas of the Ma–Xia school, the less realistic handling of space and conventionalized treatment of the motifs tie it more closely to the early Yuan period. For example, instead of dominating the setting, the one-cornered foreground in this composition is counterbalanced by a detailed display of the distant mountain range and a village, both covered by heavy snow. The conventionalized ax cut–stroke texturing over the limited space of the distant mountains tends to narrow, rather than expand, the space. The type of ax-cut brushstrokes applied to the foreground rocks is almost identical to those in the distance; hence, the work has lost the kind of contrasting visual effect so evident in reliable Xia Gui works like *Twelve Views of Landscape,* the

well-known handscroll in the Nelson-Atkins Museum of Art, Kansas City.[1] The Boston album leaf bears a spurious signature at the lower right edge that reads "Xia Gui."

1. See *Eight Dynasties,* pl. 58.

130

Anonymous (formerly attributed to Zhang Fu, 9th century)

Herd-Boys with Water Buffaloes under Willow Trees

Yuan dynasty, 14th century
Hanging scroll; ink and light color on paper
42.5 x 37.3 cm
Chinese and Japanese Special Fund 14.49

The composition takes a high perspective to display a close-up of a particular moment in time and space. The viewer looks down at a scene where a group of five figures (two boys and three water buffaloes) mindlessly stroll through a grove of five willow trees. The V-shaped branches and the knots of the willows echo the horns and eyes of the buffaloes. Beyond the figures, a gentle stream flows across the middle ground. The brushwork for the water buffaloes and two herd-boys is vivid and sensitive but, in the modeling of the willow trees it is quite naïve and uninventive. This type of buffalo departs from Southern Song models, as seen in Li Di's works in the National Palace Museum, Taipei. They also differ from the type depicted by Zhe-school painters during the Ming dynasty.

At the top of the picture, a colophon by the famous Ming scholar Gao Lian (act. late-sixteenth century) attributes this

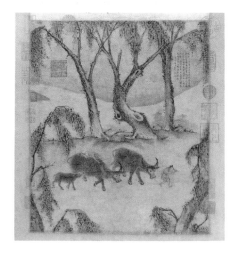

painting to a late-Tang artist, Zhang Fu. But the style has nothing to do with painting from the late-Tang period. Gao Lian, a gifted poet and playwright from the early Wanli period (1573–1620), authored *Zunsheng bajian,* a remarkable book on the lifestyle and taste of the time. Like many great Chinese scholars, despite his erudition, he was not so knowledgeable in art connoisseurship. Another colophon, dated 1760, is by Emperor Qianlong, who stamped fifteen seals on the edges of the painting and included this work in his imperial catalogue. A half seal at the left edge is hidden in a slice of the sandy bank. The deep red color of the seal ink and the carving style suggest a pre-fifteenth-century date. The remaining characters can only be identified as having the surname "Wang"—possibly, the artist's seal. In the lower-left corner, a seal of Yu Teng (act. early eighteenth century) suggests he was the owner of the painting prior to its acquisition by Emperor Qianlong.

131

Anonymous (traditionally attributed to Li Wei, 11th century)
Retreat in a Bamboo Grove

Yuan dynasty, 14th century
Hanging scroll; ink and light color on silk
75.3 x 41.9 cm
Chinese and Japanese Special Fund 12.904

The composition is dominated by the artist's depiction of the bamboo grove in which the outlined leaves are precisely and delicately rendered. The residential complex is just as carefully presented as the bamboo. Judging from the style of architecture and the furniture, the painting is likely a late-Yuan work. The artist arranged the architecture so that the openness of the structures invite the viewer through the pictorial space—from the foreground passageway through the walled gate to the main hall, where a family is in the middle of feasting. The back door then opens onto an endless forest of bamboo along the hillside roads. Compared to the bamboo grove, the architectural depiction is more amateurish. Nevertheless the detail conveys an impression that it is a realistic depiction of an actual residence at a particular location.

This painting was previously attributed to the eleventh-century painter Li Wei based on a questionable signature in the lower-left corner. Other scholars have dated it as possibly Song or Jin, up to as late as the seventeenth century. But in the late-Song period, Chinese furniture was entirely different from what may be seen in this painting. In addition, the outlined clouds and the bamboo leaves are not features typical of seventeenth-century paintings.

The upper part of the painting displays a square seal with two stylized dragons and a round seal with three horizontal lines. The seals have previously been identified as belonging to Emperor Gaozong of the Southern Song, but stylistically they are of a much later date. By contrast, the seals of Liang Qingbiao, a leading collector during the early Qing dynasty, are undoubtedly genuine.

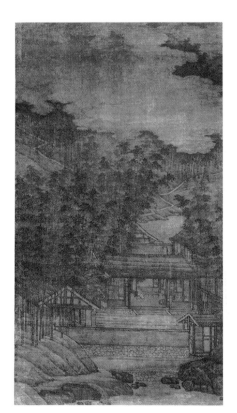

132

Anonymous (formerly attributed to Dong Yuan, act. 10th century)
Mountain Torrents

Yuan dynasty, early 14th century
Round fan mounted as album leaf; ink on silk
23.1 x 24.6 cm
Chinese and Japanese Special Fund 14.65

The image of rushing water with overhanging pine trees on a cliff has been familiar subject matter in Chinese painting since the Song dynasty. The characteristic Song approach is exemplified in the album leaf, *Birds in a Tree above a Cataract,* by Li Di (Cleveland Museum of Art), which displays the typical Song concern with detail and unity.[1] Beyond the dominant tree and the strongly outlined rocks, the rushing water is rendered in light, soft ink and wash to provide a contrast.

The emphasis on atmosphere and a shallower spatial treatment distinguishes the Boston fan from most Southern Song depictions of the same subject. The artist of this fan, using a bolder, more expressive manner typical of the Yuan aesthetic, pays special attention to surface movement and animation. By departing from the Song artist's preoccupation with clarity and spatial depth, this painter has brought intimacy and sensuousness to the landscape. The foreground and background have been given a "flat" treatment. No longer relegated to mere background scenery; the rushing water of the mountain torrents has become the key element highlighted. Water gushes out of the valley with energy and force, splashing as it crests over the cliff in exaggerated forms that suggest a dragon with its claws. The dark rock formation with hard corners at the right side

of the composition stands motionlessly against the ever-changing, curvilinear shape of the water.

The emotion expressed in the Boston fan contrasts with the naturalism of the abovementioned work by Li Di. By Yuan times, artists encouraged viewers to stretch their imaginations and fantasize about the painted images.

1. See *Eight Dynasties*, p. 52, cat. 34.

133

Ban Weizhi (act. early 14th century)
Snowy Riverscape with a Hermit in a Boat

Yuan dynasty, second quarter 14th century
Square album leaf; ink, color, and gold on silk
25.4 x 24.5 cm
Chinese and Japanese Special Fund 12.900

Ban Weizhi (*hao:* Shuzhai) was a poet, calligrapher, and follower of the versatile painter Zhao Mengfu. Ban Weizhi's knowledge and connoisseurship enabled him to succeed the painter Wang Zhenpeng in 1332 (see cat. 113 and 114) as curator in charge of the imperial art collections. This painting is a companion leaf to the calligraphy in cursive style by Ban Weizhi (cat. 134), and both leaves are part of an album that once belonged to the scholar–official Ruan Yuan. Although it bears no signature or seal of Ban Weizhi, the painting can be plausibly attributed to him. Not only is the picture a direct illustration of the poetic meaning expressed in the facing album leaf of calligraphy, but

also the amateurish, archaic painting style that of someone who is both a follower of Zhao Mengfu and a poet–calligrapher. Moreover, the silk is the same on both painting and calligraphy.[1] The low, flat land and hills in Ban Weizhi's painting are reminiscent of a number of Zhao Mengfu's archaistic treatments of landscape, such as *A Village by the Water* (Beijing Palace Museum)[2] and another handscroll, *The Pure and Remote Scenery at Wuxing* (Shanghai Museum).[3] All three works share the same conception in their extreme manner of stretching form and space. It seems reasonable to assume that Ban Weizhi playfully painted this album leaf with some inspiration from the landscape style of Zhao Mengfu.

The painting style is strongly amateurish; the artist paints his motifs as if he were writing a piece of calligraphy—with repeated brushstrokes to form similarly rendered hills, reeds, etc. The use of gold to highlight the hills and the moon above them, with the hermit painted in thick, white color, helps to create a naïve charm.

The interplay of painting, calligraphy, and poetry held great interest for the Yuan artists. Those known only as poets and calligraphers may, from time to time, have ventured into the field of painting. The spontaneity, naïveté, somewhat awkward brushwork, and unconventional coloring were aspects of painting that literati artists valued and consciously pursued in their artistic expression.

1. Only one other painting of a pine tree attributed to Ban Weizhi is recorded. It is found in the late-Ming publication, Wang Keyu, *Shanhuwang: hualu*, juan 23, p. 29.
2. See *ZMQ: huihuabian*, vol. 5, pl. 19.
3. See *Shanhai hakubutsukan*, pp. 227–28 and pl. 164.

134

Ban Weizhi (act. early 14th century)
Calligraphy of a Quatrain in Cursive Script

Yuan dynasty, second quarter 14th century
Square album leaf; ink on silk
26.3 x 24.3 cm
Chinese and Japanese Special Fund 12.901

Ban Weizhi's calligraphy often appears in colophons he wrote on ancient paintings

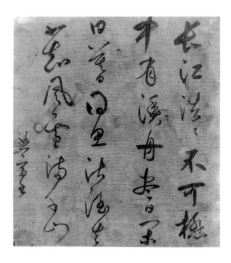

and calligraphy. The *zhangcao* (draft-cursive) style of this example records a poem probably composed by the poet–calligrapher himself. It is a companion work to the *Snowy Riverscape with a Hermit in a Boat* (cat. 133). The text can be translated as follows:

> The long river flows ceaselessly.
> A fishing boat lies idle all day long.
> With fish caught and wine bought
> at dusk,
> He does not know that wind and
> snow already cover a
> thousand mountains.

Starting at the upper right, the first line is written with heavy, strong brushstrokes. Each character is independently executed. By the time the calligrapher completed the second vertical line from the right, the speed of the writing had apparently increased. In the last two vertical lines, not only a faster pace, but also a more lyrical rhythm, is evident, especially among the characters at the extreme left. For instance, the strokes of the first two characters, *bu* (not) and *zhi* (know), were combined to form one continuous movement. Ban Weizhi then proceeded to connect the last five characters, *feng xue man qian shan* (wind and snow already cover a thousand mountains), in his remarkably fast-paced execution. The line *shuzhai shu* (written by Shuzhai), at the lower left, is written in the same manner as the rest of the characters and thus becomes part of the poetic text.

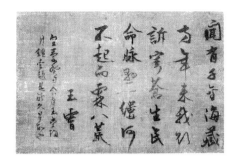

135

Teng Bin (act. 14th century)
Calligraphy of a Poem in Semi-cursive style

Yuan dynasty, dated 1313
Hanging scroll; ink on silk
26.3 x 39.3 cm
Chinese and Japanese Special Fund 17.781

The calligrapher Teng Bin (*hao:* Yuxiao) began his career as a traditional Confucian scholar serving at the Mongolian court. He was put in charge of promoting Confucian teaching in the province of Jiangxi, which was also a center of Daoism. Later, Teng Bin left his family to become a Daoist and lived in the Tiantai mountains in today's Zhejiang province. Whatever his spiritual leanings, Teng Bin was known in early fourteenth-century literati circles as an accomplished poet and calligrapher. The great Yuan literatus Zhao Mengfu once praised him in a poem, likening Teng's poetry to the style of the Daoist poet Tao Yuanming (365–457) and his calligraphy to that of Wang Xizhi (ca. 303–ca. 361).[1]

Teng's collected poems were published in a work entitled *Yuxiao ji,* but little of his calligraphy has survived. Boston's small hanging scroll consists of eight vertical lines written in the traditional manner, from top to bottom and right to the left. Teng's writing style is actually closer to those of Mi Fu (see cat. 138) and Zhao Mengfu than to Wang Xizhi's. His lyrical brushstrokes end with sensuous turns. At times he displays a tendency to exaggeration in the brush movement, with variations in the speed and pressure affecting the structural clarity of individual characters. The poem can be translated as follows:

They say the sea hides a secret worth
 its weight in gold.
All year long, I begged Heaven
 to ease our suffering.
In this world, our life hangs by
 a thread.
Why has no rain fallen on the eight
 corners of the universe?

The inscription reads

[Signed] Yuxiao. In the year *guichou* of the Huangqing era [1313], I had just returned from my office when Yuejian asked for some of my writing. I composed this poem because of the long drought that year.

1. See *Zhongguo renming dacidian* (Shanghai: Shangwu yinshuguan, 1921), p. 1523.

136

Anonymous (traditionally attributed to Priest Ziwen Riguan, act. second half 13th century)
Ink Grapes

Yuan dynasty, second half 14th century
Hanging scroll; ink on silk
24.4 cm x 74.4 cm
Gift of Mrs. Albertina W. F. Valentine, Residuary Legatee under the Will of Hervey E. Wetzel 19.660

The painter came from a family in Huating (today's Songjiang, Jiangsu province). Nicknamed "Wen the Grapes," he lived in the Ma'nao Temple near Hangzhou. He was also known by his priest name Ziwen and *hao*-name Riguan. Well-educated in both Buddhist and secular learning, Ziwen Riguan was famous for his cursive-style calligraphy and his speciality of painting ink grapes. The vines and leaves in his grape paintings are executed according to cursive calligraphy brushstrokes.

The square seal at the lower left of the composition, which reads "Fentuolihua," was often used by the artist on his works. The flower name *fentuoli* derives from the Sanskrit Puṇḍarīka, which means a species of large, white lotus blossom. According to the *Lotus Sūtra* this flower does not exist in this world, but grows in the Aruda (Anavatapta) Pond, as was recorded by the Tang monk Xuanzang in his *Datang xiyu-ji*.[1] Other than the square seal, no signature or inscription by the artist is found.

The composition consists of a central group of grapes with vines and leaves extending to the left and right. The painting was very likely executed with great speed, so the brushstrokes only lightly touched upon the surface of the silk. Such execution accords with Chinese literary records that describe the artist painting grape vines and branches as if he were writing a piece of cursive-style calligraphy. A closely related painting of ink grapes in James Cahill's collection also has the square *Fentuolihua* seal at the lower left as well as four lines of poetry with the artist's signature. The Cahill version, however, is painted on paper.[2] Scholars generally agree that the best and most reliable ink grape painting by Ziwen Riguan is one dated 1291, now in a private Japanese collection.[3]

Beginning in the late Southern Song, paintings by Chan monks and literati gradually became part of the mainstream of Chinese painting history. They formed a direct challenge to the well-established academic style that dominated Chinese painting movements from Northern Song times. The works of Chan monks reflected their Buddhist faith, ideas, and doctrine. The motifs, ranging from a few persimmons to vast landscapes, were depicted in a style that was direct, sharp, and spontaneous, one that aimed to capture their subject's essential nature.

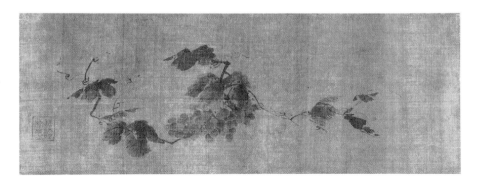

Admired by literati and denounced by academicians, the Chan artists introduced a fresh, expressive quality into Chinese painting. Liang Kai, who left the academy, was influenced by their style, and monks like Muqi Fachang had an even greater impact on Yuan artists. Ziwen Riguan is one of the representatives of this Chan style, and this *Ink Grape* exemplifies the aesthetic concerns of Song Buddhist painters.

This painting has an unusually wide format for a hanging scroll. It suggests that it was originally a long handscroll. The work, like many others in the Boston Museum collection, came from Japan and still has the original Japanese mounting. But the ink painting has lost its original backing paper, resulting in its coarse, grayish appearance. The ink tonality has been affected as well.

1. See Xuanzang, *Datang xiyuji*, juan 2.
2. See *Yiyuan Duoying*, no. 41 (June 1990) (Shanghai: Renmin meishu chubanshe), pl. 13.
3. See *Sogen no Eiga* (Tokyo: Tokyo National Museum, 1962), pl. 90.

137

Anonymous (formerly attributed to Su Shi, 1036–1101)

Ink Bamboo

Yuan dynasty, 14th century
Square album leaf; ink on silk
21.5 x 24.8 cm
Denman Waldo Ross Collection 29.946

Throughout Chinese history, bamboo has been revered and imbued with symbolic connotations. The uniqueness of ink-bamboo painting inspired Emperor Huizong to devote a chapter to such works and the artists who specialized in painting them in his catalogue *Xuanhe huapu*.[1] The artist who painted this work gives a Confucian interpretation of the plant's essential character and virtue. The boldly executed bamboo branch—severed, but with twigs growing from its node and with six new leaves—embodies the traditional view that bamboo persists, even after catastrophe. In Confucianism, a person's character is judged according to his moral conduct; a Confucianist would

strive to be inwardly humble while outwardly firm in principles, just as bamboo is internally hollow yet externally strong. Righteousness is another important Confucian virtue—just as bamboo would break before it would bend, so one should stand tall and straight in the face of crisis, accepting the consequences of one's actions rather than compromising principles.

Many Confucian scholars specialized in painting ink bamboo, not only for its moral symbolism but also because these scholars usually were calligraphers. The techniques underlying the art of calligraphy and the painting of bamboo are closely related. Unlike the more natural, objective rendering in Song bamboo paintings, this fourteenth-century work is a highly personal statement. Judging from its calligraphylike, expressive brushwork and simple composition, this anonymous painter was probably a literatus like the earlier ink-bamboo painter Wen Tong (ca. 1040–79) rather than a professional painter.[2]

The intended viewing orientation of this work has been a subject of ongoing debate. Tomita's 1961 *Portfolio* published this bamboo in a vertical position, but in one corner of the album leaf, an eighteenth- or nineteenth-century collector's seal is positioned in a direction that suggests the bamboo should be viewed horizontally. The debate remains unresolved; like the life of an artist, the painting can be understood from more than one fixed viewpoint.

1. See *Xuanhe huapu*, juan 20, pp. 247–54, in Yu Anlan, *HC*, vol. 2.
2. In the National Palace Museum, Taipei, an ink bamboo leaf attributed to the Northern Song literatus Wen Tong also depicts a broken bamboo, perhaps with the same symbolic connotations. See *Masterpieces of Chinese Album Painting*, pl. 10.

138

Anonymous

Landscape in the Style of Mi Fu (1051–1107)

Yuan dynasty or slightly later, second half 14th century
Hanging scroll; ink on paper
26.2 x 44.7 cm
Charles Bain Hoyt Collection 50.1456

A leading literatus in the Northern Song dynasty, Mi Fu originated a unique landscape style the influence of which has continued into the present. It is characterized by the use of short, horizontal ink dots to describe and build up motifs and, eventually, the entire composition—a style not unlike the pointillist techniques of modern Western paintings. As one of China's most gifted calligraphers, he employed dotting, a basic calligraphic

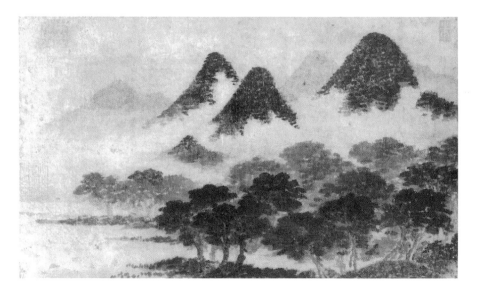

technique, in pictorial representation. Since none of the surviving painted works attributed to Mi Fu are accepted as genuine, his style is understood primarily through later imitations, copies, and original works by his son Mi Youren (1074–1151).

This ink painting represents a particular literatus' approach to rendering landscape. The artist uses Mi Fu-style dotting not only to describe the physical shapes of trees and mountains, but also to highlight spatial relationships among the motifs. Different ink tonalities and densities lend to a sense of depth, an approach also evident in the artist's handling of the mountains. Three peaks shaped by dark, dense ink dots arise from a sea of white mists. Beyond these peaks a light ink wash indicates a screen of distant mountain ranges. As if to emphasize the spatial depth of the picture further, horizontal land slopes are repeated from foreground to middle ground, ending with subtle washes at the foot of the distant mountain.

The so-called Mi-style landscape was carried on from northern China to Hangzhou by Mi Youren who fled with the court to the south. After that, the realism of Southern Song academic painting dominated during the entire thirteenth century. It was not until the revival of the Northern Song literati styles and ideas that new artists like Gao Kegong (1248–1310) rediscovered and became devoted to this particular landscape style. Although the Mi landscape style was imitated by literati painters throughout the Ming and Qing dynasties, later versions differ from those of the Yuan dynasty in one key respect: Yuan artists adhered much more faithfully to Song prototypes and concepts; they paid more attention to volume and weight. Ming artists, on the other hand, generally overlooked the importance of space. Hence their paintings are markedly flatter and lighter and appear more abstract and less articulated.[1]

Collectors' seals belonging to the Ming painters Dai Jin (act. mid-fifteenth century) and Mi Wanzhong (1570–1628) appear on this work as does a colophon by the Qing scholar Weng Tonghe (1850–1904).

1. Compare, for example, works by the leading Ming literatus Dong Qichang. See Wai-kam Ho, *The Century of Tung Ch'i-ch'ang (1555–1636)*. (Kansas City: Nelson-Atkins Museum of Art; Seattle: University of Washington Press, 1992), vol. 1, pl. 35.

139

Zhou Zhi (d. 1367)
Scenery of Yixing

Yuan dynasty, dated 1356
Handscroll; ink on paper
32.4 x 58.8 cm
Keith McLeod Fund 56.493

Zhou Zhi, who befriended the great literatus Ni Zan, was himself a known poet and calligrapher in the late-Yuan dynasty. Of the two extant paintings attributed to him, *Tall Trees in a Remote Valley* (Osaka Municipal Museum) is a much later work unrelated to this scholar. Boston's *Scenery of Yixing* therefore remains Zhou Zhi's only known surviving work. It is painted in ink on paper in a typical Yuan literati manner: abstraction emphasized over realism; brushwork over structure. Although his style is related to other late-Yuan painters such as Xu Ben (act. second half of fourteenth century), Lu Guang (act. second half of fourteenth century), and Chen Ruyan (act. 1340–70),[1] Zhou Zhi's rendering of landscape here is more monumental and has greater depth than the approaches of his contemporaries. Despite their small scale, the mountain ranges in this painting convey a sense of monumentality. The depiction of trees seems to synthesize the styles of the four masters of the Yuan dynasty (Huang Gongwang, Wang Meng (1308–85), Wu Zhen (1280–1354), and Ni Zan); in particular, the simplicity and elegance of Zhou Zhi's brushwork is related to that of Ni Zan. This landscape style depends on the subtle change of ink tones and the calligraphic quality of the lines. It is far removed from the vocabulary of Song academic landscape painting.

At the end of his long poem inscribed on the painting, Zhou wrote:

Scenery seen along the way from Xijiang (West River) to Longyan (Dragon Cliff). Last spring I composed the above poem in the mountains of Yixing. Yancheng, on behalf of a scholar Lü, has brought a scroll to me for a painting. I therefore painted this in the fourth moon of the year *bing-shen*.

As was common in the Yuan period, four contemporary poets also wrote their own poems on the painting. Unfortunately, none of them can be identified with certainty.

Zhou Zhi's painting and his poem were much admired by the great Ming master Shen Zhou (1427–1509). Upon learning of Shen Zhou's interest in Zhou Zhi's work, Huang Yuanling, the son of

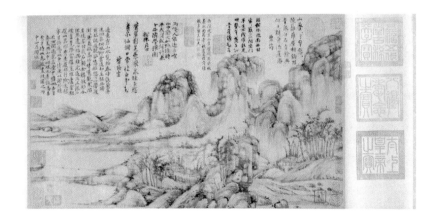

Huang Yun, the owner of the painting, decided to give it to him. In turn, Shen Zhou created *Autumn View of Tongguan* for Huang Yuanling to express his gratitude. But the original owner Huang Yun was upset that his son had given away a family treasure. After hearing of this family quarrel, Shen Zhou returned the Zhou Zhi painting to the family. Ever since, the Zhou Zhi and Shen Zhou paintings have been mounted together as one handscroll.

1. See S. Lee and Wai-kam Ho, cat. 262–63 and 265.

140

Xia Yong (act. 1340s–1360s)
The Palace of Prince Teng

Yuan dynasty, mid-14th century
Square album leaf; ink on silk
24.7 x 24.7 cm
Denman Waldo Ross Collection 29.964

The subject matter of this picture is a palace constructed in 653 by Prince Teng (Li Yuanyin, d. 684), the son of the Tang Emperor Gaozu (r. 618–26), when the prince served as the military commander of the Hongzhou district (today's Nanchang, Jiangxi province). In 675, when the new military commander of the Hongzhou district invited scholars to a literary gathering to celebrate the "double nine" festival held at Prince Teng's palace, the young scholar Wang Bo (648–76), regarded as one of the four master essay-

ists of the early Tang period, was invited to contribute a prose poem to commemorate the occasion. One year after he wrote the *Preface to the Palace of Prince Teng,* Wang Bo died at the age of twenty-nine. The artistry of Wang Bo's prose poem inspired many later painters to create an idealized image of the palace of Prince Teng. Various novelists had fictionalized the events surrounding Wang's writing, with some accounts claiming that the prose poem was composed when Wang was only thirteen. Other sources suggested that the god of the Yangzi River conveyed a favorable wind for Wang's boat to speed it through the seven-hundred-mile journey overnight, so that Wang Bo could participate in this memorable event.

On this album leaf, a sailboat sailing full speed diagonally toward the palace of Prince Teng was intentionally added at the left side of the composition. On board, in front of the sail, the young genius Wang Bo anxiously awaits his arrival at the festive party, while inside the upper story of the palace complex, other scholars are depicted with brushes and unrolled paper already composing essays.

This palace painting by Xia Yong, like many others, was once attributed to the well-known master Wang Zhenpeng. Existing works by Xia Yong are mostly limited to miniature paintings of palaces or temples. Wang Zhenpeng, on the other hand, had a much broader painting repertoire that included religious paintings (see cat. 113) and narrative paintings, like *The Hermit-Musician Boya Playing the Qin for His Friend Zhong Ziqi* (Beijing Palace Museum) and *Dragon Boat Regatta on the Jinming Lake* (Metropolitan Museum of Art, New York). Xia Yong displays a rich but somewhat rigid decorative style in his paintings, whereas those by Wang Zhenpeng are usually more original and imaginative. It is possible that Wang, who worked several decades before Xia, influenced the younger artist, who then took up one of Wang Zhenpeng's specialties, the ink drawing of architecture.

Since little is known about Xia Yong, and his painting style is clearly later then that of Wang Zhenpeng, he has often been mistakenly considered to be an early Ming artist. Fortunately, an album leaf in the Beijing Palace Museum, depicting the famous building Yueyang Lou, bears a date in the seventh year of the Zhizheng era (1347) during the Yuan dynasty. Xia Yong's 1347 inscription states he is a native of

Hangzhou and is also known by the name "Xia Mingyuan."[1] This proves that Xia Yong was indeed the late-Yuan artist referred to in the well-known late-fifteenth-century catalogue *Kundaikan Sōchōki* as Xia Mingyuan.[2]

Few of Xia Yong's works are extant. The best known are in the collections of the Boston Museum, the Freer Gallery (Washington, D.C.), and the Beijing Palace Museum. Recently, some little-known album leaves by this artist have been published: two in the Shanghai Museum and another two in the Yunnan Provincial Museum. The Boston version is close to that of the Freer Gallery's *Palace of Prince Teng,* but not identical. The major difference between them is their distinct perspectives. The Boston composition offers a lower viewing level than the Freer's. The former has a stronger sense of verticality, with the top of the highest roof closer to the upper edge of the painting. A more pronounced foreground scene with rocks and trees extends far into the area in the lower left. The composition of the Boston painting more closely captures the spirit of Wang Bo's prose poem because it emphasizes the lofty grandeur of the palace complex and the vastness of the water. The Freer version lacks such a broad visual impression because of the limited scope of the building.

1. *ZMQ: huihuabian,* vol. 5, pl. 99 and pp. 52–53.
2. Cahill, *Index,* p. 277.

141

Anonymous (formerly attributed to Qi Zhong, act. 1225–27)
Winter Landscape with Travelers

Yuan dynasty, mid-14th century
Round fan mounted as album leaf; ink and light color on silk
25.4 x 24.3 cm
Chinese and Japanese Special Fund 37.1150

No extant paintings can be reliably attributed to Qi Zhong, a Southern Song follower of Guo Xi's landscape style. He was also known as a specialist in painting the tide, waves, and bore of the Qiantang River (see cat. 87). In this fan, however, the landscape style bears no relationship to the eleventh-century master Guo Xi.

142

Anonymous (formerly attributed to Zhao Mengfu, 1254–1322)
Dragon King Worshipping the Buddha

Yuan dynasty, second half 14th century
Hanging scroll; ink and color on silk
178.5 x 115.4 cm
Keith McLeod Fund 59.650

Judging from the rendering of the foreground trees, with the repetitious patterning of the branches, the distant mountain range painted across the upper part of the composition, and the articulation of the figures in the foreground in relation to the scenery, this painting is more typically Yuan than Song.

A signature written in reverse on the rock at the lower-right corner reads "Qi Zhong." Although the 1298 publication *Huaji buyi,* by the early Yuan collector Zhuang Su, mentions that Qi Zhong usually signed his name in reverse, the reversed signature on the Boston fan does not, by itself, ensure that the painting is a genuine work by Qi Zhong.[1] A small seal reading "Zizhao" is stamped at the upper left of this fan. The Yuan painter Sheng Mou is one of a few artists who also went by the name of Zizhao. But the style of this fan differs from Sheng Mou's works and, in its spatial articulation, still recalls Southern Song tradition.[2] For example, *Returning to the Flower Village Intoxicated,* an anonymous Southern Song round fan in the Shanghai Museum, shows a compositional relationship with the Boston work. Both have a bridge crossing in the foreground and buildings in the left middle ground. Still, the Boston fan displays more Yuan characteristics than does its Shanghai counterpart.[3]

1. See Zhuang Su, p. 14.
2. Comparison with established Sheng Mou works shows no clear resemblance between his style and that seen in the Boston fan. See, for example, such works as the hanging scroll *Retreat in the Pleasant Summer Hills* (Nelson-Atkins Museum of Art, Kansas City); Sheng Mou's 1349 landscape in the National Palace Museum, Taipei; or the Nanjing Museum's famous riverscape with a man playing flute, dated 1351.
3. See *Zhonghua wuqiannian wenwu jikan,* vol. 4, pl. 163.

During and after the Northern Wei period, as Indian Buddhism gained popularity in China, Indian Buddhist subject matter was eagerly copied by Chinese sculptors and painters. The imitations and borrowings frequently resulted in a sinicization of the original imagery. In this work, the Indian Nāga, the serpent king, was conveniently replaced by the native-Chinese image of the dragon. In China, the dragon was traditionally considered king of the sea (*hai longwang*), and in pictorial representations, the Dragon King assumed human form, adorned with an outfit appropriate for human royalty, a development that parallels Chinese iconography for kings of hell.

According to the "Tipopin" chapter of the *Lotus Sūtra* the Dragon King (Sāgaranāgarāja) emerged from the depths of the sea to arrive at the foot of Vulture's Peak (Gijjhakūṭa). There, he paid his respects to the Buddha Śākyamuni by listening to his sermon. The *Lotus Sūtra* also mentions the Dragon King's eight-year-old daughter, who accompanied him and instantly reached Buddhahood through her worship. In this painting, the black-robed Dragon King is followed by three high officers from his court, as indicated by the tablet each holds. Two young women follow in the distance. The one on the left, dressed like a princess with long scarves, fluttering garments, and jewelry over her hairdo, might be the Dragon King's daughter. The other, who is more simply dressed, could be her maid. The Buddha himself, with his right hand raised in a preaching mudra, wears a red robe and sits in the middle of a cave. The red and black colors of the Buddha and Dragon King's robes serve as points of focus. The landscape is executed in the light blue-and-green style, frequently seen in late-Yuan and Ming paintings. Similar color schemes can be found in works by Zhao Mengfu depicting red-robed Lohans against a blue-and-green background, such as the one in the Liaoning Provincial Museum.[1]

The style of the painting has a pronounced descriptive quality, expressed through skillful brushwork and decorative coloring. For instance, the use of thinly applied mineral green color over the landscape and detailed depiction of the trees are reminiscent of late works by Sheng Mou, such as the beautiful hanging scroll *Enjoying Cool Air in a Mountain Retreat* (Nelson-Atkins Museum of Art, Kansas City). Sheng Mou's handling of figures and landscape is more conventional than that of Zhao Mengfu, whose approach is more individualistic. The line of inscription written in regular script together with seals bear the name Zhao Mengfu. However, they are most likely later imitations.

The richly colored narrative scene of the Dragon King and his entourage worshipping the Buddha depicted in the Boston work is presented in a style closer to Sheng Mou than Zhao Mengfu. It was formerly attributed to Zhao Mengfu by An Yuanzhong (eighteenth century), son of the early Qing Korean collector An Qi (1683–after 1742) in the 1742 catalogue *Moyuan huiguan: Minghua xubian* (Observations on Collected Calligraphy and Paintings: Additional Paintings).

1. The Liaoning painting is dated in 1304. See *ZMQ: huihuabian,* vol. 5, pl. 21, p. 31. For similar works by Zhao Mengfu, see ibid., pl. 22, pp. 32–33 and pl. 29, pp. 42–43.

143

Anonymous

Seated Lohan Holding a Stūpa

Yuan dynasty, 14th century
Hanging scroll mounted as panel; ink, color,
and gold on silk
123.6 x 56.9 cm
Chinese and Japanese Special Fund 12.884

Following a tradition established in the
tenth century, in which a single, large
Lohan image dominates the composition,
the present work has supplemented the
main figure with busy and crowded
motifs, in a fourteenth century manner.
The Lohan, holding a miniature stūpa
with a lotus base, is shown sitting in a
chair made from a tree root. He turns his
head toward the left to look at a devotee
dressed in a red court robe. A green-leafed
plantain tree issuing red blossoms provides
a shady background for the figures. Per-
haps to emphasize the non-Chinese fea-
tures of the Lohan, the artist has bared the
Lohan's right shoulder and colored the
sage's skin brown, which accords with his
Indian facial structure.

Such characterization and descriptive
rendering are echoed in the meticulous
depiction of the lavish, gilded stūpa. The
artist even details the demon supporting
the lotus base. The careful description of
the stūpa and the Lohan's head contrasts
with the more abstract handling of the
Lohan's blue garment. Its folds, painted
with a more calligraphic brushwork forms
an interesting decorative pattern that does
not always reveal the anatomy of the
body. The red color of the devotee's robe
corresponds to the red shawl over the
Lohan's shoulder and waist as well as the
hue of the plantain blossoms. The devotee
is probably someone of stature since he
wears a crown and holds a tablet that dis-
tinguish him from the more typical atten-
dants in Lohan paintings (see cat. 144,
145, and 146).

The figures and motifs in this painting
are arranged in a shallow space that
appears even more crowded since the
painting must have been trimmed on all
four sides, most extensively at the top and
bottom. The work probably belongs to a
set of sixteen or eighteen Lohans that has
little in common with the Ningbo tradi-
tion of the Southern Song. The style also
differs from the more lavish and colorful
representations of Lohans in the court
style. No artist's signature or seal appears
on the painting, nor are there any collec-
tors' seals.

144

Anonymous

*Lohan Holding a Fly Whisk,
with a Monk*

Yuan dynasty or slightly later, second half 14th
century
Hanging scroll mounted as panel; ink, color,
and gold on silk
138.5 x 74.8 cm
Chinese and Japanese Special Fund 14.72

145

Anonymous

*Lohan Holding a Staff, with
Worshipper*

Yuan dynasty or slightly later, second half 14th
century
Hanging scroll mounted as panel; ink, color,
and gold on silk
138.5 x 74.8 cm
Chinese and Japanese Special Fund 14.71

146

Anonymous

*Lohan Seated in a Lacquered
Chair, with an Attendant*

Yuan dynasty or slightly later, second half 14th
century
Hanging scroll mounted as panel; ink, color,
and gold on silk
138.5 x 74.8 cm
Chinese and Japanese Special Fund 15.889

The similarities in style, figure type, and
details shared by these three large hanging
scrolls (now mounted as panels) suggest
that they may originally have been part of
a set of sixteen Lohans. During the Song
dynasty, Lohan paintings were a popular
genre both at the imperial court and in
Buddhist centers like Ningbo. Yuan Lohan
paintings generally follow the Song mod-
els in appearance, pose, and settings, but
the Yuan Lohans appear less individualized
or dramatized than Song examples. They
are presented in a flatter but more color-
ful manner than their earlier counterparts.
Motifs became conventionalized and the
compositions were executed in softer,

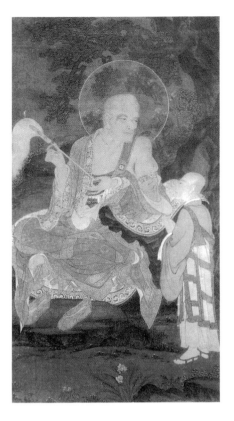

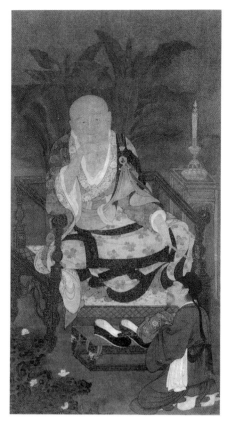

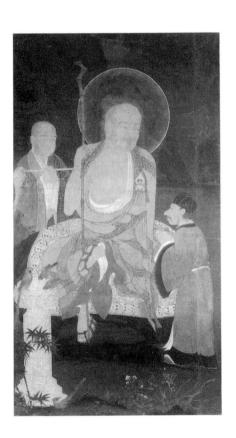

Anonymous (formerly attributed to Lou Guan, act. 1265–74)
Scholars Viewing Waterfalls

Yuan dynasty, second half 14th century
Hanging scroll; ink and color on silk
92.2 x 155.2 cm
Frederick L. Jack Fund 1979.202

Many Song landscape styles continued to be influential even after the Mongol's conquest of China in the late-thirteenth century. This landscape painting appears to be a fourteenth-century interpretation of the Ma Yuan style of the Southern Song period. While adhering to Ma Yuan's one-corner compositional concept, the relatively complicated construction—with the rocks in the foreground and undifferentiated spatial arrangement among different motifs in the middle ground—has no parallel in Song academic works. On the other hand, the Boston scroll is related to

based them on Song examples such as the three Lohans by the court painter Liu Songnian in the National Palace Museum, Taipei.[1]

All three of these paintings are dominated by a well-rendered, portraitlike depiction of a Lohan. One appears to be Chinese (cat. 146); the others, Indian. The realistically depicted flowers, trees, and rocks in the composition all play subordinate roles. Such rendering contrasts with Liu Songnian's unified, balanced composition, which is typical of the Song academic style and design for Lohan paintings. In particular, the *Lohan Holding a Fly Whisk, with a Monk* (cat. 144) relates closely to an anonymous *Lohan and Attendant* (Freer Gallery, Washington, D.C.) that is slightly larger than Boston's Lohan paintings.[2] The Boston Lohan wears a lavishly decorated green robe, and the blue and red monk's *kaṣāya* (mantle) covers his entire body except his left shoulder and the front part of his left toes. Both paintings were quite likely based on the same prototype and can be similarly dated.

1. All are dated to 1207. See *Gugong shuhua tulu*, vol. 2, pp. 103–108.
2. See Lawton, *CFP*, cat. 26.

slower brushwork in the fourteenth century. Richly colored ornaments in Yuan Lohan paintings were emphasized over the earlier interest in space and structure. The prototype of these three works is still unknown. Possibly, their Yuan painter(s)

works by Yuan followers of the Ma Yuan style, such as the landscape hanging scroll by Sun Junze (act. fourteenth century) in James Cahill's collection.[1] In mood and expression, the waterfall streaming from behind a cliff, with an overhanging pine tree, in the Boston painting closely resembles an anonymous *Waterfall* hanging scroll in the Cleveland Museum of Art.[2]

Despite its Song-like placement of small figures in a towering landscape setting, the painting's old attribution to Lou Guan cannot be confirmed. The better-known works attributed to Lou Guan are a round fan of a snowscape (private collection, Japan) and a landscape hanging scroll with a scholar visiting a hermit (Asia Society, New York). Both paintings carry Lou Guan's signature and both are painted in the general style of the late-Southern Song period. The Boston landscape, however, is unsigned and its pronounced fourteenth-century characteristics—for example, a tendency to crowd the composition instead of clarify spatial relationships; the looser, but bolder, brushwork rather than the tight, calculated strokes of the Song—differ from the two above-mentioned examples that bear the signature of Lou Guan.

1. See Cahill, *Hills Beyond a River*, pl. 4.
2. See *Eight Dynasties*, p. 98, entry 78.

148

Chen Yuexi (14th century [?])
The Daoist Immortal Magu with a Crane

Yuan dynasty, 14th century
Hanging scroll; ink, color, and gold on silk
100.7 x 54 cm
William Sturgis Bigelow Collection 11.6168

Ancient Chinese legend tells of a female Daoist immortal named Magu, a fairy whose beauty and youthful appearance made her a symbol for the independent spirit of Chinese women. A work by the great Tang calligrapher Yan Zhenqing (709–85) entitled *Magushan xiantan ji* (Essay on the Daoist Altar atop Mount Magu) celebrated and helped popularize this figure. She appears in many folk tales and plays, presenting a longevity peach as a birthday gift to the Queen Mother of the West. According to *Shenxian zhuan* (Biographies of the Daoist Immortals) by the renowned Daoist scholar Ge Hong (284–363), Magu is a nineteen-year-old girl who ties some of her hair in a knot while letting the rest hang down in long strands. Her dress is patterned with designs unknown in this world, and her long fingernails resemble bird's claws. Three times since becoming an immortal

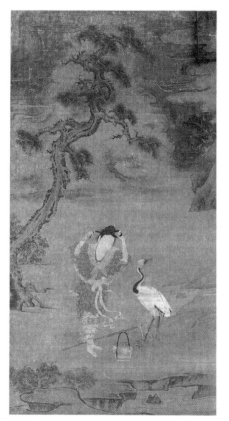

she is said to have witnessed the vast Eastern Sea turn into rice fields.

The iconography of Magu in this hanging scroll generally follows the characterization described in *Shenxian zhuan*. The scroll shows a handsome young woman arranging her hair in a bun with her long fingernails. A dress made of numerous large leaves is tied at her waist with a silky belt, the two ends of which hang in the front. A scarf is tied around her neck and under the unconventional dress, a pair of ordinary trousers are seen above her bare feet. What is not mentioned in the *Shenxian zhuan* are a basket and the *lingzhi* fungus, both tied to a hoe in front of her. In addition, a crane with white and black feathers stands nearby. Behind Magu and the crane, a magnificent pine tree grows from the foreground to the top of the painting, where the corner of a temple building is visible amidst blue clouds. A figure can just be seen striking a bell that hangs from the ceiling.

The painting exhibits two different brushwork styles, with the finer strokes reserved for the figures and architecture and the more expressive type for the trees, clouds, and rocks. Unfortunately, the colors applied to the immortal have partly worn away. Judging from its style and brushwork, the scroll can be dated to the fourteenth century. It further confirms

the unusual tolerance Mongol rulers had for native Chinese religion and popular beliefs. Later on, the immortal Magu was introduced into Japan and became a popular subject for Kano artists.

A signature at the left edge, next to a pine tree branch, reads "Yutian Chen Yuexi bi." The character *Chen* is the artist's surname, and *Yuexi* (Moon Stream) his given name. The characters *Yutian*, (Jade Field) written on top of the surname could be either the artist's *hao*-name or his place of origin. An artist's seal in the shape of a bronze *ding*-tripod bears a similar inscription: "Sanshan Yutian Chen Yuexi ji." Chen Yuexi is not found in Chinese literature. Both "Yutian" and "Yuexi" have strong Daoist connotations, and it is possible that the artist was a Daoist priest.

The painting was brought to Boston from Japan by William Sturgis Bigelow, who first loaned it to the Museum in 1889.

149

Anonymous (traditionally attributed to Chen Zhitian, second half 14th century)
Fourteen Portraits of the Daoist Wu Quanjie

Yuan dynasty or slightly later, second half 14th century
Handscroll; ink, color, and gold on silk
51.8 x 834.8 cm
Gift of Mrs. Richard E. Danielson 46.252

The Buddhist art that arrived in China during the first century A.D. had a profound impact on the subsequent history of Chinese portrait painting. The idea of "likeness" (*xiezhen*) in representing an emperor, sage, or philosopher would change from the idealized to a more realistic portrayal. This aesthetic gained momentum during the Song period, when realism was called upon for portraits of Confucian scholars and Daoist sages alike. While numerous portraits of Buddhist and Confucian figures have survived, those of Daoist priests are quite rare. Still rarer are works such as this Boston handscroll that presents a series of portraits detailing biographical highlights of a Daoist priest over a period of twenty years. Perhaps the only comparable work

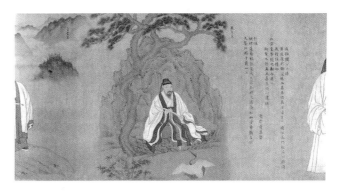

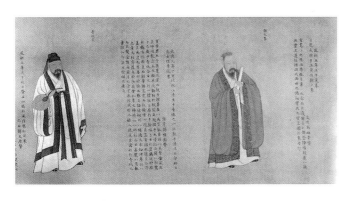

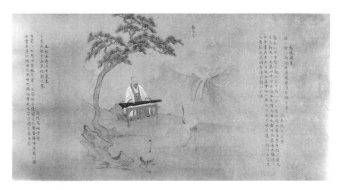

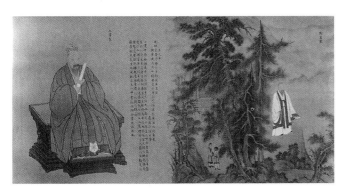

is a handscroll in the Nelson-Atkins Museum of Art's collection, which depicts various manifestations of the Daoist sage Laozi[1] in a purely idealized manner, and served an entirely different religious function from the Boston painting.

This long handscroll comprises fourteen portraits of one of the most learned and powerful Daoist figures of the Yuan dynasty. A native of the southern province Jiangxi, the Mecca of Daoism in China, Wu Quanjie was born in 1269, only a few years before the fall of the Southern Song dynasty, and died in 1346, two decades before the collapse of the Mongol empire. In 1321, he succeeded his teacher, the High Priest Zhang Liusun (1248–1321), as the new Grand Teacher of Daoism. He played a highly influential role at the Mongol court, where he was known as a poet and calligrapher.[2] More importantly, Wu Quanjie was a powerful politician among the Confucian scholars who were recruited on his recommendation by such Mongol emperors as Renzong and Wenzong to help in the administration of China.[3]

These fourteen portraits were created to commemorate Wu Quanjie's lifelong achievements in a chronological sequence. The first was completed in 1311 at the age of forty-three and the last in 1331 when Wu was sixty-three years old. Each portrait is preceded by a dated inscription written by a known scholar, which highlights Wu's particular contribution. Thus the Boston scroll documents twenty years in the career of this remarkable Chinese Daoist priest who earned himself the unfailing trust of Mongol rulers who were generally suspicious of the native Chinese and discriminated against them.

The Boston scroll has been attributed to a Yuan portrait artist named Chen Zhitian. According to Xu Youren (1287–1364), the artist's father Chen Jianru (act. early fourteenth century) was also a leading portraitist.[4] For thirty years Chen Zhitian lived in the Yuan capital, where he was a popular professional painter. During the reigns of Emperors Renzong and Wenzong, he was favored by the Mongol court and held a position there.

The Boston scroll derives from a series of at least three scrolls copied by Chen Zhitian. In 1330, Yu Ji (1272–1348), a Confucian scholar and close friend of Wu Quanjie, hired Chen Zhitian to make a composite handscroll copy after nine individual portraits of Wu Quanjie at various Daoist monasteries. In 1337, Yu Ji commissioned a second handscroll, this one with fifteen portraits of Wu by Chen Zhitian. Both times Yu Ji copied all the original inscriptions onto the new handscrolls. Yu Ji recorded that when Wu Quanjie saw the two previously copied handscrolls, he hoped a third one could be made to include all the above portraits plus a portrait of the Mongolian Emperor Shundi (r. 1333–68). He also hoped that Yu Ji would again copy all the inscriptions onto the third handscroll, but only a preface for the third handscroll was received. This last preface, together with the others, were rewritten by Wu Hao (act. mid-fourteenth century), the grandson of Wu Quanjie in the year 1344.[5]

The Boston version is obviously derived from the whole series of handscrolls by Chen Zhitian. All were of different lengths, consisted of varied contents and, naturally, embodied different artistic qualities. Since the Boston scroll is unrecorded, we can only date it based on stylistic analysis and other supporting evidence. The eighth portrait shows Wu Quanjie seated on a rock under a pine tree, playing a *qin,* while two cranes dance before him. The landscape elements here would support a date in the second half of the fourteenth century as the type of pine tree and the rock shape are familiar elements in other contemporary works. So, too, are the shapes of the *qin* and the wooden *qin* table. The influence of the literati painters Zhao Mengfu and Gao Kegong is evident in these landscapes, while there are also some traces of the Li–Guo tradition as it was represented in the Yuan period. The brushwork quality of the Boston painting is distinctly rough and bold, closer to some Yuan landscape paintings by professional painters that were recently discovered in a Ming tomb.[6]

1. See *Eight Dynasties,* cat. 18.
2. His poem and calligraphy appear in Chen Rong's handscroll, *Nine Dragons* (cat. 92).
3. See Sun Kekuan, p. 156.
4. A portrait of a Korean ambassador to the Mongol court painted by Chen's father (National Museum, Seoul) sheds light on the younger Chen's portrait style. See Ahn Hwi-joon, pl. 20, p. 28.
5. The whole episode was recorded by Zhu Cunli, vol. 3, p. 288.
6. See *Huaian Mingmu chutu shuhua,* pls. 1 and 21; and Cahill, "Xieyi in the Zhe School?"

150

Anonymous
Landscape in Blue-and-Green Style

Yuan dynasty, early 14th century
Round fan mounted as album leaf; ink and color on silk
24.4 x 226 cm
Denman Waldo Ross Collection 17.735

During the Yuan dynasty, Chinese literati painters like Zhao Mengfu and Qian Xuan developed a deliberately archaistic painting style that juxtaposed two disparate techniques: ink monochrome and the application of blue and green mineral colors. This style represents another example of *fu gu* in Chinese art. The blue-and-green style flourished during the Tang dynasty when artists used lapis lazuli and malachite to decorate paintings, especially landscapes. When Yuan literati revived this older style, the colors served more than simply a decorative purpose. They conveyed a sense of antiquity and highlighted or accentuated the landscape, as exemplified by Qian Xuan's *Dwelling in the Mountains* (Beijing Palace Museum).[1]

In this previously unpublished round fan, the rolling hills are covered by a rich mineral green with additional texturing and dotting in ink. The distant mountains, even more extensively than the green hills beyond, display different tonalities of black ink for both trees and buildings. Perhaps these motifs were meant to have the same visual effect as the calligraphy in Qian Xuan's painting.

1. See *ZMQ: huihuabian* vol. 5, pl. 4, p. 8. Two other outstanding examples of this stylistic revival are Qian Xuan's *Returning Home* and *Wang Xizhi Watching Geese,* both in the Metropolitan Museum of Art, New York. See Fong, *BR,* pls. 70 and 71.

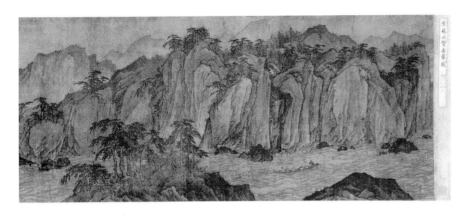

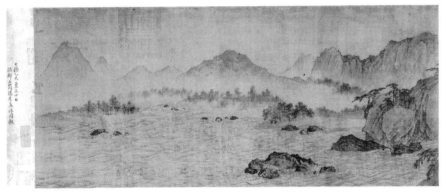

151

Anonymous (formerly attributed to Yang Shixian, act. ca. 1120–60)
The Red Cliff

Yuan dynasty or later, 14th century (?)
Handscroll; ink and light color on silk
30.9 x 128.8 cm
Keith McLeod Fund 59.960

The painting is based upon a renowned prose poem by the leading Northern Song poet Su Shi, *Qian Chibifu* (The First Prose Poem of the Red Cliff), a literary masterpiece that inspired many painters to illustrate its imagery and philosophical meanings. The subject matter is known to have been illustrated by such Song and Jin artists as Ma Hezhi, Li Song, Qiao Zhongchang (act. first half of the twelfth century), and Wu Yuanzhi.

The present scroll depicts the poet Su Shi and his friends boating on an autumn day in 1082 at the foot of the Red Cliff, which was famous as the site of a purported third-century battle of the powerful armies of Cao Cao (155–220) against the allied forces of Sun Quan (r. 222–52) and Liu Bei (r. 221–23). Amidst a dramatic, panoramic view of lofty cliffs and swiftly moving river, the painter has set the great poet and his musician friends

together in a small boat. With the rolling waters and massive, immobile mountains, the painter suggests the prose poem's profoundly Daoist themes: change and permanence, the limitations and contingencies of the human condition, and the infinite world of nature with its ever-changing play of appearances. The fragile order of human existence is represented by the seemingly insignificant boat and its figures carried along by the indomitable tides of the river. The tightly constructed cliffs provide a lofty, unsentimental backdrop for the leaflike boat and its transient figures. The texturing ax-cut strokes used for the cliff's surface reinforce its contrast with the curvilinear definition of the flowing water. Su Shi's boat is shown floating in the same direction as the handscroll unrolls—from right to left. In the first half the space of the painting is dominated by mountains on the right, while the rivers take over the rest of the composition. In the middle of the picture, between the mountains and water, a flatland with pine trees is depicted simply.

The direct style and stiff structure of the cliffs seem, at first glance, indebted to the works by Li Tang, especially *Mountains by the River* (National Palace Museum, Taipei). However, the kind of articulation and unity shown in that painting is not evident in the Boston handscroll, where the rougher, flatter modeling of the cliff,

water, and trees dominates the composition. Unlike Southern Song artists, the Boston painter pays little attention to the quality of his brushwork. Rather, it is the presentation of the forms and the play between light and dark that preoccupied him. The Boston scroll also differs from standard landscapes attributed to Jin-dynasty painters such as the Freer Gallery's *Wind and Snow in the Firpines* by Li Shan, and Wu Yuanzhi's *Red Cliff* (National Palace Museum, Taipei). Compared with these two Jin-dynasty works, the spatial arrangement in the Boston scroll is much shallower; the artist was less interested in creating an illusion of depth. (Whether in the forefront or in the far distance, for example, the waves are handled with the same degree of detail.) Although the Boston scroll generally follows Jin stylistic conventions, later elements are also clearly evident in the painting.

A large seal at the upper left of the composition reads "Xuanwen zhi bao" (Treasure of the Xuanwen Era), which seems to have some connection with the more famous seal of *Xuanwenge* (Xuanwenge Palace). An early Ming imperial half-seal from the late-fourteenth century is stamped horizontally at the lower right. Numerous other seals appear at either end of the scroll, but most are copies created by a forger who also faked the colophons at the end of the picture.

A signature appears on the rock near the beginning of the scroll. Of the four characters only the surname *Yang* and the last character *bi* (painted by) can be recognized. Judging from its writing style and ink tone, the signature appears to be a later addition.

Buddha when he preached to 1,250 disciples at a place called White Egret Pond. In Chinese Buddhism, the sūtra is also called *Bailuchi jing* (White Egret Pond Sūtra).

This painting is one of only a few such examples in Western collections. It is a more complex and earlier composition than the pair in the Metropolitan Museum of Art, New York. The major motifs of egrets and lotus blossoms are meticulously described with fine line drawing and rich, gradated coloring to provide immediate visual impact. The background displays other motifs with more subtlety, including hummingbirds and a variety of water vegetation that draw the viewer in and enhance the overall composition. The Boston scroll has no artist's signature. An as yet unidentified seal appears in the lower-left corner. Judging from its placement, it is most likely a collector's seal.

152

Anonymous
White Egrets and Red Lotus Blossoms

Yuan dynasty, late 13th–early 14th century
Hanging scroll mounted as a panel; ink and color on silk
154.2 x 65.6 cm
Gift of Mrs. Richard E. Danielson 48.1273

Within the Chinese bird-and-flower (*hua niao hua*) genre is a group of Song and Yuan works depicting white egrets and red and/or white lotus blossoms. These paintings have always been associated with Buddhism, and most are preserved in Japanese temples and collections. White and red lotus blossoms are associated with ideas of purity, beauty, and rebirth as well as with the Pure Land sect or Wonderful Law of Chinese Buddhism. The religious significance of white egrets is linked to the Mahāprajñāpāramitā sūtra, which describes the sixteenth gathering of the

153

Wei Jiuding (act. ca. 1350–70)
River Crab

Yuan dynasty, early 14th century
Album leaf mounted as a hanging scroll; ink on silk
23.5 x 31.7 cm
Keith McLeod Fund and Asiatic Curator's Fund 1996.244

Wei Jiuding is first recorded in Xia Wenyan's 1365 publication *Tuhui baojian* (Precious Mirror of Paintings), where he is cited simply as having specialized in *jiehua*, detailed painting of architecture, following the style of the early Yuan master Wang Zhenpeng (see cat. 113–14). However, neither of the only other surviving works by this artist—an ink landscape album leaf and a figure-painting hanging scroll[1]—display such a talent. The ink landscape is typical of the late-Yuan literati style, and the figure painting, *The Nymph of the Luo River,* is executed in the *baimiao* ink-drawing manner. The Museum's painting, a crab delicately depicted in ink in the *xiesheng* (life study) tradition, is a work in a genre not previously associated with this artist. It shows Wei Jiuding's much broader interest and ability in rendering a greater diversity of subjects than was reported by his contemporaries.

This crab painting is not signed, but it bears a seal at the upper right that reads "Wei Mingxuan shi" (Mingxuan is the *zi*-name of Wei Jiuding). This is significant because the painter was better known to his literati friends in the late Yuan period as Wei Mingxuan. For instance, the above-mentioned figure painting in Taipei's National Palace Museum, though neither signed nor bearing Wei's seals, is identified as being by Wei Mingxuan in the 1368 colophon written on the painting by the renowned literati painter Ni Zan (1301–74). The name Wei Mingxuan is also mentioned repeatedly by many poets of the time. Wei's friendship with many leading artists along with master Ni Zan's praise for Wei's figure painting—in which he addresses Wei as "mountain man" (*shanren*)—suggest that Wei Jiuding, too, was an accomplished literatus who excelled in painting, calligraphy, and literature.[2]

For the present composition, the painter has centered the lively creature

against an empty background in keeping with the *xiesheng* tradition of depicting birds, fish, and insects that had continued since the tenth century. Crabs also frequently provided a subject for Chinese poets and artists, who considered the crab's culinary delicacy as well as its association with the arrival of autumn.

A realistically articulated crab like Wei Jiuding's, with its delicate but precise brushwork and exquisite handling of shape and light-dark shading, is quite rare in early Chinese painting. The painter has successfully conveyed the crab's movement through the slightly asymmetrical arrangement of its eight side-legs as well as its different positioning of the two front claws, with the right one raised high and the other folded. The viewer is thus inspired to imagine a crab moving ever so slowly in a vast playground. Here, Wei Jiuding's attention to the details and animation of his subject reminds us of a style close to the Southern Song period, when artists and poets delighted in the presentation of this motif.

Not only did Emperor Huizong, who was a tea master as well as an aritst, classify images of crabs as a subgenre of fish paintings in his imperial catalogue of paintings, but in another of his publications, *Daguan cha lun* (Tea Study in the Daguan Era, 1107–1110), he coined the term *xie yan* (crab's eye) to describe vividly the very moment at which water just reaches the boiling point (i.e., when it shows bubbles in the shape of crab's eyes). Sketchy, semiabstract crab paintings in the

xieyi (literally, painting the idea) style became more popular in the Ming and Qing dynasties and maintained their appeal into modern times, when painters like Qi Baishi (1863–1957) became well known for such *xieyi,* rather than *xiesheng,* crabs.

1. The former was in Emperor Qianlong's collection, but its present location is unknown. The latter is in the collection of the National Palace Museum, Taipei.
2. The formal name, however, was used by Wei Jiuding himself when he wrote a lengthy colophon on a river-scape by his long-time friend, the painter Sheng Mou (act. 1310–60), now in Taipei's National Palace Museum. Wei's 1361 colophon reveals that he was also a friend of another influential literati master, Wang Meng (1308–85).

Glossary

This glossary defines for the Western reader the principal Chinese terms used in the entries as well as the major schools, styles, and traditions discussed in the catalogue. Readers should also consult "Techniques, Materials, and Formats," in "The Lure of Antiquity," the catalogue essay, for illustrations and more detailed discussion.

In general, specialized terms, whether Chinese or English, are grouped together under a common heading. For example, both "*xing su*" and "semi-cursive" style will be found under the primary heading "calligraphy."

academy, painting. *See* **huayuan.**

antiquity.

fu gu (return to antiquity): Confucian ideal of reverence for the past. Its broad influence on Chinese society and culture is seen in philosophy—where it took the form of emulating ancient sages and rulers as models for moral behavior—and in painting, where it informed practice of copying ancient paintings to capture animate quality, or "spirit," of old masterworks.

gu (ancient): reference to antiquity in both historical and mythological senses.

gu dai (ancient dynasties): "Golden Ages" of China's past, which were idealized as eras of social harmony and enlightened rule.

gu hua: ancient or classical paintings.

guyi (ancient aesthetic): spirit of antiquity.

blue-and-green landscape. *See* **qinglu shanshui.**

brushwork.
Traditional Chinese connoisseurship emphasized brushwork as the key to evaluation of quality and authenticity in painting and calligraphy. Chinese painters developed a wide variety of brushwork styles and techniques, many derived from calligraphy and some from the influence of Central Asian Buddhist art. The basic categories include:

baimiao (ink line drawing): motifs defined solely by line drawing.

ca (shading; modeling): brushwork that relies on use of the side of the brush; displays little or no calligraphic movement.

cun (texturing): calligraphic brushwork used for forming landscape motifs.

dian (highlighting and dotting): short vertical or horizontal strokes, or different types of dotting, used to accent certain painted areas. Used since the Five Dynasties, mainly in landscape.

dunbi (blunt brush): effect created by slow, restrained (rather than expressive) brush movement.

fupi cun (ax-cut strokes): sharp, angular brushstroke technique used for depicting rocks and mountains; applied by pressing side of a brush tip forcefully against painting surface. Originated by the landscapist Li Tang.

mogu (boneless style): derived from Central Asian painting styles; used for motifs executed in color without "bone," or ink, as it is commonly referred to by Chinese painters.

gou (outlining): brushwork used to define the contour of motifs including figures.

pima cun (hempstrokes): thick-line drawing technique that uses both long and short strokes to define rock or mountain surfaces. Originated by Five Dynasties master Dong Yuan; popular among literati painters.

jiehua (ruler-aided painting): used for depiction of architectural structures and motifs.

ran (washing): used to create soft definition of distant mountains or to enhance both painted areas and unpainted space (e.g. sky and water).

shuanggou (outlined in ink): used for depicting flowers and vegetation (e.g. outlining leaves in a bamboo painting).

tiexian miao (iron-wire style drawing): even-width line-drawing technique used in figure painting.

yudian cun (raindrop texturing): technique used to texture surface of, and build volume in, mountains and rocks by repeatedly touching brush tip against painting surface. Originated by eleventh-century landscapist Fan Kuan.

calligraphy.

The general term for ancient Chinese system of writing. The affinity between calligraphy and painting in China was so natural that traditional connoisseurs frequently referred to painting as *xie* (something written). Primary stylistic categories include:

cao shu (cursive script): reached its height in the Tang Dynasty and was later adapted by Chan Buddhist and Song and Yuan literati. Characterized by its spontaneous, expressive quality in ink painting.

kai shu (regular script) and *xing su* (semi-cursive script): mainstream calligraphy styles from fourth century onward. Their symmetrical structure and highly disciplined brush movement strongly influenced landscape styles of such Song-era masters as Fan Kuan, Guo Xi, and Li Tang.

li shu (clerical script): emerged in late Western Han dynasty. Its modulated, expressive brushstrokes influenced native Chinese figure-painting styles (see cat. 1).

shoujin shu (slender gold style): perhaps the most personalized calligraphic technique and style. Created by the Northern Song Emperor Huizong and adapted by his court artists for their figure painting.

zhuan shu (seal script): earliest form of calligraphy. Its even-width, curvilinear line dominated pre-Han figure painting.

colophons.

Written texts added to paintings and calligraphy by connoisseurs and collectors, or by artists other than the creator of the work. Their content may include anecdotes about the artist, the work, its history, analytical comments about style or quality; and poems or other encomia.

fengsu hua (genre painting).

Appeared much earlier in China than in the West. By ninth century, Chinese connoisseurs included narrative works, the *hua niao hua* (bird-and-flower paintings), and images of such subjects as crabs, insects, fish, fruits, and scenes of daily life as subcategories of genre painting. Landscape art was generally classified as a distinct category independent of genre painting.

formats.

Early Chinese paintings, whether on silk or paper, fall into one of three basic formats:

handscroll: highly portable, horizontal format that appeared earliest and allowed for cinematic presentation in both narrative and landscape passages.

hanging scroll: developed, along with vertical screen, when Near Eastern–style seating came to China during Tang dynasty. The consequent need to decorate higher interior wall space contributed to emergence of this often large-scale format; later used for monumental landscapes of Northern Song.

album leaf: appears both in circular or square/rectangular shapes. Latter generally used to decorate a piece of furniture or architectural space. Subsequently, collectors remounted them onto album-sized leaves for preservation. Round-form album leaves originally served as sides of circular fans. In fourteenth century, Chinese produced folding fans based on Japanese and Korean prototypes.

genre painting. *See* fengsu hua.

huayuan (painting academy).

Although imperial patronage of artists began at least as early as Western Han, it was Emperor Huizong who organized most rigorous academy structure for the arts. The tradition continued in various guises into the Qing dynasty.

inscription.

Text written by an artist to accompany his or her painting or piece of calligraphy.

landscape. *See* shanshui and qinglu shanshui.

Li-Guo school.

Tradition derived from landscape styles of the early Northern Song painters Li Cheng and his follower Guo Xi. Original works by these masters are exceedingly rare, but their influence was far-reaching. Works by their followers are typified by curvilinear compositions with distinctive, animated depictions of tree and rock motifs.

Ma-Xia school. Dominant style of Southern Song academy painting; developed by Ma Yuan and Xia Gui. Characterized by asymmetrical, one-corner compositions with angular-shaped motifs. It borrowed techniques from northern landscape traditions and applied them to the scenery of southern China.

names. Last, or family, names of native Chinese are always cited first. Chinese artists and literati used multiple nomenclature to identify themselves in their signatures and writings. A *hao*-name is the "artist" name; a *zi*-name is an alias used for less formal occasions.

Ningbo school. Ningbo, the main trade port of Southern Song dynasty, became the leading center for workshops of professional artists who specialized in depicting religious (primarily Buddhist) subject matter. Ningbo-school works were more appreciated and better preserved in Japan than in China.

painting academy. *See* **huayuan.**

perspective.
Chinese artists developed techniques of spatial representation quite distinct from geometrical and scientific systems of perspective of Western artists during the Renaissance. Chinese favored more atmospheric and moveable perspective, which better suited their metaphysical notions of landscape and nature. They recognized two main types:

gao yuan (high-distance view): incorporates aerial, or bird's-eye, view of landscape, but with shifting perspective that progresses up from ground to middle to high levels.

ping yuan (level-distance view): receding spatial arrangements in landscape viewed from ground-level perspective.

qinglu shanshui **(blue-and-green landscape).** Landscape style characterized by application of mineral green and blue colors with occasional use of gold. Inspired by early Central Asian prototypes; became popular in Tang dynasty and then reemerged in works of Song, Yuan, and later painters.

religious painting. Comprises native-Chinese artistic traditions derived from shamanism and Daoism as well as art influenced by foreign traditions of Buddhism. Buddhist art revolutionized native-Chinese figure-painting styles, but these were quickly sinicized, as is evident in Chinese representations of Lohans and the bodhisattva Guanyin. Daoist art would also borrow from Buddhist aesthetic traditions.

sanjue **(Three Perfections).** The arts of calligraphy, poetry, and painting. During reign of Emperor Huizong, himself an esteemed artist, the Three Perfections were often combined to become a single art form, an aesthetic synthesis that is one of China's singular contributions to the world history of art.

shanshui **(landscape art).** Chinese term for landscape painting; comprised of the characters *shan* (mountain) and *shui* (water).

stūpa. In Indian Buddhist architecture, a sacred structure containing remains of monks and holy persons. It was the prototype for Chinese pagodas.

sūtra. Any sacred Buddhist text. In India, sūtras were originally written on tree leaves. When Chinese translated original Buddhist scriptures, they developed a particular form and technique of calligraphy that called for specially made brushes and paper. Later, these were widely adopted in Japan and Korea.

xiesheng **(life study).** Painting tradition characterized by accurate, naturalistic description of motifs.

xieyi **(idea painting).** A more conceptual painting style, using a looser, more expressive brush technique than *xiesheng;* originated by such Northern Song literati as Su Shi and Mi Fu; became dominant aesthetic of Yuan literati.

wenren **(man of letters).** Term used for any educated person.

Xuanhe huapu **(imperial painting catalogue).** The most comprehensive catalogue of early Chinese painting. Compiled during reign of Emperor Huizong.

yushu. Any form of imperial writing.

Selected Bibliography

Abbreviations of frequently cited works

Cahill, *Index*
Cahill, James F. *An Index of Early Chinese Painters and Paintings: T'ang, Sung, and Yüan.* Berkeley: University of California Press, 1980.

Eight Dynasties
Eight Dynasties of Chinese Painting: The Collections of the Nelson-Atkins Museum, Kansas City, and the Cleveland Museum of Art. Cleveland: Cleveland Museum of Art, 1980.

Fenollosa
Fenollosa, Ernest F. *A Special Exhibition of Ancient Chinese Buddhist Paintings, Lent by the Temple Daitokuji, of Kioto, Japan.* Boston: Alfred Mudge & Son, 1894.

Fong, *BR*
Fong, Wen C. *Beyond Representation: Chinese Painting and Calligraphy 8th–14th Century.* New York: Metropolitan Museum of Art, 1992.

Lawton, *CFP*
Lawton, Thomas. *Freer Gallery of Art Fiftieth-Anniversary Exhibition II: Chinese Figure Painting.* Washington, D.C.: Smithsonian Institution, 1973.

Portfolio
Tomita, Kōjirō. *Museum of Fine Arts, Boston: Portfolio of Chinese Paintings in the Museum (Han to Sung Periods).* Cambridge: Harvard University Press, 1933.

Suzuki, *CICCP*
Suzuki, Kei, comp. *Comprehensive Illustrated Catalog of Chinese Paintings.* 5 vols. Tokyo: University of Tokyo Press, 1983.

WH
Wang Shizhen. *Wangshi huayuan.* (Reprint ed.) Shanghai: Taidong shuju, 1922.

Yu Anlan, *HC*
Yu Anlan, ed. *Huashi congshu.* Shanghai: Renmin meishu chubanshe, 1963.

ZMQ
Zhongguo meishu quanji: huihuabian. 21 vols. Beijing: Wenwu chubanshe, 1986–89.

Ahn Hwi-joon. *The National Treasure of Korea,* vol. 10: *Paintings.* Tokyo: Take shobo, 1985.

Art of the Muromachi Period. Tokyo: Tokyo National Museum, 1989.

Barnhardt, Richard. *Painters of the Great Ming: The Imperial Court and the Zhe School.* Dallas: Dallas Museum of Art, 1993.

———. *Wintry Trees, Old Forests: Some Landscape Themes in Chinese Painting.* New York: China Institute in America, 1972.

———. "Yao Yen-ch'ing, T'ing-mei, of Wu-hsing." *Artibus Asiae* XXXIX, no. 2 (1977), pp. 105–23.

Baxandall, Michael. *Painting and Experience in Fifteenth-Century Italy.* Oxford: Oxford University Press, 1988.

Brinker, Helmut. "Ch'an Portraits in a Landscape." *Archives of Asian Art* XXVII (1973–74), pp. 8–29.

Bussagli, Mario. *Painting of Central Asia.* Geneva: Skira, 1963.

Cahill, James F. *The Art of Southern Sung China.* New York: Asia House, 1962.

———. *Chinese Painting.* Geneva: Skira, 1972.

———. *Hills Beyond a River: Chinese Painting of the Yüan Dynasty, 1279–1368.* New York: Weatherhill, 1976.

———. *The Painter's Practice: How Artists Lived and Worked in Traditional China.* New York: Columbia University Press, 1994.

———. "Xieyi in the Zhe School? Some Thoughts on the Huaian Tomb Paintings." *Bulletin of the Shanghai Museum,* vol. 6 (1992), pp. 1–23.

Chen Gaohua. *Song Liao Jin huajia shiliao.* Beijing: Wenwu chubanshe, 1984.

———. *Yuandai huajia shiliao.* Shanghai: Renmin meishu chubanshe, 1980.

Chen, K. S. *Buddhism in China: A Historical Survey.* Princeton: Princeton University Press, 1964.

Chinese Art Treasures. Geneva: Skira, 1961.

Chuandeng lu in Mingfu. Zhongguo foxue renming cidian. Taipei: Fangzhou chubanshe, 1974.

Dafengtang cang Zhao Wenmin Jiuge shuhuace. Kyoto: Benrido, n.d.

Deng Bai. *Zhao Ji.* Shanghai: Renmin meishu chubanshe, 1985.

Ding Fubao. *Foxue dacidian.* (Reprint ed.) Beijing: Wenwu chubanshe, 1984.

Ebine Toshirō. "The Home of Ningbo Buddhist Paintings." *Kokka,* vol. 1097 (October 1986), pp. 60–66.

Ecke, Tseng Yu-ho. *Chinese Calligraphy.* Philadelphia: Philadelphia Museum of Art, 1971.

Edwards, Richard. *Li Di.* Freer Gallery of Art Occasional Papers, vol. 3, no. 3. Washington, D.C.: Smithsonian Institution, 1967.

———. "Mou I's Colophon to His Pictorial Interpretation of 'Beating the Clothes.'" *Archives of the Chinese Art Society of America* XVIII (1964), pp. 7–12.

———. *The World Around the Chinese Artist.* Ann Arbor: University of Michigan, 1987.

Exhibition of Japanese Paintings from the Collection of the Museum of Fine Arts, Boston. Tokyo: Nippon Television Network, 1983.

Fong, Wen C. *The Lohans and a Bridge to Heaven.* Freer Gallery of Art Occasional Papers, vol. 3, no. 1. Washington, D.C.: Smithsonian Institution, 1958.

Fontein, Jan, and Money L. Hickman. *Zen Painting and Calligraphy: An Exhibition of Works of Art Lent by Temples, Private Collectors, and Public and Private Museums in Japan.* Boston: Museum of Fine Arts, 1970.

Fontein, Jan, and WU Tung. *Han and T'ang Murals.* Boston: Museum of Fine Arts, 1976.

———. *Unearthing China's Past.* Boston: Museum of Fine Arts, 1973.

Gombrich, E. H. "The Style all'antica: Imitation and Assimilation." In *Gombrich on the Renaissance,* vol. 1: *Norm and Form.* London: Phaidon, 1985.

Gugong shuhua tulu. vols 1–4. Taipei: National Palace Museum, 1989–90.

Hawkes, David. *Songs of the South.* Harmondsworth, Eng.: Penguin, 1985.

Hopkirk, Peter. *Foreign Devils along the Silk Road.* Amherst: University of Massachusetts Press, 1984.

Huaian Mingmu chutu shuhua. Beijing: Wenwu chubanshe, 1988.

Huang Miaozi, ed., *Zhongguo meishu lunzhu congkan.* Beijing: Renmin meishu chubanshe, 1963.

Ide Seinosuke. "On Lu Xinzhong: Historical Changes in Nirvana Paintings." *Bijutsu Kenkyu,* no. 354 (Jan. 1993), p. 89.

Illustrated Catalogue of Selected Works of Ancient Chinese Painting and Calligraphy. Beijing: Wenwu chubanshe, 1986–

Jin Weinuo. "Tang Dynasty Flower-and-Bird Painting." In *Flowers and Birds Motif in Asia.* Kyoto: Society for International Exchange of Art Historical Studies, 1982.

Kries, E. *Legend, Myth, and Magic in the Image of the Artist.* New Haven: Yale University Press, 1981.

Lao-tzu. *Tao Te Ching.* D.C. Lau, trans. and ed. Everyman Classics. 1994.

Lee, Rensselaer E. *Ut Pictura Poesis: The Humanistic Theory of Painting.* New York: Norton, 1963.

Lee, Sherman E., and Wai-kam Ho. *Chinese Art under the Mongols: The Yüan Dynasty (1279–1368).* Cleveland: Cleveland Museum of Art, 1968.

Li Chu-tsing. "The Freer Sheep and Goat and Chao Meng-fu's Horse Painting." *Artibus Asiae* 30, no. 4 (1968), pp. 279–326.

Liangsong minghuace. Beijing: Wenwu chubanshe, 1963.

Lin Boting, ed. *A Special Exhibition of Horse Paintings.* Taipei: National Palace Museum, 1990.

Lindholm, Josef III. "Lories May Be Hazardous...," in *A. F. A Watchbird,* vol. XXII, no. 5 (Sept./Oct. 1995), pp. 22–27.

Liu Daochun. *Shengchao minghua ping* (ca. 1057). In Yu Jianhua, *Zhongguo hualun leibian.* Hong Kong, 1973.

Lodge, John E., "Ch'en Jung's Picture of Nine Dragons." *Bulletin of the Museum of Fine Arts, Boston* XV (Dec. 1917), p. 68.

Loehr, Max. *The Great Painters of China.* New York: Harper & Row, 1980.

Masterpieces of Chinese Album Painting in the National Palace Museum. Taipei: National Palace Museum, 1971.

Masterpieces of Chinese Figure Painting in the National Palace Museum. Taipei: National Palace Museum, 1973.

Masterpieces of Chinese Painting in the National Palace Museum. Taipei: National Palace Museum, 1971.

Merton, Thomas. *The Way of Chuang Tzu.* New York: New Directions, 1969.

Midian zhulin shiqu baoji sanbian. Taipei: National Palace Museum, 1969.

Midian zhulin shiqu baoji xubian. Taipei: National Palace Museum, 1971.

Mingfu (priest). *Zhongguo foxue renming cidian.* Taipei: Fangzhou Press, 1974.

Munakata, Kiyohiko. *Sacred Mountains in Chinese Art.* Exhib. cat. Urbana: University of Illinois; Chicago: Krannert Art Museum, 1991.

Nakata, Yujiro, and Shen Fu, eds. *Masterpieces of Chinese Calligraphy in American and European Collections.* 6 vols. Tokyo: Chuokoronsha, 1981–83.

Nanchao Tang Wudai ren huaxue lunzhu. Taipei: Shijie shuju, 1962.

National Palace Museum Monthly of Chinese Art, no. 147 (June 1995). Taipei: National Palace Museum.

Noami. *Kundaikan Sōchōki.* In *Gunsho ruiju,* vol. 12.

Owen, Stephen, ed. and trans. *An Anthology of Chinese Literature.* New York: Norton, 1996.

Panofsky, Erwin. *Renaissance and Renascences in Western Art.* Stockholm: Almqvist & Wiksell, 1960.

Rorex, Robert A., and Wen C. Fong. *Eighteen Songs of a Nomad Flute: The Story of Lady Wen-chi: A Fourteenth-Century Handscroll in the Metropolitan Museum of Art.* New York: Metropolitan Museum of Art, 1974.

Rosenfield, John, and S. Shimada. *Traditions of Japanese Art.* Cambridge: Harvard University Press, 1970.

Selected Masterpieces of Asian Art. Boston: Museum of Fine Arts; Tokyo: Japan Broadcast Publishing Co., 1992.

Shanhai hakubutsukan. Tokyo: Kodansha, 1983.

Sickman, Laurence, and Alexander Soper. *The Art and Architecture of China.* 3d ed. New Haven: Yale University Press, 1968.

Siren, Osvald. *Chinese Painting: Leading Masters and Principles.* 7 vols. London: Lund Humphries, 1956.

Smith, Bradley, and Wan-go Weng. *China: A History in Art.* New York: Harper and Row, 1973.

Song Ma Yuan shui tu. Beijing: Wenwu chubanshe, 1958.

Soper, Alexander, C. *Kuo Jo-hsü's Experiences in Painting.* Washington, D.C.: American Council of Learned Societies, 1951.

———. "The Relationship of Early Chinese Painting to Its Own Past," in Christian G. Murck, ed., *Artists and Traditions: Uses of the Past in Chinese Culture.* Princeton: Princeton University Press, 1976.

Sun Kekuan. *Yuandai Daojiao zhi fazhan.* Taichung: Tung Hai University, 1968.

Suzuki, Kei. *Meidai egashi kenkyu.* Tokyo: Tokyo University, 1968.

Tang Hou. *Huajian.* In *Meishu congshu,* vol. 85. (Reprint ed.) Shanghai: Shenzhou guoguangshe, 1928–36.

———. *Huajian.* Beijing: Renmin meishu chubanshe, 1959.

Three Hundred Masterpieces of Chinese Painting in the Palace Museum. Taichung: National Palace Museum and National Central Museum, 1959.

Tomita, Kōjirō. "A Dated Buddhist Painting from Tun-huang." *Bulletin of the Museum of Fine Arts, Boston,* vol. 25, no. 152 (Dec. 1927), pp. 87–89.

Tomita, Kōjirō, and A. Kaiming Chiu. "Scroll of Six Odes from Mao Shih." *Bulletin of the Museum of Fine Arts, Boston.* vol 50, no. 280 (Oct. 1952), pp. 41–49.

Tomita, Kōjirō, and Tseng Hsien-chi. *Portfolio of Chinese Paintings in the Museum (Yüan to Ch'ing Periods).* Boston: Museum of Fine Arts, 1961.

Toso Genmin meiga taikan. Tokyo: Otsuka Kogeisha, 1930.

Tseng Hsien-chi. "A Study of the Nine Dragon Scroll." *Archives of the Chinese Society of America,* 1957, pp. 17–39.

Tuotuo, et. al., comps. *Liao shi.* Beijing: Zhonghua shuju, 1972.

Wang Jie, et. al. *Midian zhulin xubian.* (Reprint ed.) Shanghai: Tan Ouzhai, 1948.

Wang Keyu. *Shanhuwang: hualu.* Shiyuan congshu edition.

Wang Yun. *Yutang Jiahua.* In *Qiujian xiansheng daquan wenji,* juan 94–95.

Wang Yuxian. *Huishi beikao.* 17th-century ed.

Wei Zheng, et al., comps. *Sui shu.* (Preface dated 636; reprint ed.) Beijing: Zhonghua shuju, 1973.

Weidner, Marsha, ed. *Latter Days of the Law: Images of Chinese Buddhism 850–1850.* Lawrence, Kansas: Spencer Museum, University of Kansas; Honolulu: University of Hawaii Press, 1994.

Weng Keyu. *Shanhuwang: hualu.* (Preface dated 1643; reprint ed.) Shiyuan congshu edition.

Whitfield, Roderick. *The Art of Central Asia: The Stein Collection in the British Museum.* 2 vols. Tokyo: Kodansha, 1982.

WU Tung. "From Imported Nomad's Seat to Chinese Folding Armchair." *Bulletin of the Museum of Fine Arts, Boston,* vol. 71, no. 363 (1973), pp. 36–51.

———. "Zhangzong ti Tianshui mo Zhang Xuan Guoguo furen youchuntu xiaokao." *International Colloquium on Chinese Art History, 1991,* part 1, pp. 1–12; pp. 1–11 (text in Chinese). Taipei: National Palace Museum, 1992.

Xixia Wenwu. Beijing: Xinhua shudian, 1988.

Xu Bangda. *Gu shuhua wei'e kaobian.* Nanjing: Jiangsu guji chubanshe, 1984.

Xu Youren. *Zhizheng ji.* (Late-19th-century reprint).

Yang Jialuo, comp. *Nanchao Tang Wudai ren huaxue lunzhu* (Records of Painting Studies of the Southern Dynasties: Tang and Five Dynasties). Taipei: Shijie shuju, 1962.

———, ed. *Songren huaxue lunzhu.* Taipei: Shijie shuju, 1962.

Yu Jianhua, comp. *Zhongguo meishujia renming cidian.* Shanghai: Renmin meishu chubanshe, 1981.

Yuan Haowen. *Yishan xiansheng ji.* Yangquan shanzhuang ed., 1850.

Zhang Guangbin. *Yuan Sidajia.* Taipei, National Palace Museum, 1975.

Zhang Zi. *Nanhu ji,* vols. 29–30. Zhibuzuzhai congshu ed., 1872.

Zhonghua wuqiannian wenwu jikan: Song hua bian. Taipei: National Palace Museum, 1986.

Zhou Mi. *Wulin Jiushi.* In *Yingyin Wenyuange sikuquanshu.* Taipei: Shangwu yinshuguan, 1983.

Zhu Cunli. *Shanhu munan.* (Reprinted from Ming MS.) Taipei: National Central Library, 1970.

Zhu Huiliang. "Imperial Calligraphy of the Southern Song." In A. Murck and Wen C. Fong, *Words and Images: Chinese Poetry, Calligraphy and Painting,* pp. 289–312. Princeton: Princeton University Press, 1991.

———. "Nansong Huangshi Shufa." *Gugong xueshu jikan* 2, no. 4 (Summer 1985), pp. 17–52.

Zhuang Su. *Huaji buyi, juan xia.* (Reprint of 1299 ed.) Beijing: Renmin meishu chubanshe, 1963.

Appendix

Anonymous (formerly attrib. to Monk Zhiguo, ca. 607)
Buddhist Figures
Modern copy (reportedly from Dunhuang caves)
Panel; ink and color on paper
32.3 x 41.4 cm
Samuel Putnam Avery Fund 27.562

Anonymous (formerly attrib. to Li Zhaodao, act. 670–730)
The Jiucheng Palace
Ming dynasty, 16th century
Hanging scroll mounted as panel; ink and color on silk
36.5 x 30.9 cm
Denman Waldo Ross Collection 20.1830

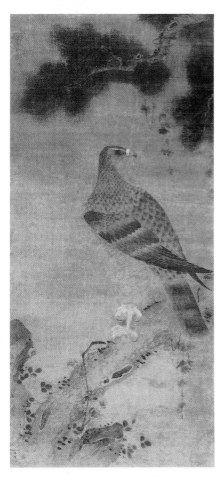

Anonymous (formerly attrib. to Jiang Jiao, early 8th century)
Eagle on a Pine Branch
Yuan dynasty, late 14th century
Hanging scroll; ink and color on silk
120.5 x 56.4 cm
Denman Waldo Ross Collection 17.785

Anonymous
Vimalakīrti
Modern copy (inscription bears date 590)
Panel; ink and color on silk
113.4 x 98.3 cm
Keith McLeod Fund 58.1003

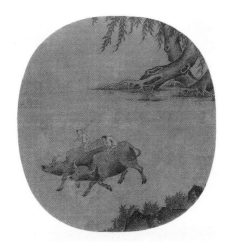

Anonymous (formerly attrib. to Dai Song, 8th century)
Buffaloes
Ming dynasty, 15th–16th century
Round fan mounted as album leaf; ink and color on silk
22.5 x 21.6 cm
Denman Waldo Ross Collection 17.739

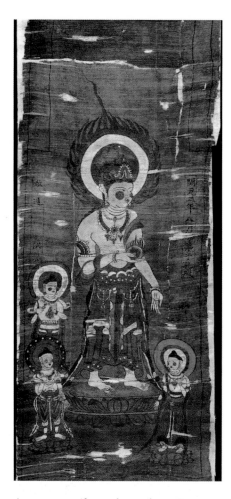

Anonymous (formerly attrib. to the monks Hongjing, Pude, Jishan, and Liaochen, ca. 797)
Three Buddhist Deities and Attendants
Modern copy (reportedly from Dunhuang caves)
Sūtra album mounted as panel; ink and color on paper
28.8 x 120.8 cm
Frederick Brown Fund 27.561

Anonymous (formerly attrib. to Kong Wei, ca. 715)
Buddhist Deities
Modern copy (reportedly from Dunhuang caves)
Banner mounted as hanging scroll; ink and color on silk
88 x 36.5 cm
John Ware Willard Fund 58.346

Anonymous
Guanyin (Avalokiteśvara)
Tang dynasty, late 9th century (reportedly from Turfan)
Banner with streamers mounted as panel; ink and color on cotton
46.5 x 18 cm
Denman Waldo Ross Collection 31.405

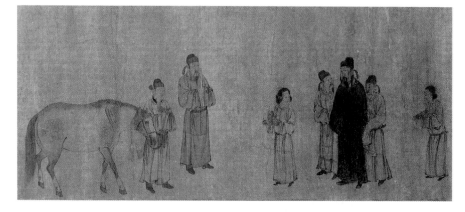

Anonymous (formerly attrib. to Wu Daozi, act. 710–60)
Emperor Minghuang Viewing Horses (detail)
Yuan dynasty, late 14th century
Handscroll; ink and light color on silk
36.8 x 332.5 cm
Denman Waldo Ross Collection 17.711

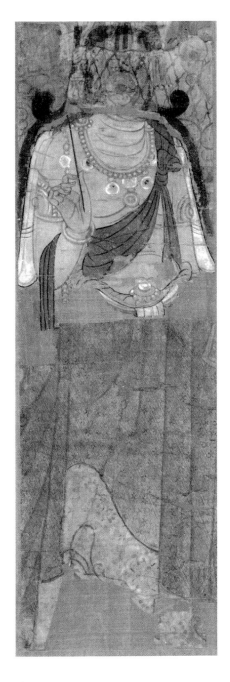

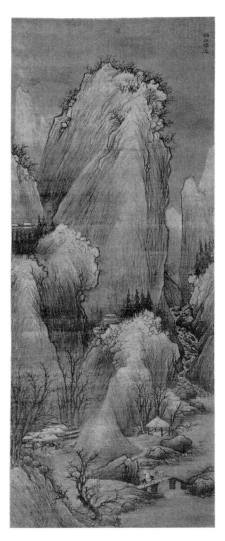

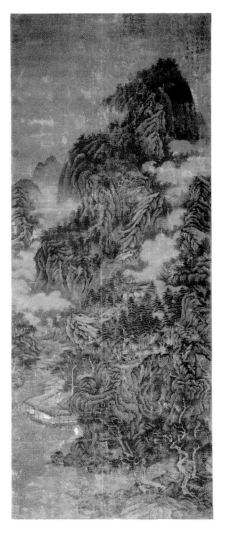

Anonymous (formerly attrib. to Li
Cheng, 919–67)
Winter Landscape
Ming dynasty, 15th century
Hanging scroll; ink and color on silk
131.5 x 54.1 cm
Anonymous Gift Res. 46.5

Anonymous (formerly attrib. to Guan
Tong, act. 10th century)
Drinking and Singing at the Foot of a Precipitous Mountain
Modern copy
Hanging scroll; ink and color on silk
218.2 x 90.2 cm
Keith McLeod Fund 57.194

Anonymous
Bodhisattva
Tang dynasty, late 9th century (reportedly from
Dunhuang caves)
Hanging scroll; ink and color on silk
43.2 x 14 cm
Chinese and Japanese Special Fund 14.48

Anonymous (formerly attrib. to Li
Gonglin, ca. 1049–1106)
White-Robed Guanyin with Sixteen Lohans
Ming dynasty, 17th century or slightly later
Round fan mounted as album leaf; ink and
color on silk
20.9 x 17.4 cm
Denman Waldo Ross Collection 17.737

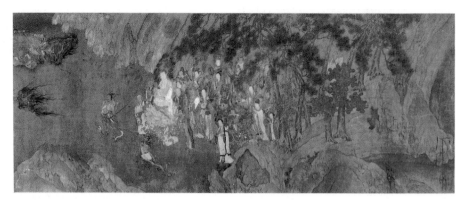

Anonymous (formerly attrib. to Li Gonglin, ca. 1049–1106)
The Conversion of Hārītī to Buddhism
Ming dynasty, 16th century
Handscroll; ink, color, and gold on silk
34.6 x 367.5 cm
Denman Waldo Ross Collection 17.710

Anonymous (formerly attrib. to Chen Yongzhi, early 11th century)
Buddha under the Mango Tree (detail)
Ming dynasty, 16th century (?)
Hanging scroll mounted as panel; ink, color, and gold on paper
210.5 x 71 cm
Keith McLeod Fund 56.256

Anonymous (formerly attrib. to Li Tang, 1060s–after 1150)
Palace in the Mountains
Ming dynasty, 15th century
Hanging scroll mounted as panel; ink and color on silk
112.2 x 52.3 cm
Gift of Mrs. Richard E. Danielson 48.1276

Anonymous (formerly attrib. to Zhao Lingrang, act. late 11th–early 12th century)
Cottage among Trees by a Lakeside
Southern Song dynasty, second half 13th century
Round fan mounted as album leaf; ink and light color on silk
24.2 x 26.4 cm
Chinese and Japanese Special Fund 14.51

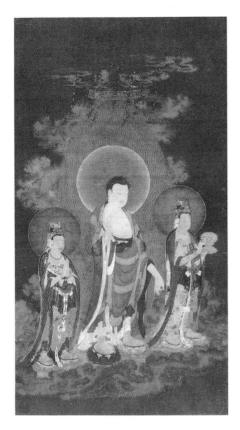

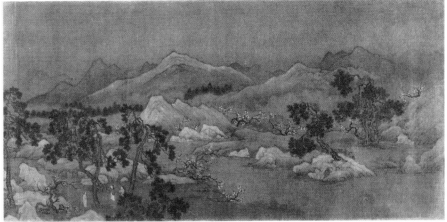

Anonymous (formerly attrib. to Zhao
Bosu, 1124–82)
Peach Blossom Spring (detail)
Ming dynasty, late 16th century
Handscroll; ink and color on silk
32.7 x 199.2 cm
Denman Waldo Ross Collection 17.709

Anonymous
Amitābha Trinity Descending on Clouds
Southern Song dynasty, 12th century
Hanging scroll mounted as panel; ink, color,
and gold on silk
97.1 x 53.8 cm
Denman Waldo Ross Collection 09.86

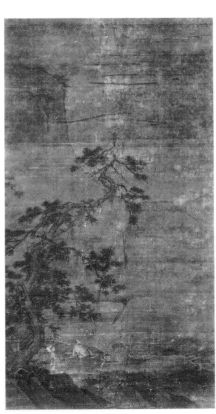

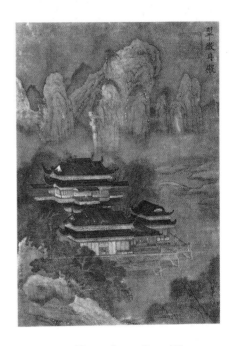

Anonymous (formerly attrib. to Liu
Songnian, ca. 1150–after 1225)
Landscape with Pine Tree
Yuan dynasty, late 14th century
Round fan mounted as album leaf; ink and
light color on silk
23.1 x 26.3 cm
Denman Waldo Ross Collection 17.731

Anonymous (traditionally attrib. to Liu
Songnian, ca. 1150–after 1225)
Scholar by Lotus Pond under a Pine Tree
Southern Song dynasty, first half 13th century
Hanging scroll; ink and light color on silk
177.3 x 96.1 cm
Chinese and Japanese Special Fund 12.885

Anonymous (formerly attrib. to Zhao
Boju, d. ca. 1162)
Palaces
Qing dynasty, 18th century
Album leaf; ink and color on silk
36.5 x 25.4 cm
Denman Waldo Ross Collection 17.728

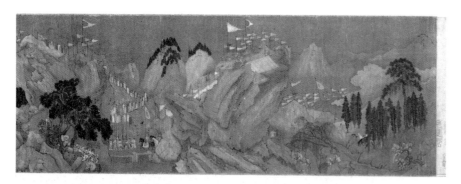

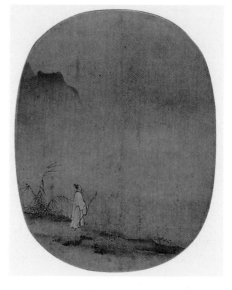

Anonymous (formerly attrib. to Zhao
Boju, d. ca. 1162)
*Entry of Emperor Gaozu of Han into
Guanzhong* (detail)
Ming dynasty, 16th century
Handscroll; ink, color, and gold on silk
29.7 x 312.8 cm
William A. Gardner Fund 31.910

Anonymous (formerly attrib. to Ma Yuan,
act. 1190–1235)
A Solitary Poet by a Lakeside
Southern Song dynasty or later, late 13th–14th
century
Oval fan mounted as panel; ink and color on
silk
24.3 x 19 cm
Charles Bain Hoyt Collection 50.1453

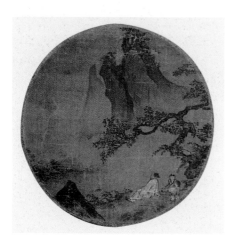

Anonymous (formerly attrib. to Ma Yuan,
act. 1190–1235)
Scholar with Attendants under a Tree
Yuan dynasty, 14th century
Round fan mounted as hanging scroll; ink and
light color on silk
Diam. 27.1 cm
Denman Waldo Ross Collection 08.61

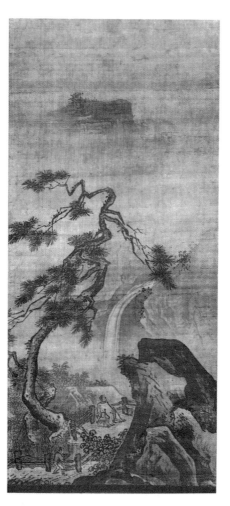

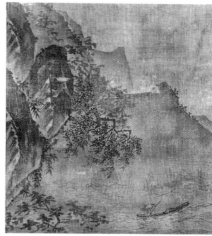

Anonymous (formerly attrib. to Ma Yuan,
act. 1190–1235)
Fisherman in Rain Storm
Korea, Chosŏn dynasty, 16th century
Hanging scroll; ink and light color on silk
22 x 19.8 cm
Charles Bain Hoyt Fund 1989.197

Anonymous (formerly attrib. to Ma Yuan,
act. 1190–1235)
Scholar Viewing a Waterfall
Ming dynasty, 15th century
Hanging scroll; ink and color on silk
94.8 x 44.2 cm
Fenollosa-Weld Collection 11.4004

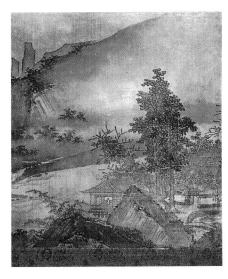

Anonymous (formerly attrib. to Ma Yuan, act. 1190–1235)
Landscape
Korea, Chosŏn dynasty, 16th century
Hanging scroll; ink and light color on silk
22 x 19.8 cm
Charles Bain Hoyt Fund 1989.198

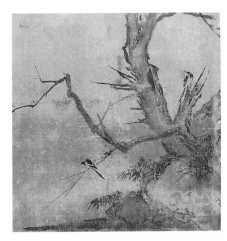

Anonymous (traditionally attrib. to Liang Kai, early 13th century)
Two Birds in a Wintry Landscape
Southern Song dynasty, second half 13th century
Album leaf; ink on silk
25.8 x 26.7 cm
Denman Waldo Ross Collection 29.962

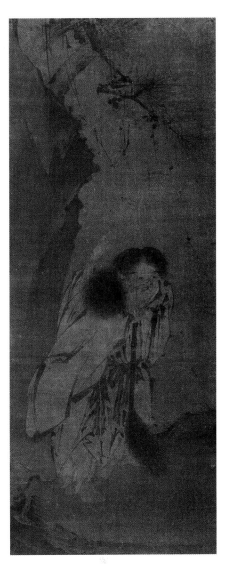

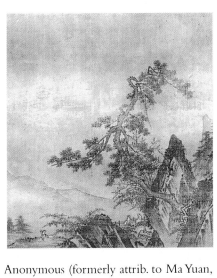

Anonymous (formerly attrib. to Ma Yuan, act. 1190–1235)
Landscape with Two Scholars under a Pine Tree
Korea, Chosŏn dynasty, 16th century
Hanging scroll; ink and light color on silk
22 x 19.8 cm
Charles Bain Hoyt Fund 1989.199

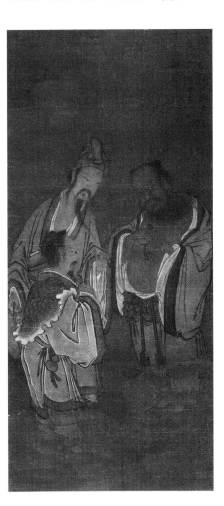

Anonymous (formerly attrib. to Liang Kai, act. early 13th century)
Monk Poets Hanshan and Shide
Yuan dynasty or Muromachi period (Japan), 14th century or later
Hanging scroll; ink on silk
126.6 x 50.9 cm
Charles Bain Hoyt Collection 50.1459

Attrib. to Daoist Bai Yuchan (also known as Ge Changgeng), early 13th century
Three Daoist Immortals
Yuan dynasty, second half 14th century or slightly later
Hanging scroll; ink and color on silk
117.9 x 54.5 cm
Fenollosa-Weld Collection 11.4006

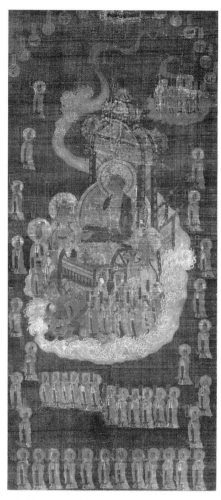

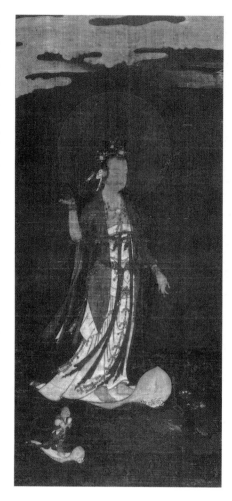

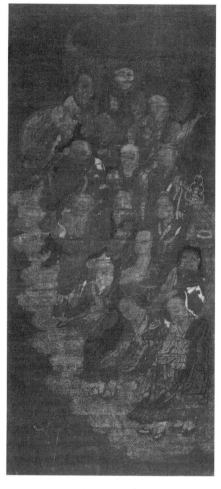

Anonymous

The Buddha of Blazing Light and Stellar Deities
Southern Song or Koryŏ dynasty (Korea), 13th century
Hanging scroll mounted as panel; ink and color on silk
126.4 x 55.9 cm
Fenollosa-Weld Collection 11.4001

Anonymous

Guanyin and Shancai Crossing the Sea
Southern Song dynasty, 13th century
Hanging scroll mounted as panel; ink and color on silk
88.3 x 41 cm
William Sturgis Bigelow Collection 11.6140

Anonymous

The Sixteen Lohans
Southern Song dynasty, 13th century
Hanging scroll; ink, color, and gold on silk
81.8 x 37 cm
William Sturgis Bigelow Collection 11.6144

Anonymous

Calligraphy of a Ci Poem by Su Shi in Clerical Script
Southern Song dynasty, 13th century
Round fan with lacquered bamboo handle; ink on silk
H. 50 cm, Diam. 27.3 cm
Asiatic Curator's Fund 1990.2

Qian Duanli, 1109–77
Calligraphy in Semi-Cursive Script
Southern Song dynasty, late 12th century
Album leaf; ink on paper
33 x 31.8 cm
Keith McLeod Fund 1996.245

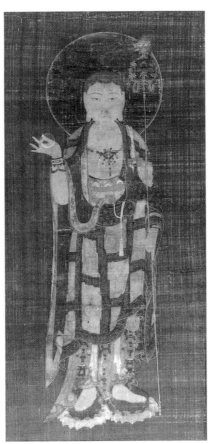

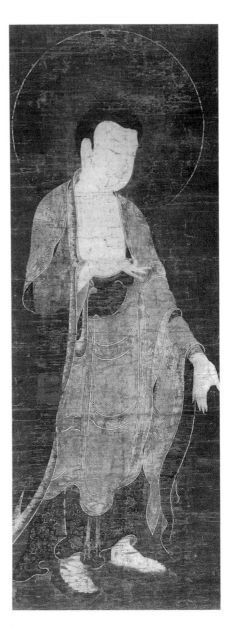

Anonymous
Dizang (Bodhisattva Ksitigarbha)
Korea, Koryŏ dynasty, late 13th–early 14th
century
Hanging scroll mounted as panel; ink, color,
and gold on silk
91.6 x 40.4 cm
William Sturgis Bigelow Collection 11.6139

Anonymous
Amitābha Buddha
Southern Song dynasty, mid-13th century
Hanging scroll mounted as panel; ink, color,
and gold on silk
100.2 x 37.2 cm
Denman Waldo Ross Collection 17.685

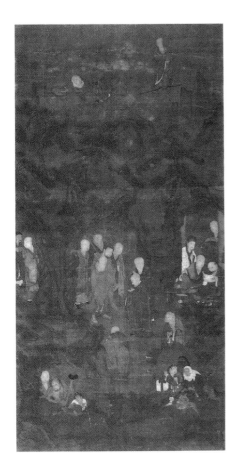

Anonymous
Buddha and Sixteen Lohans
Yuan dynasty, late 13th century
Hanging scroll; ink, color, and gold on silk
111.7 x 55.7 cm
William Sturgis Bigelow Collection 11.6155

Anonymous
A Hundred Geese
Yuan dynasty, late 13th–early 14th century
Handscroll; ink and light color on silk
22.3 x 223 cm
Charles Bain Hoyt Collection 50.1455

Chen Sheng and Chen Ning (late
13th–early 14th century)
*Illustration and Text to the Mahāparinirvāna
Sūtra (Jisha edition)*
Yuan dynasty, datable 1301
Album; woodblock print on paper
30.5 x 11.3 cm
Marshall H. Gould Fund 1984.415

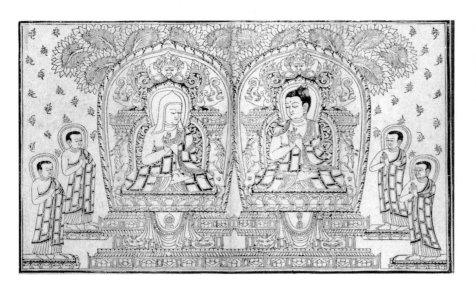

Anonymous
*Illustration and Text to the Guhya-samāya-
tantra-rāja Sūtra (Jisha edition)*
Yuan dynasty, datable 1301
Album; woodblock print on paper
30.5 x 11.3 cm
Marshall H. Gould Fund 1987.65

Anonymous
White Heron on a Snow-Covered Willow
Yuan dynasty, 14th century
Hanging scroll; ink and color on silk
66.8 x 37 cm
William Sturgis Bigelow Collection 11.6161

Anonymous
Five Lohans and Attendants at a Waterfall
Yuan dynasty, 14th century
Hanging scroll mounted as panel; ink and
color on silk
125.7 x 67 cm
James Fund 07.8

Anonymous
Five Lohans and Devotees with a Dragon
Yuan dynasty, 14th century
Hanging scroll mounted as panel; ink and
color on silk
125.7 x 67 cm
James Fund 07.9

Anonymous
Palaces with Figures in Landscape
Yuan dynasty, 14th century
Hanging scroll; ink and color on silk
99.5 x 143.5 cm
James Fund 08.120

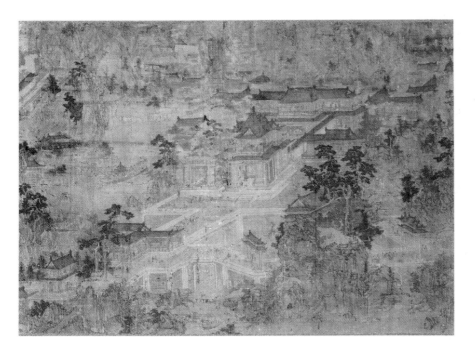

Anonymous
Four Oranges on a Leafy Branch
Yuan dynasty, 14th century
Round fan mounted as album leaf; ink and
color on silk
Diam. 22.8 cm
Chinese and Japanese Special Fund 14.66

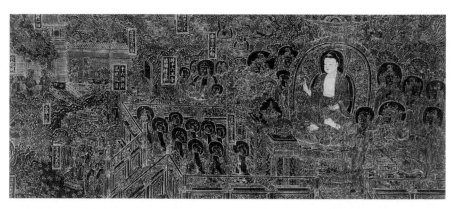

Yin Deshi (?)
Illustration to the Saddharmapuṇḍarīka Sūtra
Yuan dynasty, 14th century
Sūtra album mounted as hanging scroll; gold
on dark-blue paper
20.4 x 45.3 cm
Gift of Miss Lucy T. Aldrich 50.3605

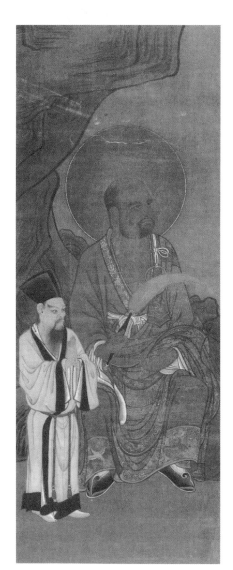

Anonymous (traditionally attrib. to Qian
Xuan, ca. 1235–after 1301)
Peonies and Butterfly
Yuan dynasty, 14th century
Hanging scroll; ink and color on silk
55 x 96.9 cm
Gift of Mrs. W. Scott Fitz 06.1899

Anonymous
Lohan with an Attendant
Japan, Kamakura period, 14th century
Hanging scroll mounted as panel; ink, color,
and gold on silk
96.1 x 38 cm
Anonymous Gift 1980.633

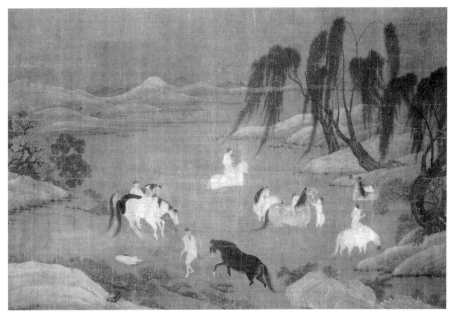

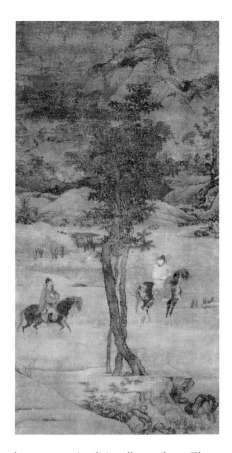

Anonymous (traditionally attrib. to Zhao Mengfu, 1254–1322)
Landscape with Two Horsemen
Yuan dynasty, late 14th century (?)
Hanging scroll mounted as panel; ink and color on silk
108.5 x 55.7 cm
James Fund 08.118

Anonymous (formerly attrib. to Zhao Mengfu, 1254–1322)
Grooms Washing Horses in a River
Qing dynasty, 18th century
Hanging scroll; ink and color on silk
116.8 x 173.8 cm
Denman Waldo Ross Collection 17.689

Anonymous (formerly attrib. to Zhao Mengfu, 1254–1322)
Horses under Willow Trees
Ming dynasty, 15th century
Hanging scroll; ink and color on silk
170.6 x 81.5 cm
Chinese and Japanese Special Fund 17.187

Anonymous (formerly attrib. to Zhao Mengfu, 1254–1322)
Mongol Hunters
Yuan dynasty, late 14th century
Hanging scroll; ink and color on silk
110 x 66.2 cm
Denman Waldo Ross Collection 17.746

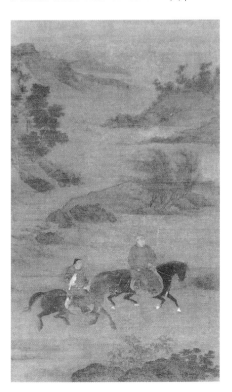

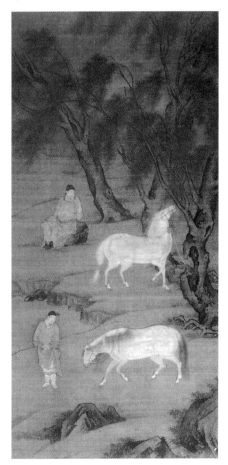

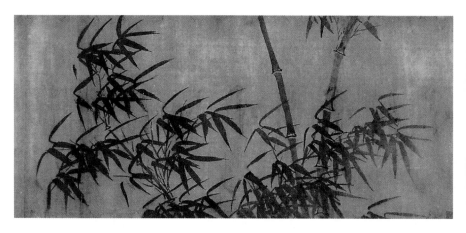

Anonymous (formerly attrib. to Guan Daosheng, 1262–1319)
Ink Bamboo (detail)
Ming dynasty, 17th century
Handscroll; ink on silk
28 x 135.8 cm
James Fund 08.133

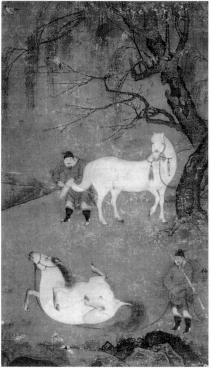

Anonymous (formerly attrib. to Zhao Yong, ca. 1289–ca. 1362)
Two Grooms and Horses
Ming dynasty, 15th century
Panel; ink, color, and gold on silk
121.3 x 70.8 cm
Gift of Mrs. Richard E. Danielson 48.1274

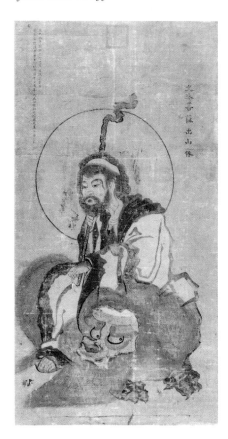

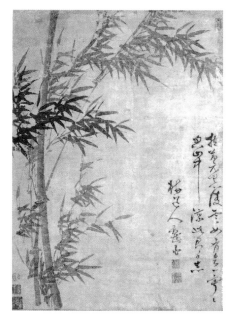

Anonymous (formerly attrib. to Wu Zhen, 1280–1354)
Bamboo
Ming dynasty, 17th century
Hanging scroll; ink on paper
75.2 x 54.3 cm
Chinese and Japanese Special Fund 15.907

Anonymous (inscription attrib. to Yu Ji, 1272–1348)
Wenshu (Mañjuśrī)
Ming dynasty, ca. 1578
Hanging scroll mounted as panel; hand-colored woodblock print
118.6 x 61.8 cm
Gift of Robert Treat Paine, Jr. 55.988

Anonymous
Landscape with Palaces in Blue-and-Green Style
Yuan dynasty, second half 14th century
Round fan mounted as hanging scroll; ink, color, and gold on silk
Diam. 30.6 cm
William Sturgis Bigelow Collection 11.6158

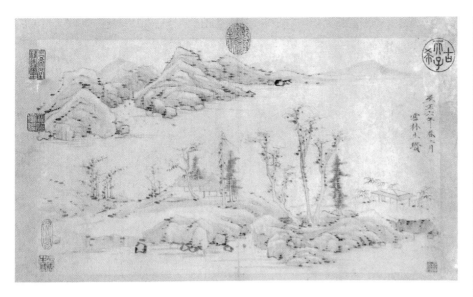

Anonymous (formerly attrib. to Ni Zan,
1301–74)
Landscape
Qing dynasty, 18th century
Album leaf mounted as panel; ink on paper
31 x 54.5 cm
Gift of Mrs. Richard E. Danielson 48.1277

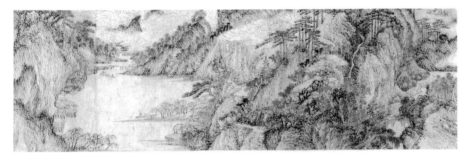

Anonymous (formerly attrib. to Wang
Meng, 1308–85)
Scenery of Mount Taibai
Ming dynasty, 15th century
Handscroll; ink and color on paper
28.8 x 274.5 cm
Keith McLeod Fund 55.618

Anonymous (formerly attrib. to Fang
Congyi, act. 1340–80)
Ink Landscape (detail)
Qing dynasty, 19th century
Hanging scroll; ink on paper
84.7 x 37.4 cm
Chinese and Japanese Special Fund 15.905

Anonymous
Landscape in Guo Xi Style
Yuan dynasty, second half 14th century
Hanging scroll; ink on silk
30.5 x 51.8
William Sturgis Bigelow Collection 11.6174

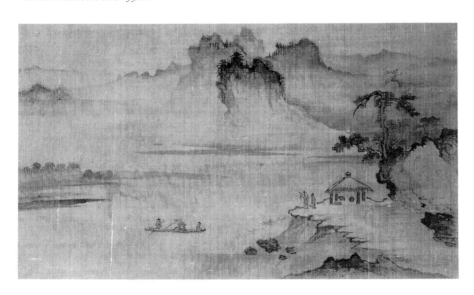

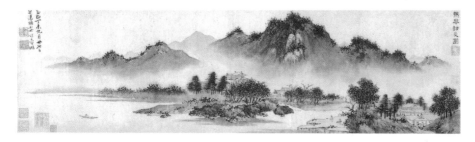

Anonymous (formerly attrib. to Fang Congyi, act. 1340–80)
Landscape
Ming dynasty, 17th century
Handscroll; ink and light color on paper
94.5 x 26.2 cm
Chinese and Japanese Special Fund 20.758

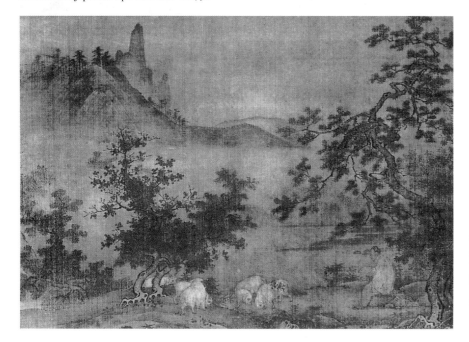

Anonymous
Śākyamuni
Yuan dynasty, late 14th century
Hanging scroll; ink and color on silk
125.4 x 59.2 cm
William Sturgis Bigelow Collection 11.6157

Anonymous
The Daoist Wang Chuping and His Sheep
Yuan dynasty, late 14th century
Hanging scroll; ink and color on silk
35.6 x 50.8 cm
Fenollosa–Weld Collection 11.4824

Anonymous
Snowscape
Yuan dynasty, late 14th century
Oval fan mounted as album leaf; ink on silk
20.9 x 17.4 cm
Denman Waldo Ross Collection 17.738

Anonymous
Bamboo and Melons
Yuan dynasty, late 14th century
Hanging scroll; ink and color on paper
50.3 x 32.4 cm
Chinese and Japanese Special Fund 15.903

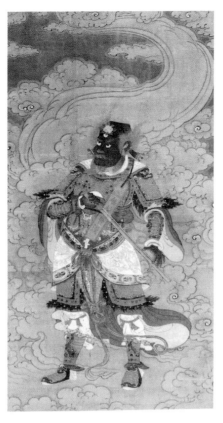

Attrib. to Jiang Zicheng (act. late
14th–early 15th century)
Daoist Protector Against Plague
Ming dynasty, late 14th–early 15th century
Hanging scroll mounted as panel; ink and
color on silk
124 x 66.1 cm
Fenollosa-Weld Collection 11.4008

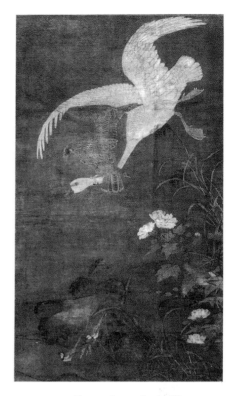

Anonymous (formerly attrib. to Bian
Wenjin, ca. 1355–ca. 1428)
Falcon Striking a Swan
Yuan dynasty or later, late 14th century
Hanging scroll; ink and color on silk
159.7 x 94.2 cm
Chinese and Japanese Special Fund 14.77

Anonymous
Eight Horses and Grooms
Yuan dynasty, late 14th century
Hanging scroll mounted as panel; ink and
color on silk
124 x 95 cm
Denman Waldo Ross Collection 17.742

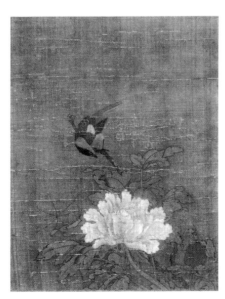

Anonymous
Flower and Bird
Yuan dynasty, 14th century or slightly later
Hanging scroll; ink and color on silk
34.9 x 27.1 cm
William Sturgis Bigelow Collection 11.6145

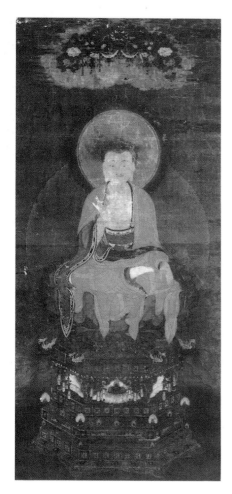

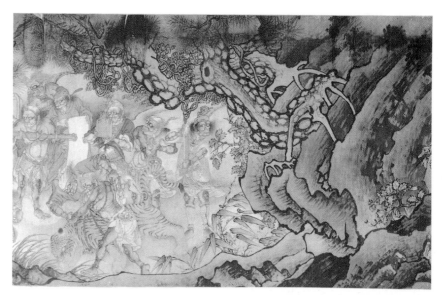

Anonymous
Śākyamuni on a Lotus Throne
Yuan dynasty, 14th century (?)
Hanging scroll mounted as panel; ink, color,
and gold on silk
140.1 x 64.7 cm
William Sturgis Bigelow Collection 11.6141

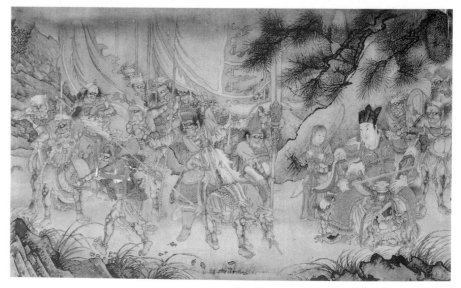

Anonymous
Daoist Deities Exorcising the Mountain
(details)
Ming dynasty, 15th century
Handscroll; ink and color on silk
61 x 806 cm
William Sturgis Bigelow Collection 13.481

Anonymous (formerly attrib. to Du
Dashou, early 17th century)
*Poet Li Bai Drinking with Emperor
Minghuang*
Ming dynasty, early 15th century
Handscroll; ink and light color on silk
29.4 x 82.8 cm
James Fund 08.81

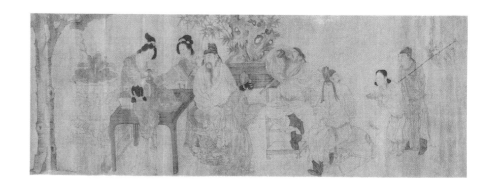

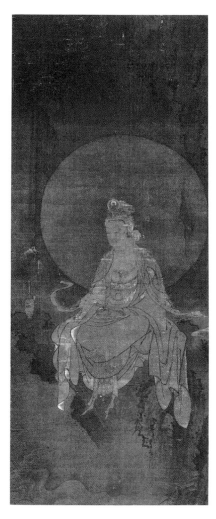

Anonymous (traditionally attrib. to Jin Shi, act. mid-15th century)
Guanyin of Mount Putuo
Yuan dynasty, late 14th century
Hanging scroll; ink, color, and gold on silk
91.3 x 38 cm
Charles Bain Hoyt Collection 50.1457

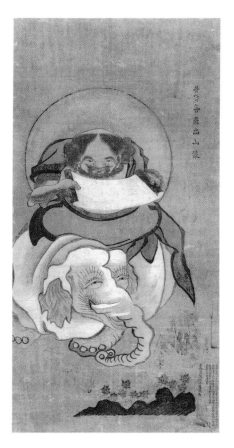

Anonymous
Puxian (Samantabhadra)
Ming dynasty, inscription dates to 1578
Hanging scroll mounted as panel; hand-colored woodblock print
118.4 x 61.8 cm
Gift of Robert Treat Paine, Jr. 55.989

Kano Tomonobu (act. mid-19th century)
Copy after the Song Lohan at Daitoku-ji, Kyoto
Japan, Meiji period, second half 19th century
Panel; ink and color on paper
132.9 x 61.5 cm
Fenollosa-Weld Collection 11.4988

Attrib. to Andō Hirochika
Copy after Yuan Painting:
The Chan Master Niaoke
(see cat. 116)
Japan, Meiji period, late 19th century
Panel; ink, color, and gold on paper
92 x 40.6 cm
Fenollosa-Weld Collection 11.4984

Index
of Artists

Numbers in *italics* refer to pages on which reproductions of works by or presently attributed to the artists are found. Numbers in **boldface** type indicate locations of catalogue entries for works by or presently attributed to the artists; black-and-white reproductions will also be found on these pages.